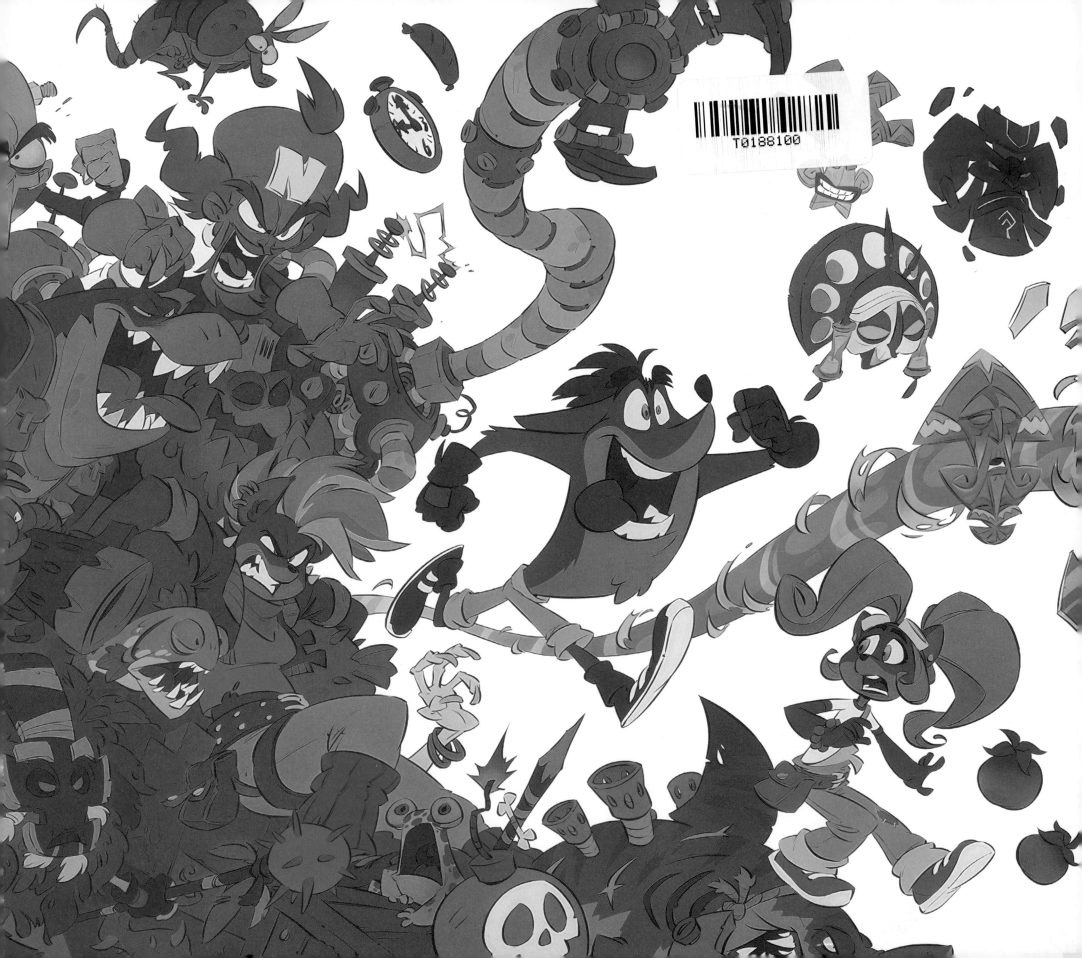

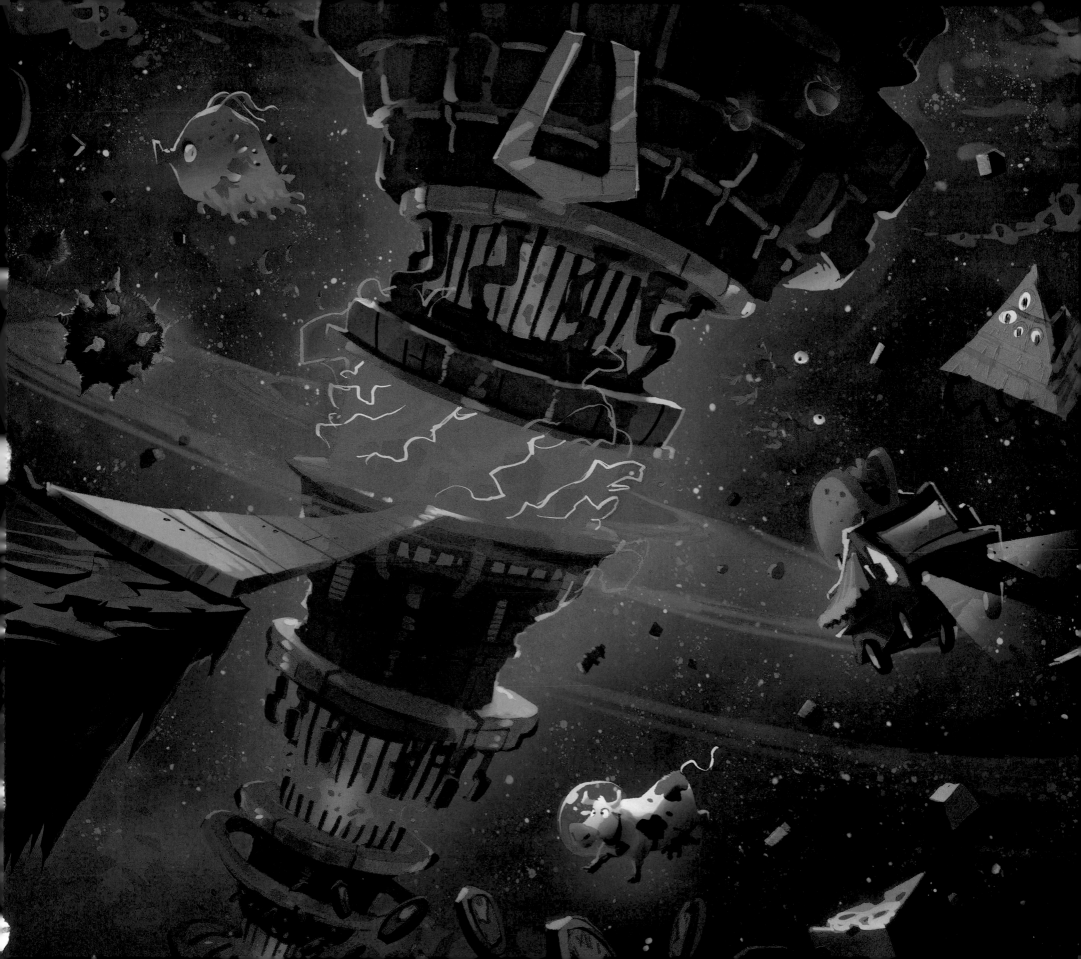

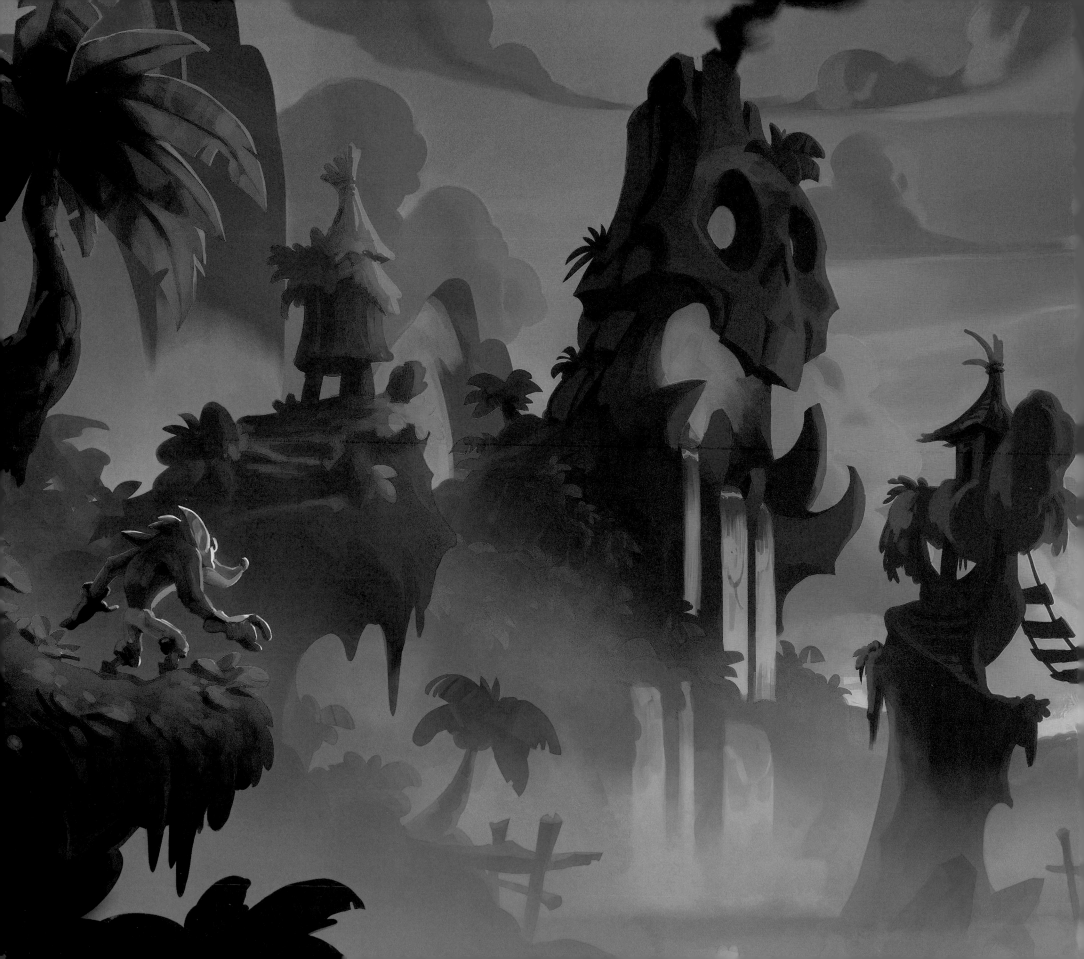

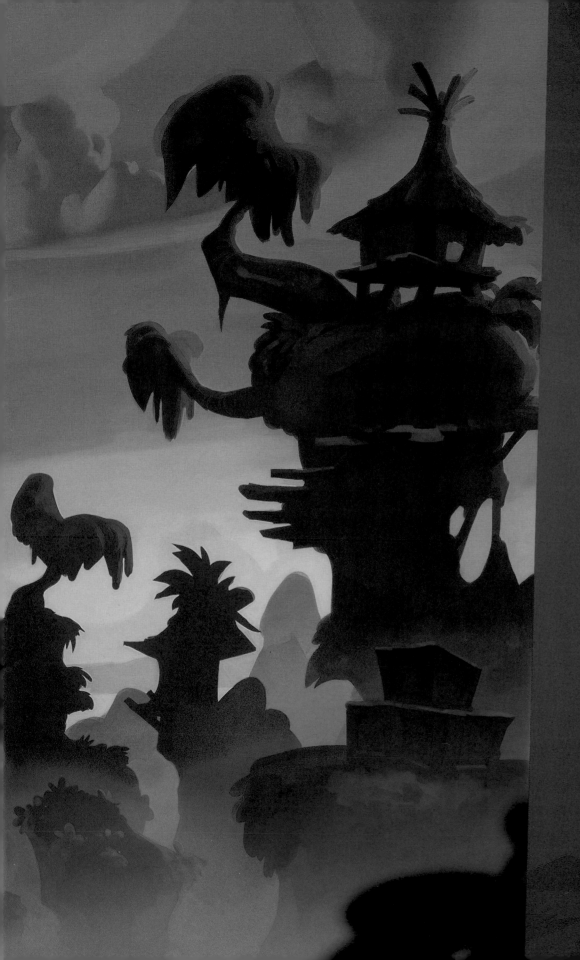

THE ART OF
CRASH
BANDICOOT 4
IT'S ABOUT TIME

WRITTEN BY **Micky Neilson**

FOREWORD BY **Josh Nadelberg**

ACTIVISION.

Toys For BOB

BLIZZARD
ENTERTAINMENT

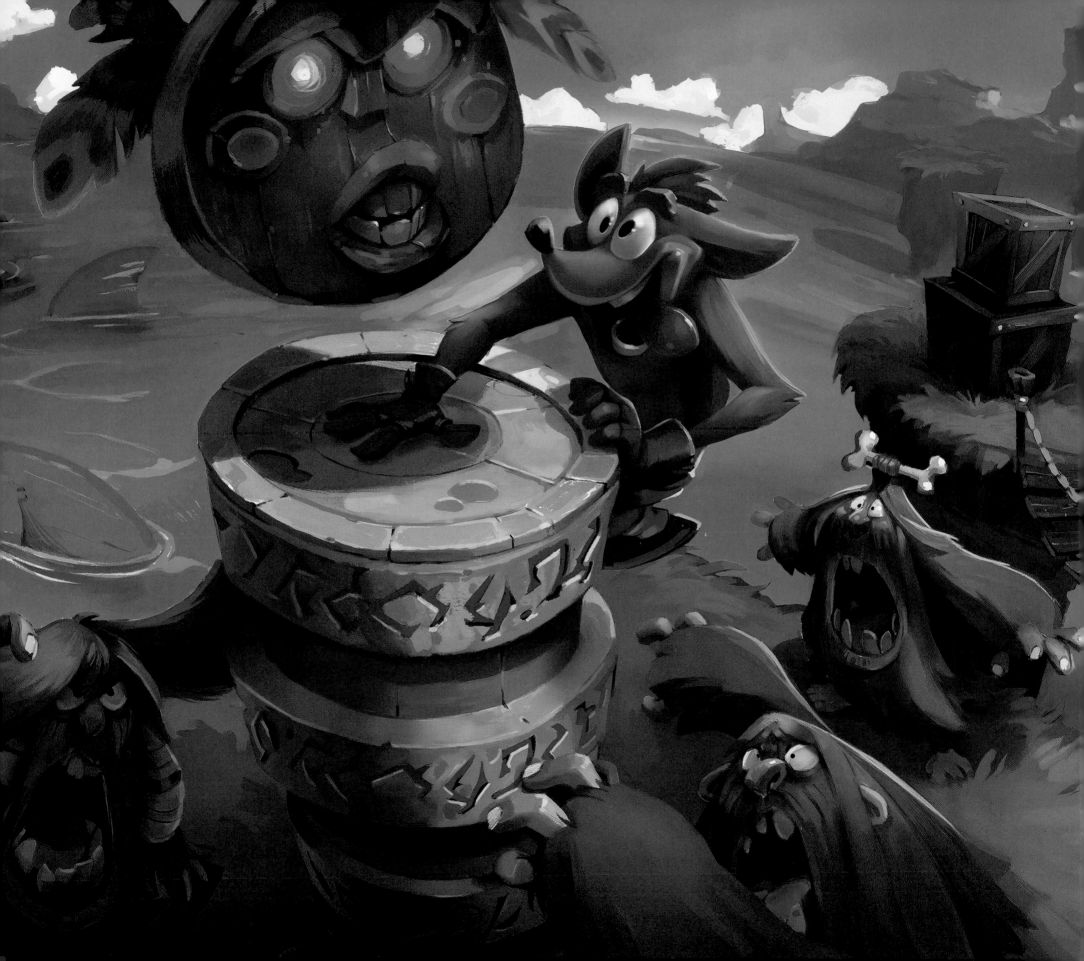

WRITTEN AND EDITED BY MICKY NEILSON
ART DIRECTION JOSH NADELBERG
CREATIVE CONSULTATION ANTHONY DELUCA,
PHIL HOFMAN, SCOT MCCARON, SUMMER NAZER,
KELLY PATT, JOSEPH PEREZ, RYLEE SHUMWAY

ACTIVISION/BLIZZARD
PRODUCTION MIKE GONZALES, DEREK ROSENBERG, ANNA WAN
DIRECTOR, CONSUMER PRODUCTS BYRON PARNELL
LEGAL KATE OGOSTA, FRANCES JENSEN, CHRIS SCAGLIONE
SPECIAL THANKS BRETT BEAN, MANDY BENANAV,
FLORIAN COUDRAY, BRUN CROES, MAX DEEGAN, ROB DUENAS,
JEAN BRICE DUGAIT, JOHANNES FIGLHUBER, ILKA HESCHE,
RON KEE, NICHOLAS KOLE, SIMON KOPP, JAMES LOY MARTIN,
THOMAS MICHAUD, JEFF MURCHIE, DIDIER NGUYEN,
VINOD RAMS, GERAUD SOULIE, KHOA TRAN VIET, PAUL YAN,
OLEG YURKOV, AIRBORN STUDIOS

DESIGNED BY CAMERON + COMPANY
PUBLISHER CHRIS GRUENER
CREATIVE DIRECTOR IAIN R. MORRIS
DESIGNER ROB DOLGAARD
PRODUCTION AMY WHELESS

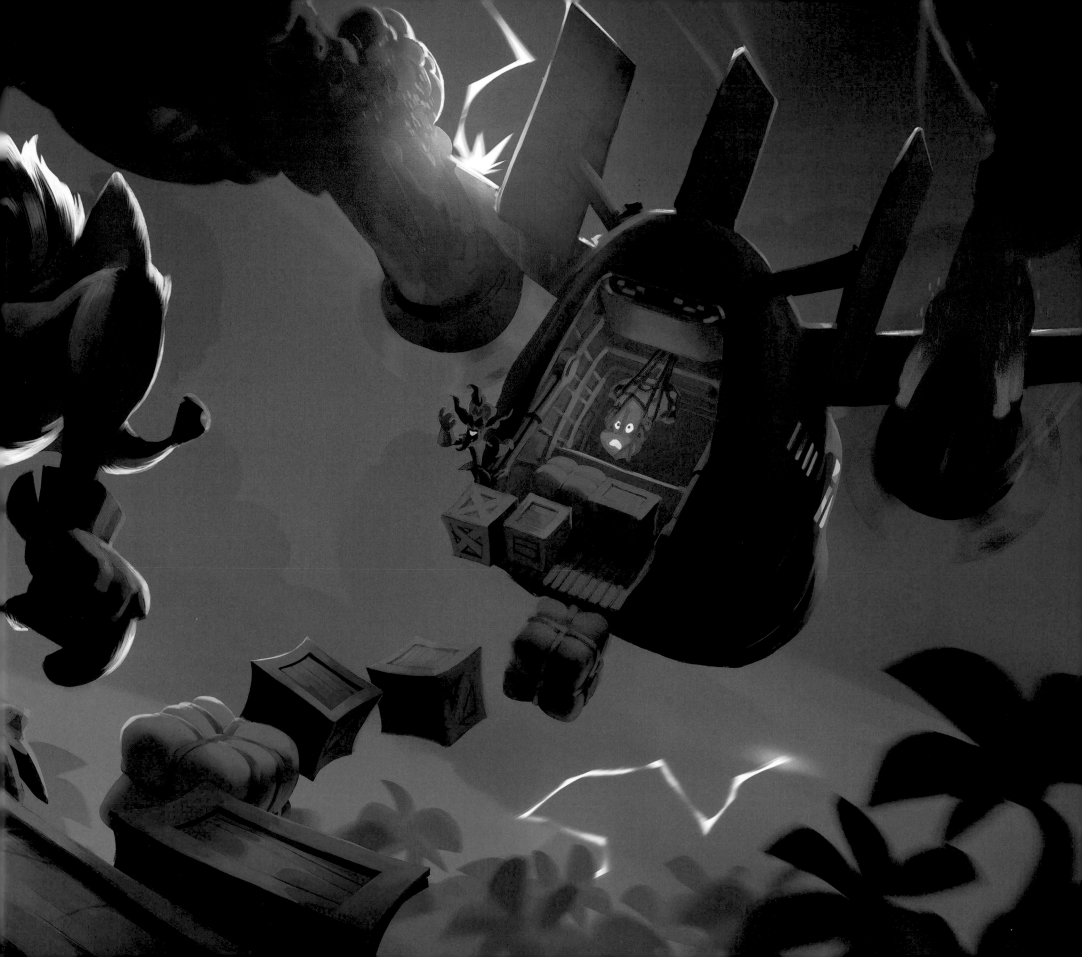

BY JOSH NADELBERG

FOREWORD

Whenever we're working on a new project I like to flood the office with artwork. Dozens of eight-foot-tall black foam core boards line the hallways and common spaces of the studio, each covered in pinned-up prints of character designs, environments, and visualizations of fun gameplay scenarios. Pulling the work out from the digital realm and into our physical space helps everybody on the team become immersed in the world we're creating and provides a ton of insight into the evolution of the visual development process. With Crash 4, things actually got a little out of hand with black boards stacked on top of black boards leaning up against every free inch of wall, desk, or tiki bar that I could find. Yes, TFB is really decorated like a tiki bar and a pirate ship! This created a lot of work moving everything into storage closets and meeting rooms whenever we'd have visitors to the studio! No leaks, right??? At one point early on I remember there being an entire wall covered in iterations of Crash's character design. When I say an entire wall, I mean literally hundreds of sketches of Crash from the hands of different artists showing Crash in a variety of styles and poses, exploring a full range of expressions and interactions, with each sketch adding something to the conversation we were having: "Who is Crash Bandicoot, and what (as the core design of the game that would drive the style and direction of the other characters and the world we would build around them) should he look like?"

Now, our friends at Vicarious Visions had already brought Crash back in spectacular fashion with the *N. Sane Trilogy* just a few years ago. They did for Crash what we aspired to do for Spyro in the Reignited Trilogy. They put on those rose-tinted glasses of nostalgia and brought back to life in vivid, detailed HD graphics the characters and worlds that players remembered from the late '90s. They knocked it out of the park, and fans loved it! So it felt like a big risk when we set out to define a new style and direction for *Crash 4*, but we knew we needed to set Crash 4 apart from the remasters. This was a

brand-new game, and we wanted people to know that from the moment they set eyes on it. So... Who is Crash Bandicoot? Where do we look for inspiration? How do we refresh something that was just refreshed?

The experience of making the Reignited Trilogy turned out to be the perfect test drive for the challenges ahead of us on *Crash 4*. To bring back Spyro we honed in on an art style that was defined by clean shapes, soft gradients, and just enough "wonk" to give the world a playful and lived-in fairytale feel. That worked perfectly for the little purple dragon, but Crash isn't a fairytale. There have been plenty of iconic video game characters, but the thing that makes Crash stand out from the crowd is how perfectly he captures the essence of classic cartoons. You can clearly see their inspiration in his original design, in the way he moves, his extreme expressivity, and his irreverent tone. To capture that, we wanted to take that core aesthetic direction of Spyro and dial things up to eleven! Where Spyro's world was whimsical and playful, Crash's world would be wild and chaotic. Where Spyro charmed and delighted, Crash needed to "Whoa!" and wow!

When you're lucky enough to work with so many talented artists on a project like this, making decisions can be insanely difficult. Going in one direction oftentimes means leaving other incredible ideas behind. With Crash, however, the team managed to bring together all of the best stuff, taking an expression we loved from this sketch, an inspiring pose from that one, the way the chin flowed into the chest just right from another, and found a way to distill it all into something fresh and exciting. At the end of the process, standing in front of that wall of amazing work you could see a dozen Crashes that would have been great directions, but in the final design you could see hints of them all, and the end result was a Crash who was more than who we thought he could be when we started. He is wild and chaotic, whimsical and playful, charming and delightful, and he still wows and "whoas" like all good Crashes should!

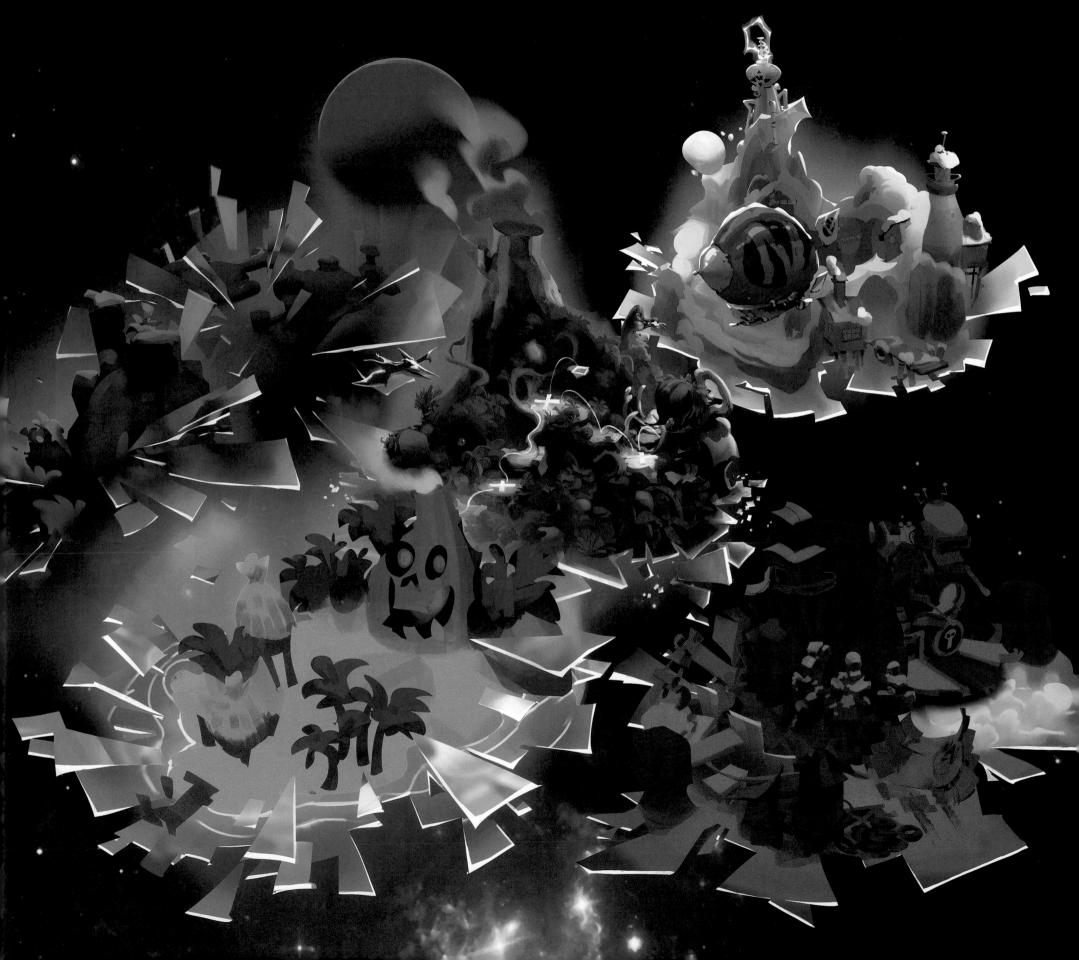

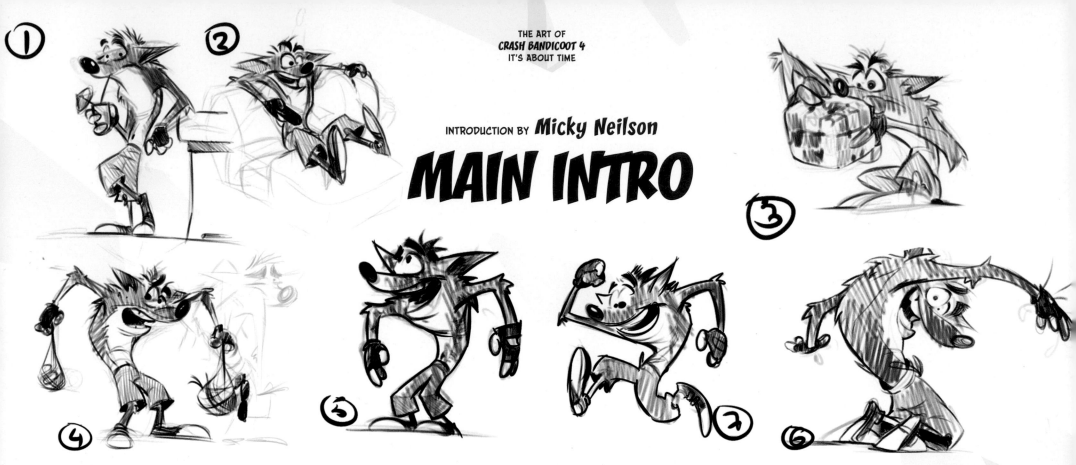

INTRODUCTION BY **Micky Neilson**

MAIN INTRO

WILD RIDE

Since its first release in 1996, the Crash Bandicoot series has remained a staple of gaming fans worldwide, spawning numerous sequels and spinoffs, as well as a wildly successful remaster–the *Crash Bandicoot N. Sane Trilogy*–in 2017.

When Toys for Bob set out to develop an all-new entry in the Crash franchise, they immediately focused on ways to create a fresh, bigger, and more exciting game than any that had come before, while still capturing the hyperkinetic, zany, irreverent spirit that legions of Crash Bandicoot fans had come to know and love.

GOALS!

The team knew early on that any new addition to the series would need to retain all of the elements that made Crash Bandicoot unique against other platformers. To gain a better understanding of why Crash stood out, the team dusted off old consoles to play the original games on. They compared these against the remaster, and on top of all that, they not only pored through Crash gaming community channels, they also engaged with hardcore fans within the studio.

Once the team had a clearer idea of why Crash–especially the first three games–and the *N. Sane Trilogy* resonated so strongly with gamers, they began contemplating how to put a fresh spin on the franchise.

TECHNICALLY SPEAKING...

Next the team took a close look at the mechanics of the original games, a process described by Studio Head Paul Yan:

> *"We started to do some design and technical dissection of what those previous games were mechanically–how they were sequenced, the types of challenges they had asked, and we started to chart them all out."*

With this "technical dissection" complete, Toys for Bob decided they would add two new "axes" of gameplay flavor...

QUANTUM LEAP

One of these axes was inspired by a game mechanic and character, Aku Aku– a talking mask who gives Crash Bandicoot brief invulnerability. This led to experimentation with other "Quantum Masks" that would bestow additional abilities on the player. According to Art Director Josh Nadelberg:

> *"Masks are a very common theme in the Crash Bandicoot games, so it just felt right to introduce these awesome new powers through masks."*

After a period of prototyping, Toys for Bob landed on four different masks, all of which would provide Crash with unique powers. In the words of Paul:

> "Once we had locked those four then it was this very methodical approach of, 'How do we sprinkle this along the course of dozens of levels in ways that would create a variety of challenges for Crash and would be able to escalate in their difficulties toward the end in interesting ways?'"

So if masks were the first axis, what was the second? Glad you asked!

CHARACTER STUDY

In addition to introducing an updated Crash for this new adventure, the Toys for Bob team was inspired to include even more playable characters in the game. In the words of Josh Nadelberg:

> "You've got Crash, you've got Coco, so the two of them are a pair; throughout the game you can push a button and swap which one you want to play. The idea is that they're on an adventure together and you get to choose which one you want to be along the way."

But Toys for Bob didn't stop there. They put a fresh spin on classic favorites such as Dingodile and Neo Cortex, and they aggressively pursued a dramatic redesign of Tawna Bandicoot. And yes, the studio made these additional characters playable as well.

Of course vibrant characters like these need an equally dynamic world to play in. Once again, Toys for Bob rose to the occasion.

NEXT LEVEL

One of the challenges encountered early on was to create what the team envisioned as a "classic Crash Bandicoot game" while at the same time communicating the world's massive scale. In the words of Josh:

> "The camera's most often looking down, so we had to really think hard about how we could create moments that would allow us to present larger vistas and make the world feel bigger because it really is. The landscapes feel huge. What we really want the player to feel is that they can see what's coming from far away at certain points in the game. At the beginning of one level you might actually see in the distance the next level. So we've tried our best to make the world feel big while also respecting the core gameplay of the franchise."

It's not just the size of the levels, however, that sets this new adventure apart from previous outings...

ELEMENTS OF STYLE

Josh pushed the artists to create a world that was "super wacky and full of motion and energy everywhere you look"—a directive that was applied throughout the process of development.

Everything in the game, from main characters, to the backgrounds, to the hazards, to the supporting characters, was carefully cultivated to hit just the right tone, one that would be faithful to the franchise, while allowing Toys for Bob to put their own unique stamp on the series. This process was not an unfamiliar one, especially after the team's recent remastering of another '90s classic character, Spyro the dragon. Per Josh:

> "The aesthetic that we developed on SPYRO REIGNITED TRILOGY was helpful on Crash. There's been crossover between the two characters, so there were similarities in style. That said, with Spyro there's a storybook charm that we were trying to evoke. Crash is much more wild and zany and edgy, so we wanted his world and all of the designs to reflect that to a certain degree. We asked the artists to push the wonkiness to a place that feels almost a little chaotic, just like Crash himself. The style is over the top and a little out of control."

Such time-honored franchises carry a huge responsibility as well, one recognized by the Toys for Bob team. From Paul:

> "We're just a lot more sensitive to things people remember and cherish from their past because we're talking about memories that people had in their adolescence and as they were growing up; these are formative years in their gaming experience."

The team's hard work, sensitivity, and creative passion all paid off, as evidenced by the amazing art collected in this book. Over the following pages we'll explore every angle of the game's concept art, from Crash himself to the supporting characters, the Quantum Masks, and the levels, props, and minor characters that all coalesced to create the crazy, unforgettable, and wildly imaginative world of Crash 4.

So what are you waiting for? It's about time... for you to jump right in!

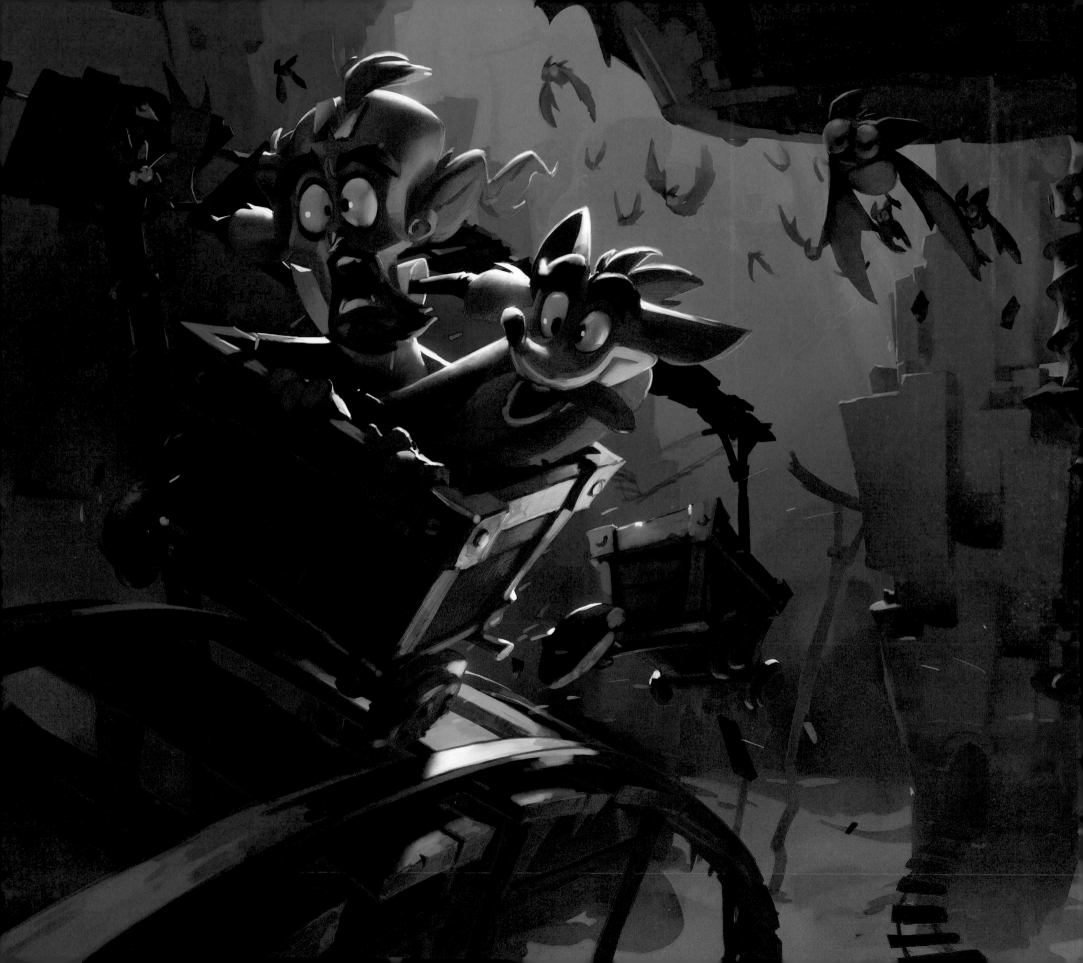

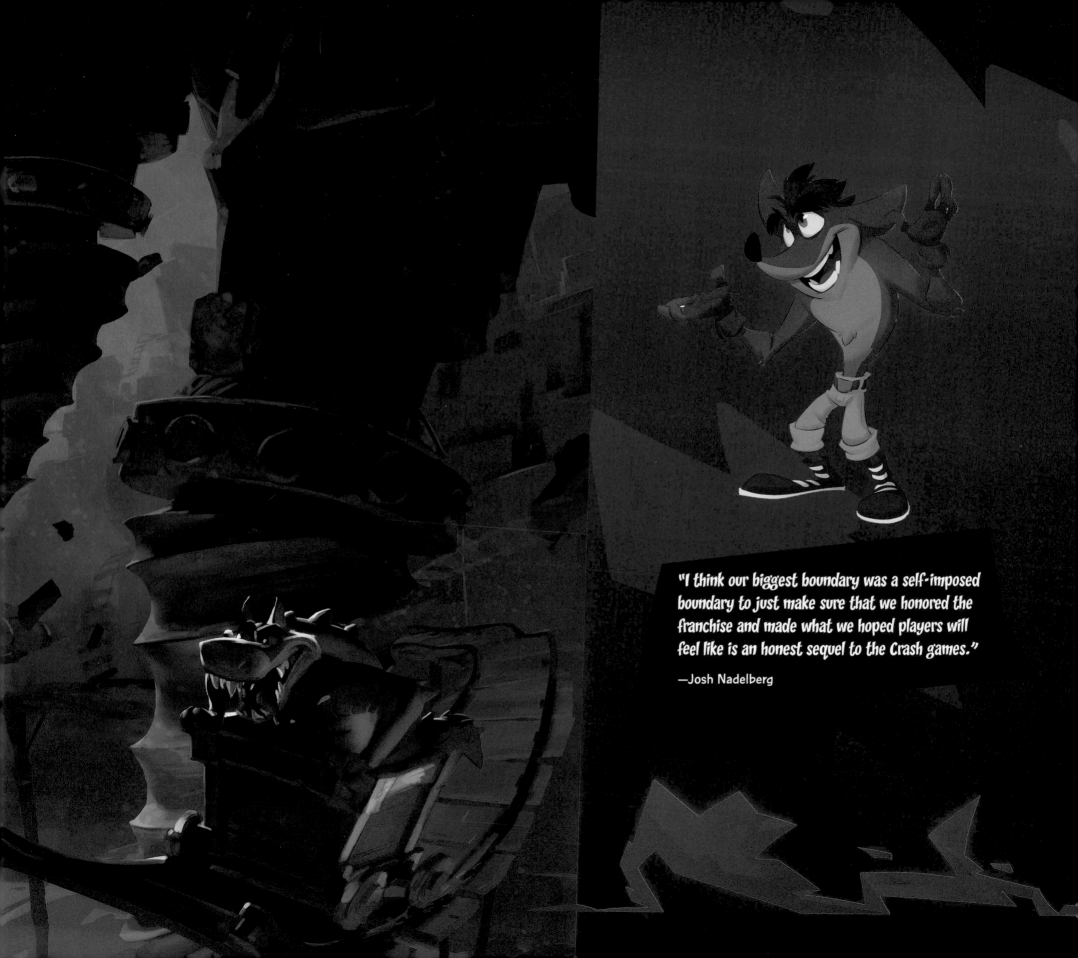

"I think our biggest boundary was a self-imposed boundary to just make sure that we honored the franchise and made what we hoped players will feel like is an honest sequel to the Crash games."

—Josh Nadelberg

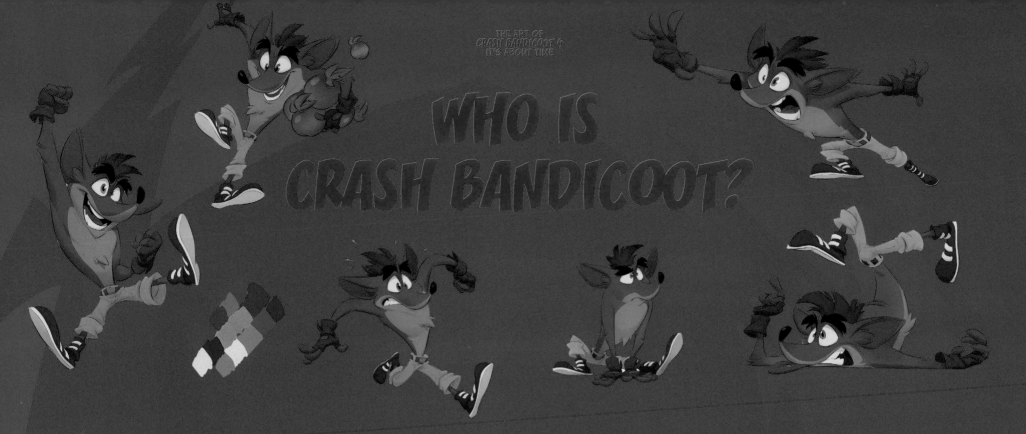

WHO IS CRASH BANDICOOT?

GETTING TO KNOW CRASH

Early on, Toys for Bob explored several different versions of Crash in an effort to nail down the character's new look without changing it too dramatically from the original. Per Art Director Josh Nadelberg:

"For us it was really an exercise as a studio in figuring out 'Who is Crash Bandicoot?' We realized that people had very different ideas about him as a character."

Some people viewed Crash as simply wild and out of control, while others saw him as a troublemaker who constantly stumbles into bad situations but miraculously makes his way through them. Again from Josh:

"There was a lot of conversation with the whole leadership team to just understand who this guy was. We ended up honing in on this idea of Crash as this dude who's always in the wrong place at the wrong time. He just manages to get himself out of all these crazy situations in a heroic way, but he's not your classic hero."

So what would this updated Crash Bandicoot look like? Such was the question posed to an all-star squad of eager concept artists, each of whom set about answering it in their own way.

BANDICOOT OF A THOUSAND FACES

Each artist tackled the assignment from a different angle, with guidance at various phases from Josh Nadelberg.

Rob Duenas imagined a multiplicity of Crashes, different versions from different dimensions, each with his own unique style and flavor.

James Martin called upon memories of Crash from childhood, exploring the round shapes of the old concept art as well as the more angular version of the original in-game model.

Oleg Yurkov took a more playful approach, viewing Crash as a human child, acting out various scenarios through a variety of animations and poses.

Nico Saviori pursued a variety of different styles, beginning with a "heavy and grotesque" approach, which was later refined to a more "goofy" and "soft" version.

ITERATION, REITERATION

The job of combining the most suitable elements from all of the various explorations fell to artist and illustrator Nicholas Kole.

As with many of the other artists, Nicholas was just coming off of work on the *Spyro Reignited Trilogy*, a situation that in the beginning made finding his footing with Crash tricky. In Nicholas's words:

"There was a bit of an adjustment period because while they're similar games, they're related and you obviously compare, they're very different in tone. So I think at the beginning I personally was having a little bit of a hard"

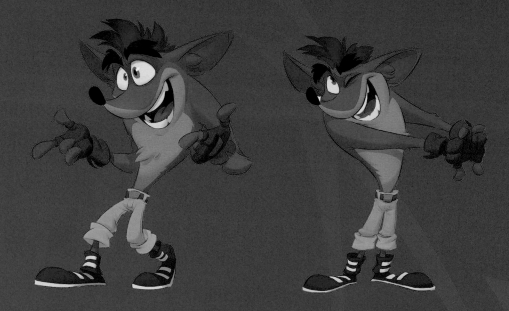

time catching the right tone, and the group in general, we were all just kind of coming around to sort of feel out what was distinct about Crash's world and Crash's character from Spyro and that world."

Recalling his "teenage mindset," Nicholas attempted a variety of styles, from edgy and aggressive to cartoony to cute and "super stylized."

"We were just kind of triangulating, and it was an adjustment period, and every time I would draw something we would talk about 'Is this right?' What's working, what's not?' I think there's a process at the beginning of every project where you really have to catch the scent of it. It's like calibrating, you know? And you want to calibrate to the frequency, tone to the frequency of Crash. I tried too edgy, I tried too cute, and I was realizing that it was more about the type of character Crash is. And of course at this point there's a whole team of other artists who are taking whacks at it as well. So their work started to come in and we started to bounce off of each other's vibe."

WAIT, A BANDICOOT'S A REAL THING?
While many artists utilize reference during the concepting phase of their work, for Nicholas, real-world reference didn't prove particularly helpful:

"Every time I tried to use reference, like real photo reference as part of the drawing process, it would start to feel less and less like Crash Bandicoot no matter who I was drawing. I think for me a model for how to approach the project is with Crash himself, who looks kind of not at all like a bandicoot. He looks like someone saw a bandicoot once and was trying to draw one from memory but it had been a couple years."

WHOEVER HAD THE TUSKS, HE'LL BE MISSED
In the end, landing on the final look of Crash Bandicoot was most definitely a team effort. Again from Nicholas:

"There's an anecdote about the blind men and the elephant, you know, where one of them has the tail and one of them has the ears and one of them has the trunk and they're all trying to explain what an elephant is—I think all of us had a piece of Crash. Somebody had the trunk, like 'he's totally wacky' and someone else was like 'he's got an edge to him,' or 'he's kind of a dork,' and all of that needed to boil together. So I actually got to take my stuff that I had been developing as well as their stuff and kind of bring it home, which I was really excited to do. I felt really lucky."

STRETCHING EXERCISES
At this stage, although Crash's look had been relatively nailed down, the concept artists still hadn't reached the finish line. One final consideration was how the new look would translate to an actual 3D model. In some cases Nicholas took the exploratory poses drawn by other artists and restyled them in the new and improved Crash's image. According to Nicholas:

"No single concept is really able to capture everything, especially in a concept that's meant to be modeled from because Crash is so much about being in motion and squashing and stretching and reacting to his circumstances. It's really more of an exploration, exploring those shapes and pushing them to see 'Can we do this?' 'Can we do that?' 'What needs to change?' I think that really helped with the whole team,—the sculptors and the animators and everybody who was gonna be a part of this—just to see poses that had that energy and sort of defined the parameters for where this was likely to go."

One interesting challenge for the 3D modelers came in the form—or lack thereof—of Crash's neck. Again from Nicholas:

"That was one of the biggest challenges on Crash himself is that he doesn't canonically have a neck. He's just shoulders and then a head. It was actually kind of a big technical challenge to pull that off just right."

Neck or no neck, the team eventually landed on a version of Crash that combined all of the best elements from the various explorations: And despite the many different approaches, in the end, Toys for Bob found their elephant. Or in this case, their bandicoot.

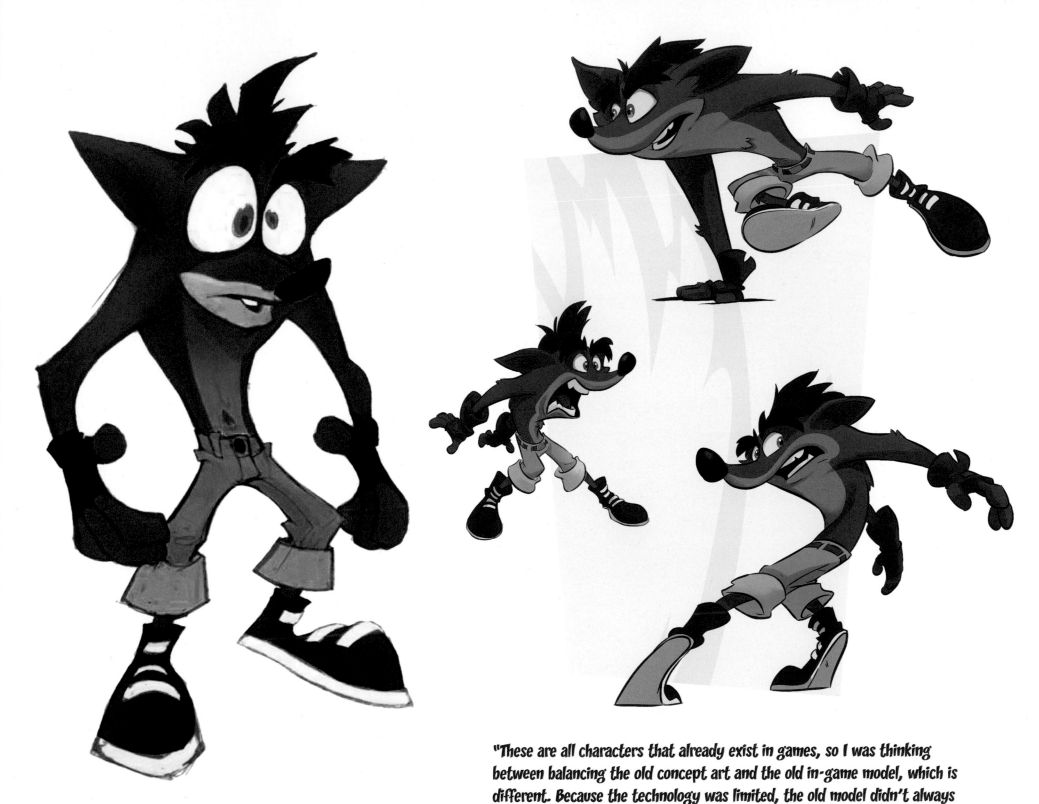

"These are all characters that already exist in games, so I was thinking between balancing the old concept art and the old in-game model, which is different. Because the technology was limited, the old model didn't always match the concepts. Also, balancing the memory I had as a kid. I had a strong idea of what these characters were, so I had to balance those three things."

—James Martin

WHO IS CRASH BANDICOOT?

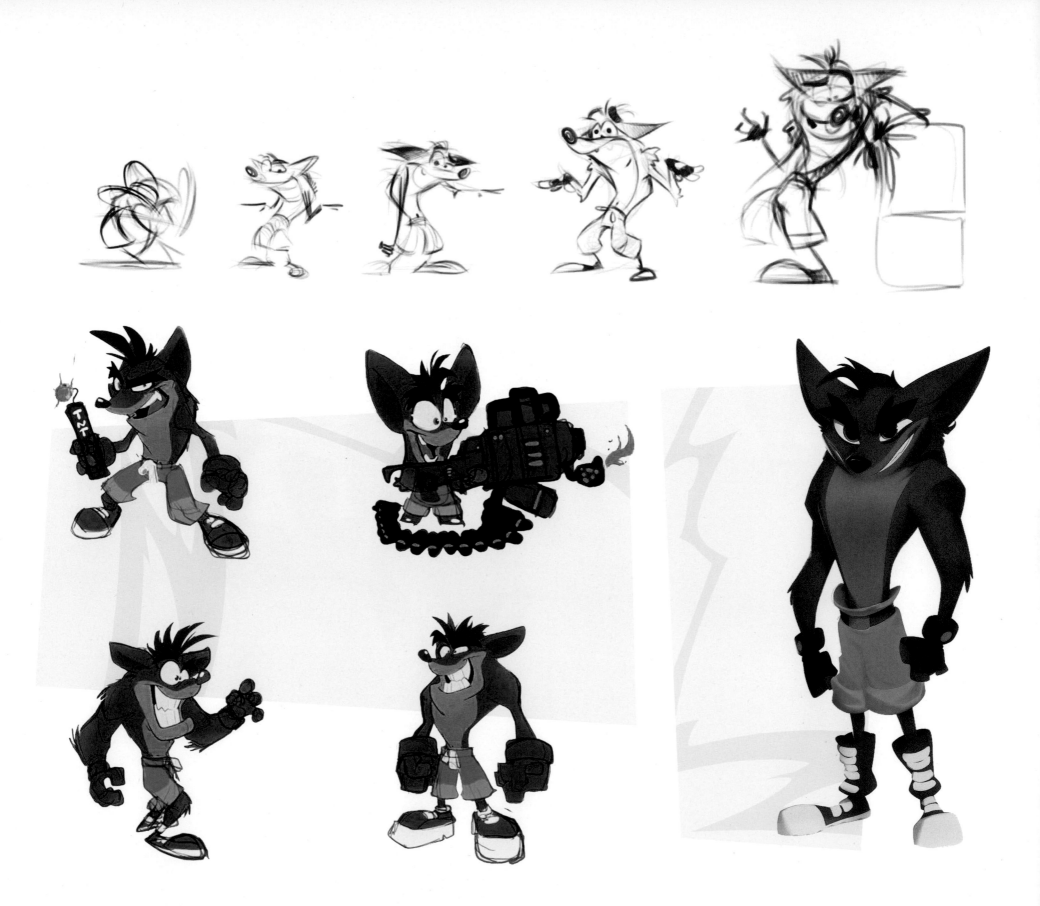

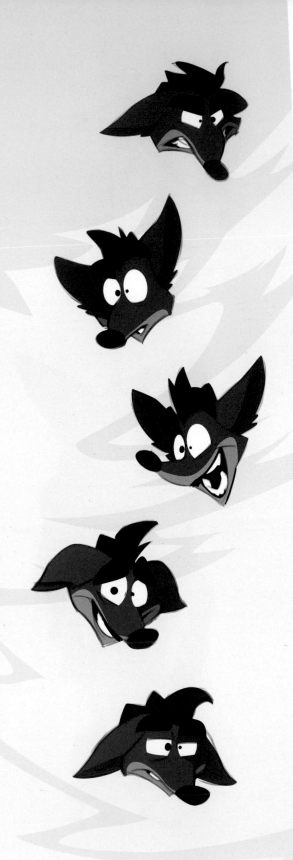

"These early sketches by Ryan might have been the first to omit the fleshy color around his mouth and just stick with a two-tone fur treatment. That felt like the right choice the moment we saw it. You'll note he also gave Crash a chin, which was something we felt was too big of a departure. Having a neck/chin/chest/mouth is one of Crash's defining features, after all..." —Josh Nadelberg

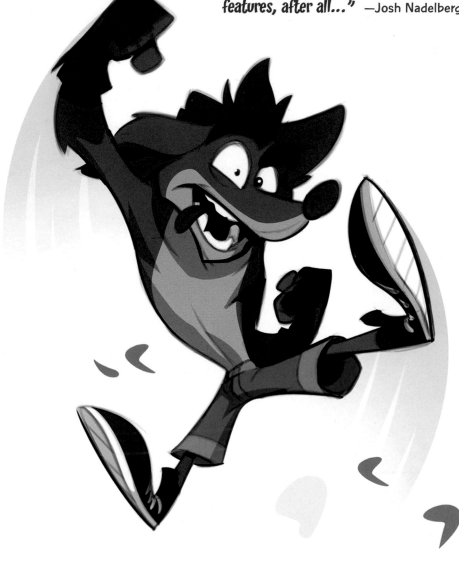

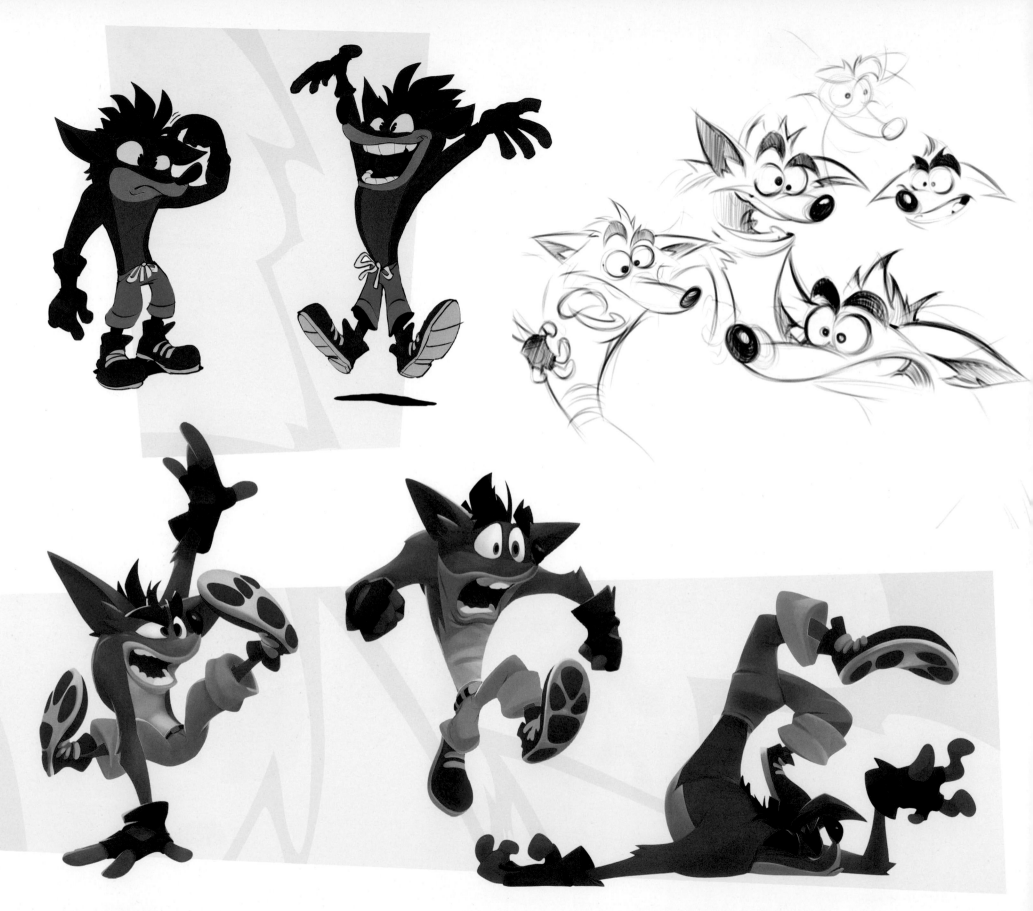

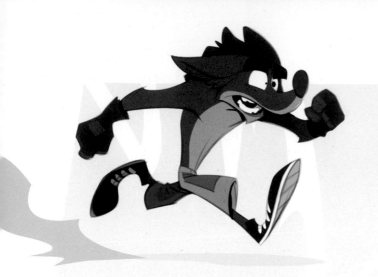
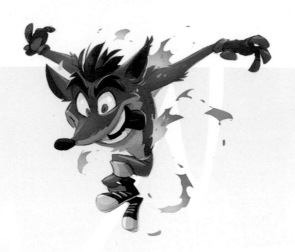
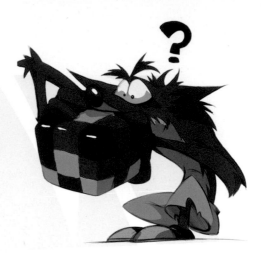

"I can get very stuck in my own head, and the challenge with Crash was to loosen up and be more silly—design for humor and hunt for visual gags. Often I'd start overly complicated, then pull back, loosen it up, make it more fun. Designing for humor is its own skill set. It really stretched my imagination! My hope overall was to heighten the appeal of these classic characters and be very intentional with shapes and colors to bring out the classic cartoony-ness of Crash."

—Nicholas Kole

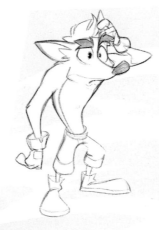
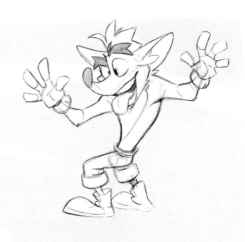

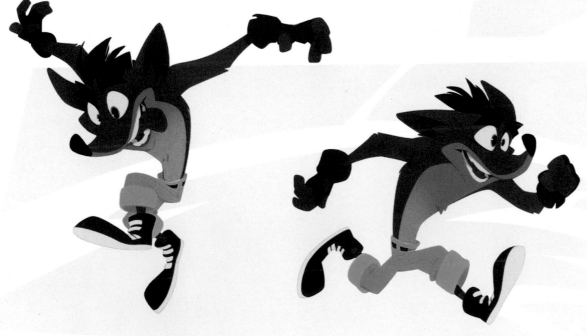

WHO IS CRASH BANDICOOT?

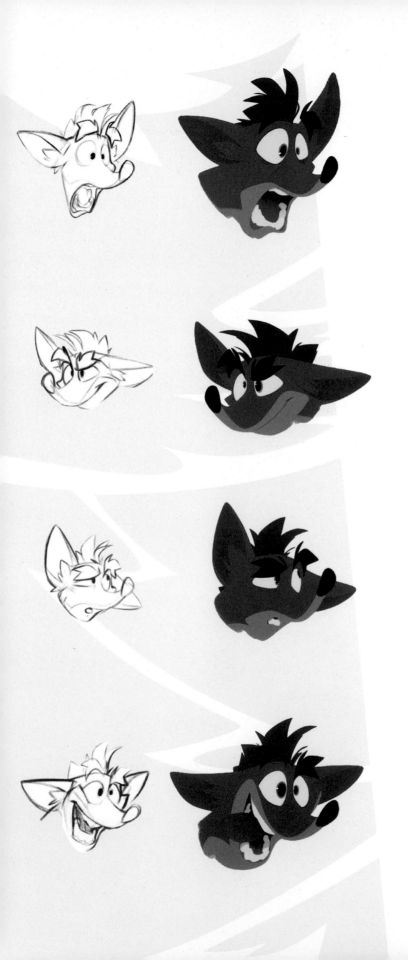
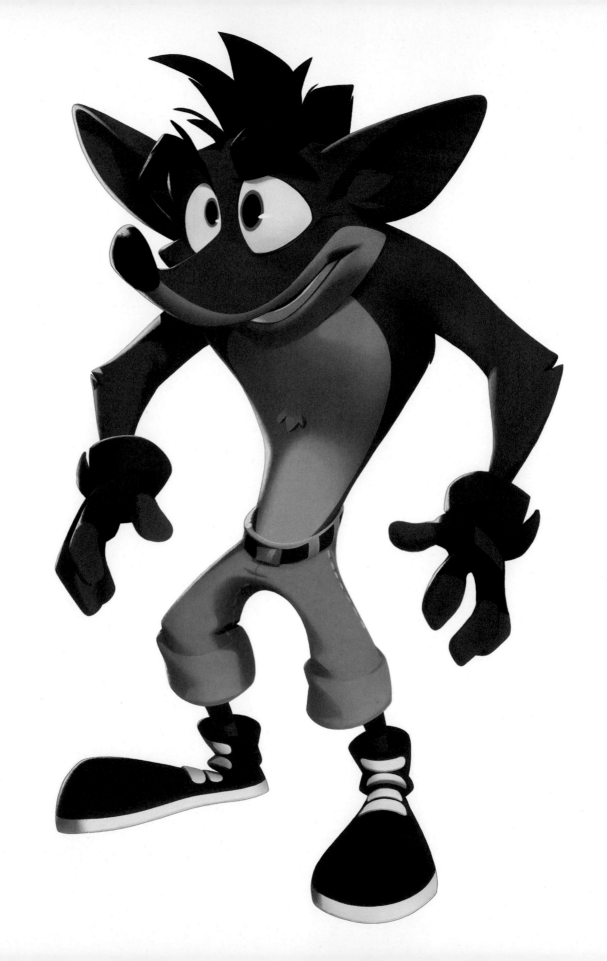

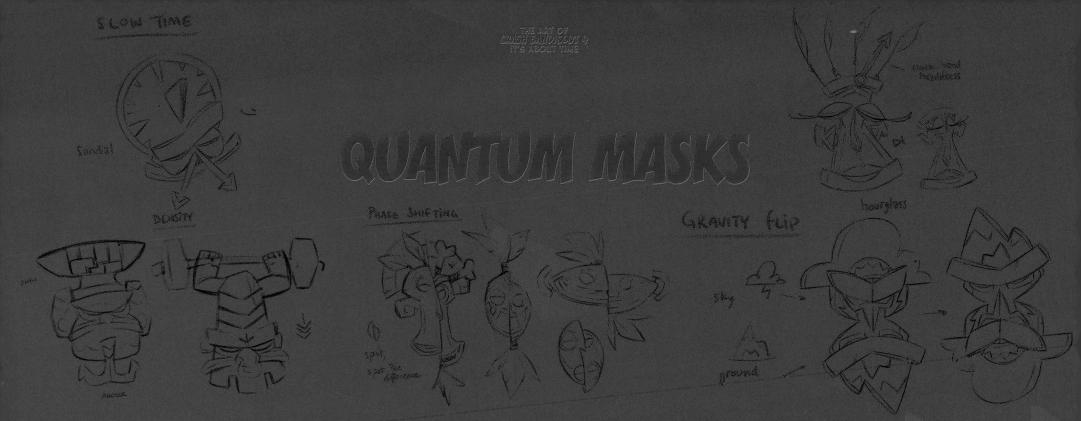

QUANTUM MASKS

POWER PLAY

Masks have played an important role in Crash Bandicoot right from the start: Throughout the series a character named Aku Aku often served double duty as both a "pickup item" that granted Crash unique powers and the franchise's core narrator. No surprise then that Toys for Bob chose to feature him prominently in Crash 4, a decision that had an immediate ripple effect. From Paul Yan:

"We said 'Hey what would it look like if we introduced more of these masks?' And so we did a whole bunch of prototyping of several different ideas—we had twenty or thirty different ideas—and we started to round them out, we built out a bunch of white rooms to create some interesting puzzles."

After much brainstorming on what abilities the masks would introduce and how they would affect gameplay, the team landed on four new character masks—Lani-Loli, 'Akano, Kupuna-Wa, and Ika-Ika, each of which would provide Crash with unique powers.

MAKING FACES

Next up, artist and illustrator Nicholas Kole tackled visual design, a task he viewed as a natural fit:

"I felt like a fish in water designing these 'cause it's so much fun. The design space they occupy is right between super-simple form and really interesting function. And you have to tell the story of the power that they represent visually as quickly and as simply as you can, 'cause they don't take up a lot of scene space—they don't have arms, they don't have legs, they don't have a costume. It's just this face, and what can you do with the amount of tools you have, designing a face and a mask to tell the story of these really cool new abilities that Crash has, that the characters have in this game."

The concept stage, however, wasn't without its challenges. First among them was finding exactly the right style, a process that led artists down a slightly different path than that of the game's overall aesthetic. Again from Nicholas:

"It's funny 'cause that whole first pass the ideas were beginning to take shape but it was too silly, which was not a problem that we had across most of the project. Most of the project was very silly. We wanted these to feel like they were coming out of time and space from someplace else and to have kind of a weird spiritual quality while still being cartoony. So that's very fun for me, but finding that balance was the challenge throughout."

While two of the masks, Kupuna-Wa and Ika-Ika, flew smoothly through both the art and game design phases, two others proved trickier to nail down:

DARK MATTER, ELUSIVE AS EVER

One of the mask abilities considered early on was known as "dark matter" or "density," represented by 'Akano. It was an intriguing concept that was visualized by Nicholas:

——

"Density was one of the most straightforward ones, just finding this very serious kind of gravity to the design and the idea that his mask would be made of all these floating pieces that would drift slightly apart, and then when you activate his power they would crush into the middle. And I wanted him to resemble a black hole, so the motif of a black hole became the dominant one for him."

The power granted by the dark matter mask proved challenging in the game design stage, however. According to Josh Nadelberg:

"It started out as a mask that would give you the power to be extremely dense so you would move more slowly, you could walk through explosions and you couldn't jump very high and you would fall through things— it actually was pretty neat, but the feeling after we built a bunch of levels was it started to almost feel like we were making the player have less power by limiting their ability to jump, making them slower... it felt like we were taking fun away from the player to a certain degree, so the game design for the mask ability changed."

Rather than focusing on the "heavy weight" angle, the team came up with the idea that the mask would provide a "quantum spin" that would send Crash into perpetual motion, like a twirling top. From Josh:

"He can jump and float and jump again, so it's much more about being a little bit out of control and having to work within that boundless freedom of being able to jump and spin around, which is much more fun for the player."

So would the tweaking of the game mechanic result in an art do-over from Nicholas? Nope! Per Josh:

"The reference we had for the mask originally was this idea of black holes and darkness and density, and as we were starting to think about the new power we were like, 'Oh my god do we have to redesign this mask?' and we realized that no, the black hole, this idea of the singularity sucking energy and sucking life and light into a black hole is very easily rethought as this quantum spin singularity, so thankfully we were able to stick with the design that we'd all come to love."

GOING THROUGH PHASES... SEVENTY OF THEM

While Nicholas Kole knocked two more masks out of the park: Ika-Ika, who provided the ability to flip gravity, and Kupuna-Wa, who allowed Crash to slow time... one final challenge remained: Lani-Loli, a mask that would phase objects in and out of reality. An early concept by Nicholas Kole focused on the idea of the mask as twins:

"I love the idea of cosmic twins that share a personality and the phase shift is sort of you choosing between one character and the other."

The idea of dual personalities, however, was already in use for Ika-Ika, the gravity-flip mask. So Nicholas went back to the figurative and literal drawing board. Per Nicholas:

"When we realized we didn't want the twins for phase shift, it unlocked this huge question of 'What do we want?' And we basically went through almost seventy different sketched iterations of the idea of phase shift. Just loose iterations, back and forth talking with the art director and design about what they wanted."

Locking in Lani-Loli's personality ultimately aided Nicholas in achieving the design:

"We dialed in on a personality and an idea of like, 'Okay he's really frantic, nervous, he always feels like he's lost something,' and condensing that— there's a bunch of puzzle piece motifs, puzzles and scattered arrows, and phases swapping in and out, but it wound up being a much more sort of simple, elegant solution where either the bottom half of his face and his ears are phased in or his head and the headdress are phased in, and it's always one or the other so he's always missing a part of him. But his eyes and this mouth always remain."

With Lani-Loli at the finish line, the vision for all four Quantum Masks was fully realized, allowing Toys for Bob to inject exciting new game mechanics and vibrant original characters into the franchise. More importantly, the team achieved one of its primary goals: to honor the classic series while setting Crash 4 on a bold new path.

"*I did Uka Uka and Aku Aku just to style them up and give us a version that looked like our game. That was super simple, the simplest the masks ever got; it was just like, 'Here are two great designs that I think speak for the whole franchise,' and I'll just do my take.*"

—Nicholas Kole

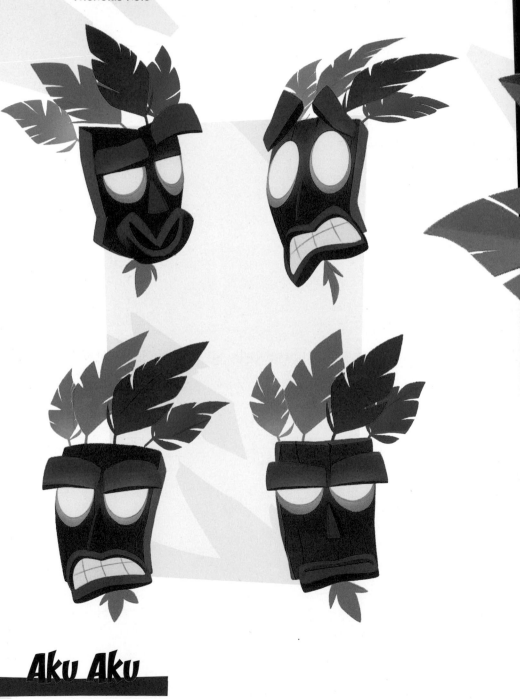

Aku Aku

QUANTUM MASKS

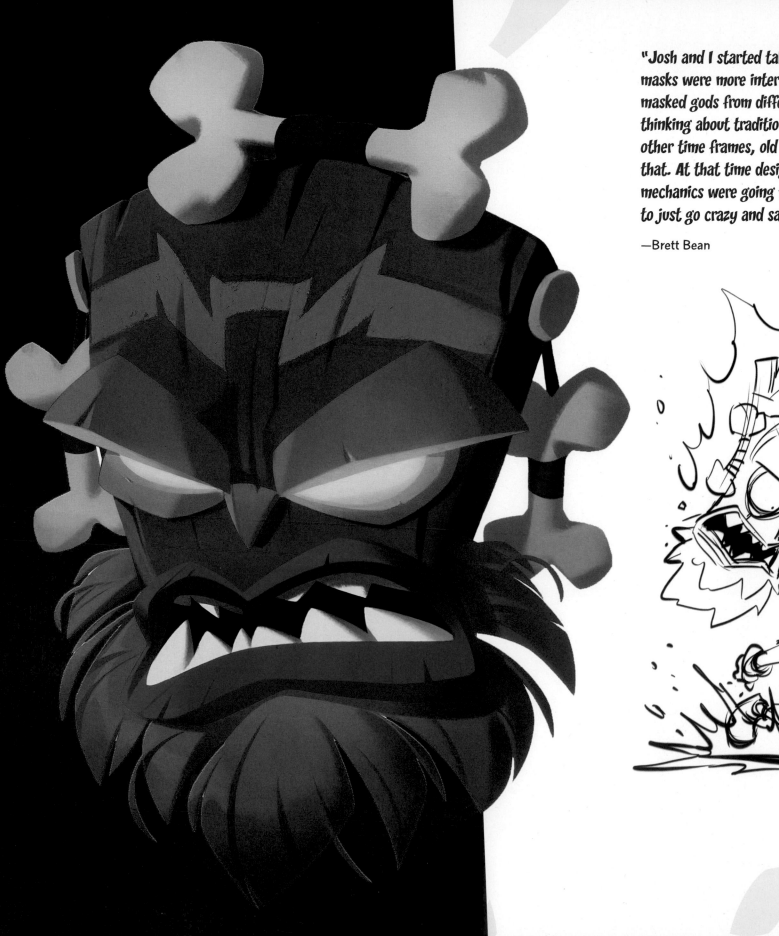

"Josh and I started talking about maybe each of the masks were more internationally themed, like different masked gods from different cultures. So we started thinking about traditional ones but also going back into other time frames, old wilderness gods and stuff like that. At that time design hadn't decided what game mechanics were going to be in it, so I was really free to just go crazy and say, 'What would be fun to do?'"

—Brett Bean

Uka Uka

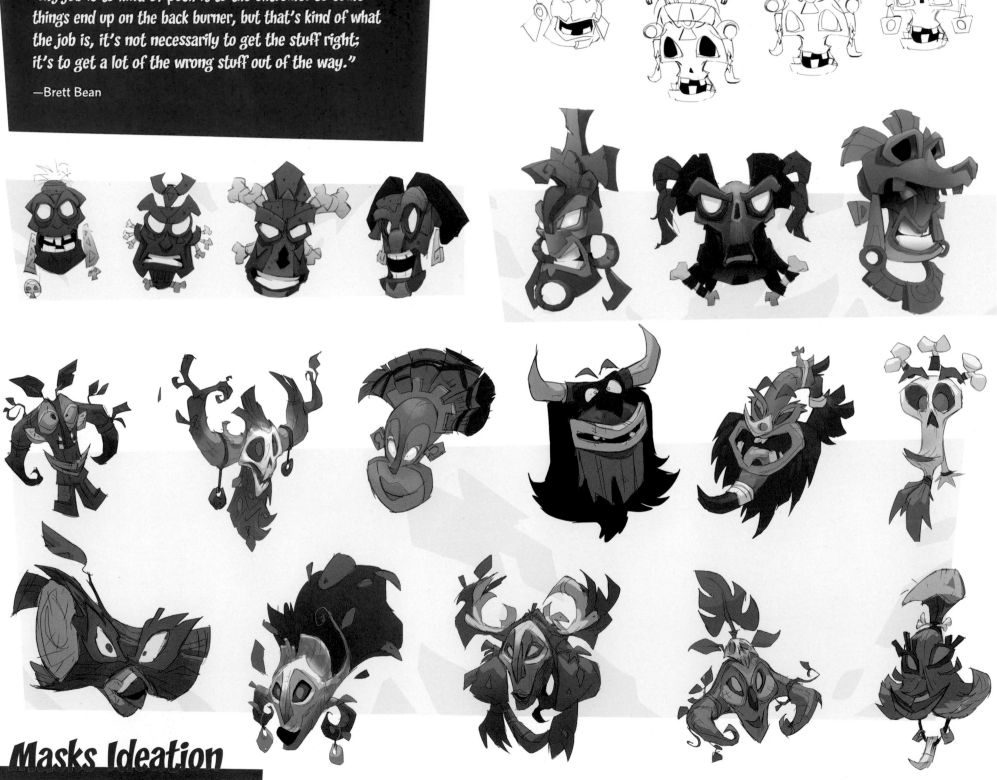

"My job is to kind of push it to the extreme. So some things end up on the back burner, but that's kind of what the job is, it's not necessarily to get the stuff right; it's to get a lot of the wrong stuff out of the way."

—Brett Bean

Masks Ideation

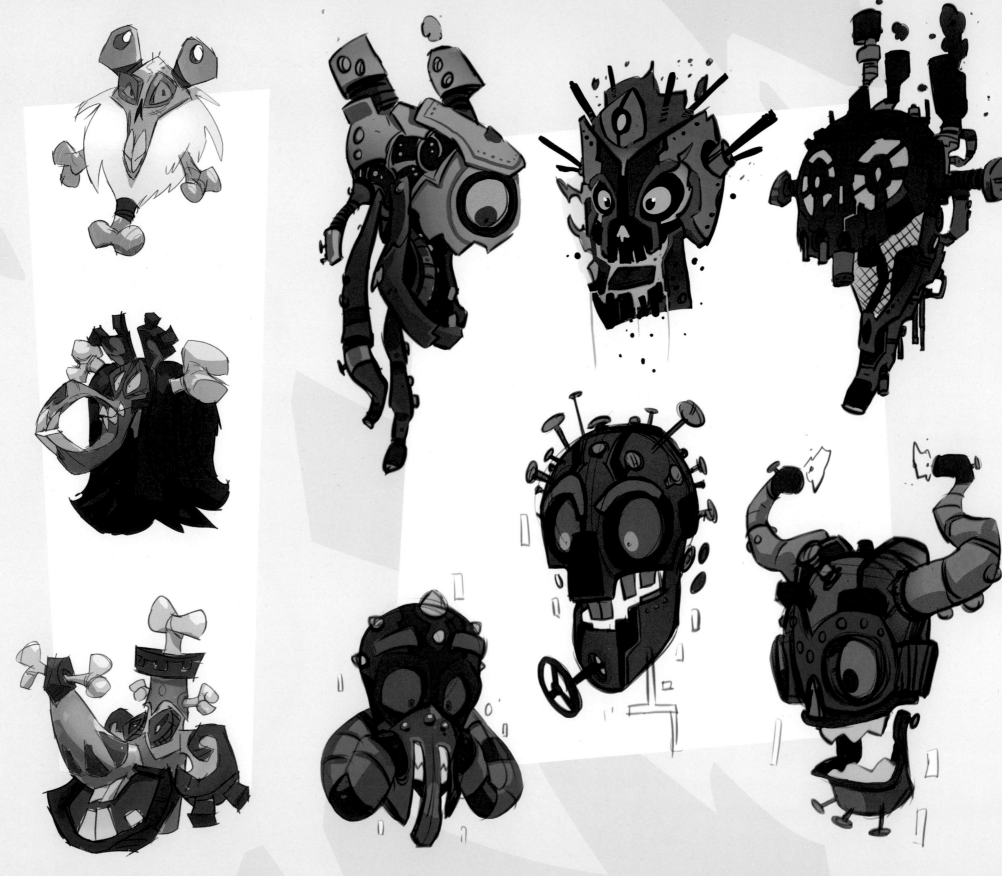

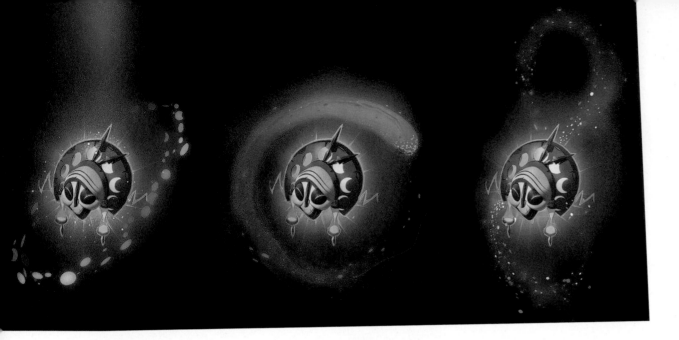

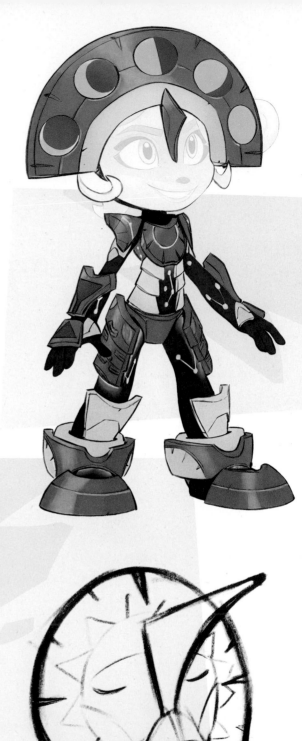

"*The time mask took shape pretty quickly. Her eyes and chin and nose and headdress were all very easy for me, just shapes that I gravitate toward naturally. But I thought it would be fun to mash as many time symbols in there as possible, so her earrings are hourglasses, her headdress is a sundial with a moon phase pattern, and in this iteration she has an hour and minute hand kind of bow on her head. I was just searching for different ways to mix those symbols.*"

—Nicholas Kole

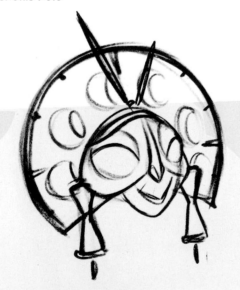

Kupuna-Wa

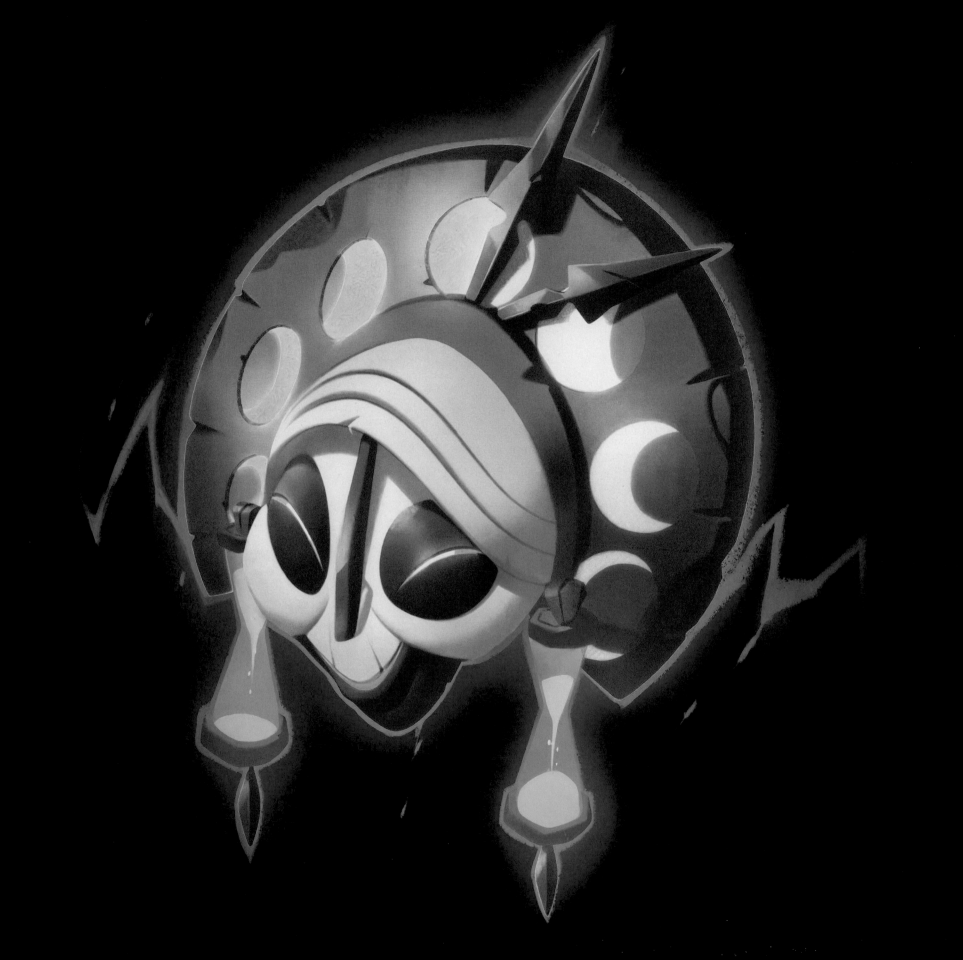

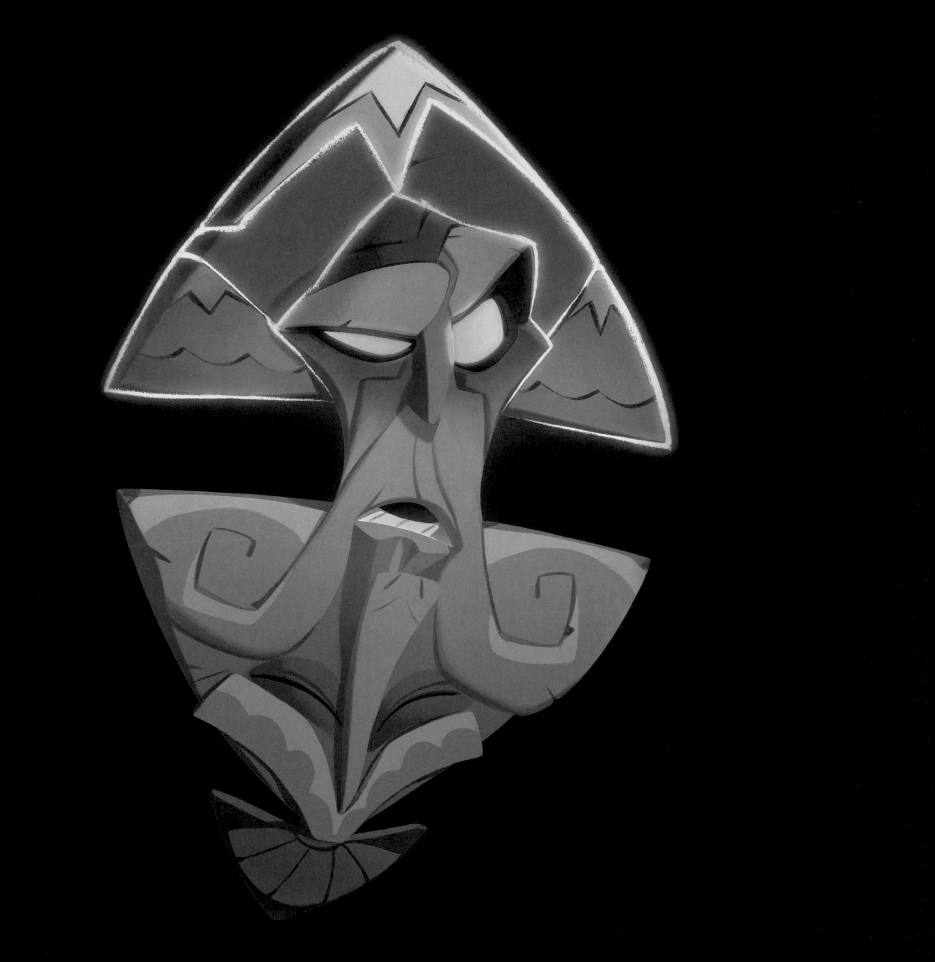

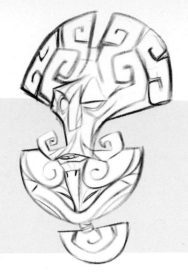
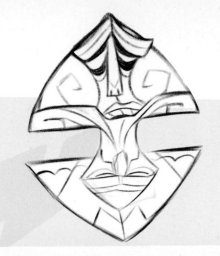
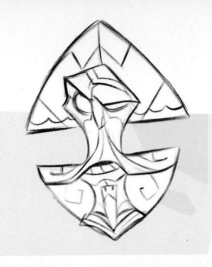

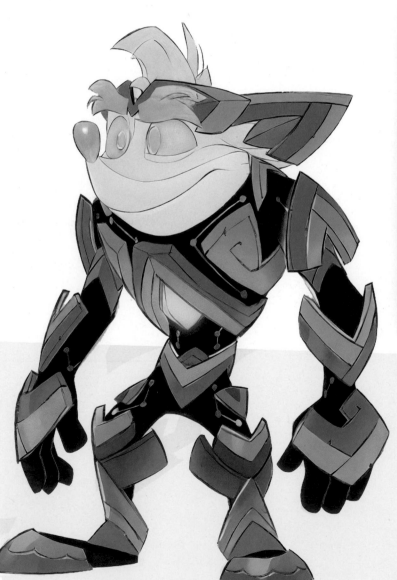

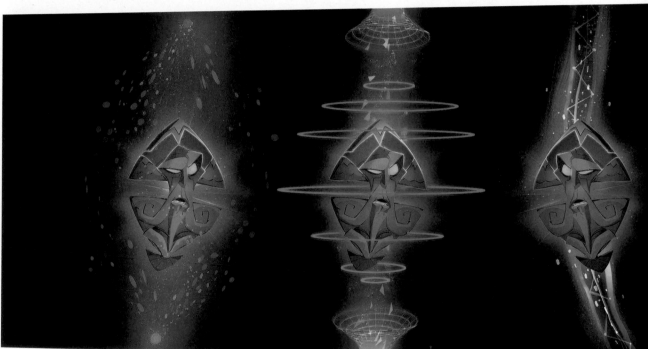

"I got excited about the idea of a mask that would flip and reveal a second face. I thought of this very blustery old gentleman, and then you'd activate the power and it would flip and have this nauseous face on the bottom. I was looking for shapes that would show a mountain motif for the first upright face with a wave motif at the bottom, and the nauseous face is meant to be an underwater portion of the wave, which gives us a color break as well as telling the story with sky and ground, mountains and water; it helps to bring home those motifs."

—Nicholas Kole

Ika-Ika

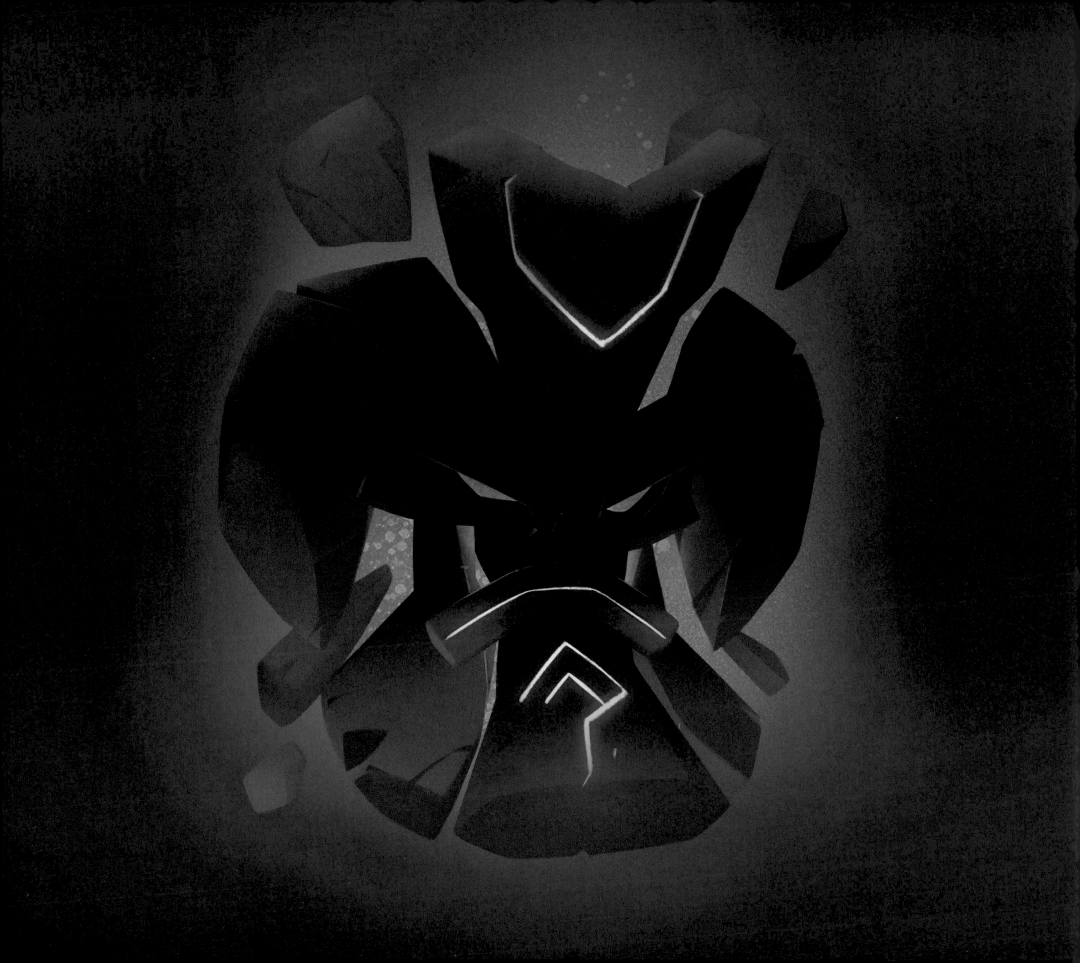

"Quantum Masks in general were a challenge to design because we were trying to tell the story of their ability and personality with just the parts of a face. We had this very serious angry density character. I was trying to tell the story in as many ways as possible in a limited space—even his nose, the frown of his mouth, the furrow of his eyebrows, they're all arrows that point right into the middle to reinforce the black hole motif."

—Nicholas Kole

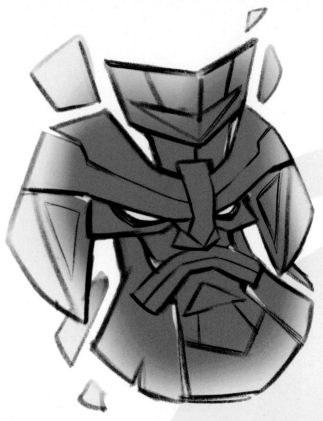

'Akano

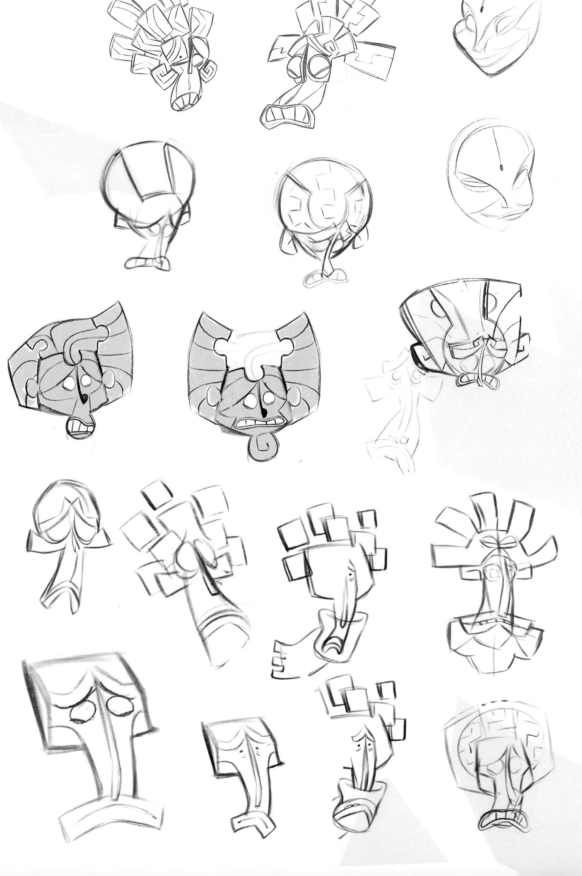

"Phase shift was probably one of the biggest struggles of the project for me. Usually these things happen so quickly, you know, there's three or four, maybe five different versions, and we move on, but phase shift really sat in this in between space. The other three everyone was so excited about; everyone saw them and really liked them, which was really gratifying, but then when it came time to decide on the fourth one there was more pressure because we had done well with the first three. So finding that design took a long time."

—Nicholas Kole

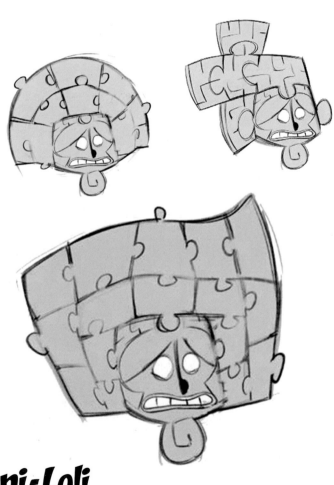

Lani-Loli

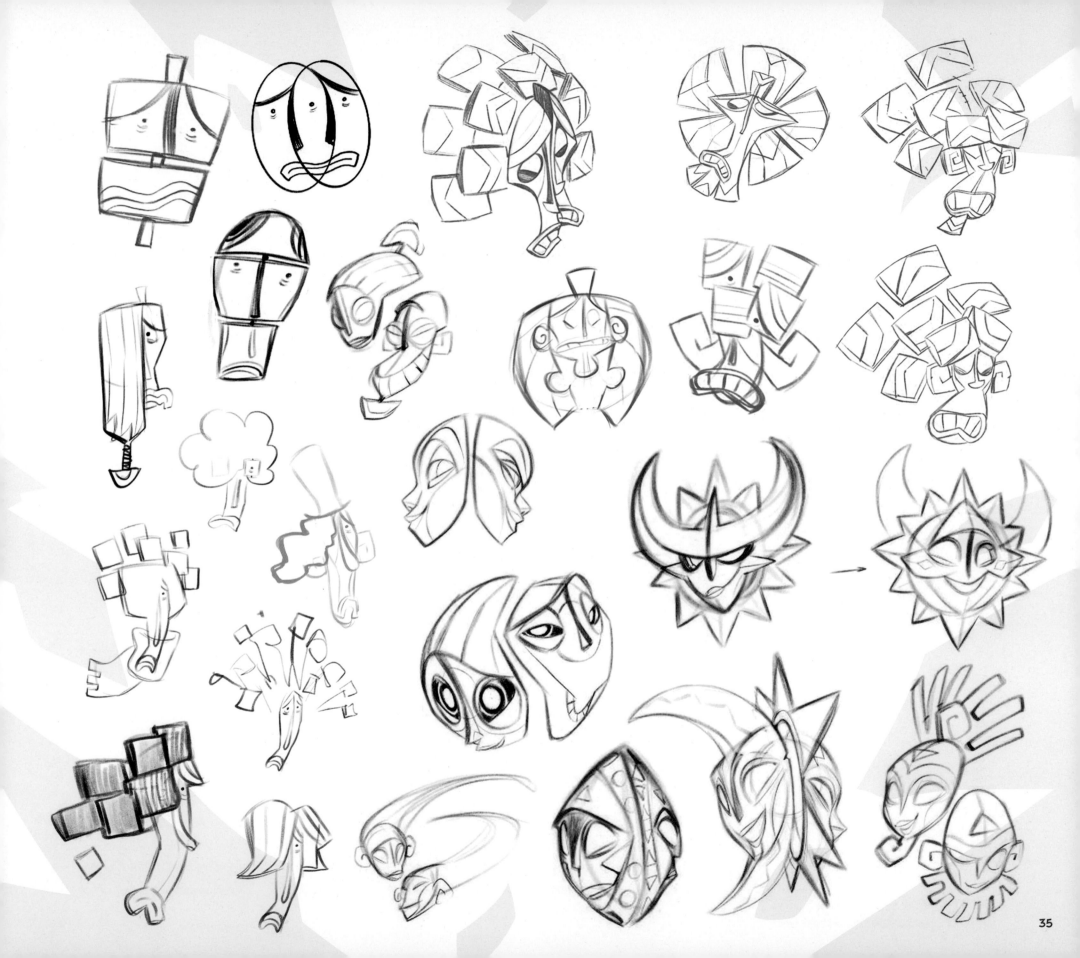

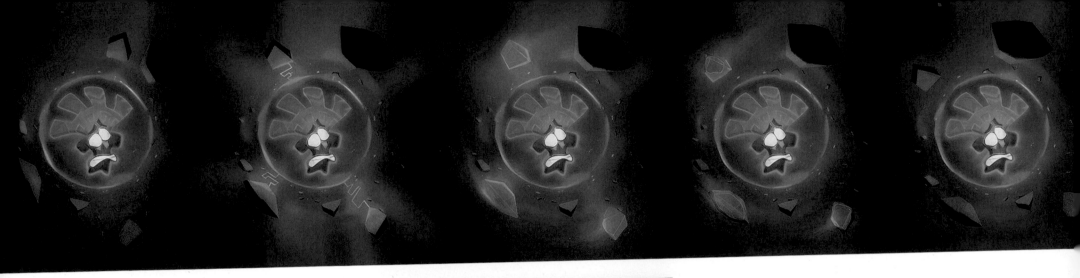

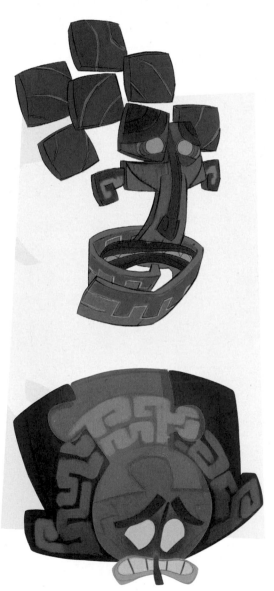

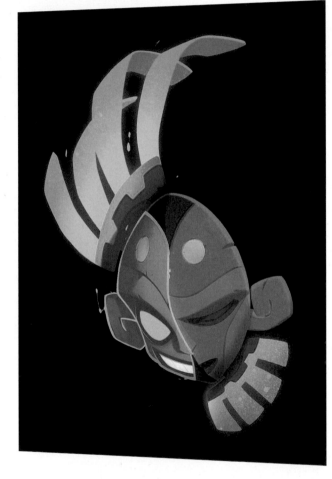

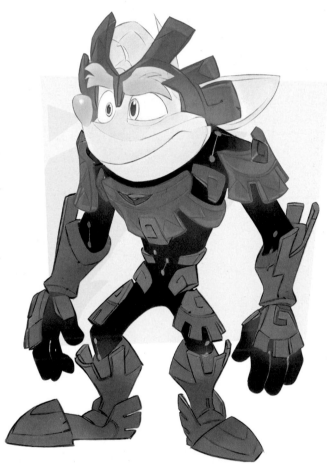

"When we were prototyping the gameplay, there were pink and blue states of objects that would swap back and forth, so the original designs were based upon that visual story. Nick came up with this great split personality idea, and it went all the way through to modeling. As we refined the gameplay, we realized it felt better to have a blue 'out of phase' state and a solid state. It was just a much clearer expression of the mechanic. So we went back to the drawing board and did an entirely new set of explorations before landing on the final design." —Josh Nadelberg

QUANTUM MASKS

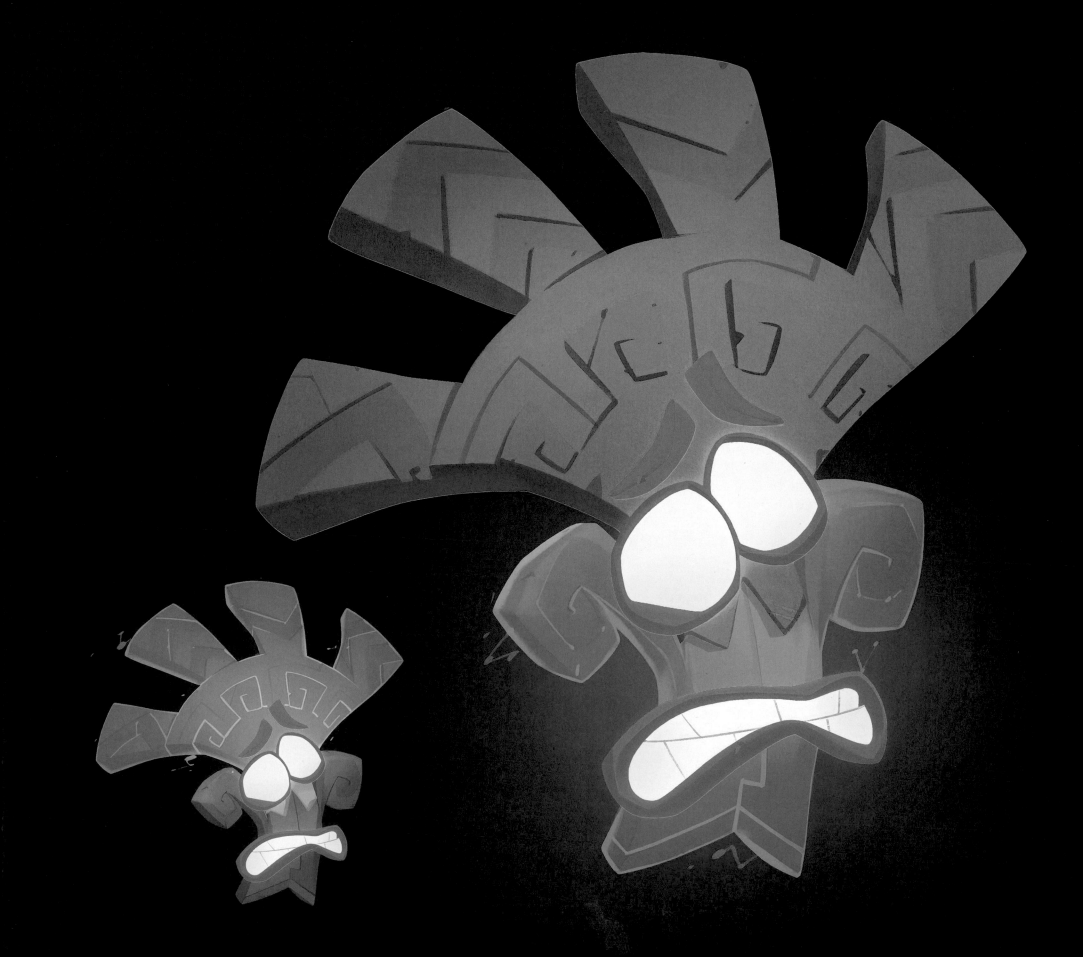

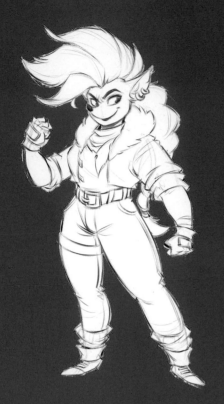

HEROES & VILLAINS

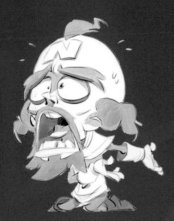

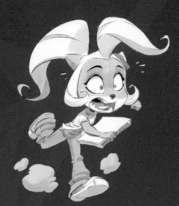

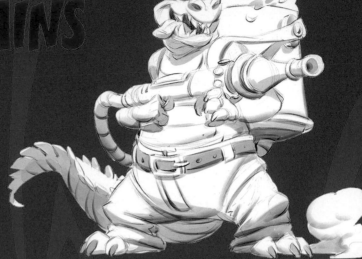

TIMELINES

As mentioned earlier on, one of the team's primary goals on Crash 4 was to revisit iconic characters in the franchise and make them playable—a thrilling prospect all by itself, but one that Toys for Bob took a step further. In the words of Paul Yan:

"We wanted to make sure that it's not just a skin swap and these characters do essentially the same thing—they actually have completely different move sets, and the levels that are crafted around them are very specifically asking for skill checks that require that you know their moves and their abilities intimately."

In those aforementioned levels, players will use the characters' unique move sets to pursue individual paths that will cross over with Crash's adventures. Aside from Crash and Coco, the new playable characters are Dingodile, Neo Cortex, and Tawna—names that will no doubt spark fond memories among legions of Crash fans.

FAMILIAR FACES

Once the team decided on which characters to revisit, it was time for concept artists to begin the process of updating and redesigning them, all under the keen eye of Josh Nadelberg:

"I would work with them to just try to pull out different ways to imagine what a new version might be. We had all these great artists just give us their take, and then I would present my favorite bits from different interpretations to Nicholas Kole, who worked on Spyro and then on Crash, and he would help synthesize those into the final designs."

Some characters called for minimal fine-tuning, while others required a bit more time and attention.

THE DEBONAIR DOCTOR?

The update for Crash 4's diminutive doctor, Neo Cortex, was arrived at fairly quickly. Nicholas Kole found it easy to manipulate the villain's extreme shapes and proportions to arrive at the classic "evil doctor who always gets defeated." The only real speed bump, according to Nicholas, came later in the process:

"There was a funny problem with him, which was that once they got him into animation it felt like everything he was doing was turning out too handsome, which I felt was a really funny problem for Neo Cortex to have. His proportions just skewed more debonair than they had before. So doing an expression sheet helped us to get a range of expressions that felt more classically Neo Cortex."

DIALING IN DINGODILE

Dingodile was a more difficult character for artists to nail down, partially because his in-game model differed from early game concepts. In the words of illustrator James Martin:

"Dingo's definitely a hard one to put your finger on— like what is he and what does he look like? Cause there are many variations of him throughout canon."

Adding to the challenge was the character's hybrid anatomy. From Nicholas Kole:

"We wanted to find a unique mix with Dingodile, so it was always a bunch of us artists chasing how much crocodile can we add to the design just to up the mixture a little bit; maybe his lower jaw is a croc's jaw but you really want to see the dingo, the warm colors of his face and torso versus the greens of the crocodile bits, and you don't want to get too distracted by all the different colors across the design."

The team settled on a version that was classic, with what Nicholas calls "super-clear, playful shapes."

TAWNA: MULTIDIMENSIONAL

While Crash's sister, Coco, required only minor adjustments aside from modernizing her laptop to a tablet, another female character, Tawna, was given special attention in the redesign process. In the words of writer Mandy Benanav:

"It made a lot of sense to make an alternate-dimension Tawna who's led this whole different life. One of the things that was fun about that was we got to envision a Tawna who's basically the Crash of her universe. So in her universe she's the hero, and Crash and Coco are like her sidekicks. We get to fill in her backstory a little bit which is really fun. She has a history with one of our villains, and a lot of our story choices came from figuring out what we wanted to do with Tawna. In my eyes she's sort of the main character, even though she's not the main playable character."

After extensive exploration, the team arrived at a version that was modern and confident and still in keeping with the overall tone and aesthetic of the Crash franchise.

N. TROPY: PROVIDING ALTERNATIVES

On the non-playable side of characters is Crash 4's main villain, N. Tropy. As was the case with Tawna, the dimension-colliding theme of the game allowed illustrators ample opportunities for exploration, described here by Nicholas Kole:

"With N. Tropy uniquely we wouldn't have to commit to any one take—we could have multiple takes in the game because time and space is shattered and he's at the center of it. So there could be an alternate version that, you know, sort of flickers back and forth or mixes with different alternate versions."

The various takes on N. Tropy covered a wide range of imaginative variations, including a baby piloting a mech suit. With art being a step ahead of design, however, tough calls had to be made later in the process, and not every concept made the final cut. One of the most exciting prospects for the team ended up being the chance to add another female character to the Crash canon. Per Josh Nadelberg:

"The original Crash games hardly had any female characters. There's Coco and Tawna, but hardly any of the villains are women, and so we were really excited about the opportunity these different realities provided us to do something like make an alternate-reality where N. Tropy is female."

EMOTE CONTROL

While artists used action poses to study characters in motion during the 2D phase, another particularly powerful tool in the artists' arsenals was expression sheets, which proved more valuable than the name suggests. From Nicholas:

"One of the things the expression sheets do besides showing the literal emotional expressions is just show the geometry, like when you open Dingodile's mouth, as wide as it can go, here's what that does to deform his chin and his mouth and when it closes as squished up as it can go, here's what that looks like. And I think that helps the riggers and animators get a sense of how to proceed."

CHALLENGE ACCEPTED

One of the game's challenges, identified by Josh Nadelberg, was to take the "super-wacky" world of this new Crash and bring that flavor to the redesigned characters without changing them too dramatically.

The heroes and villains on the following pages serve as a testament to that vision, embodied by a cast of diverse, colorful, fun characters that honor the franchise while representing Crash 4's epic new direction.

"Since the early phase of the production we decided to go another way with this character. I tried different clothes—I added spikes to the jacket to give her a more aggressive style, very eighties, and then we found the right way to draw her. She looks like an explorer. She looks like a very strong and powerful girl. She represents girl power; she's my favorite character in the whole game."

—Nico Saviori

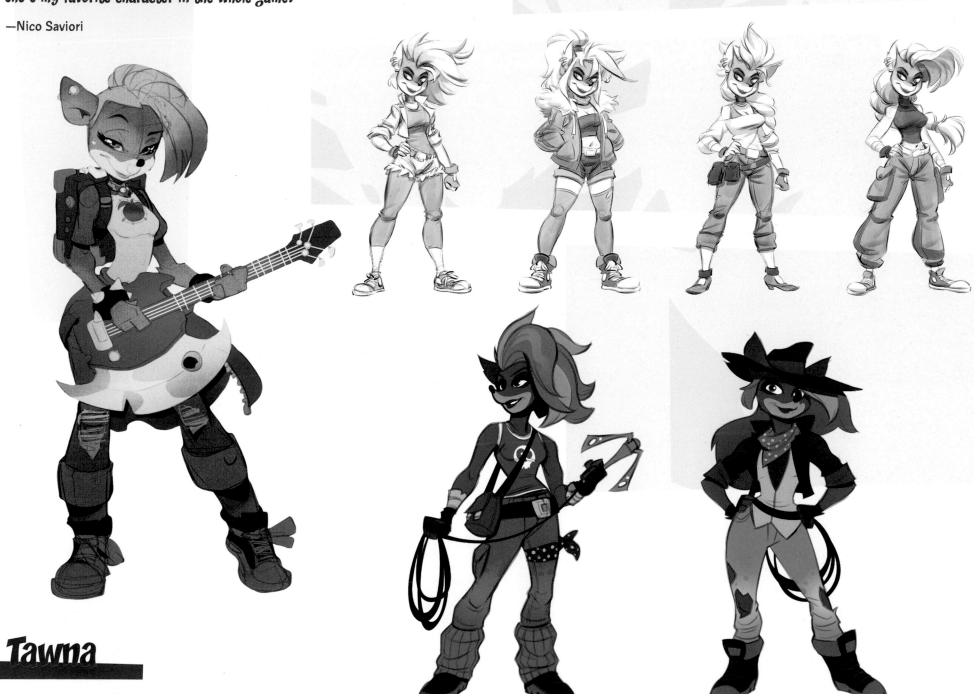

Tawna

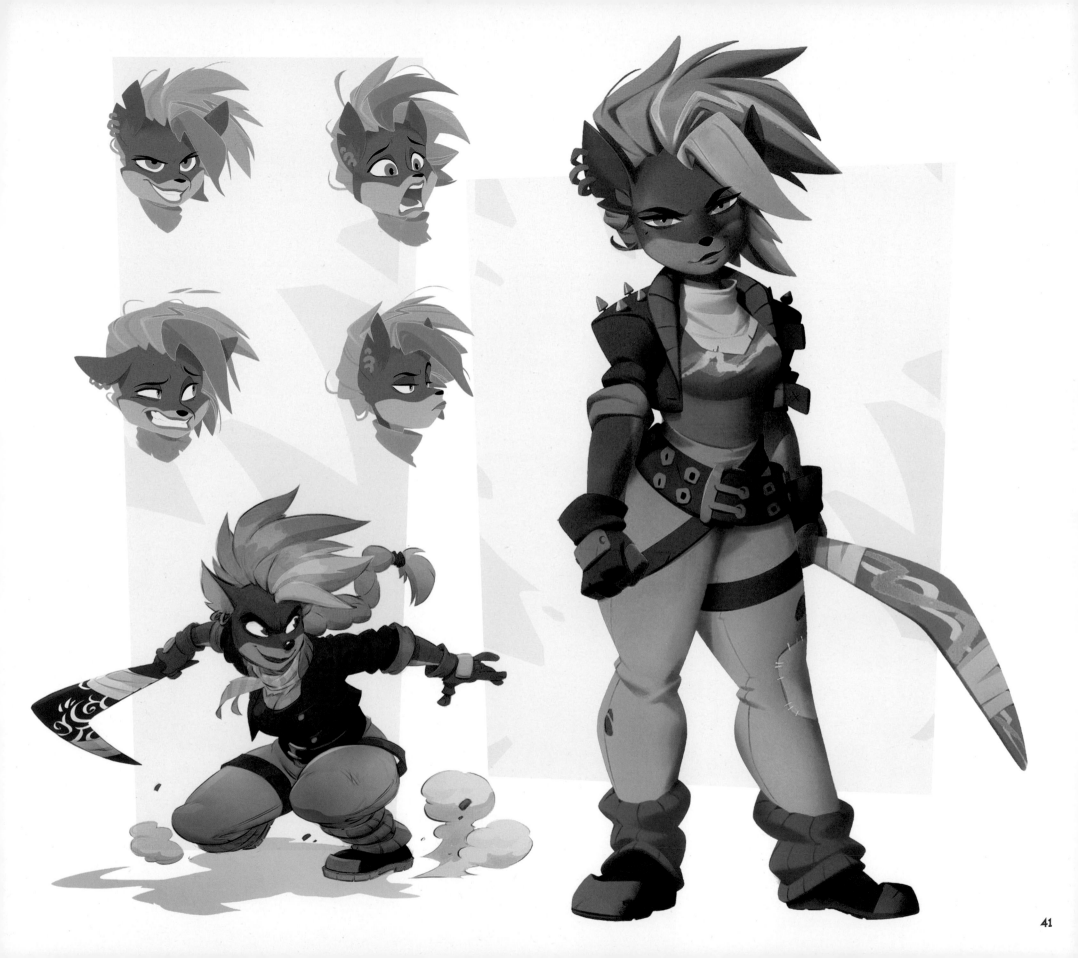

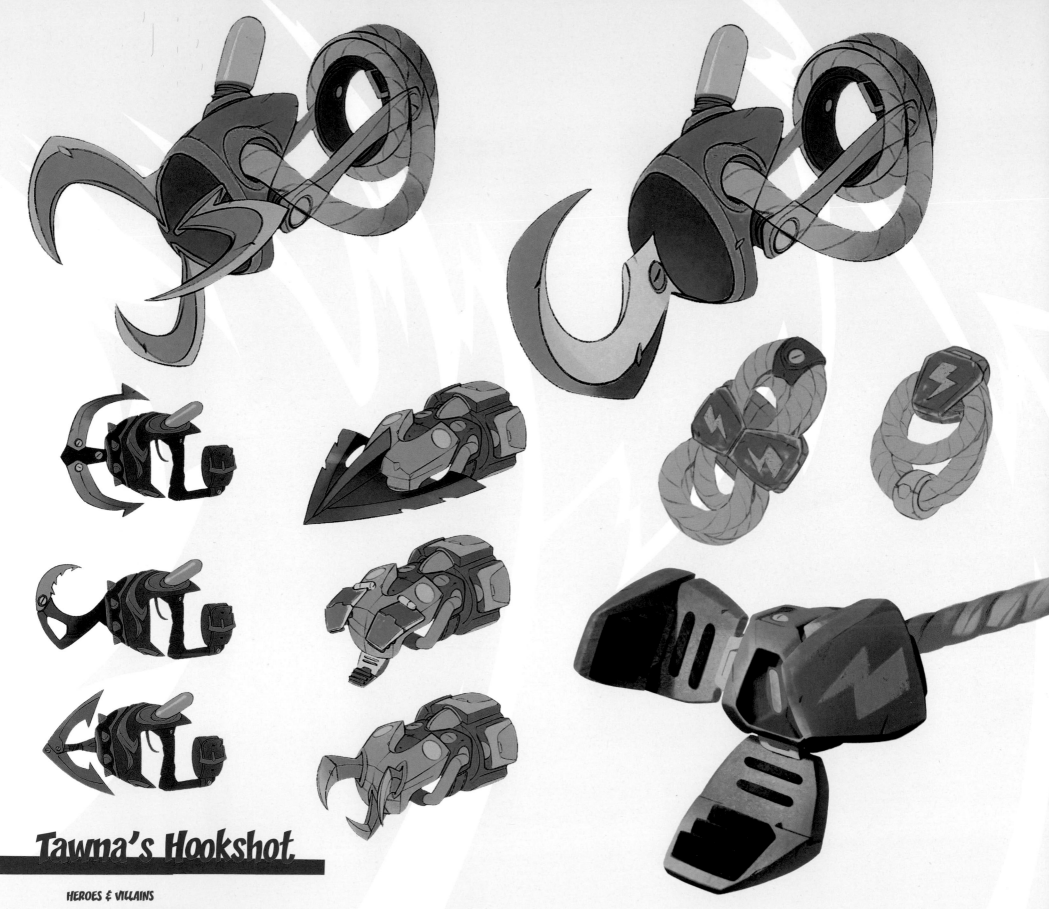

Tawna's Hookshot

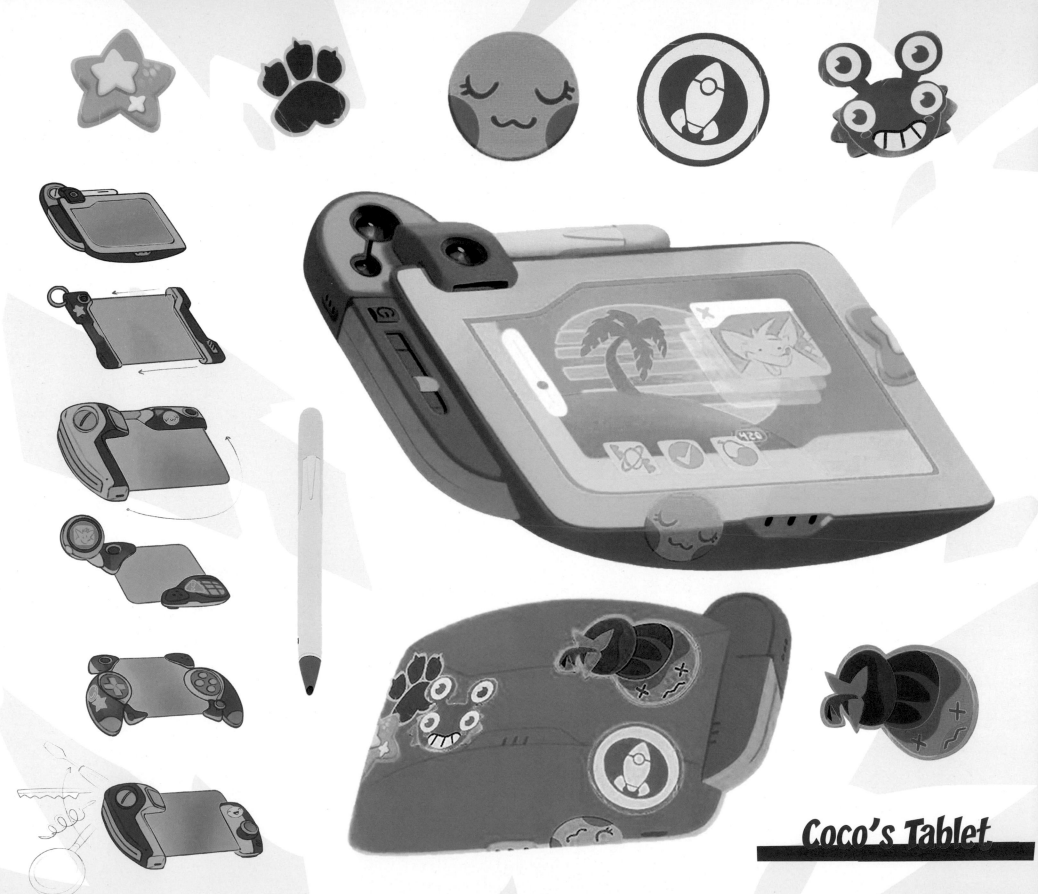

Coco's Tablet

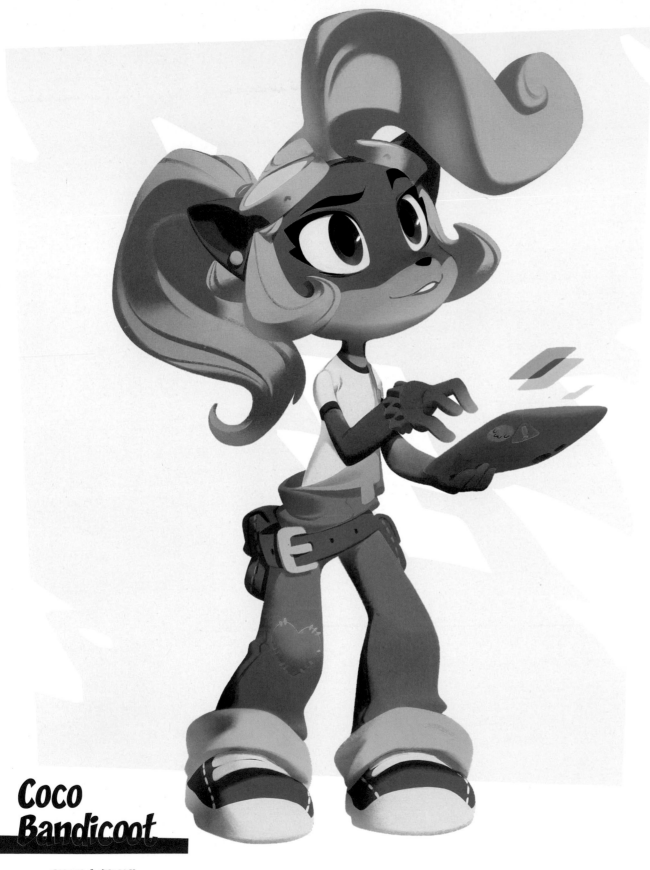

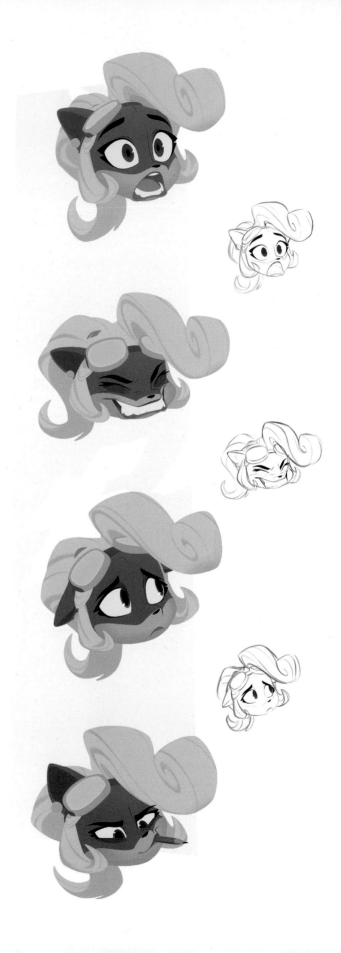

Coco Bandicoot

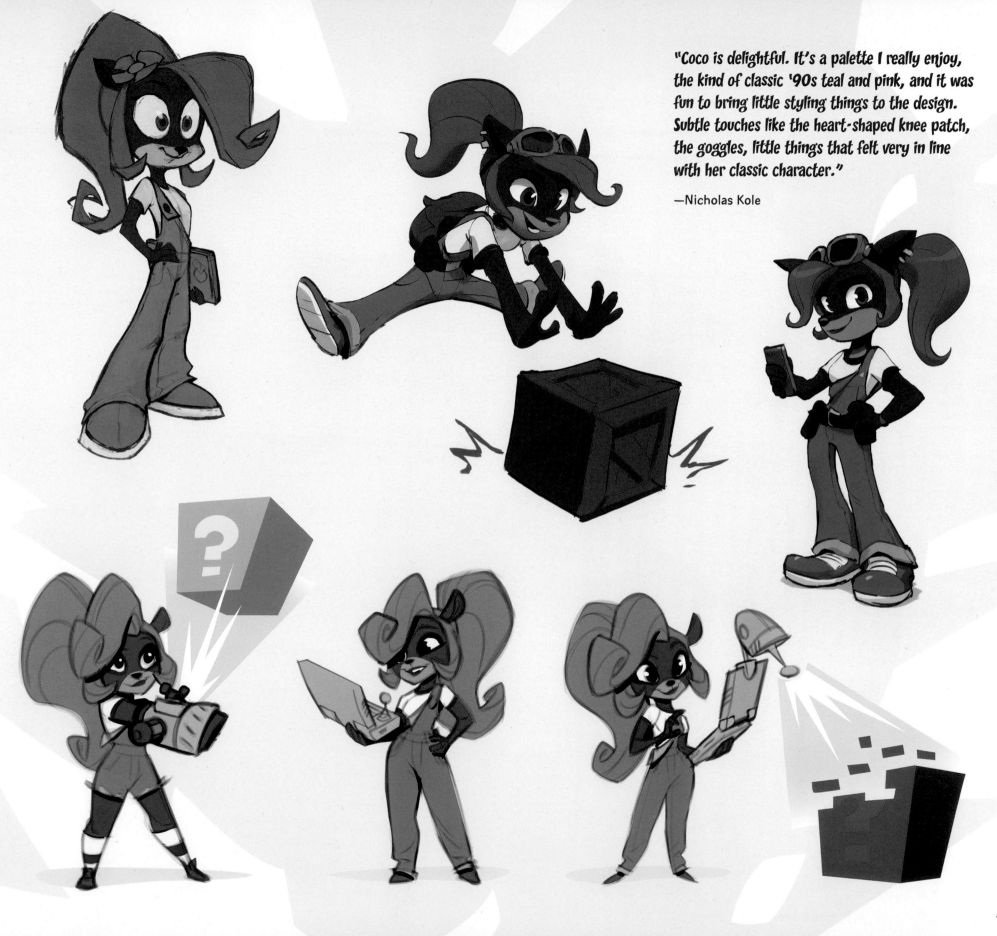

"Coco is delightful. It's a palette I really enjoy, the kind of classic '90s teal and pink, and it was fun to bring little styling things to the design. Subtle touches like the heart-shaped knee patch, the goggles, little things that felt very in line with her classic character."

—Nicholas Kole

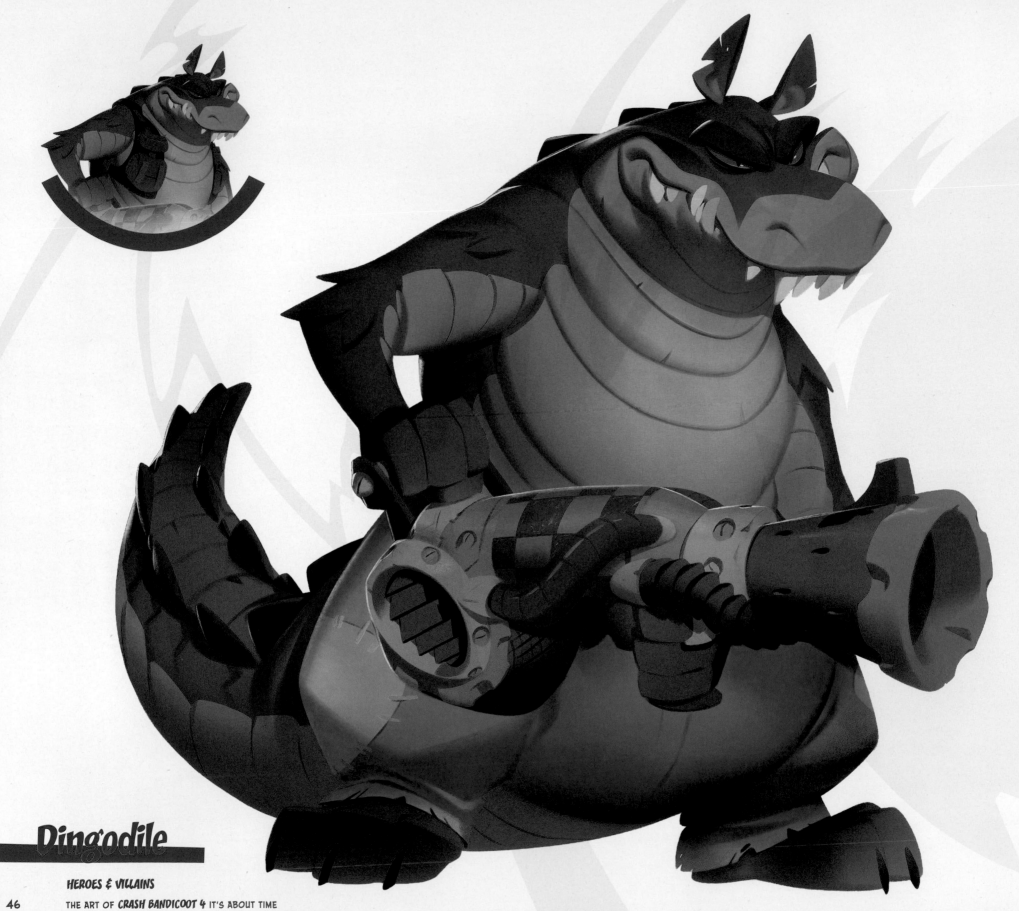

Dingodile

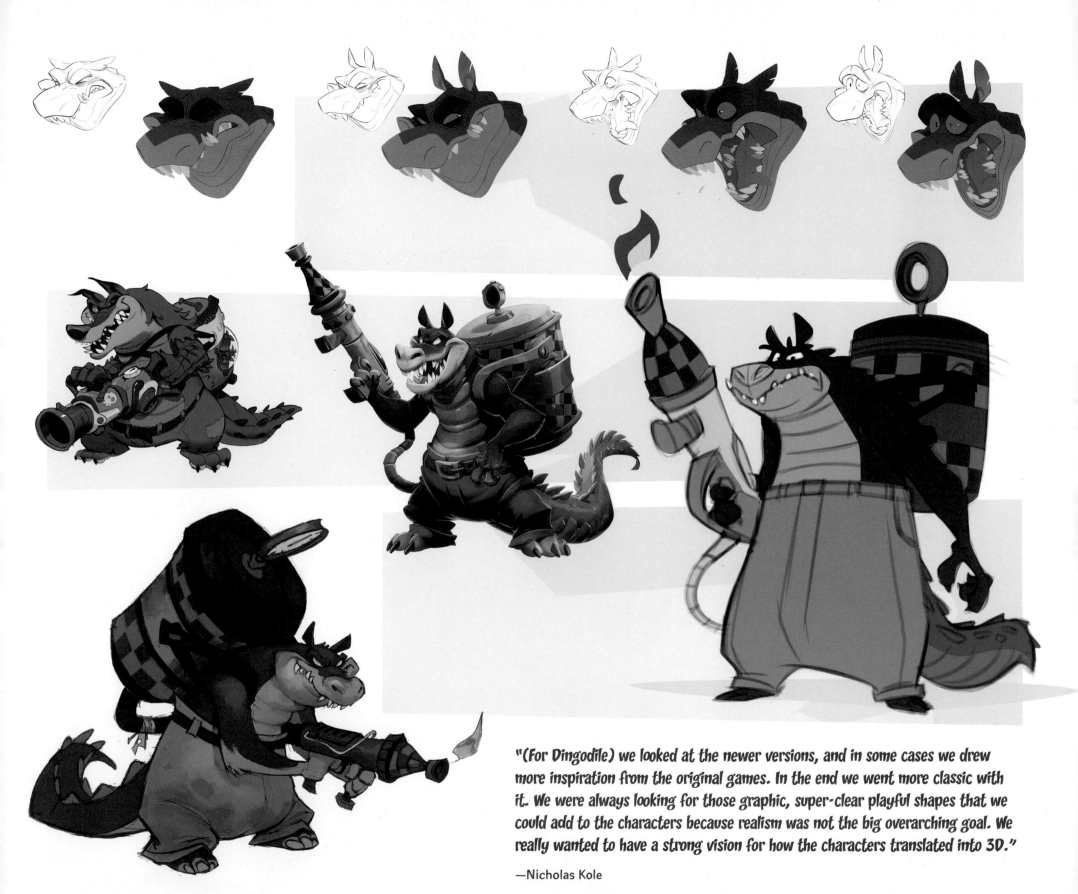

"(For Dingodile) we looked at the newer versions, and in some cases we drew more inspiration from the original games. In the end we went more classic with it. We were always looking for those graphic, super-clear playful shapes that we could add to the characters because realism was not the big overarching goal. We really wanted to have a strong vision for how the characters translated into 3D."

—Nicholas Kole

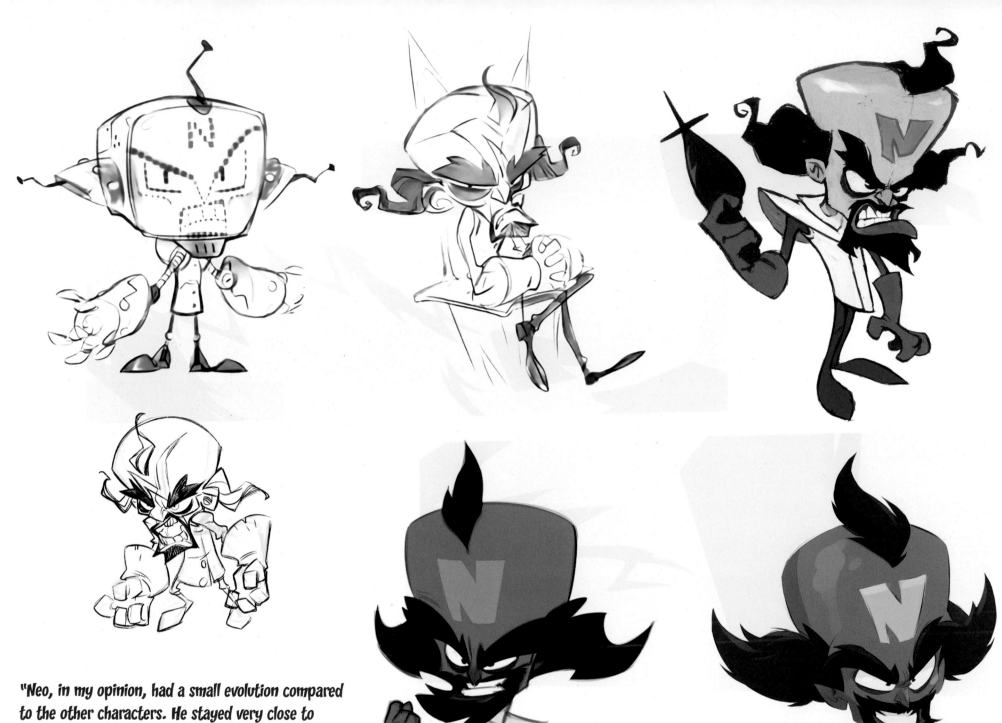

"Neo, in my opinion, had a small evolution compared to the other characters. He stayed very close to the previous game. I think it means that this was a great character who didn't need a big upgrade."

—Nico Saviori

Dr. Neo Cortex

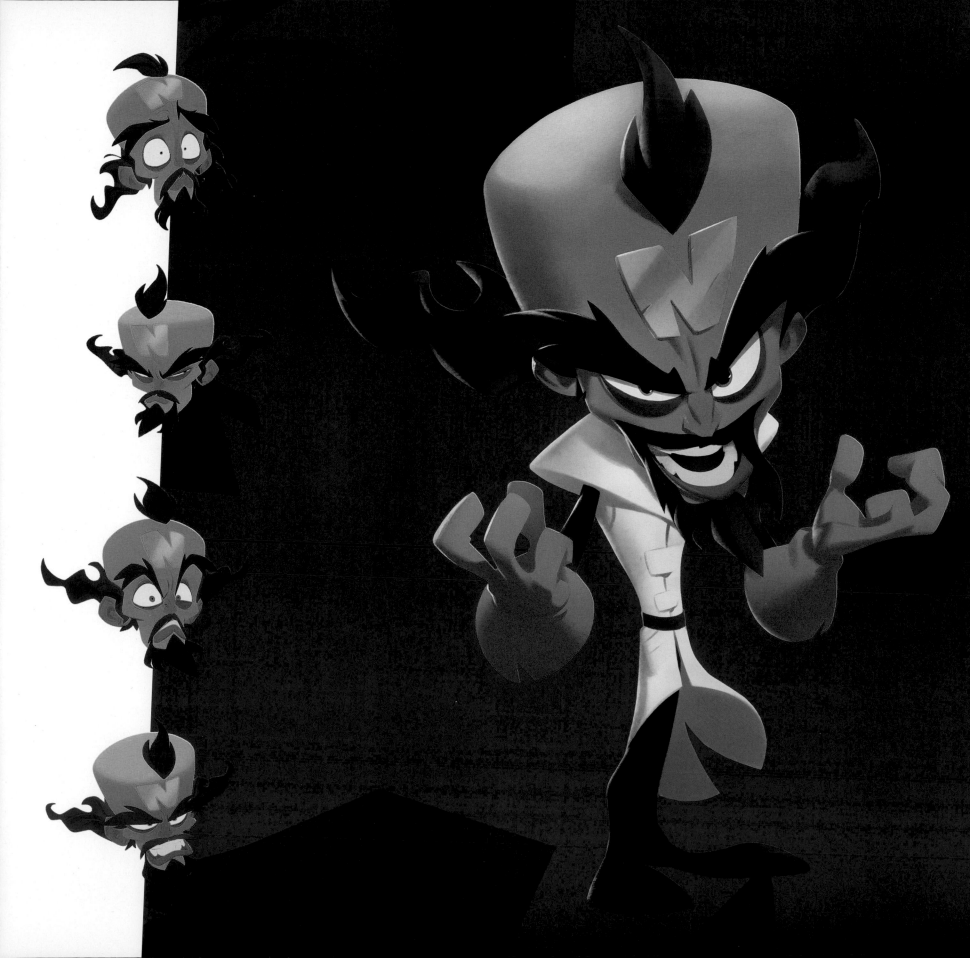

WATCH TOWER

CRASH 4: LEVEL BY LEVEL

A WHOLE NEW WORLD

Toys for Bob set out to create a Crash 4 world that was incredibly diverse, colorful, and fun while still staying true to the classic spirit of the franchise.

But where to start?

As we saw in our earlier chapter, *Who is Crash Bandicoot?*, finding the game's tone began with designing and updating its main character. Once Crash's look and feel was established, artists began imagining what kinds of situations the star of the series might find himself in. Per Art Director Josh Nadelberg:

"Early on one of the first things the team did was to sketch out a whole lot of fun gameplay ideas to inspire design and help figure out what scenarios we could throw Crash into."

RUNNING WILD

Thus began what Josh calls "a really loose and liberating process" for the art team. With no script to work off of and no preexisting game design, illustrators were given free rein to visualize levels, imagine different ways that Crash might interact with his environment, and create exciting and fun gameplay moments.

Sometimes the wide-open ideation phase was a two-edged sword. In the words of Lead Concept Artist Ron Kee:

"We were at that phase where an artist is basically allowed to play and we don't necessarily have the game prototyped or specific gameplay in place just yet. On one hand it's really fun to be pie in the sky and to daydream and kind of put it all out there, but at the same time it's also a little bit difficult because you can go in so many different directions."

Some of those directions, however, began with small ideas that grew into huge gameplay moments. When game designers asked Ron to help with a jumping puzzle, he provided sketches of Crash bouncing on drums, a concept that turned into something much bigger. According to Josh Nadelberg:

"That ended up becoming one of the boss battles in the game. It reimagined itself as this big heavy-metal drumming sequence, all from the core idea of 'Wow, Crash and drums.' That was something we wanted to explore."

Through all of the exploration, the team landed on an overall aesthetic for Crash that was, according to Josh:

"Super wacky and full of motion and energy everywhere you look."

FLIPPING THE SCRIPT

So what about the story? That came after the team and the artists allowed their imaginations to roam free. Per Josh:

"Even before we understood what the narrative would be, we were already off and running on 'let's create an amazing alien landscape, let's create an amazing post-apocalyptic wasteland,' and the narrative rationale, that came way later. That's just part of the process. We can't wait to start designing things until we understand the script, the story of the game, at least for a title like this, which is a platforming, jump-around fun romp rather than a storytelling game."

The story *really* took off when it was decided that the new masks could bend time and space. Again from Josh:

"The idea of them opening these rifts through time and space was a really great way for us to have this diverse array of environments, themes, and experiences that Crash explores throughout the adventure. That was a great way to tie everything together."

While the masks largely solved a narrative problem, Josh goes on to explain that there was still a need to maintain visual consistency from one world to another:

"Crash is in an icy snow scape with Neo Cortex's Nitro factory on a mountaintop. That's one experience. Then he's in the prehistoric world with dinosaurs chasing him. How do we get that all to gel? We wanted to create a visual language to tell that story of time and space being shattered. The way we viewed it was these broken pieces of different realities, so Crash travels from one bit of time and space to another bit of time and space by jumping through these tears in reality, and he glides on these reality rails through these shattered realms until he gets to his destination. So we're trying really hard to establish a visual language that matches this really abstract narrative."

BRINGING IT HOME

So in the end, did it all gel? Josh sums it up best:

"Every time I look at a different level, I'm just like, 'Wow, I wanna be there. I wanna visit that place I wanna explore it. And it's not an exploration game, right? It's a platforming game, but it still feels like you're traveling through a place where there's a story in every level. That was just something we were doing in the art before we had any reason for it to be in the story, and almost every level has something like that."

At the end of the day, the team not only created the diverse and colorful world they envisioned from the beginning, but perhaps most important of all...
 They had fun doing it.

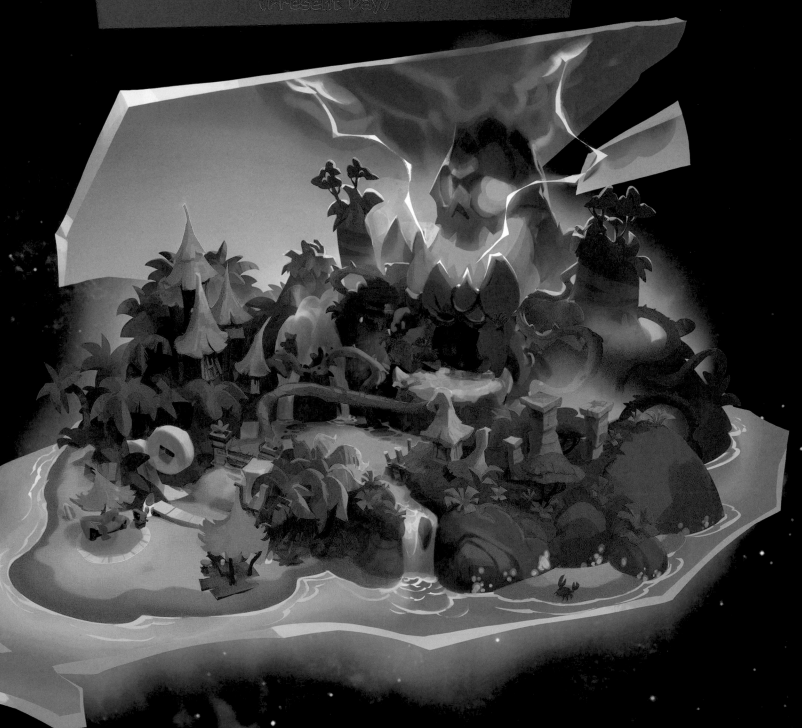

N. SANITY ISLAND

(Present Day)

Rude Awakening

"Early in the game, Crash is snoozing on N. Sanity Beach when Aku Aku senses a great power awakening in N. Sanity Peak. He wakes Crash and urges him to explore it. Crash runs through a familiar stretch of the jungle featuring classic Crash hazards like crabs and rolling stone wheels. After going through a tunnel, we present the player with their first big vista of the game, and Crash steps out into the sunlight and looks up at N. Sanity Peak across a beautiful lagoon. This is the first moment where the player experiences the scope of this new world."

—Josh Nadelberg

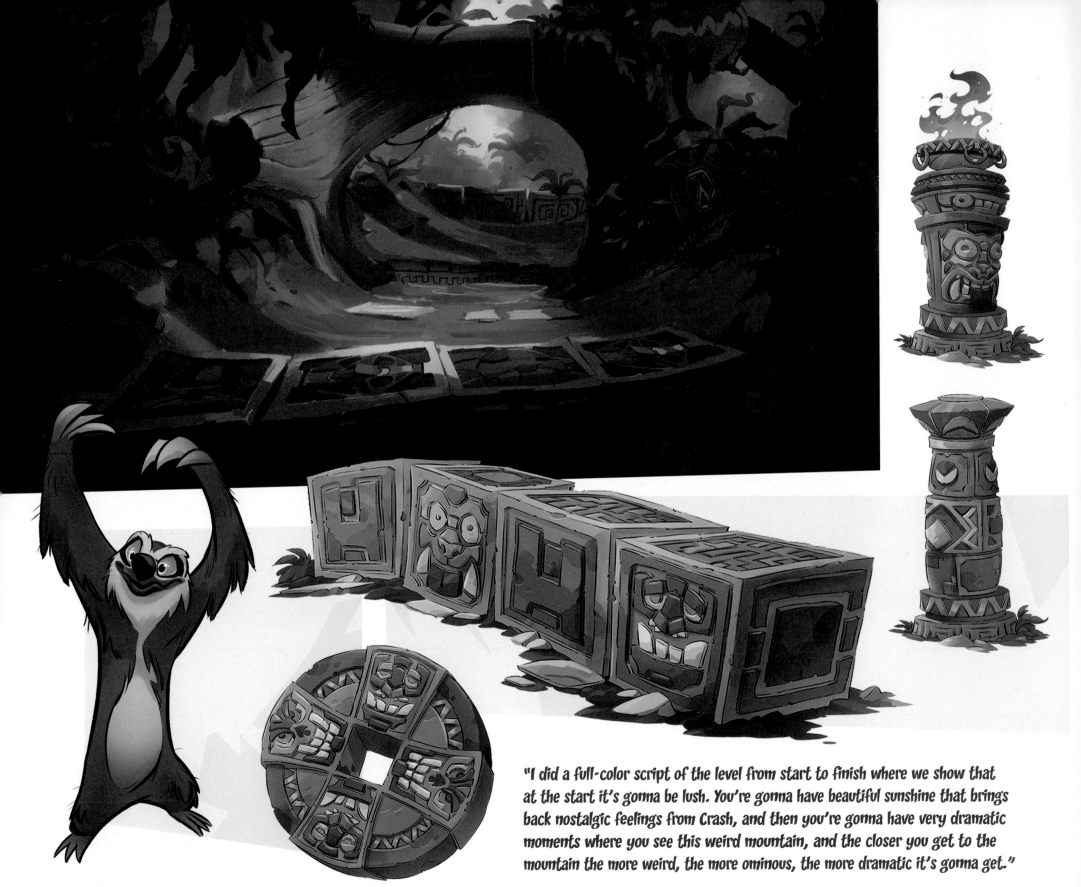

"I did a full-color script of the level from start to finish where we show that at the start it's gonna be lush. You're gonna have beautiful sunshine that brings back nostalgic feelings from Crash, and then you're gonna have very dramatic moments where you see this weird mountain, and the closer you get to the mountain the more weird, the more ominous, the more dramatic it's gonna get."

—Florian Coudray

N. SANITY ISLAND

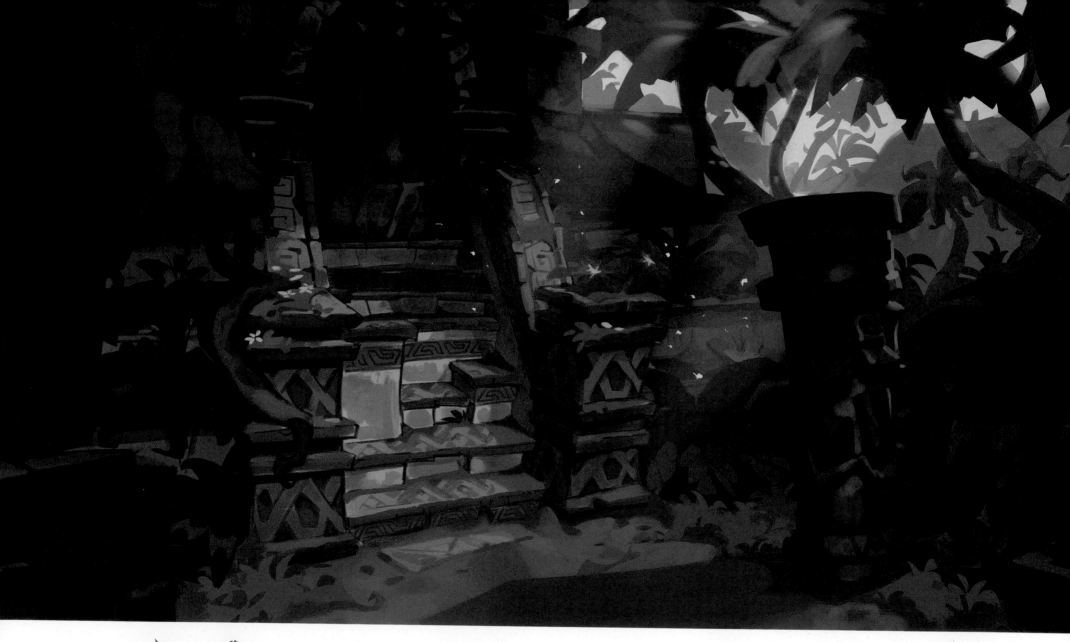

"I thought of these guys as little dudes that were just a permanent pain in the butt. They would have these blow darts and mosquito poppers that would shoot mosquitos and coconut bombs and fruit-flingers."

—Brett Bean

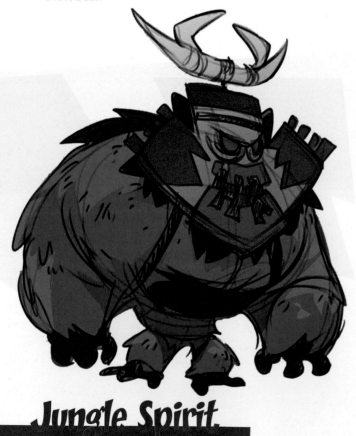

Jungle Spirit

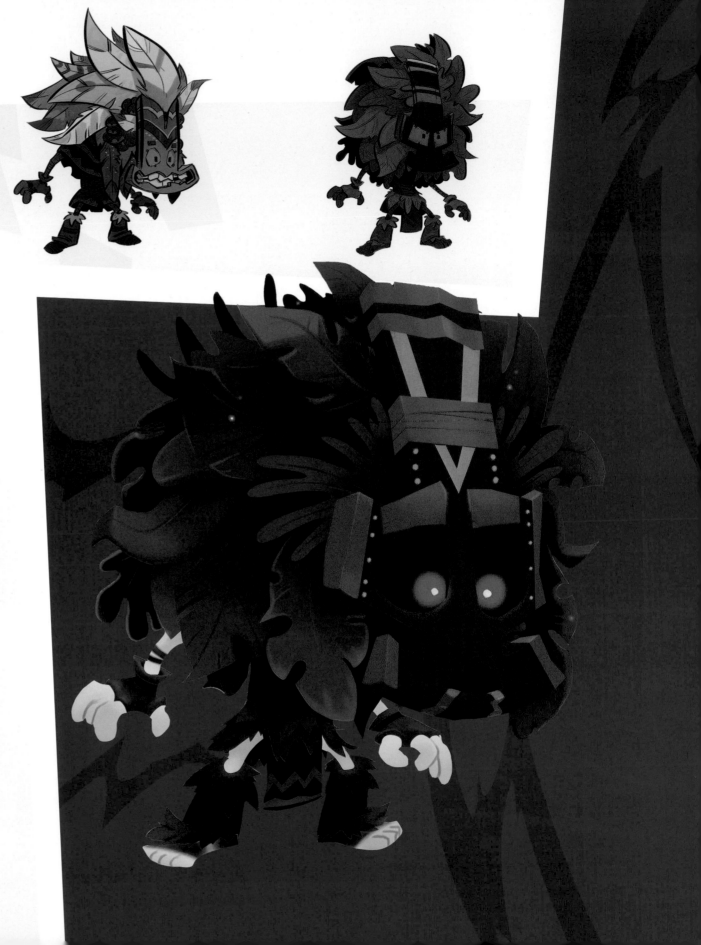

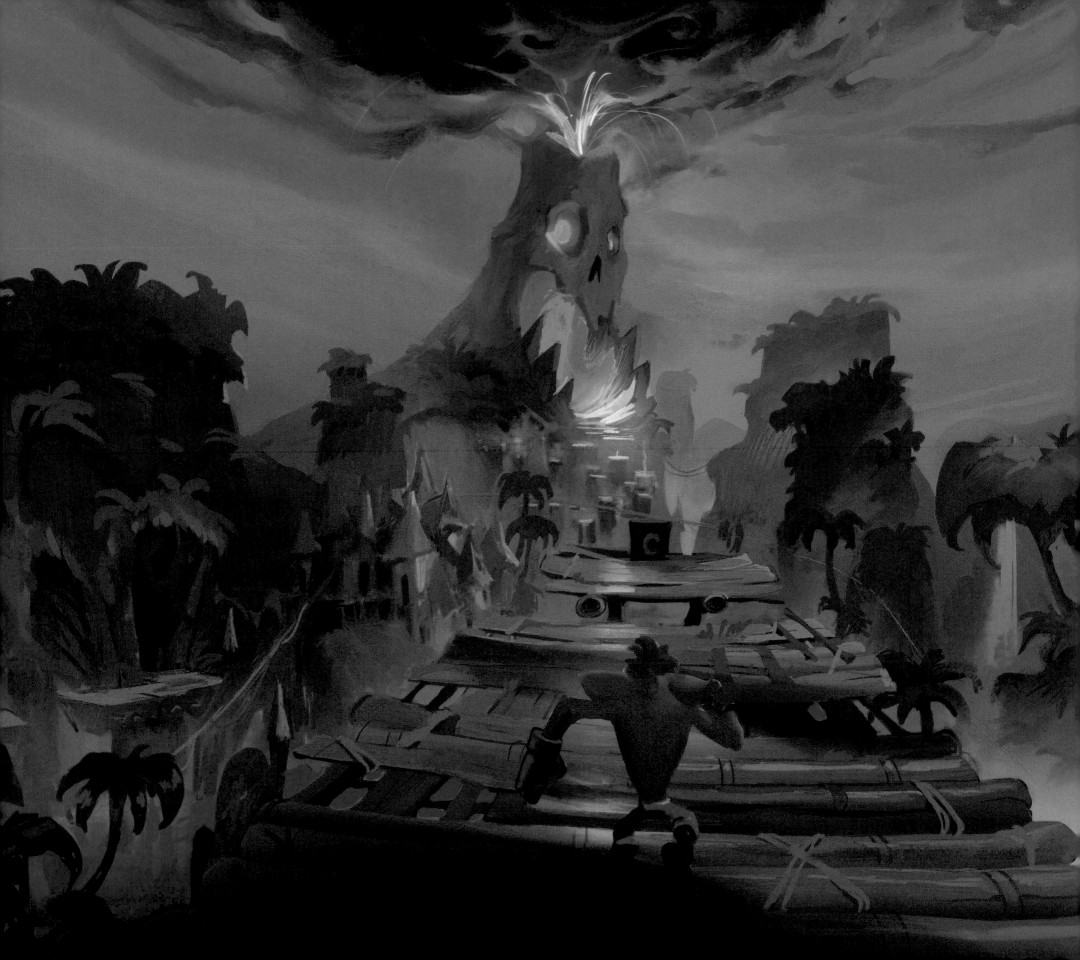

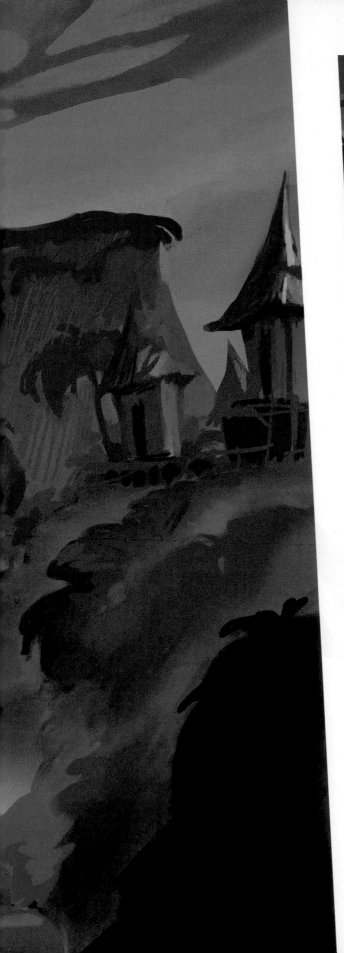

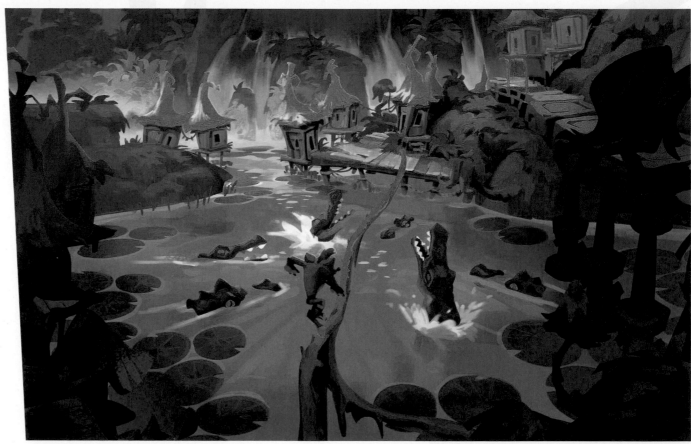

"We revised this level midway through production to accentuate how we're opening up the level design while still retaining the classic Crash gameplay. We added this big reveal moment as Crash steps out of the first tunnel and you see N. Sanity Peak and this big vista before you jump on your first rail grind and cruise around the lagoon. Being able to see upcoming platforming sequences from afar really brings things to life."

—Josh Nadelberg

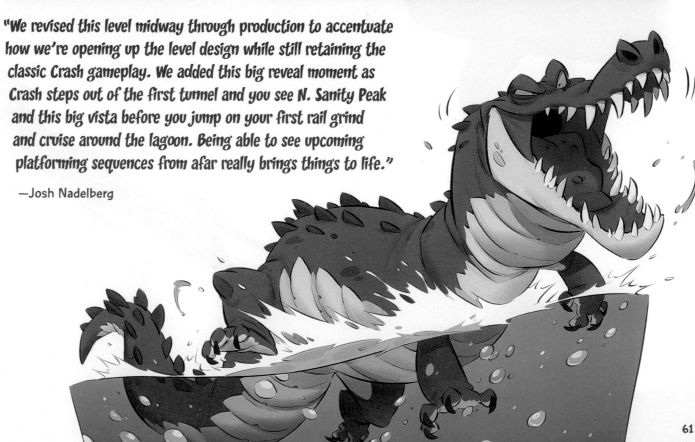

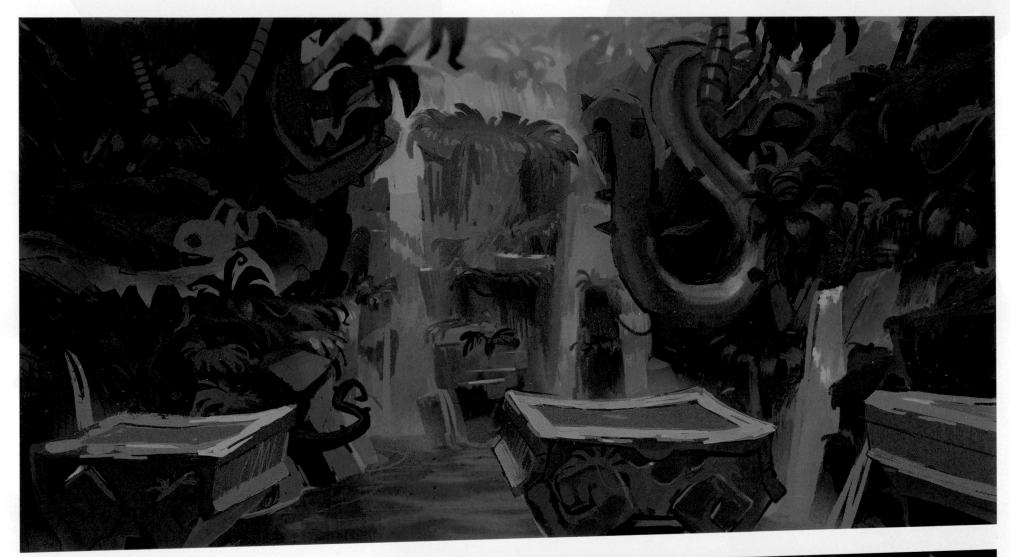

"Doing so many drastic changes in just one level is amazing because I believe the player is gonna really understand the storytelling behind these changes. And I hope it's gonna create this feeling that 'Okay, this is Crash Bandicoot,' and suddenly it's like 'Okay this is actually kind of a new take on the Crash Bandicoot that I know and I want to explore more of this new Crash Bandicoot.'"

—Florian Coudray

N. SANITY ISLAND

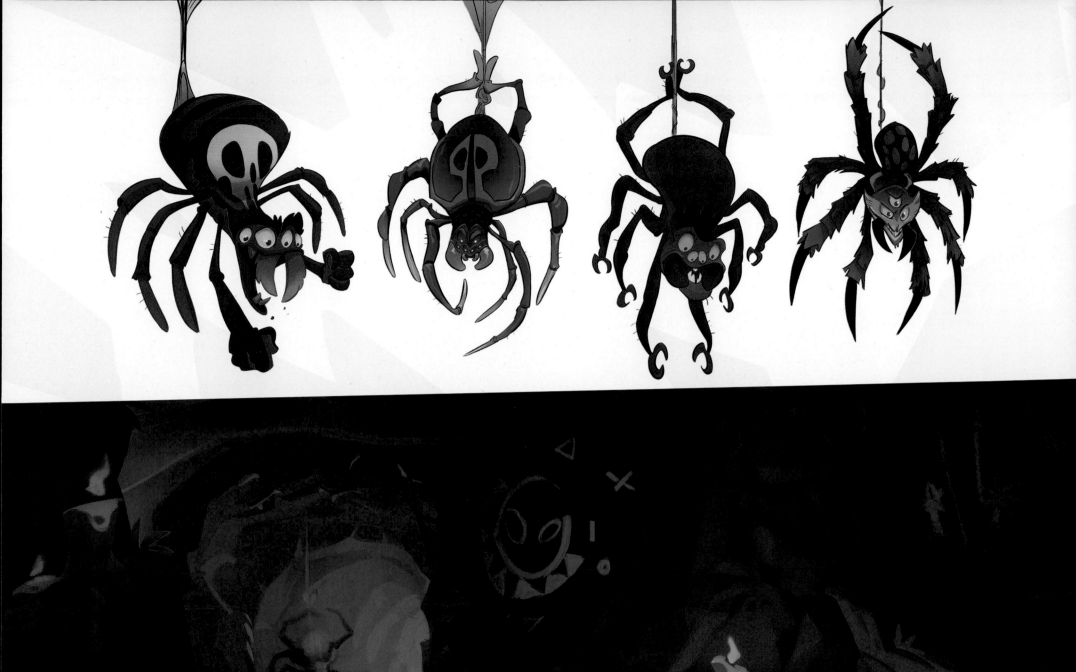

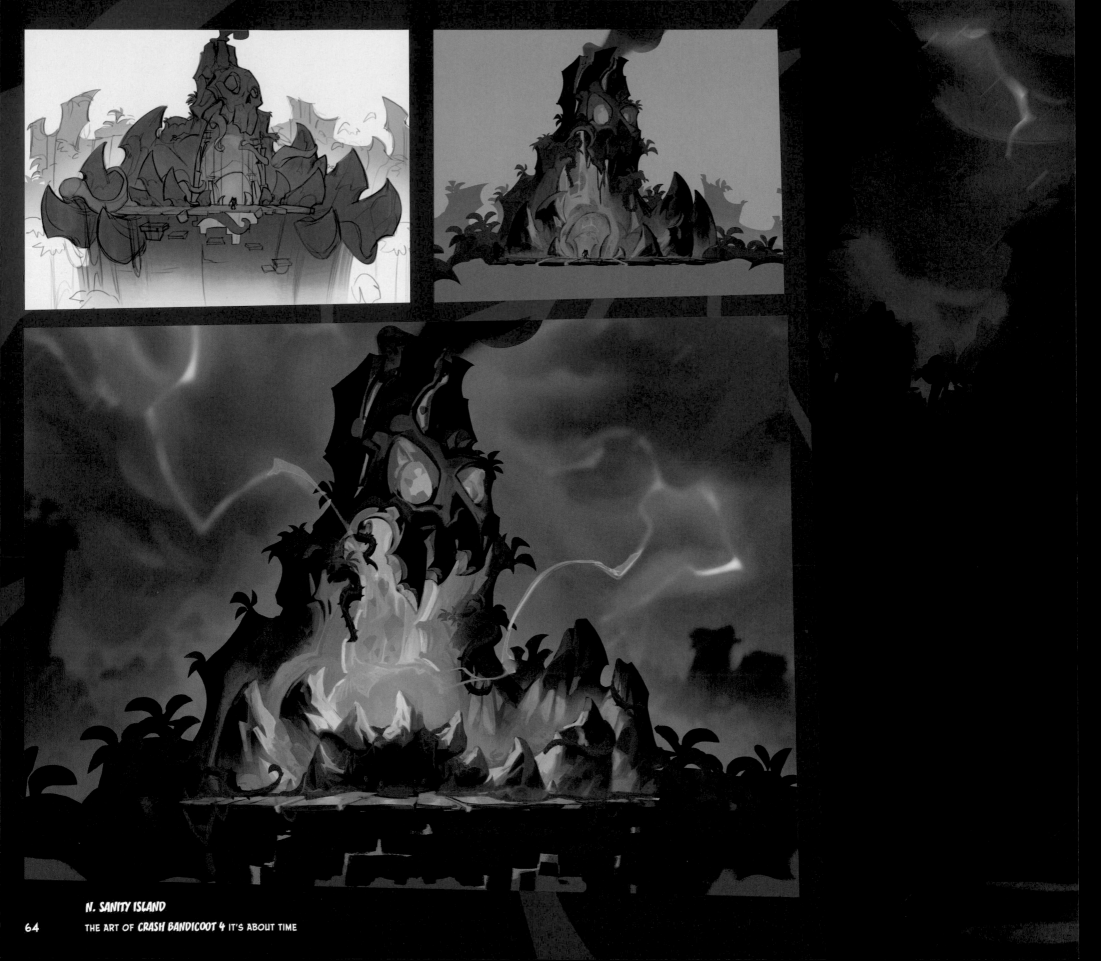

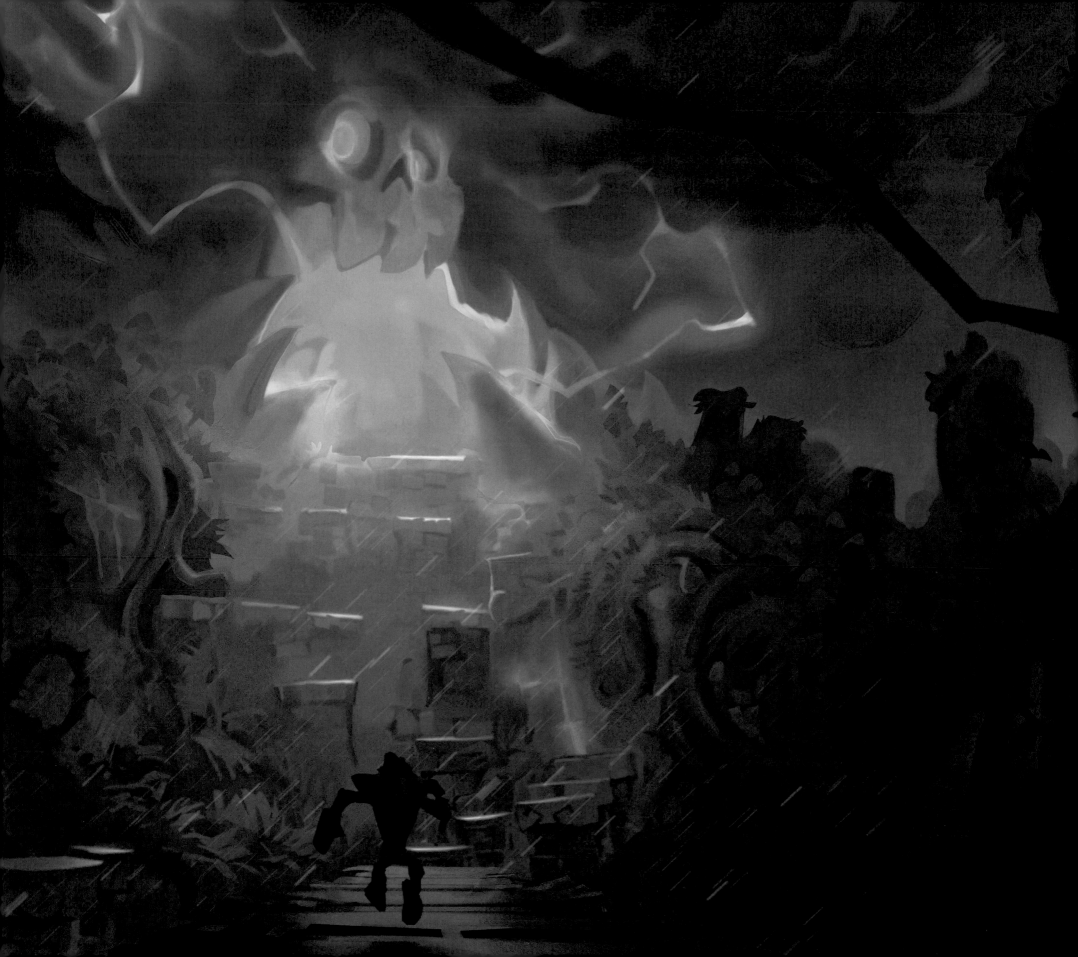

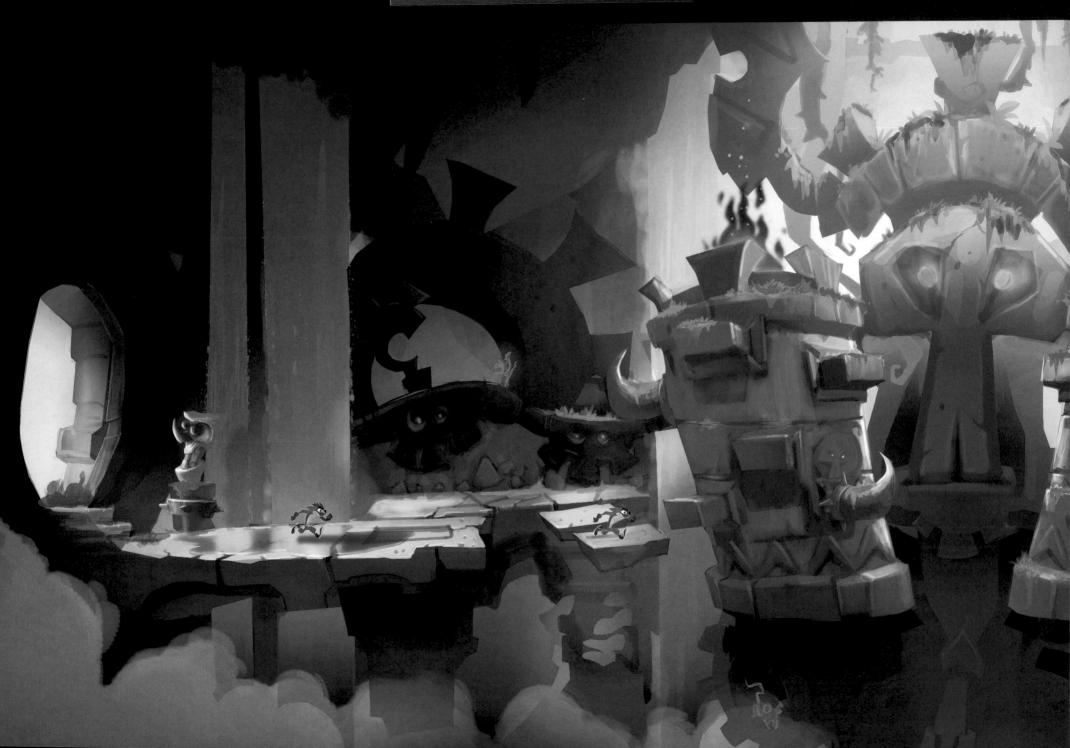

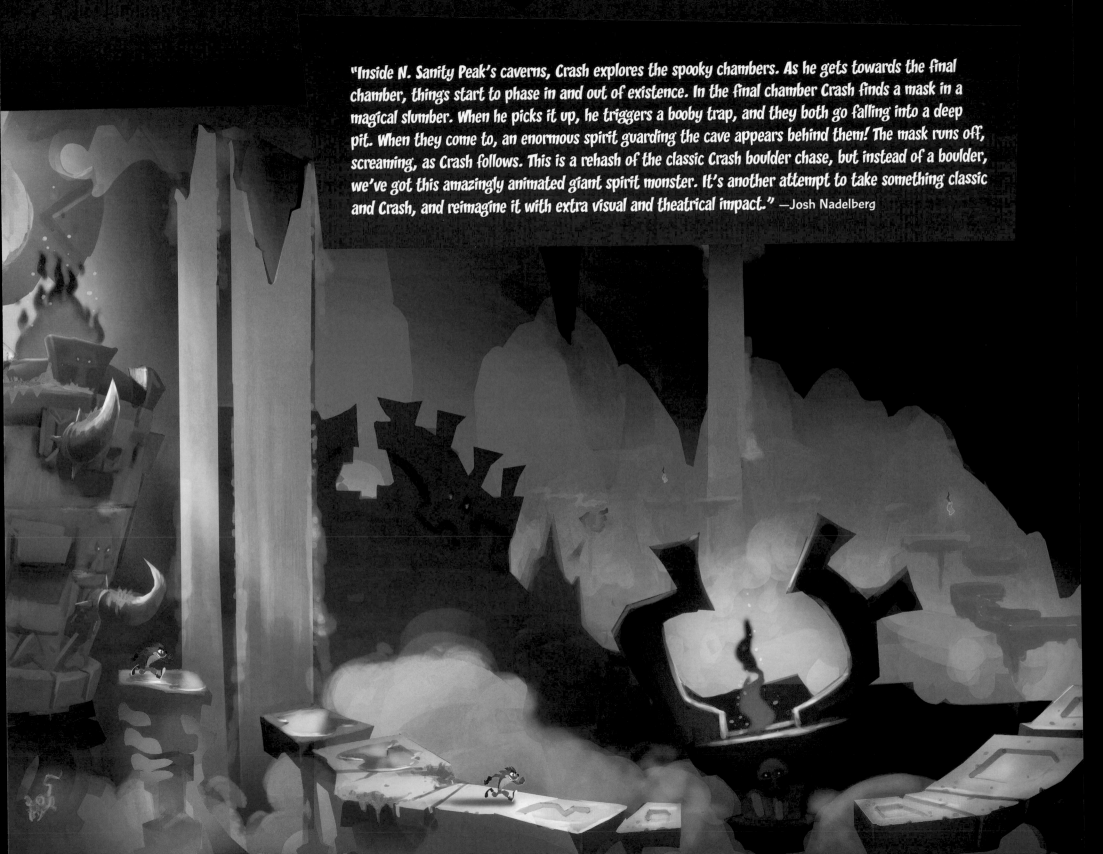

"Inside N. Sanity Peak's caverns, Crash explores the spooky chambers. As he gets towards the final chamber, things start to phase in and out of existence. In the final chamber Crash finds a mask in a magical slumber. When he picks it up, he triggers a booby trap, and they both go falling into a deep pit. When they come to, an enormous spirit guarding the cave appears behind them! The mask runs off, screaming, as Crash follows. This is a rehash of the classic Crash boulder chase, but instead of a boulder, we've got this amazingly animated giant spirit monster. It's another attempt to take something classic and Crash, and reimagine it with extra visual and theatrical impact." —Josh Nadelberg

"We had opportunities to think of completely crazy things that we thought were cool. I didn't have to compromise on the art style. Usually people tell me to chill out on the crazy shapes, but on this one it was like, 'Keep it coming.' I loved it."

—James Martin

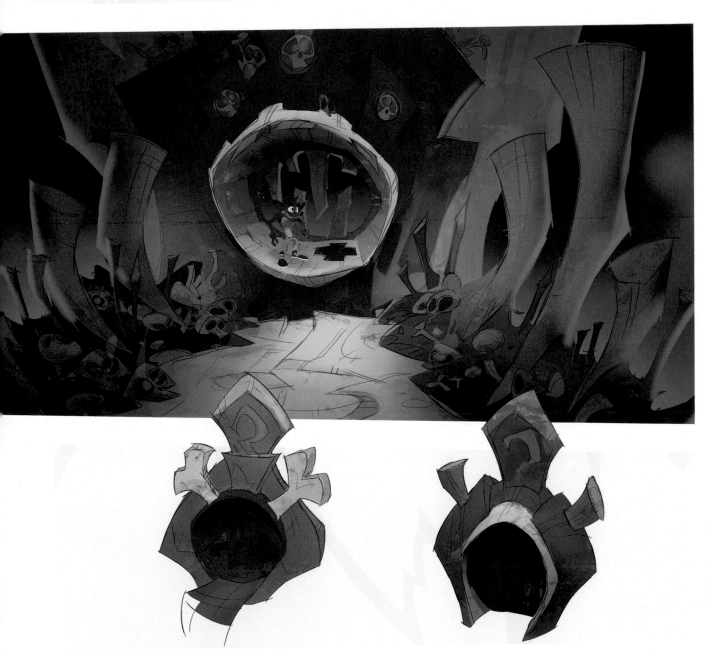

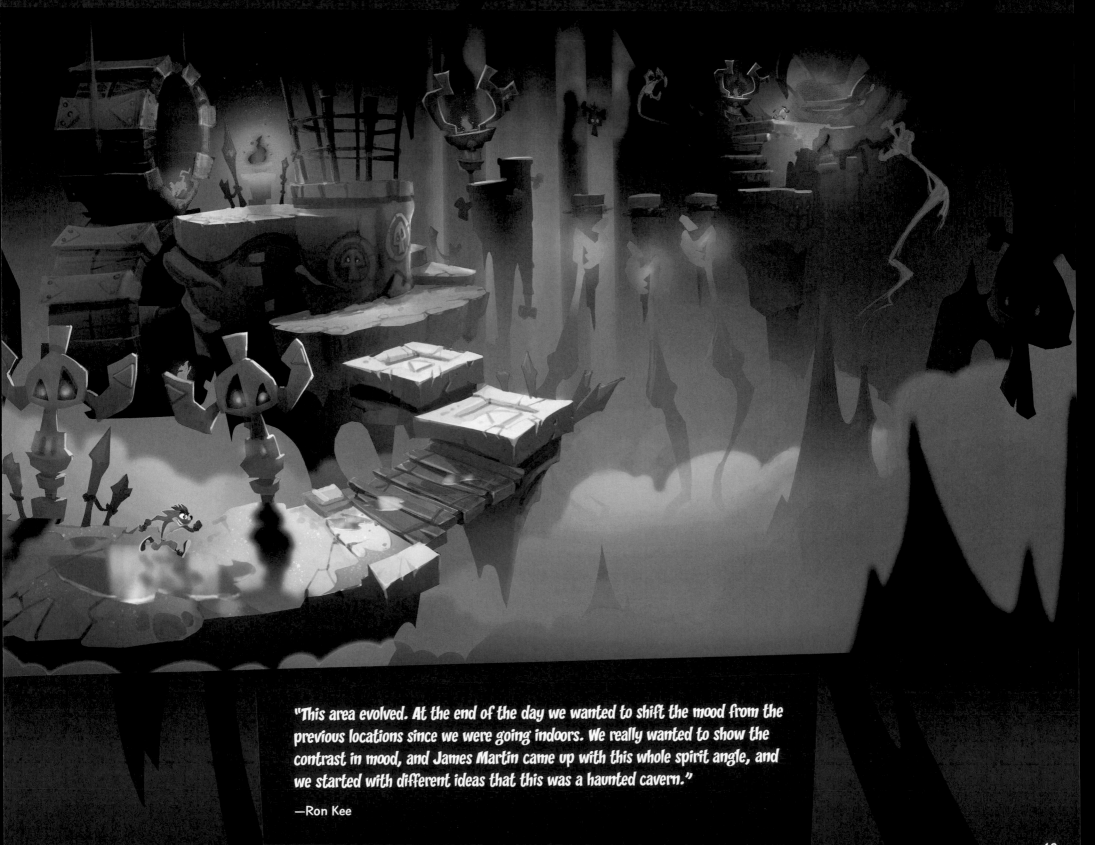

"This area evolved. At the end of the day we wanted to shift the mood from the previous locations since we were going indoors. We really wanted to show the contrast in mood, and James Martin came up with this whole spirit angle, and we started with different ideas that this was a haunted cavern."

—Ron Kee

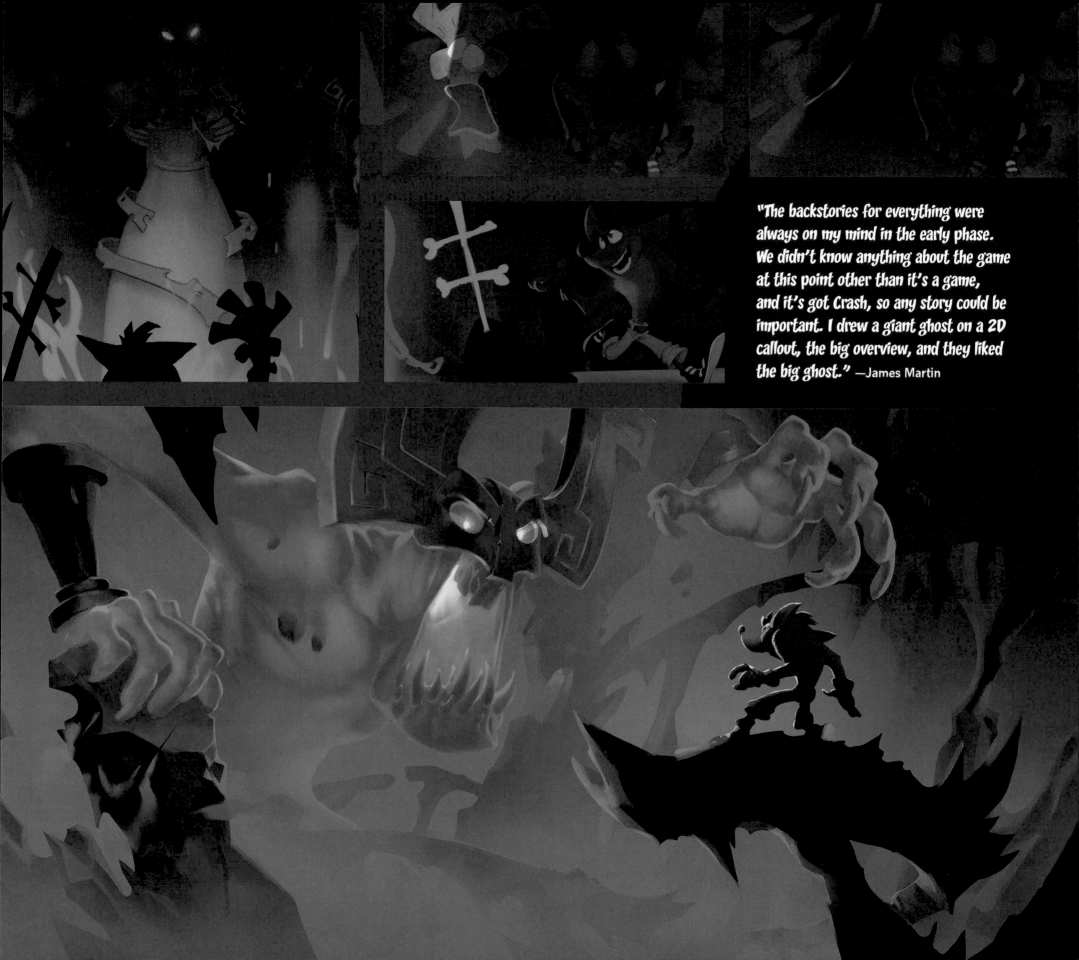

"The backstories for everything were always on my mind in the early phase. We didn't know anything about the game at this point other than it's a game, and it's got Crash, so any story could be important. I drew a giant ghost on a 2D callout, the big overview, and they liked the big ghost." —James Martin

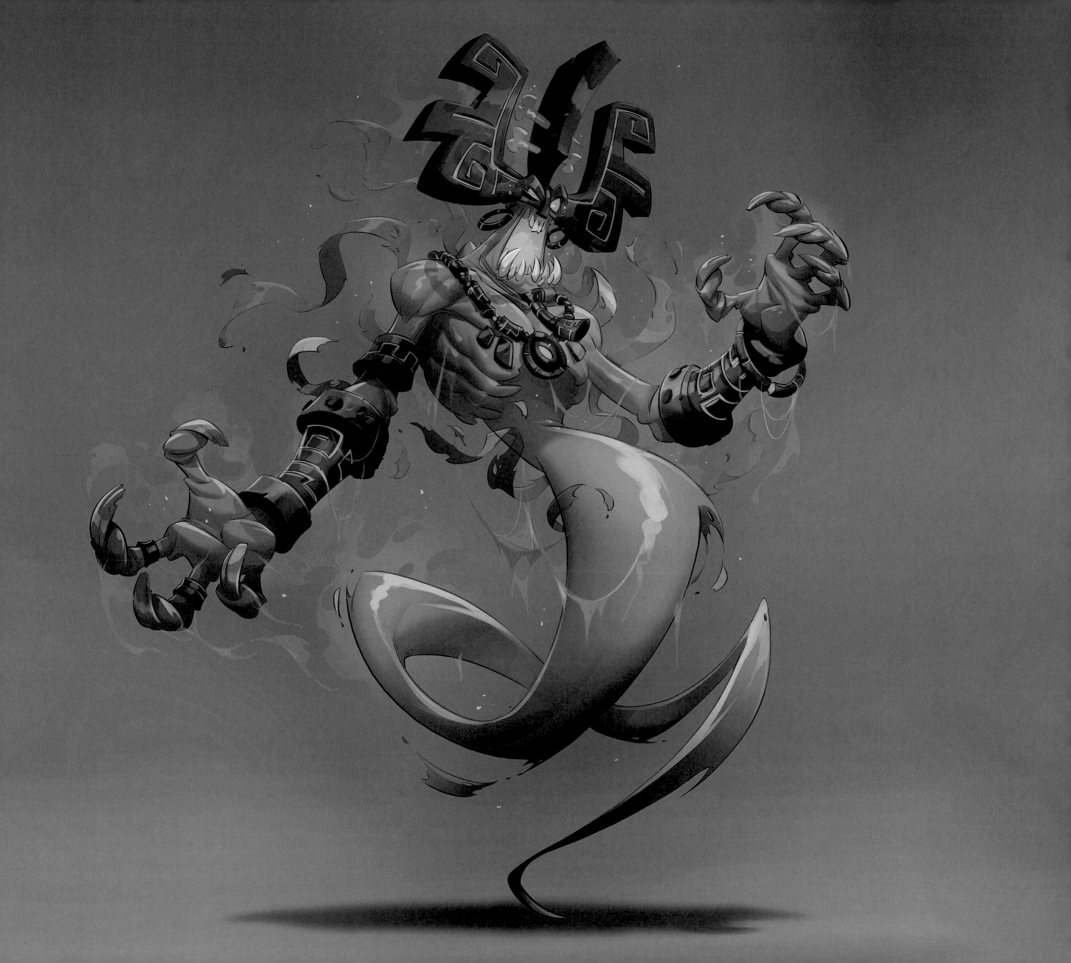

"This was another take on (the chase sequence), and we were saying instead of him jumping from platform to platform, maybe it's solid ground. In this case we were like, 'Well, if this giant creature is right behind you, maybe it's almost a roller coaster; it's more like a wooden platform, and this giant spirit is right behind you. As he's swinging his hands, he's smashing the wooden platform, and you see bits of it flying all around,—it can be very dramatic.'"

—Ron Kee

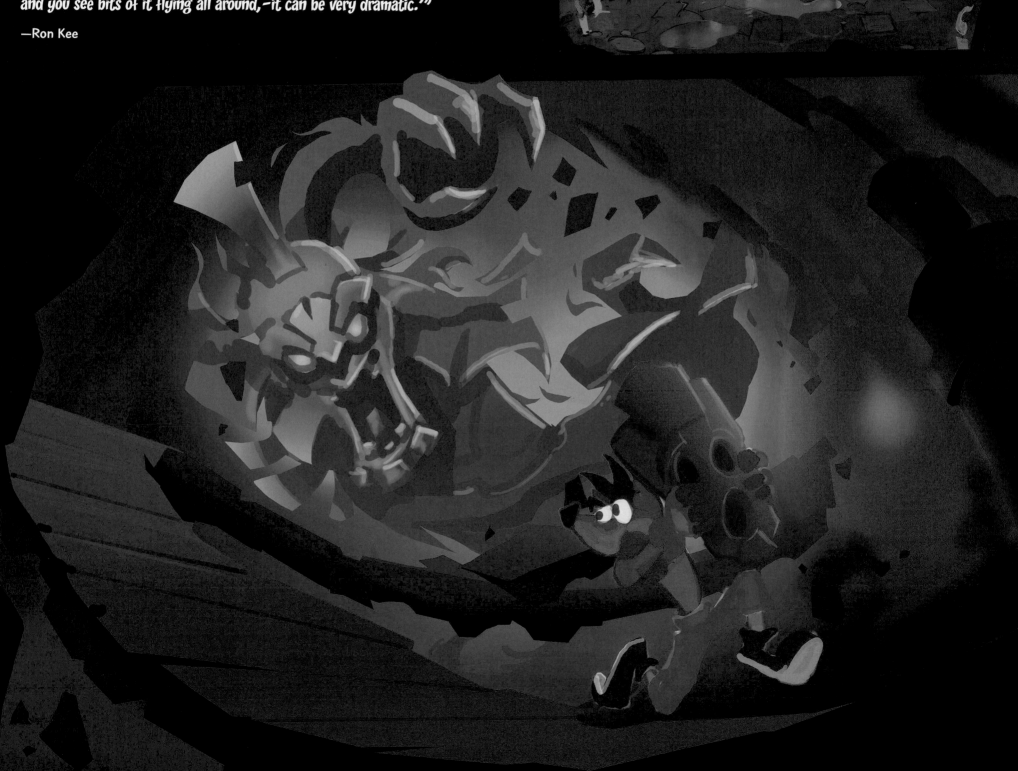

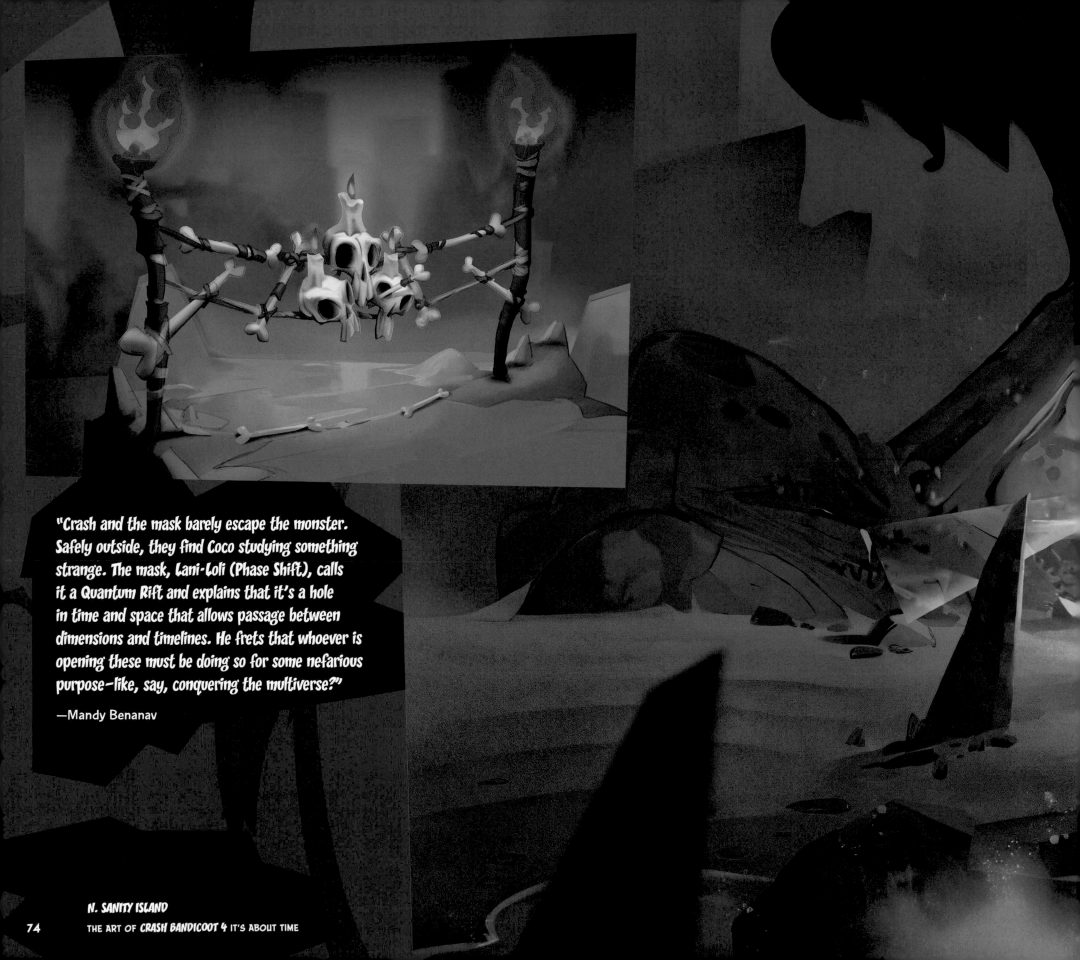

"Crash and the mask barely escape the monster. Safely outside, they find Coco studying something strange. The mask, Lani-Loli (Phase Shift), calls it a Quantum Rift and explains that it's a hole in time and space that allows passage between dimensions and timelines. He frets that whoever is opening these must be doing so for some nefarious purpose—like, say, conquering the multiverse?"

—Mandy Benanav

N. SANITY ISLAND

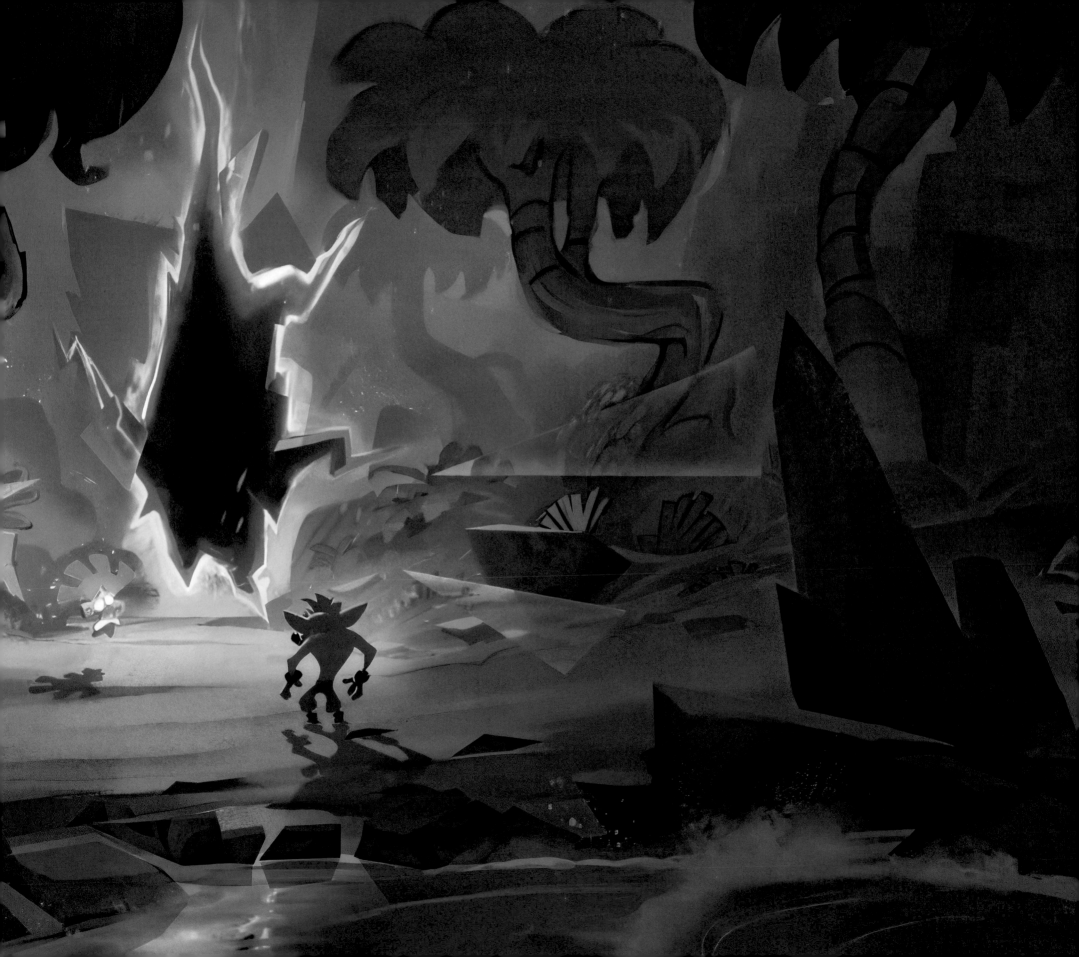

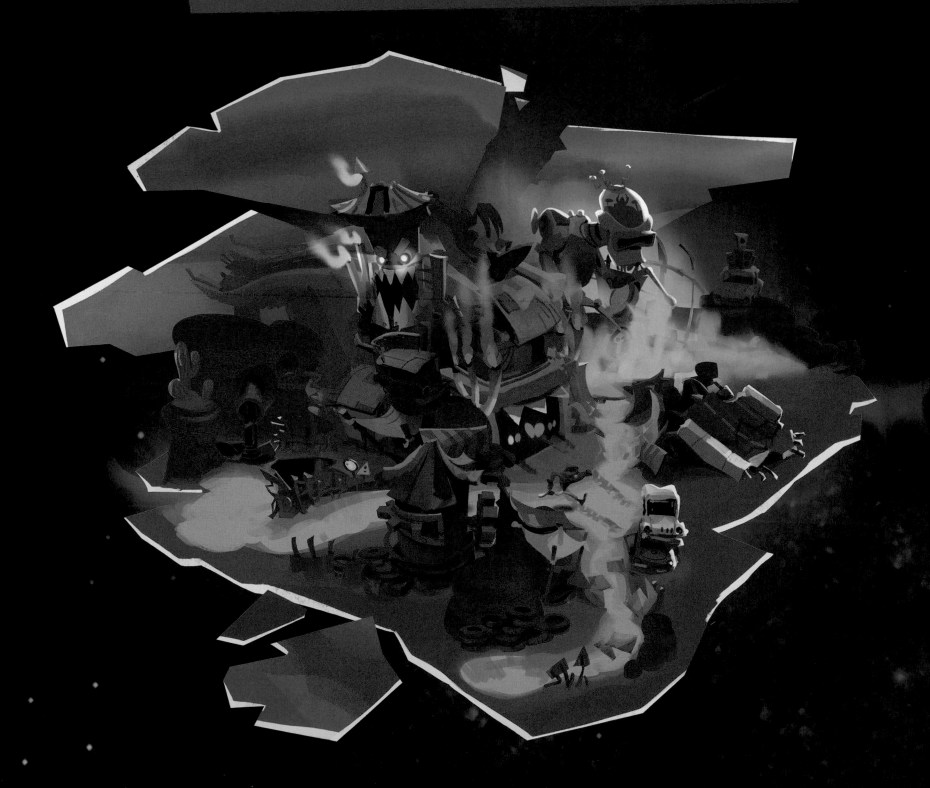

THE HAZARDOUS WASTES
(2084)

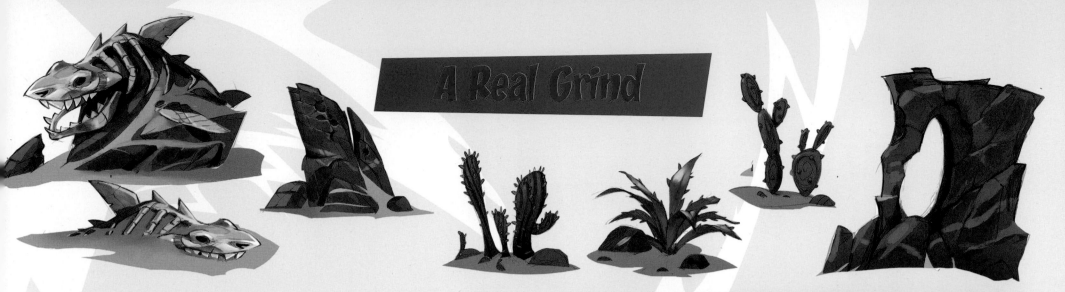

A Real Grind

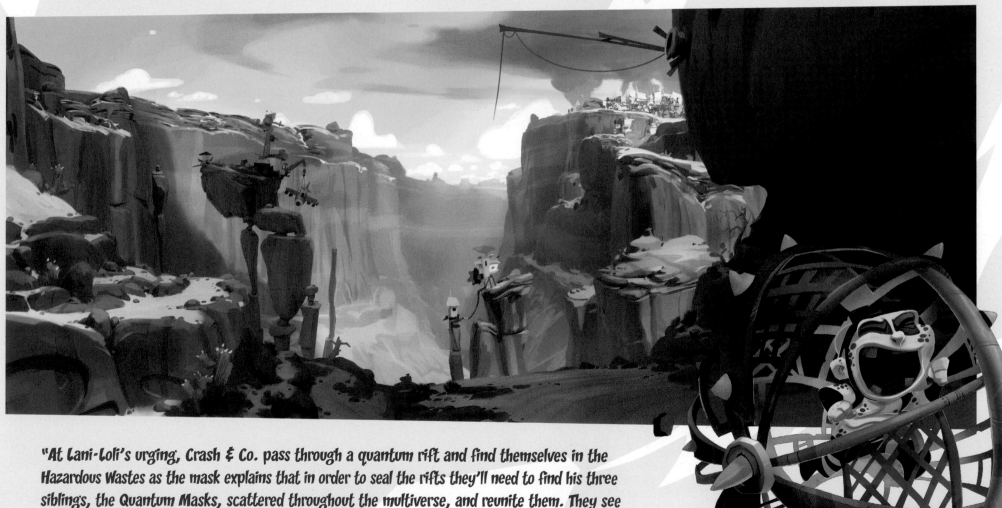

"At Lani-Loli's urging, Crash & Co. pass through a quantum rift and find themselves in the Hazardous Wastes as the mask explains that in order to seal the rifts they'll need to find his three siblings, the Quantum Masks, scattered throughout the multiverse, and reunite them. They see the next mask—'Akano,—in the distance and begin to head toward him... but a massive wrench is thrown in the works when N. Gin appears. He tells them that he's kidnapped 'Akano and challenges them to a fight for him—if they can make it to his "show," that is."

—Mandy Benanav

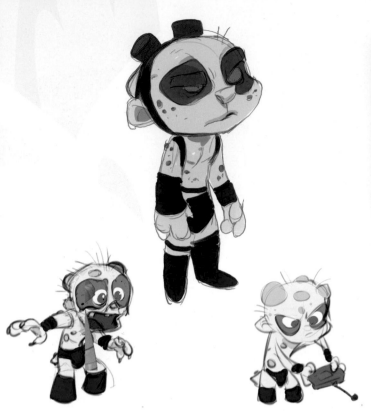

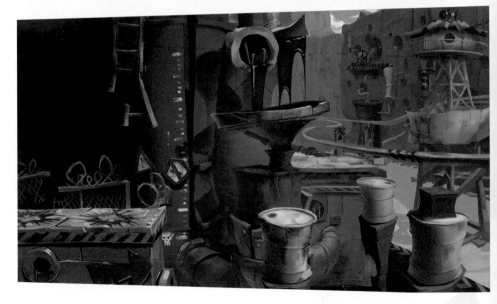

"Crash makes his way from the rift out in the middle of the desert to the outskirts of Klang City, a ramshackle postapocalyptic town perched on a red rocky ridge. Throughout the level we're introduced to the little blue muties that inhabit Klang City and are out on patrol (in my head canon, they were raised on petro fluids in the desert that mutated them into these little bratty dudes) along with dudes on rocketpacks tossing bombs at Crash and sandsharks that swim through the desert floor. The sandsharks have been "tamed" by the muties, and with their iron jaws and exhaust pipe enhancements, they patrol the desert, keeping intruders from invading Klang City. Crash rides abandoned rails through the desert until he reaches an outpost built into the side of a rocky cliff."

—Josh Nadelberg

"I was trying to draw villains that right off the bat you could tell if they were powerful or not, so these guys were basically just these little weak muties that seemed easy to beat', but then they would use all this postapocalyptic stuff to create havoc so you had to defeat what they were using or get around that to get to them."

—Brett Bean

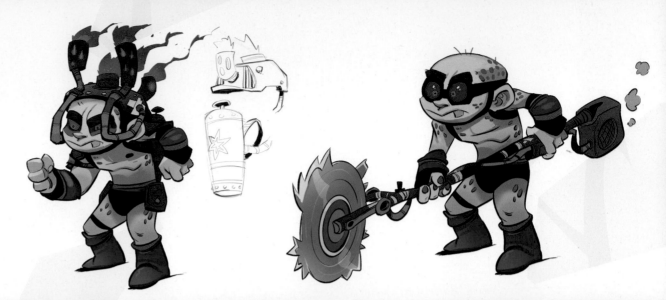

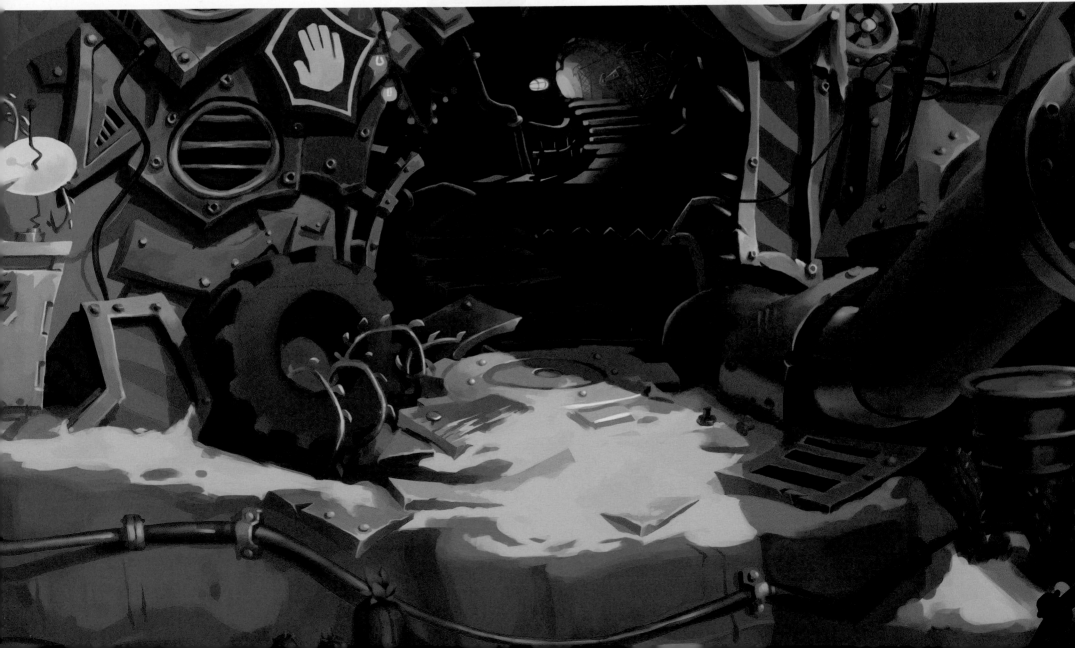

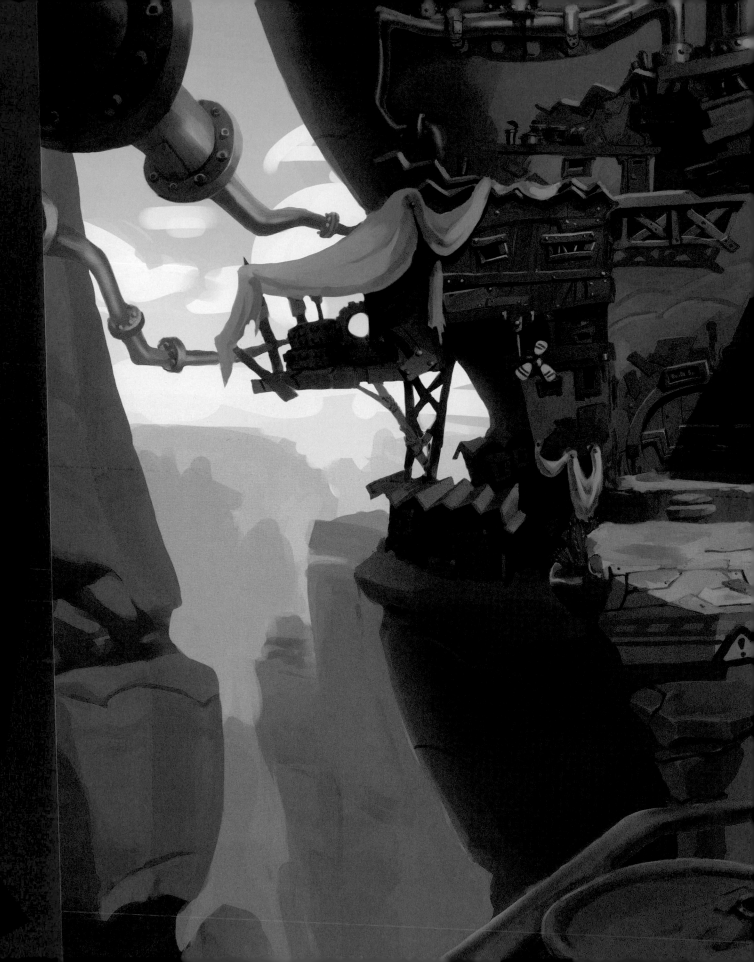

"The main idea of the canyon was an oil drilling spot, so we had the idea to add pipes everywhere, and that can add some dynamics, lines that can lead the player's eye to a direction or to a focus. Initially on this kind of artwork we have simple blockout 3D shapes of the map with the gameplay paths and constraints, and you have to build around it; you have to paint in order to highlight the gameplay path."

—Geraud Soulie

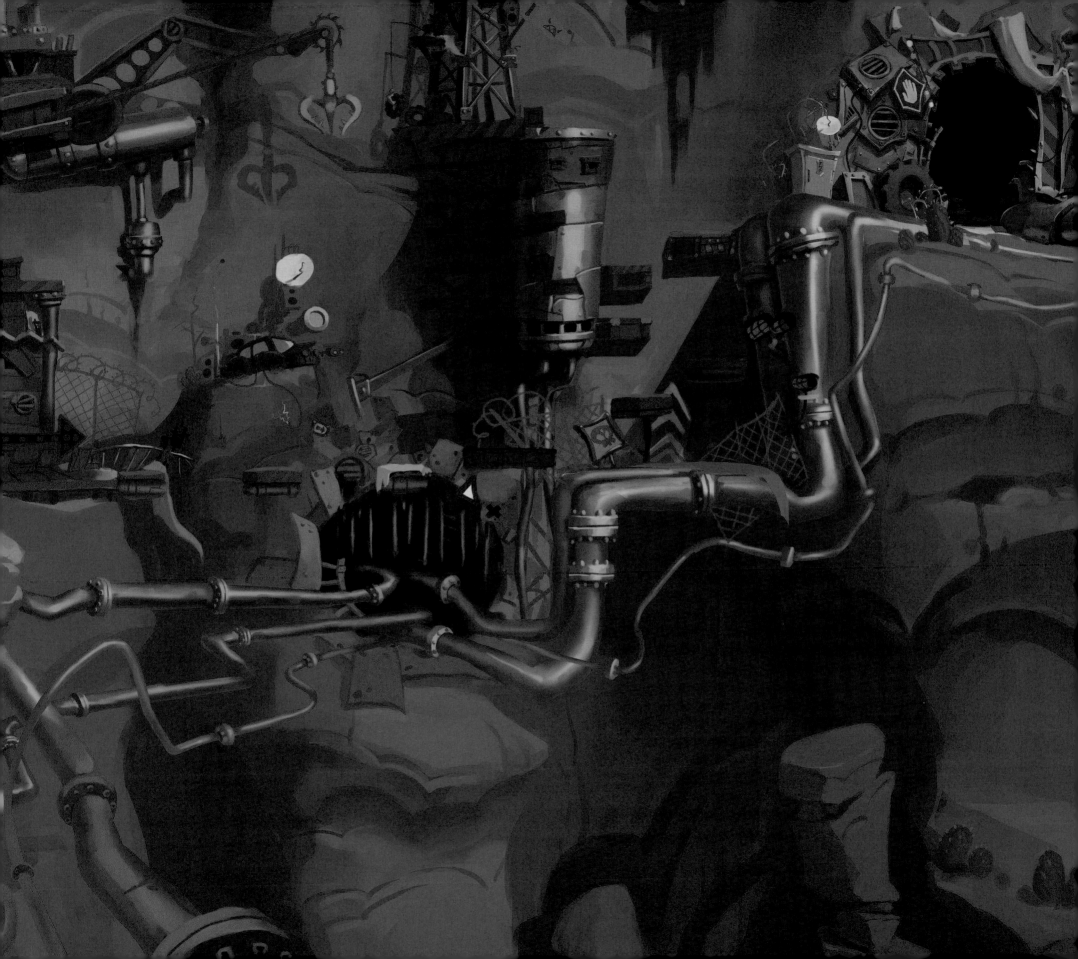

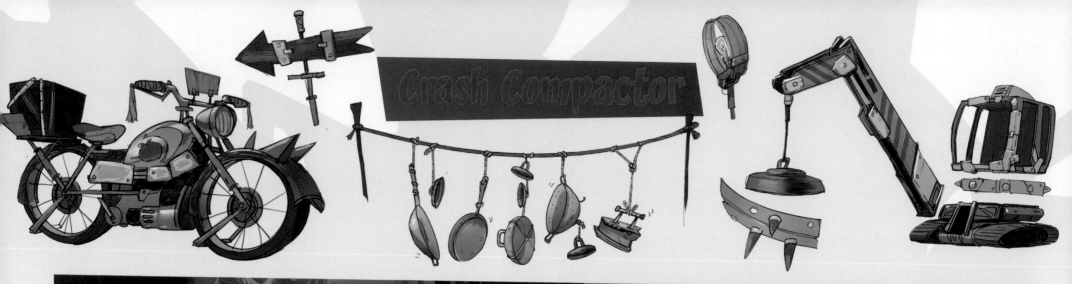

"Klang City is a beautiful mess of scrapped cars, neon signs, and scavenged bits and pieces. The designs were almost too detailed when we started working on them, but they perfectly capture the wild and wacky world of Crash 4. Throughout the city Crash sees signs for "Rawkit Hed," a heavy-metal show that's playing that night. The logo looks an awful lot like Doctor N. Gin. Crash makes his way through the city to the end of a broken-down overpass..."

—Josh Nadelberg

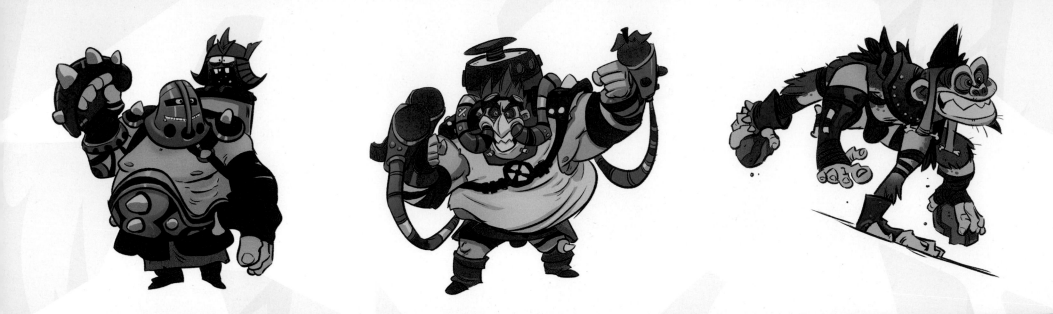

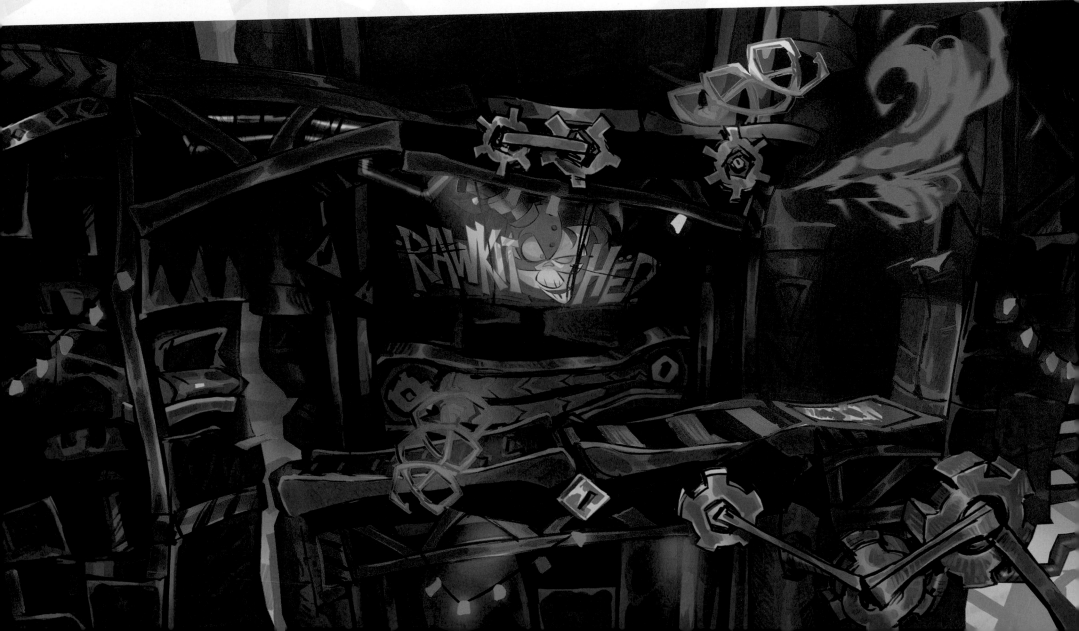

"The Klang City level was one of the very first we worked on. We wanted the world to have the same wild and out of control energy as Crash himself. I loved the design direction and was so delighted to see how well the 3D artists captured that chaos as they brought the level to life. This really set a bar for how much visual storytelling we could cram into the environments."

—Josh Nadelberg

Berserk Bomber

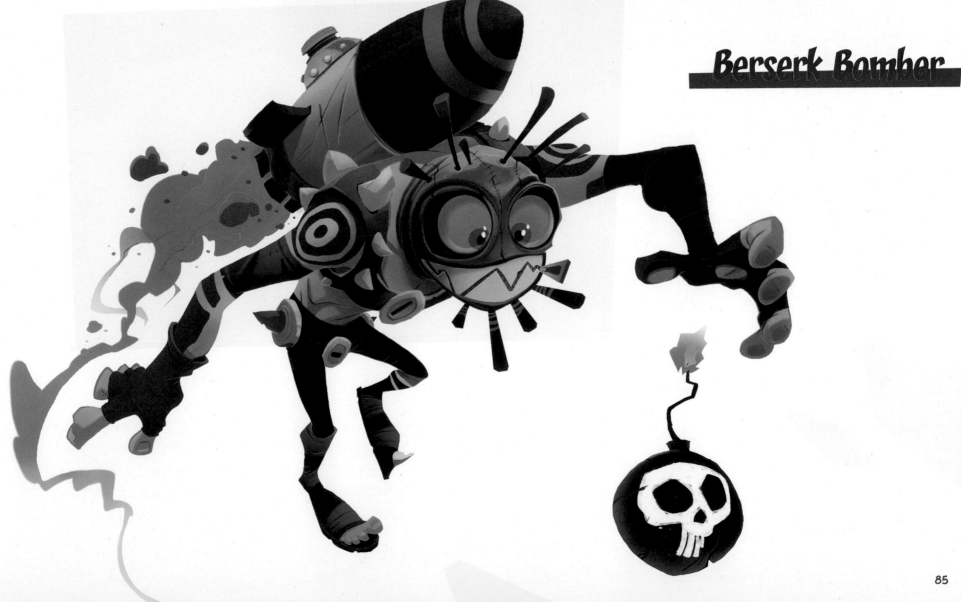

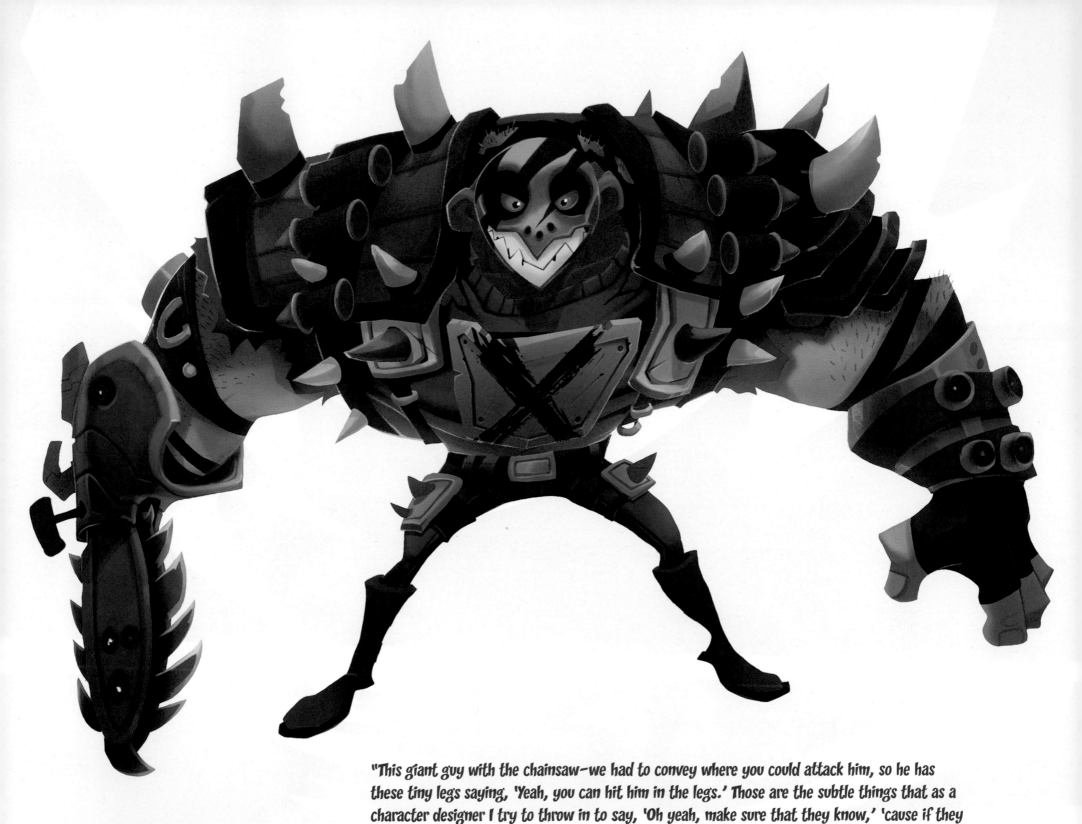

"This giant guy with the chainsaw—we had to convey where you could attack him, so he has these tiny legs saying, 'Yeah, you can hit him in the legs.' Those are the subtle things that as a character designer I try to throw in to say, 'Oh yeah, make sure that they know,' 'cause if they don't know what to do we've kind of failed design-wise. It's like in film if they don't know how to feel about somebody or they don't know what to think about somebody, it's kind of a fail."

—Brett Bean

Chop Shop

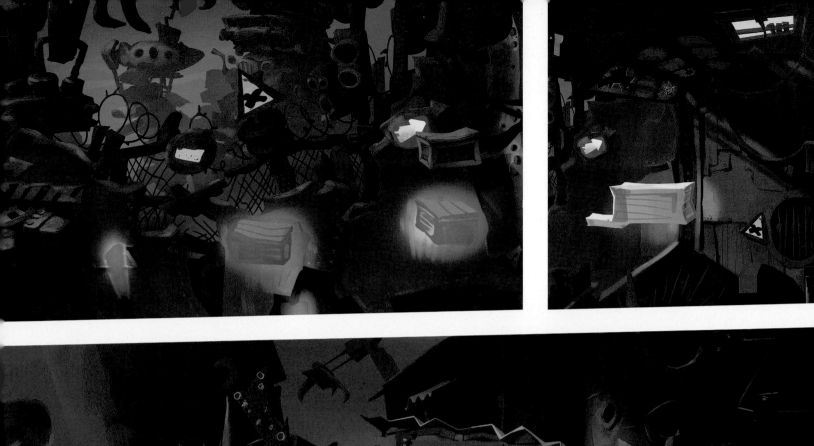
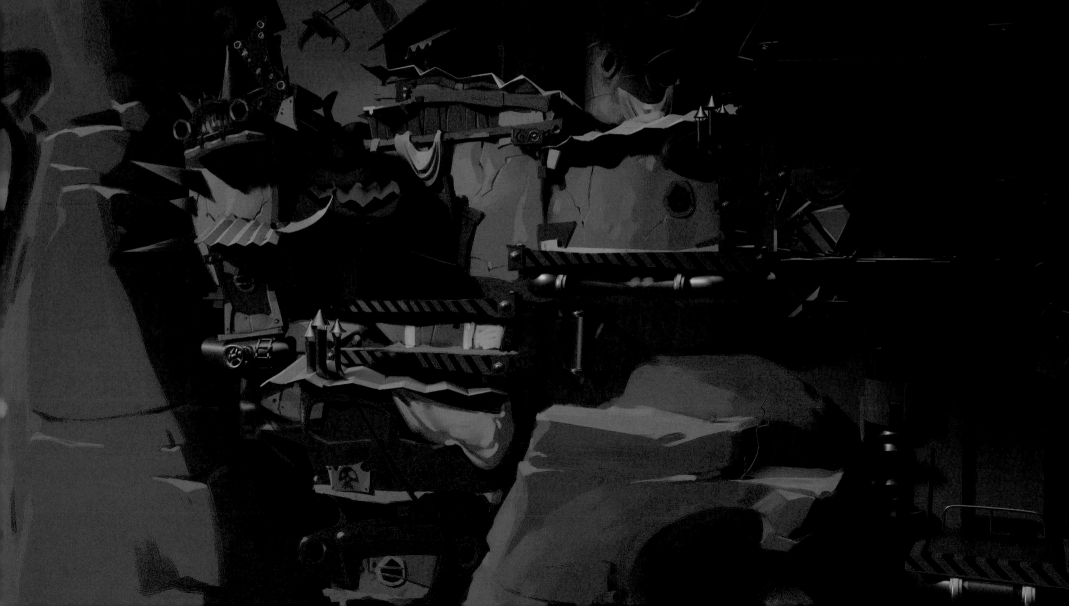

Hit the Road

OMNOMNOM

"We wanted a segment of Crash running away from vehicles, so we were like, 'Let's use this one smaller vehicle,' and then, 'What can we do to change the base model into other things?' So there's the big ol' punching glove in the front, and you got flames out the back, and of course I put a marshmallow and a hot dog on the back because I would do that. I mean, if I were going to kill Crash Bandicoot, I would also want a meal afterwards."

—Brett Bean

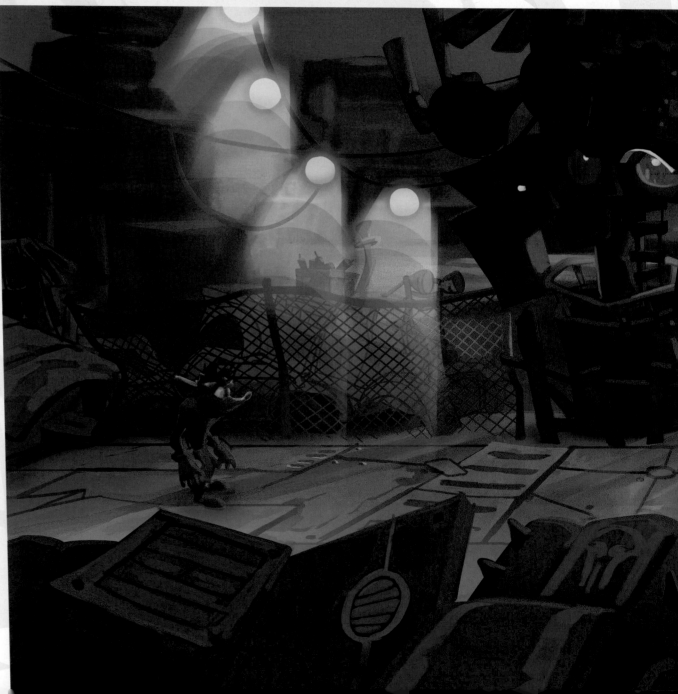

"Crash makes his way along a busted-up, highway that leads to a giant garage. As he runs past it, the big door opens up and the headlights of a giant monster truck shine on Crash. Something keeps the truck from starting, giving Crash a little time to get a head start! (Huh??? Turns out that Tawna was helping Crash on her "Timeline" which the player will experience later to see how she lent a hand.) Crash jumps in a rollerball and starts to roll away from the oncoming truck. This is another one of those run-toward-the-camera Crash chases. Finally eluding the truck, Crash finds himself at the entrance to the big Rawkit Hed concert..." —Josh Nadelberg

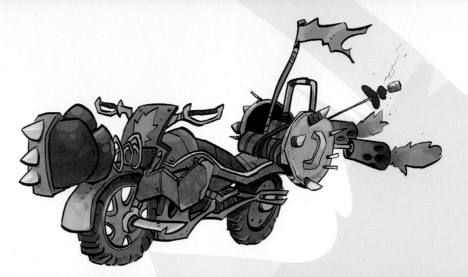

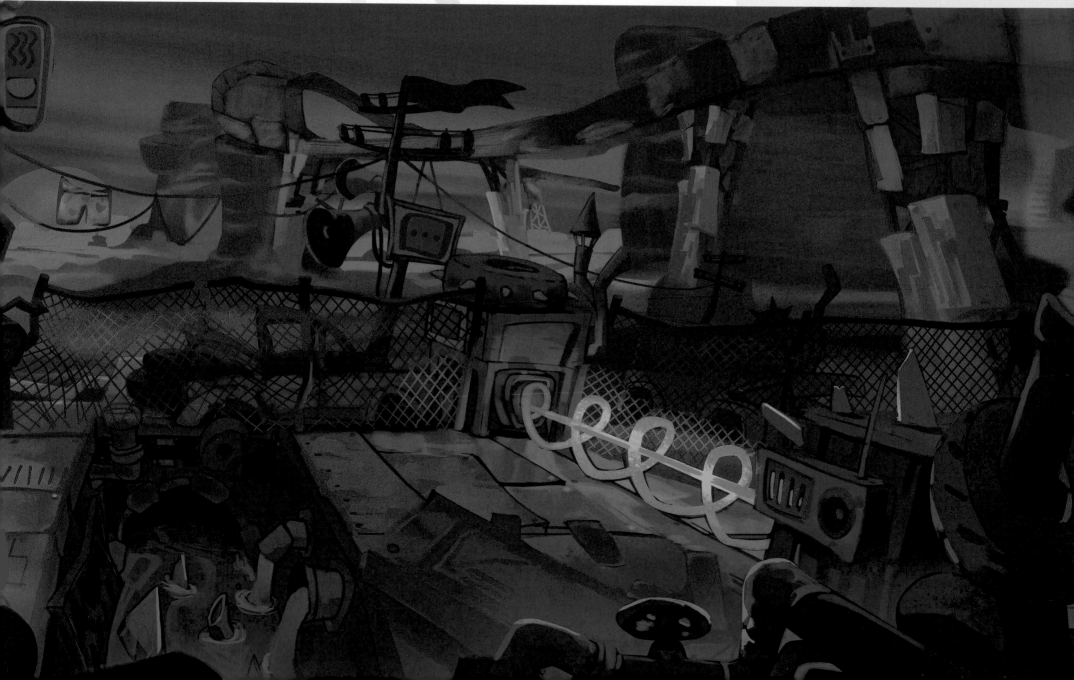

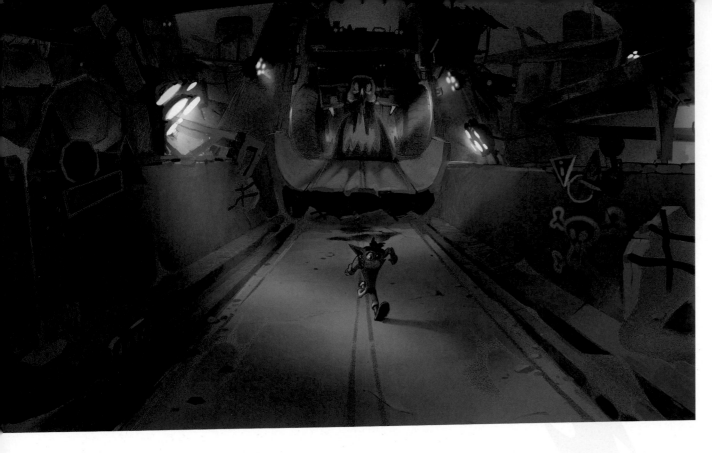

"There is a truck that's supposed to chase Crash, and you are running toward the camera, so that's kind of a fun way to do a concept because you have to work on the opposite side of it. I had a lot of fun with this one because Josh wanted a thrilling chase and I could play with a lot of effects."

—Didier Nguyen

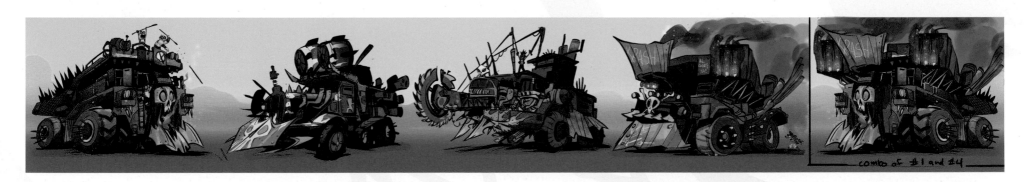

combo of #1 and #4

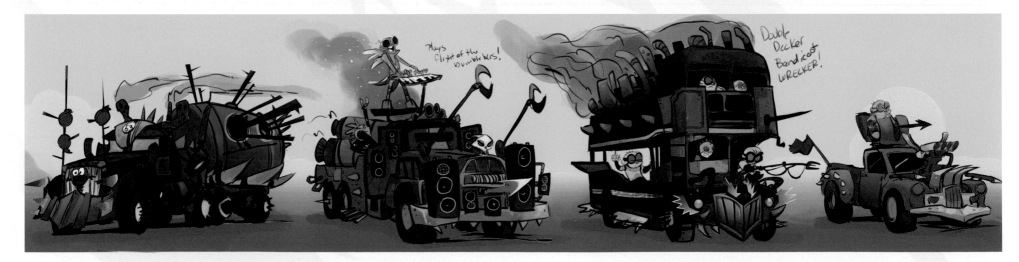

Plays flight of the bumblebees!

Double Decker Bandicoot WRECKER!

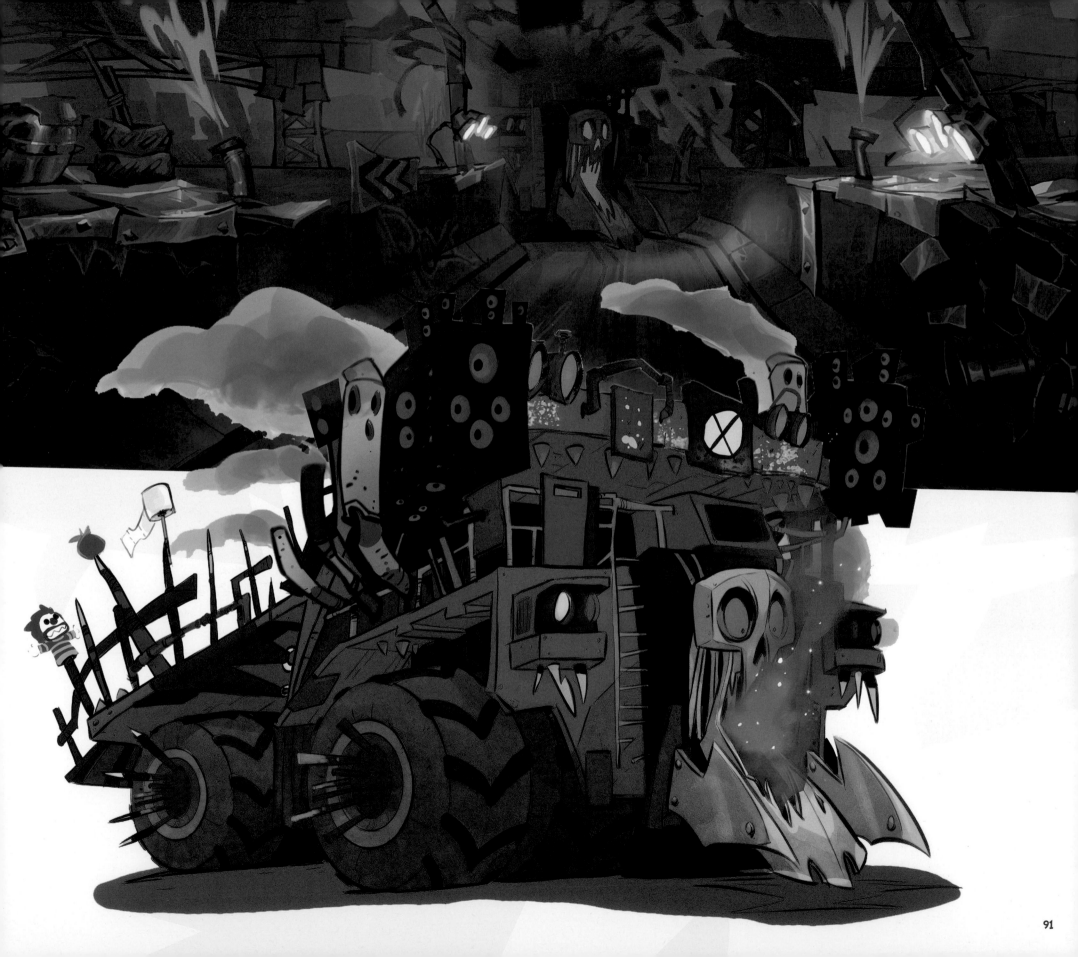

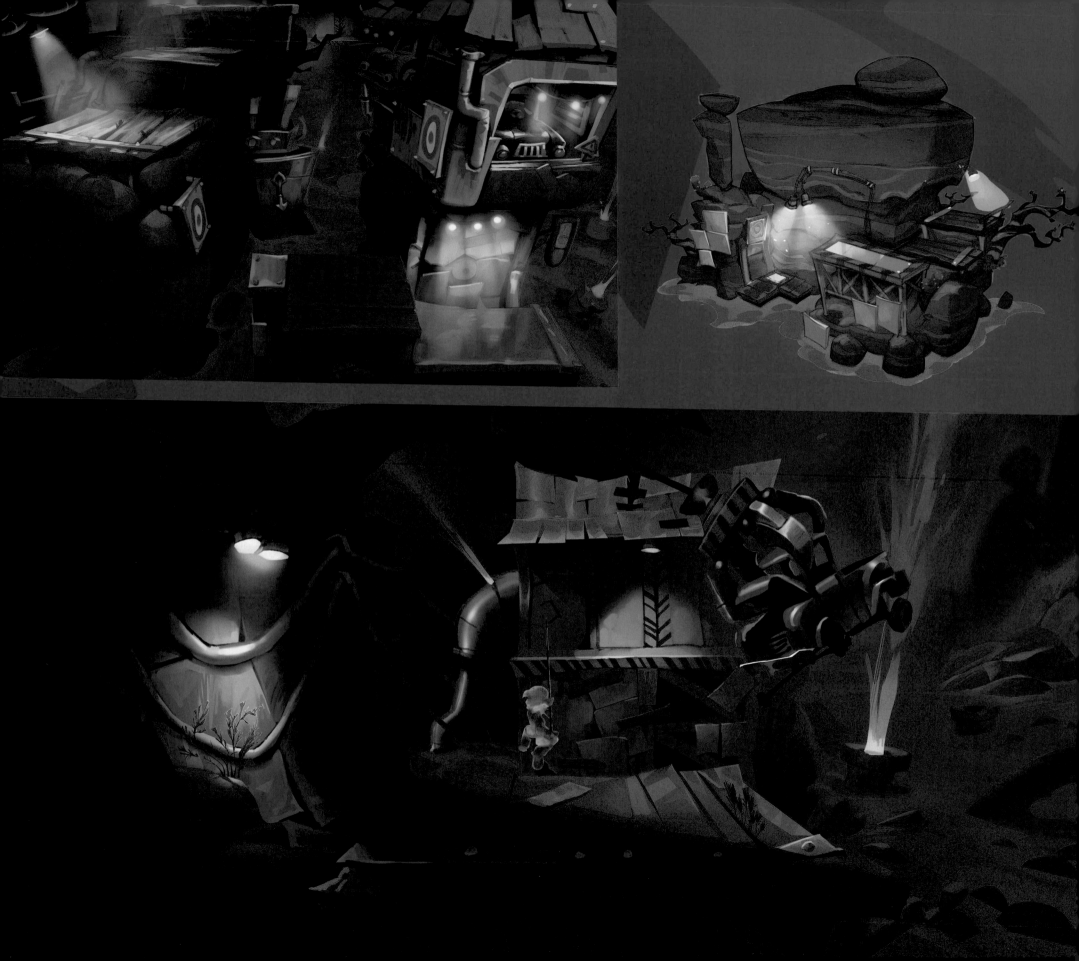

"Everything needs to be easy to read. The path needs to be always flat enough for running with no objects that can be misunderstood as blocking objects. I make sure the background objects do not conflict with playable objects by simplifying their form and toning down their color and contrast so they don't pop."

—Khoa Tran Viet

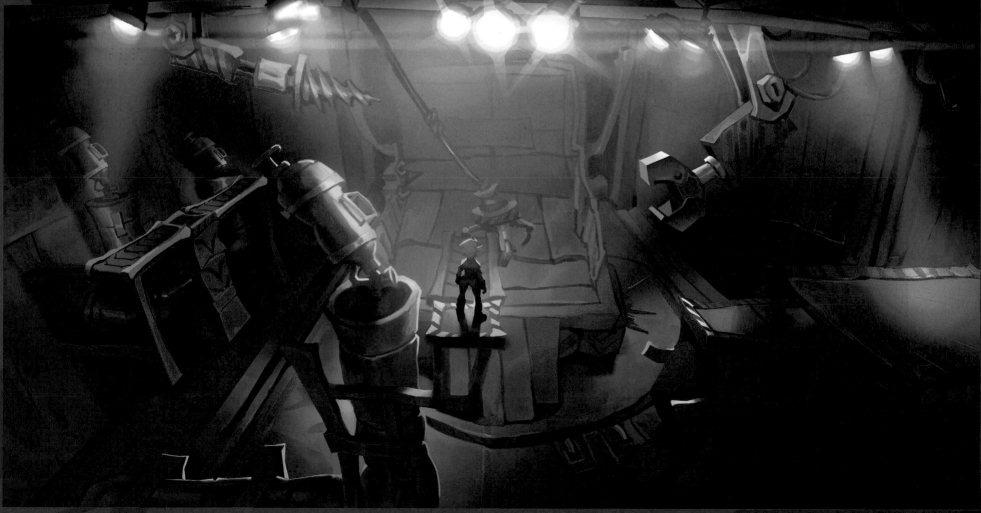

RAWKIT HED

RAWKIT HED

"Rawkit Hed turns out to be a massive robot drummer piloted by N. Gin–a "weapon of mass percussion." The boss battle plays out with Crash dodging dangerous electric pulses that correspond to the music. With much skill, the bandicoots destroy his robot, but before they can rescue 'Akano (still in a magic slumber) he bounces off N. Gin's drum set and flies through an open rift. The gang gives chase..."

—Mandy Benanav

Dr. N. Gin

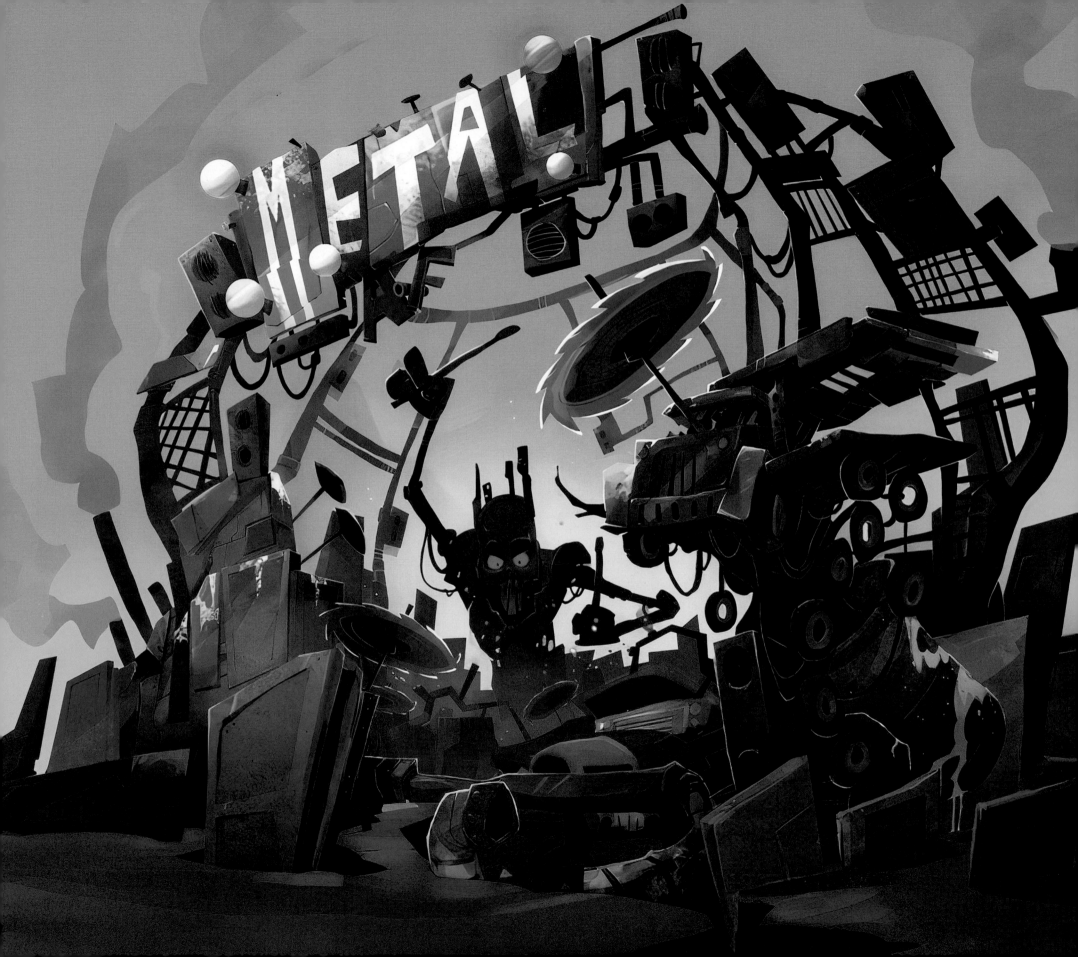

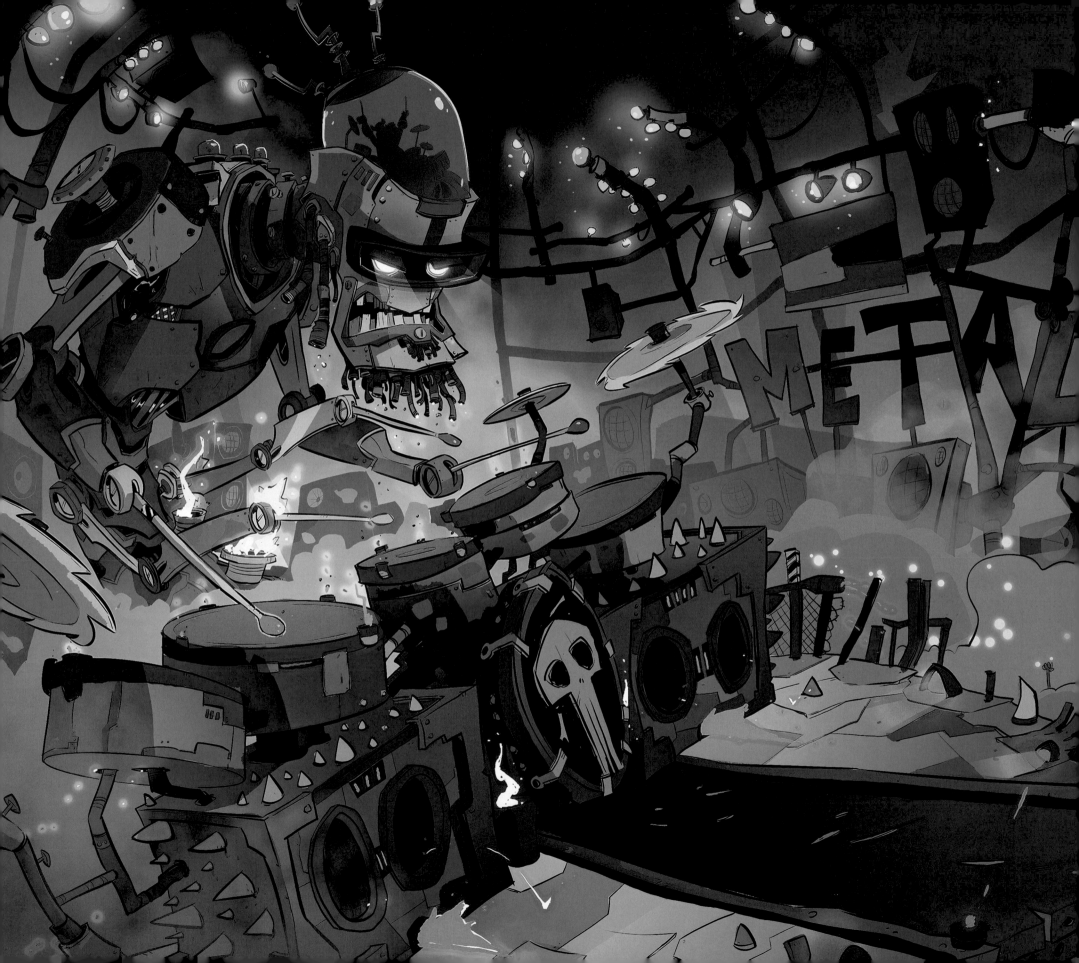

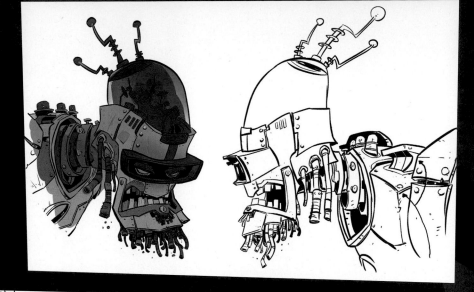

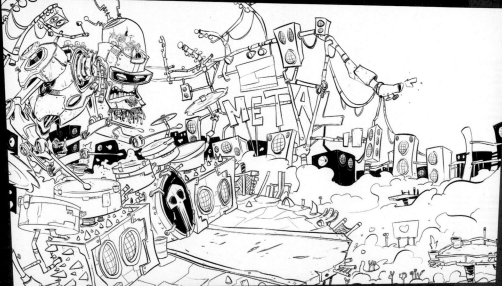

"We couldn't do all the audience, so I had to make the fog at the bottom instead of a bunch of people. I would like them all holding up lighters, but there was no way we could do that. We had to figure out how to cheat the system, so a lot of it we used little signs, little flashes and stuff, so it feels like there's things happening. That's sort of back and forth with design saying, 'That's a little bit too much. What can we get away with?'" —Brett Bean

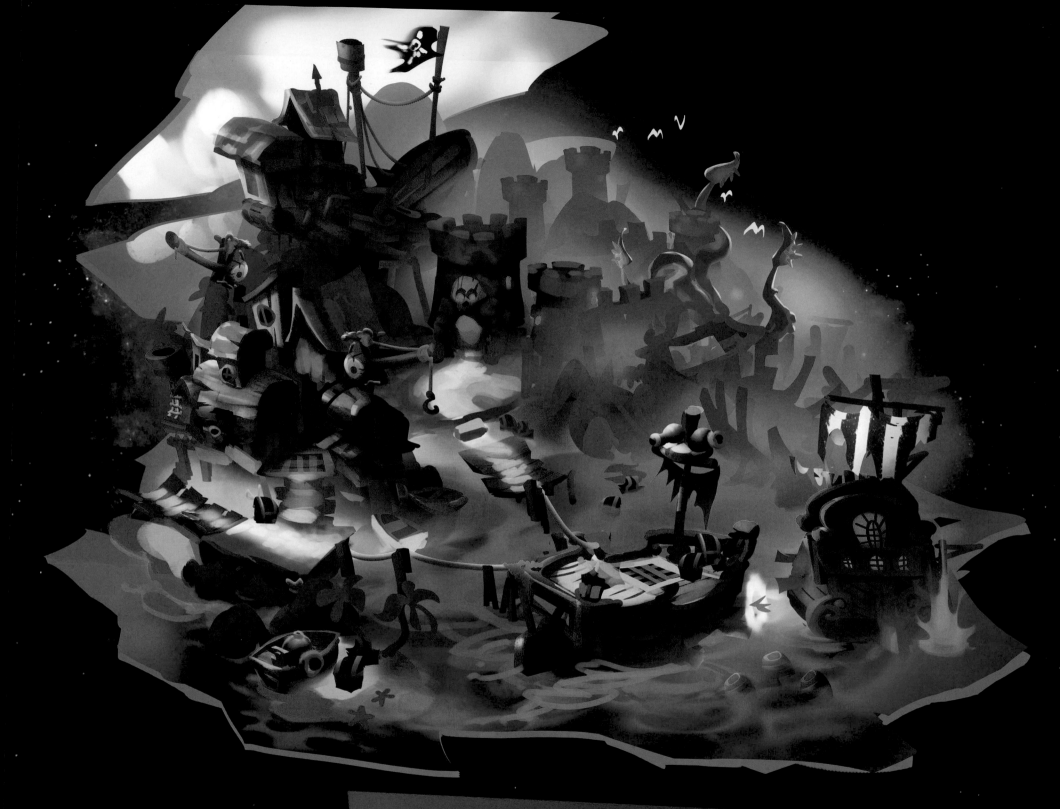

SALTY WHARF

(1717)

Booty Calls

"Our heroes arrive at a new, pirate-y location where they begin to search for 'Akano. There Crash finds himself at the end of a dock by a beached pirate ship, and he makes his way through a dark cave that leads to a hidden pirate outpost nestled in a cove. Again, this level features some amazing artwork and designs that not only capture a perfectly playful pirate aesthetic but also manage to reinforce that same off-kilter whimsy that we've established previously in the Hazardous Wastes." —Josh Nadelberg

"Crash slides on a rope that skirts the town and lands at the gates of the village. He cruises through town and into the pirates' underground vault, thinking that's where he might find 'Akano, but instead he stumbles into their treasure room. He gets captured by the pirates and taken away!!!!"

—Josh Nadelberg

"This is not elaborate artwork, but it's made to have us think and talk, and then we can choose what we feel is the best solution. For instance, in this one Josh chose the pirate pile, the little gang of pi-rats. Since he liked the idea, but I'm not the best one to draw characters, he sent it to Nico Saviori, and he did a super-beautiful artwork with very clean lines and nice colors, so we can give that to the 3D department and they can produce it."

—JB Dugait

SALTY WHARF

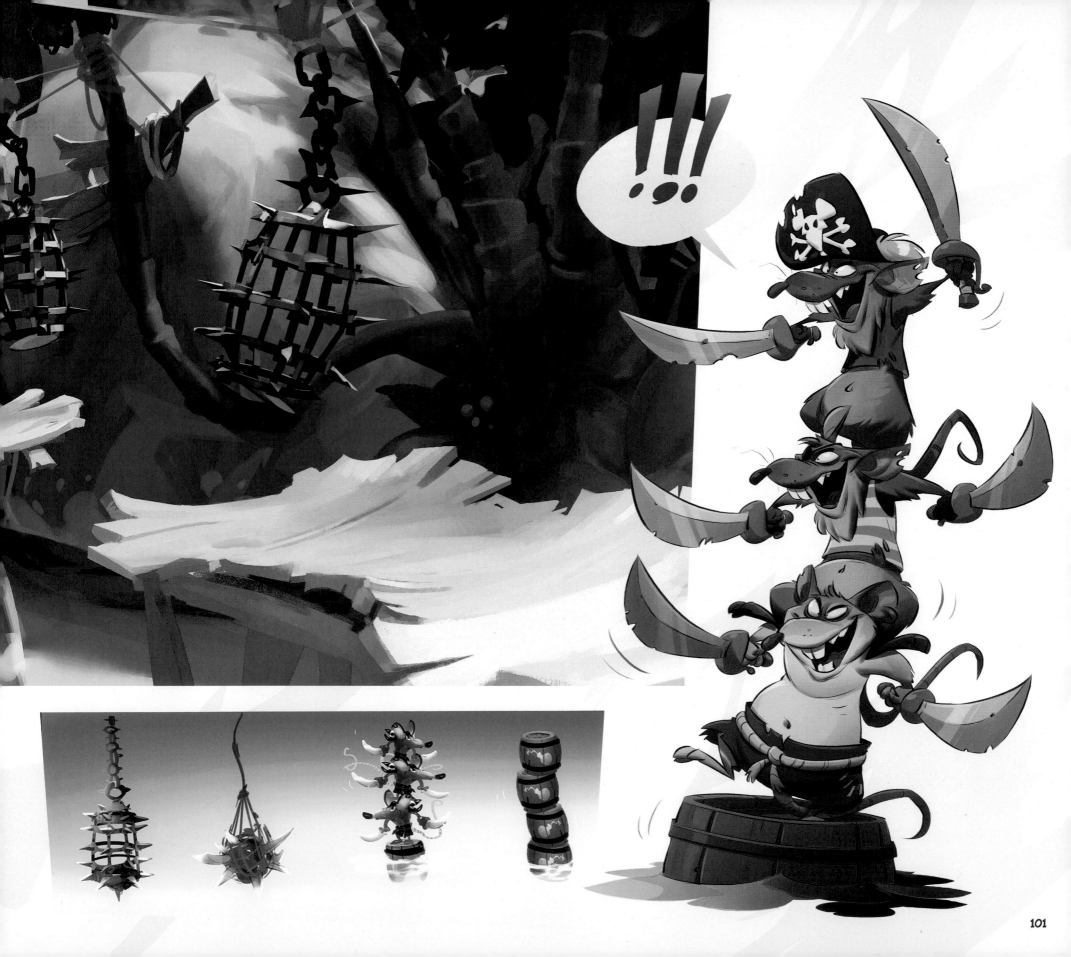

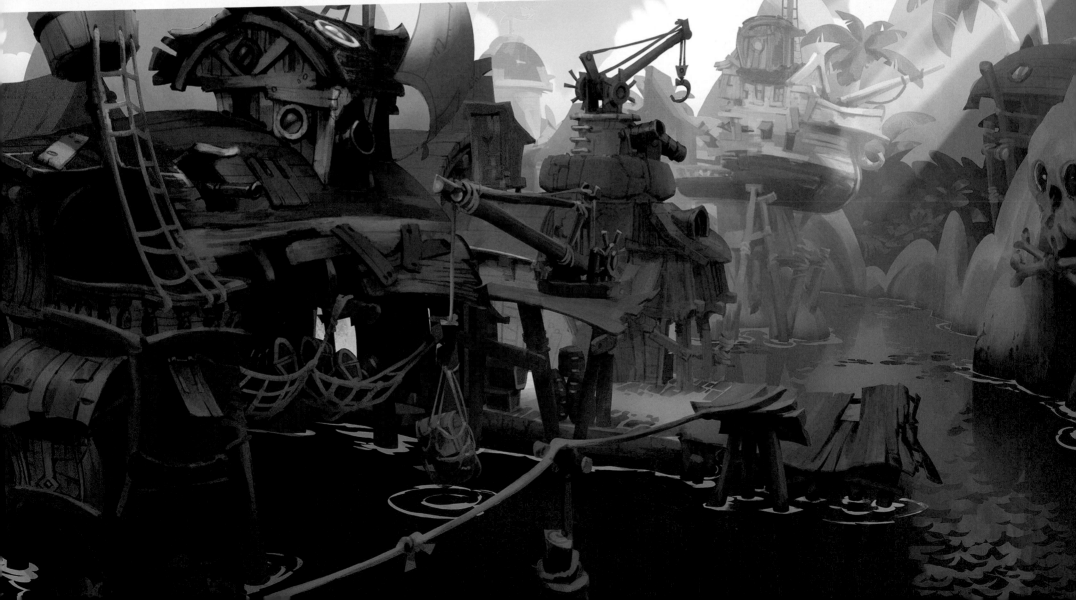

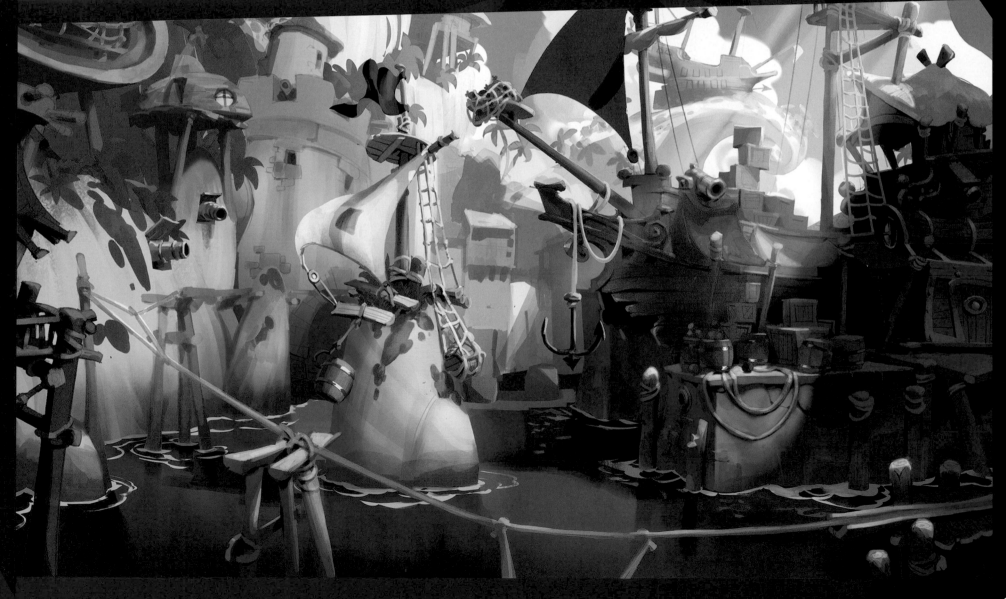

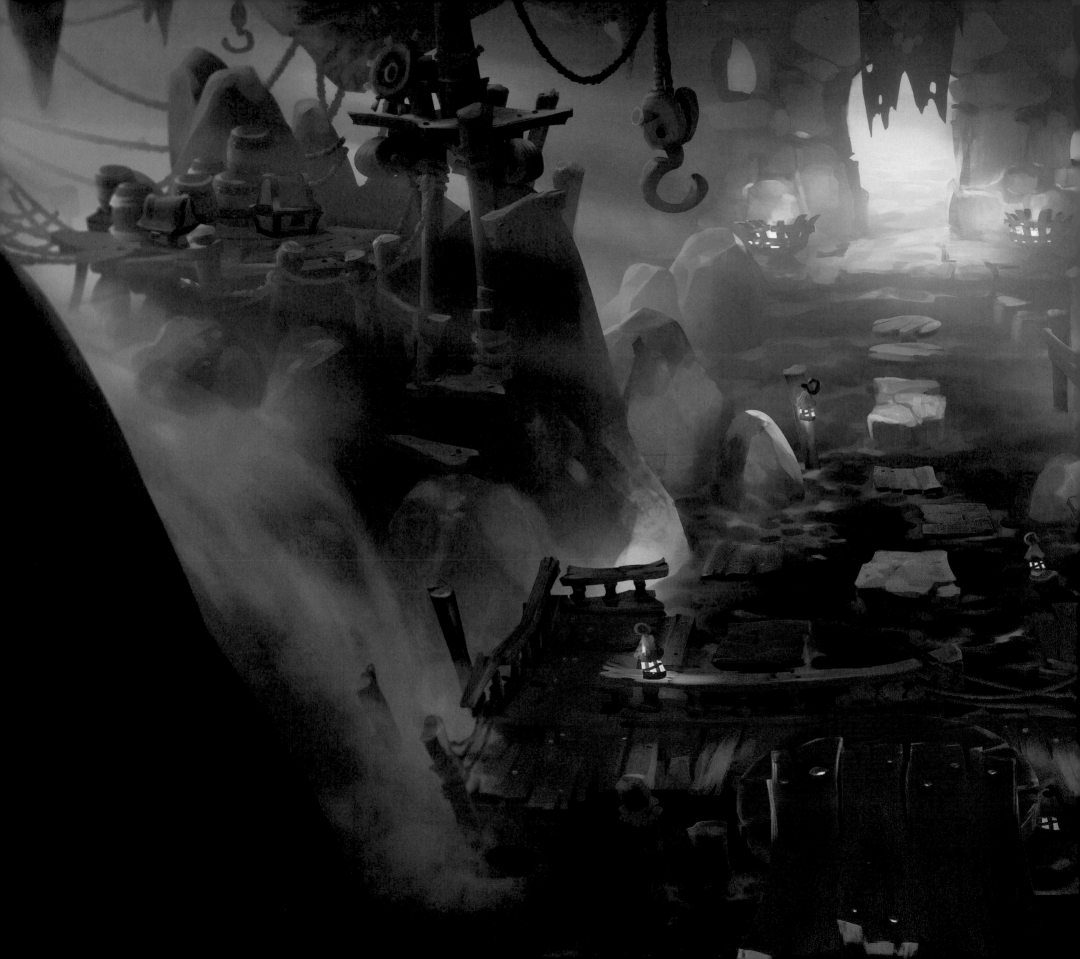

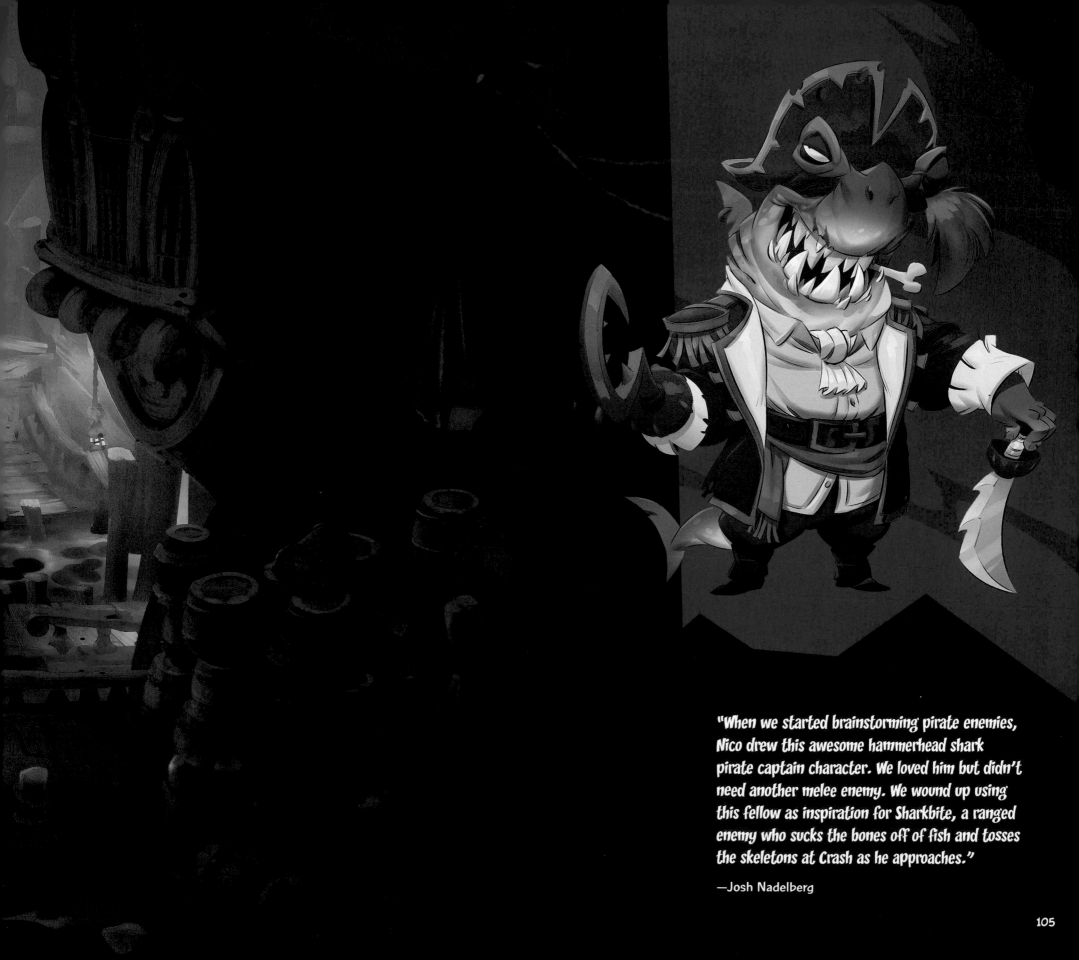

"When we started brainstorming pirate enemies, Nico drew this awesome hammerhead shark pirate captain character. We loved him but didn't need another melee enemy. We wound up using this fellow as inspiration for Sharkbite, a ranged enemy who sucks the bones off of fish and tosses the skeletons at Crash as he approaches."

—Josh Nadelberg

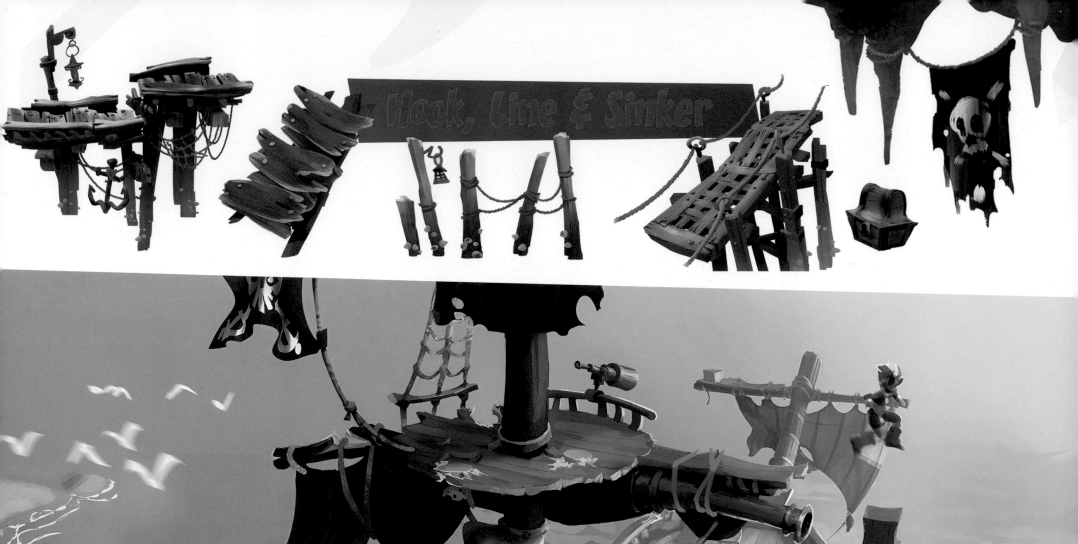

Hook, Line & Sinker

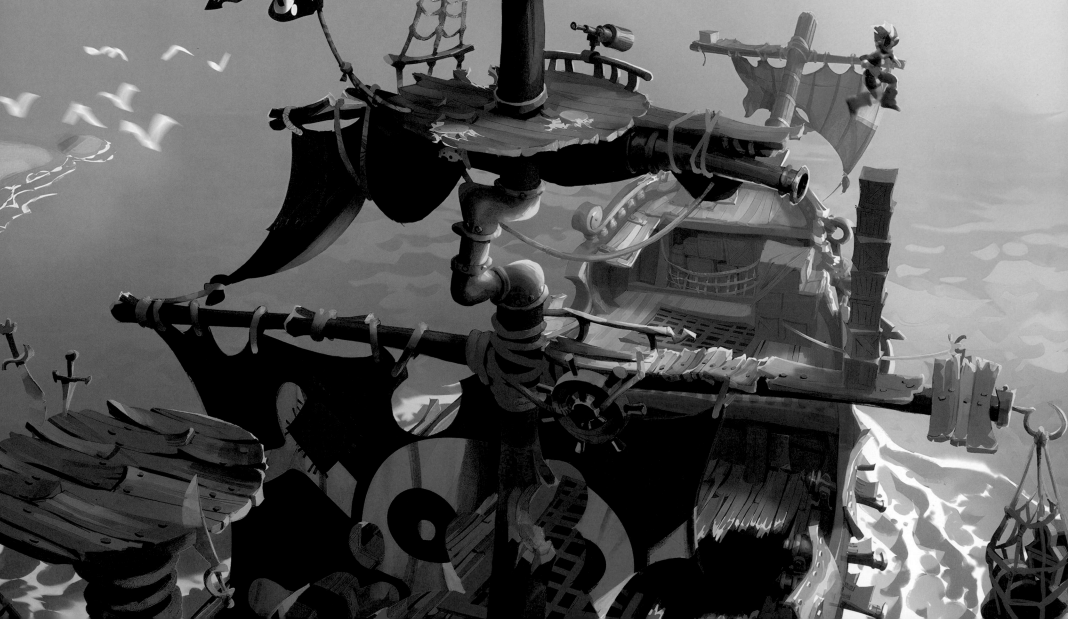

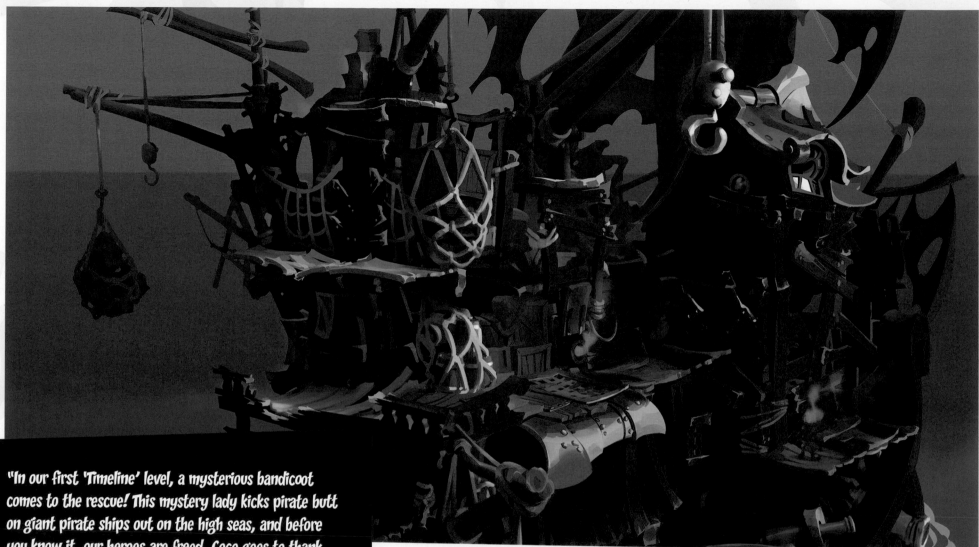

"In our first 'Timeline' level, a mysterious bandicoot comes to the rescue! This mystery lady kicks pirate butt on giant pirate ships out on the high seas, and before you know it, our heroes are freed. Coco goes to thank her but is taken aback when she recognizes her rescuer —Tawna?! But... she looks different. She's from an alternate universe! Bingo! Crash examines Tawna from every angle, trying to understand. In the end, though, he's just happy to see her.

Tawna is thrilled to see her friends. It's been a long time. But when the question of Crash and Coco from her universe comes up, she gives a potently vague answer. Sensing it's an uncomfortable topic, Coco drops it and fills Tawna in on the quest at large: saving the world (well, all worlds)! Tawna wishes them luck, and Coco is shocked that Tawna isn't coming with them. Tawna, it seems, is strictly a solo flyer." —Mandy Benanav

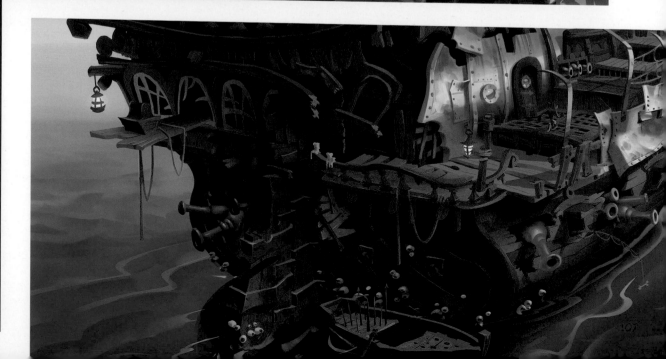

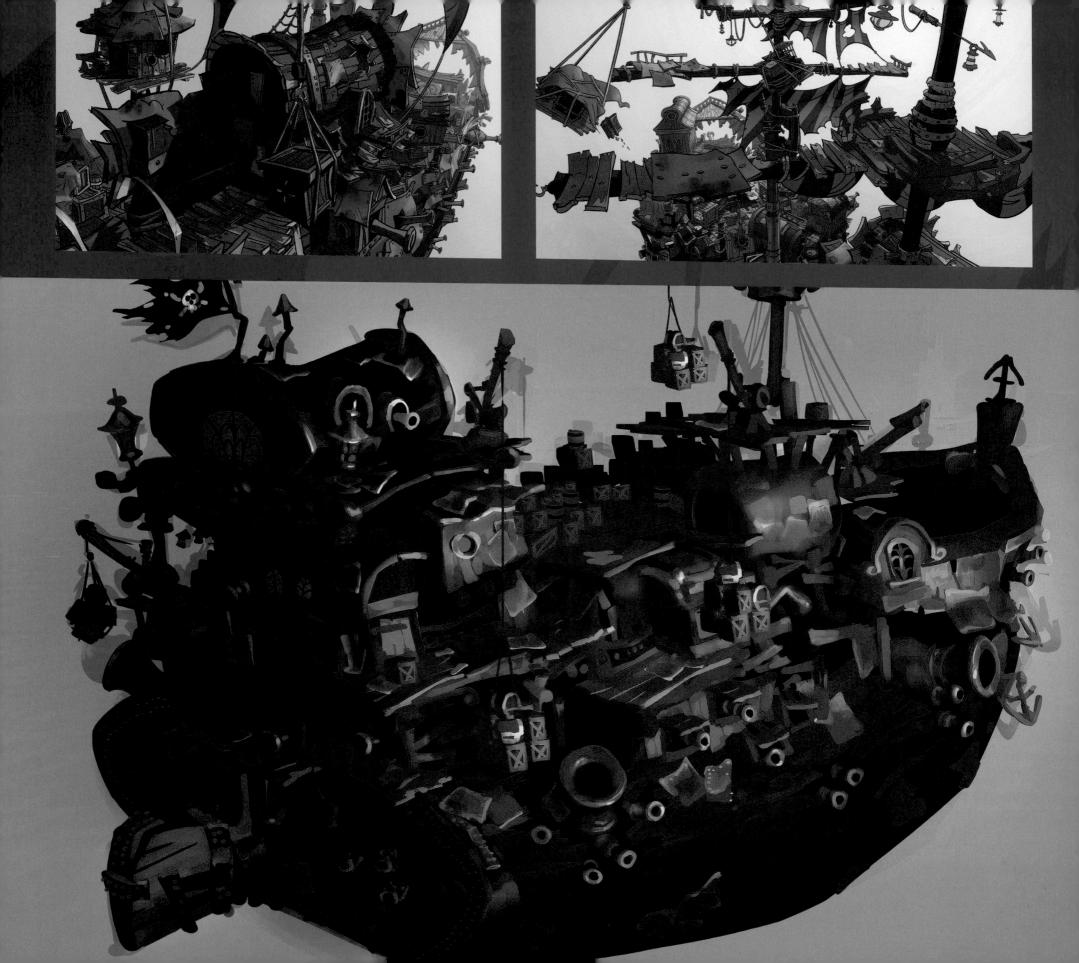

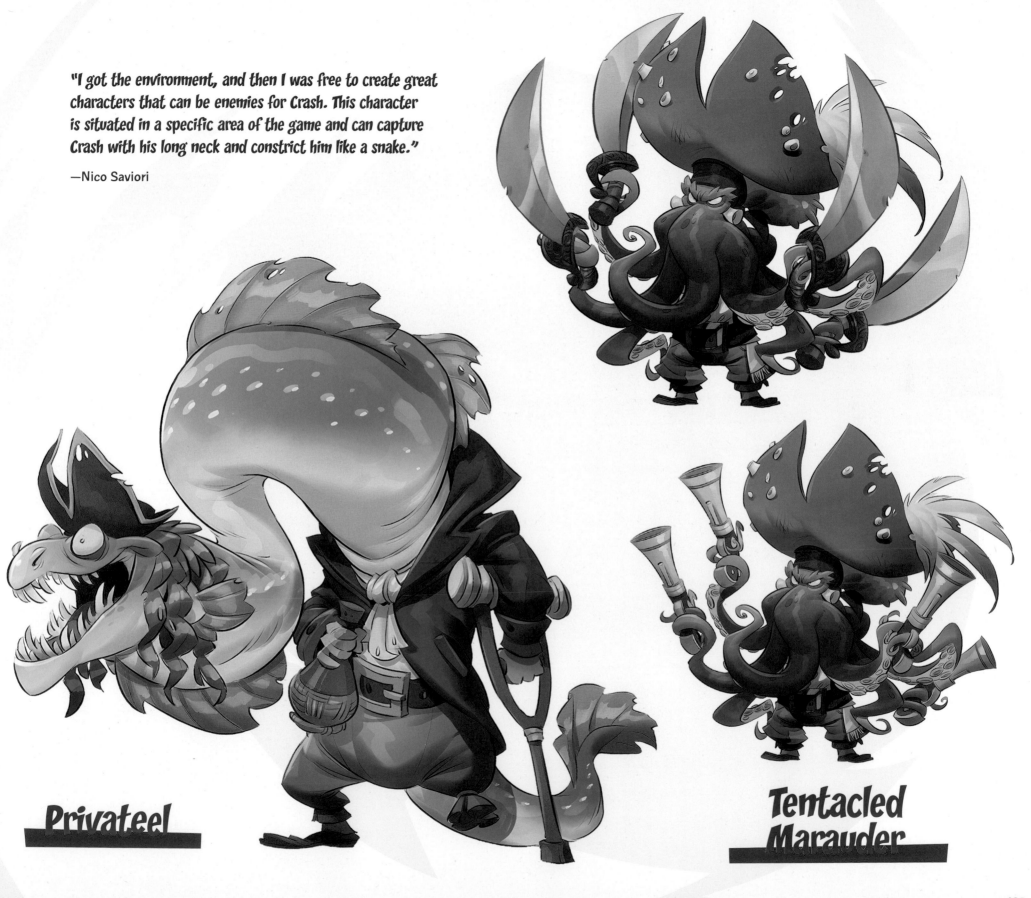

"I got the environment, and then I was free to create great characters that can be enemies for Crash. This character is situated in a specific area of the game and can capture Crash with his long neck and constrict him like a snake."

—Nico Saviori

Privateel

Tentacled Marauder

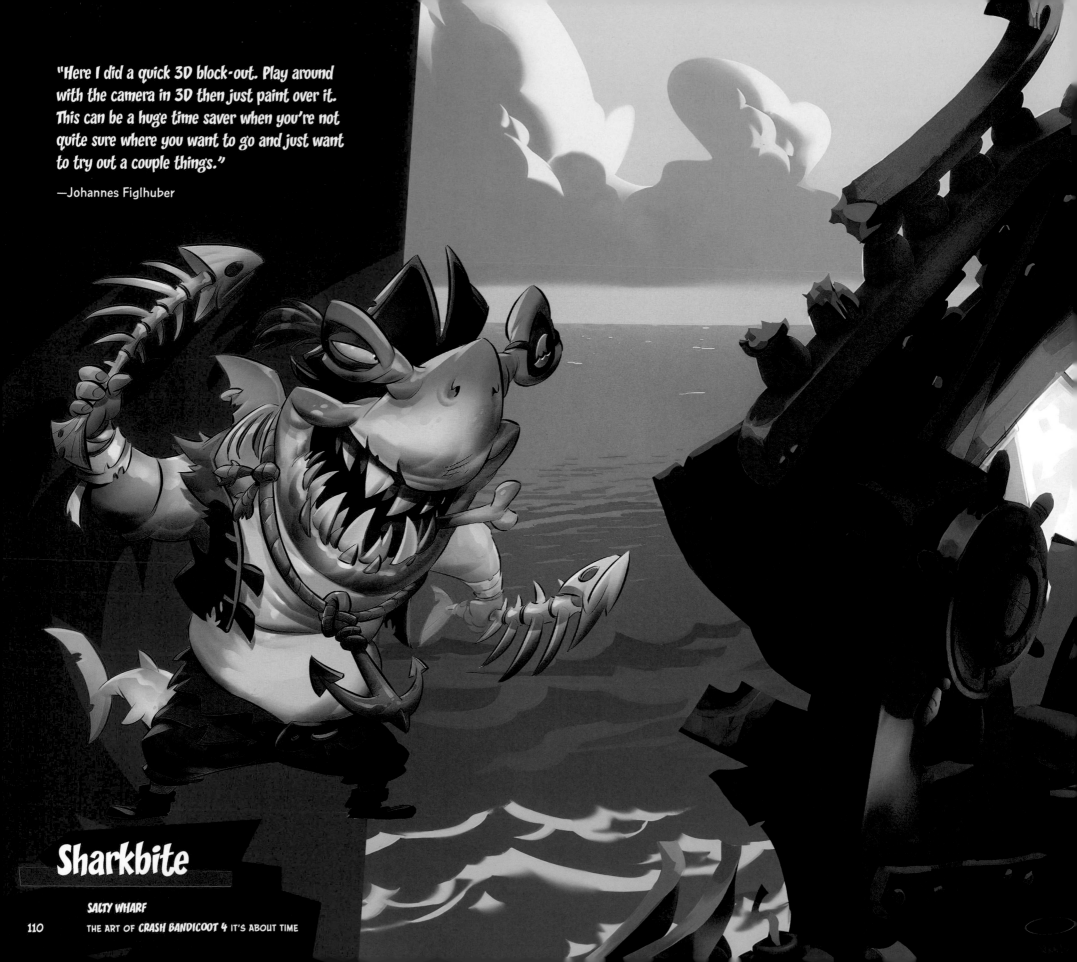

"Here I did a quick 3D block-out. Play around with the camera in 3D then just paint over it. This can be a huge time saver when you're not quite sure where you want to go and just want to try out a couple things."

—Johannes Figlhuber

Sharkbite

SALTY WHARF

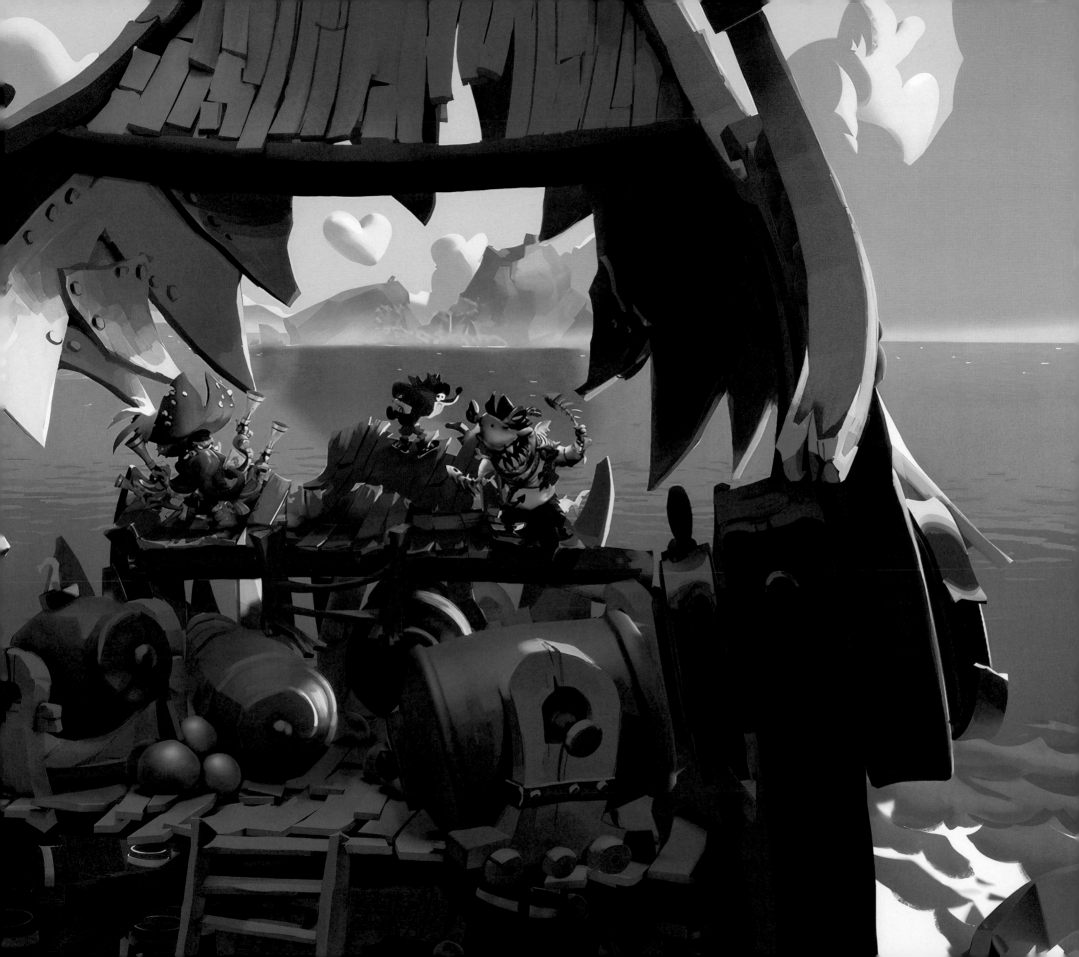

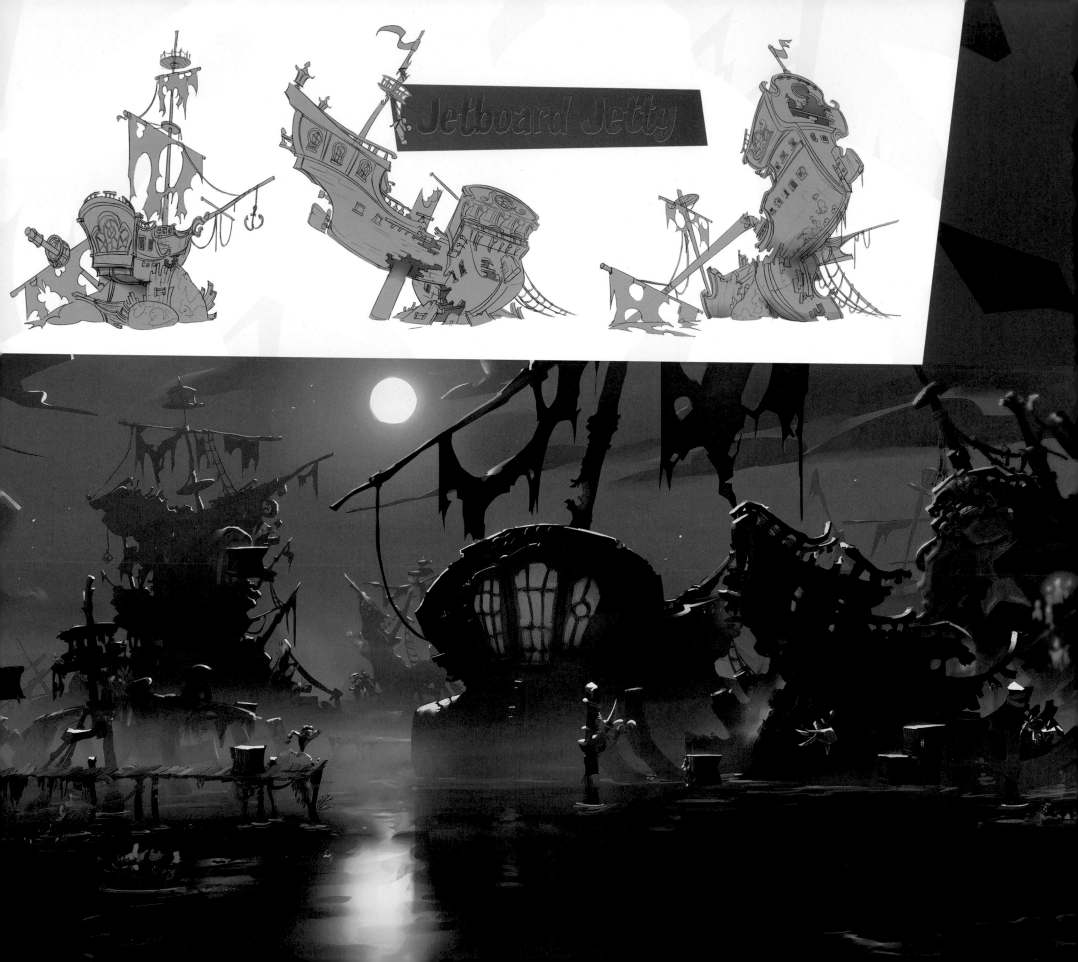

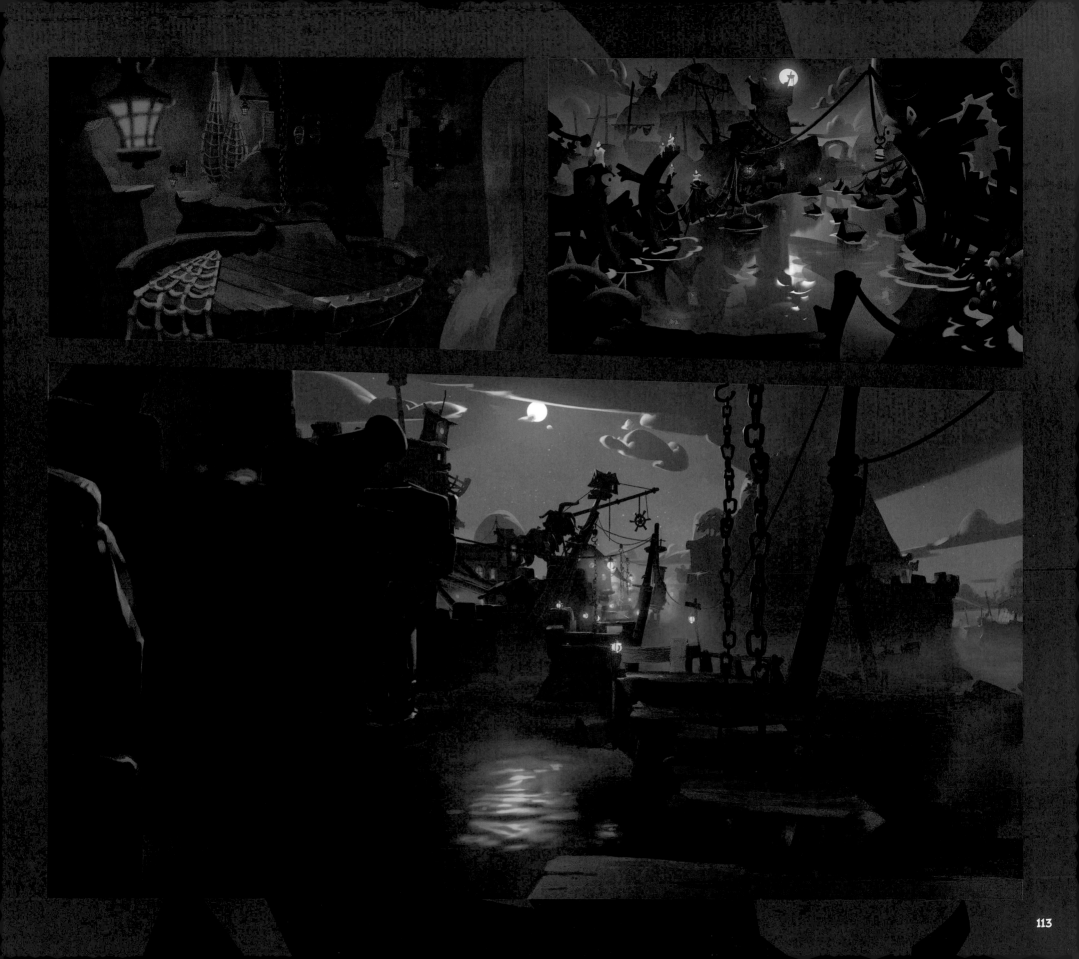

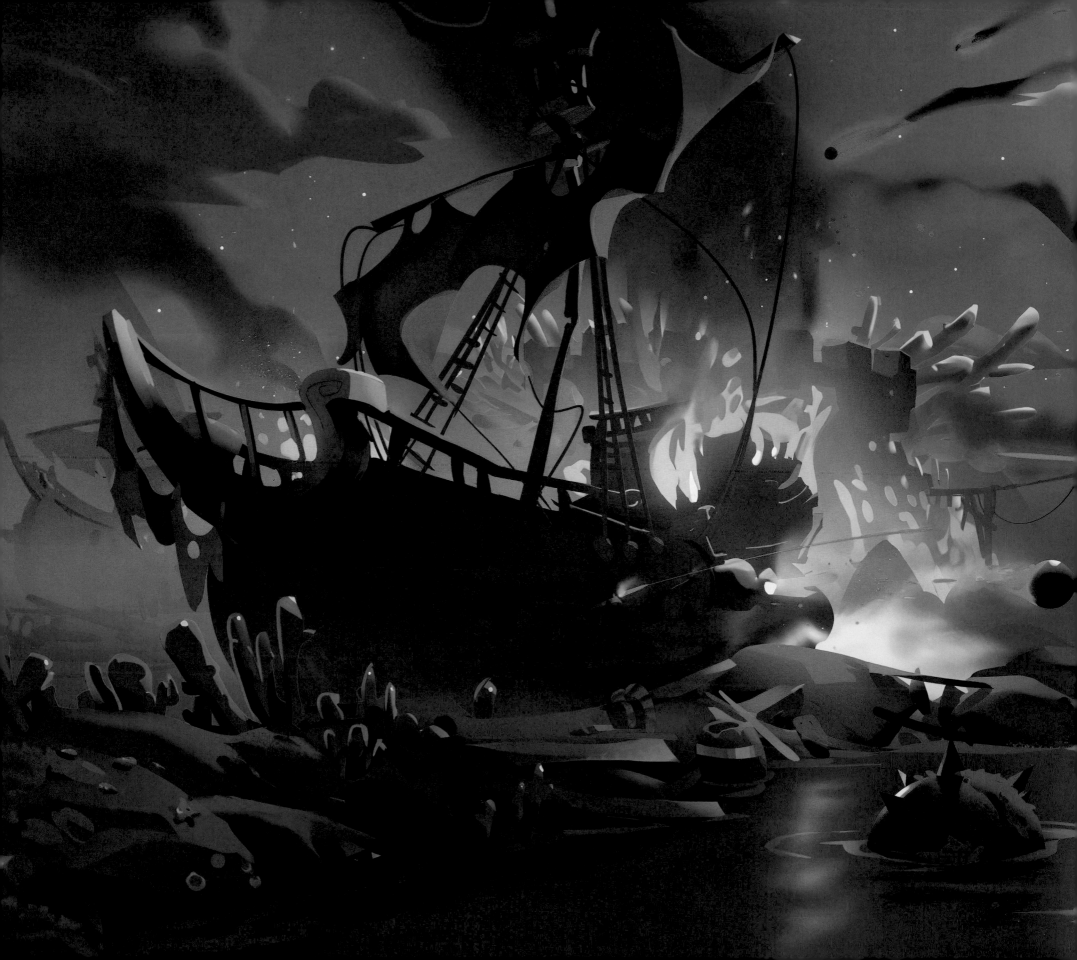

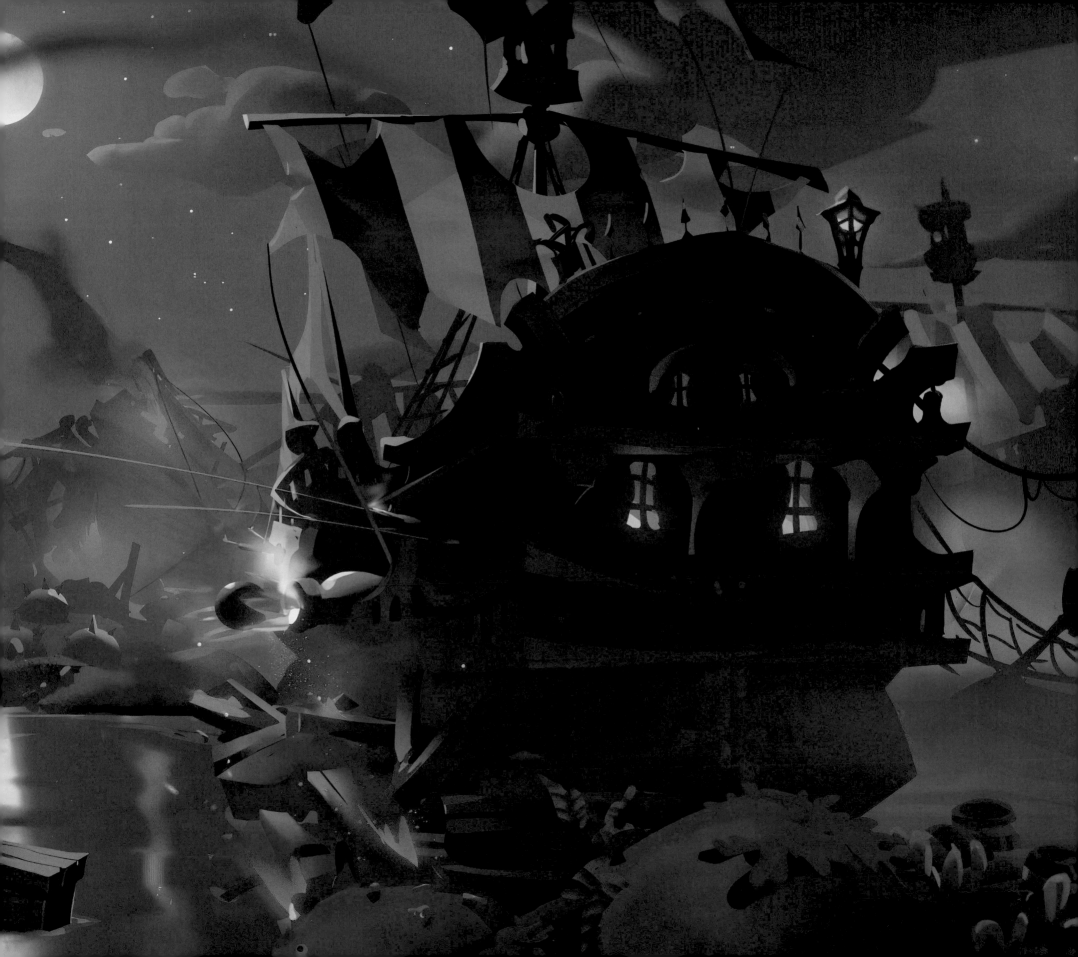

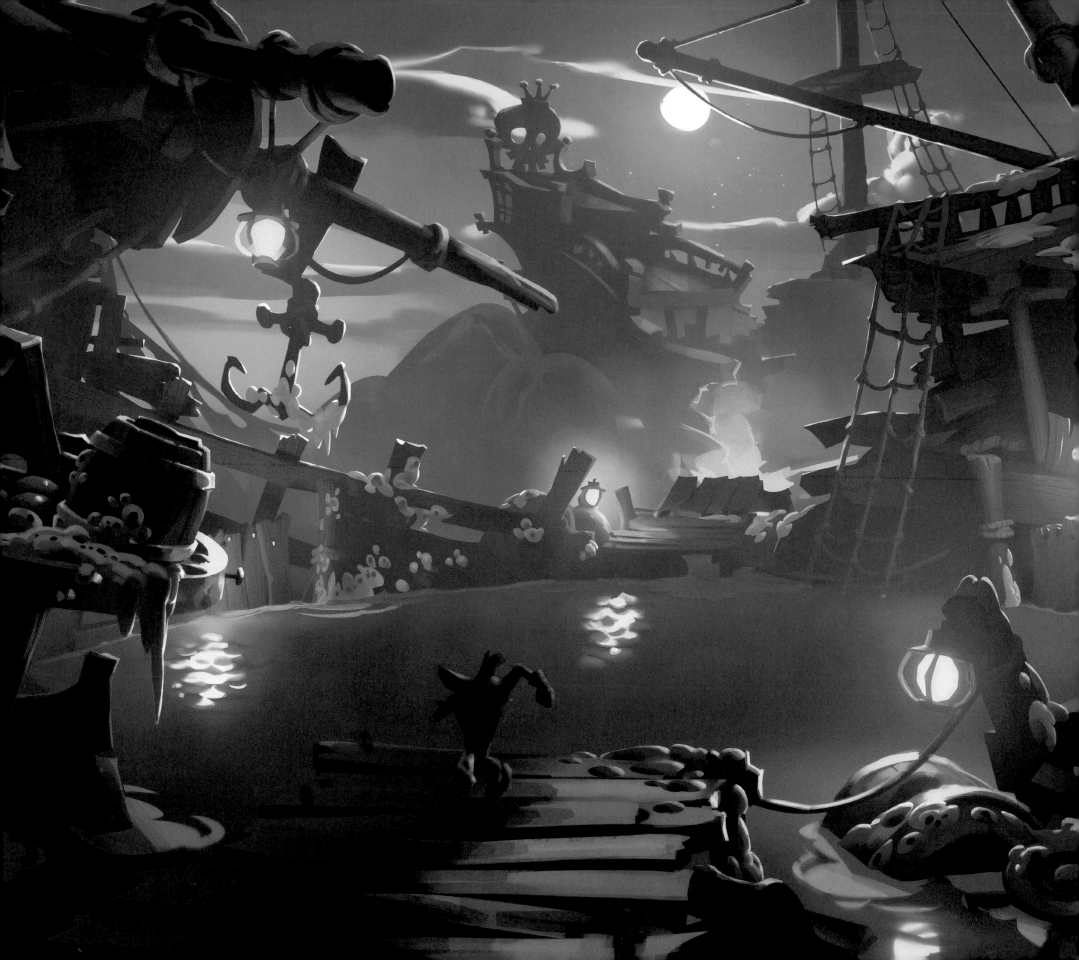

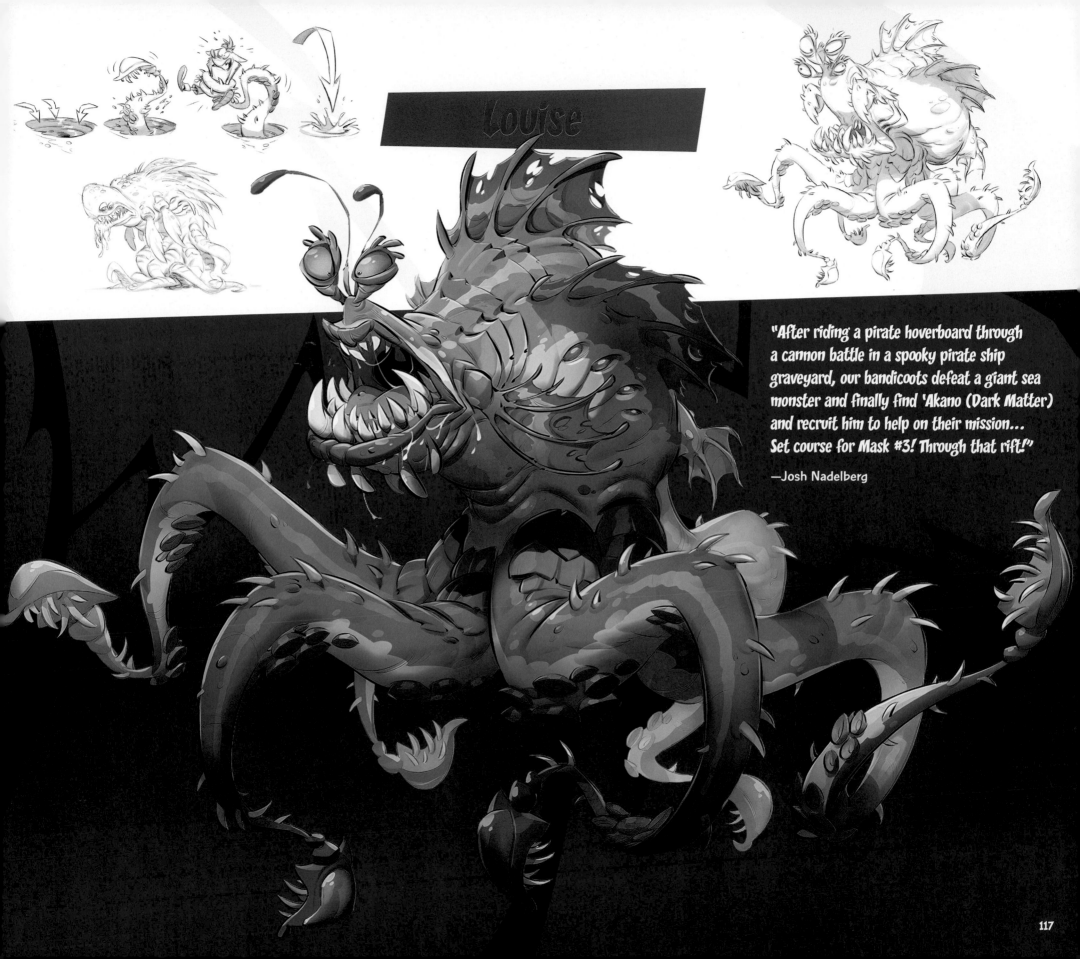

Louise

"After riding a pirate hoverboard through a cannon battle in a spooky pirate ship graveyard, our bandicoots defeat a giant sea monster and finally find 'Akano (Dark Matter) and recruit him to help on their mission... Set course for Mask #3! Through that rift!"

—Josh Nadelberg

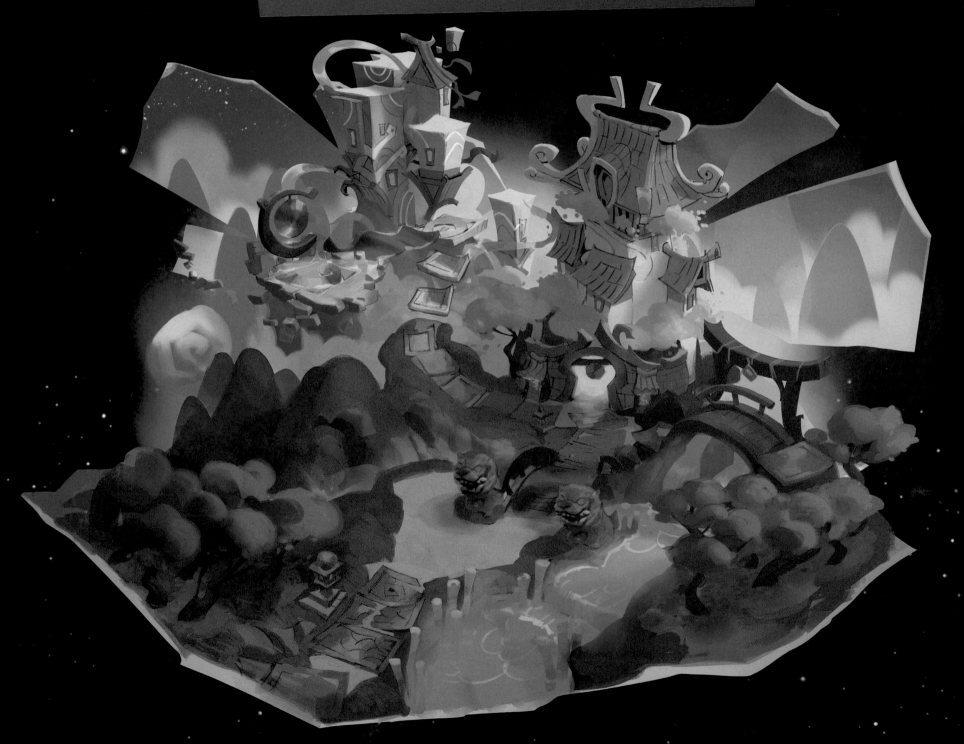

TRANQUILITY FALLS
(1402)

Give It a Spin

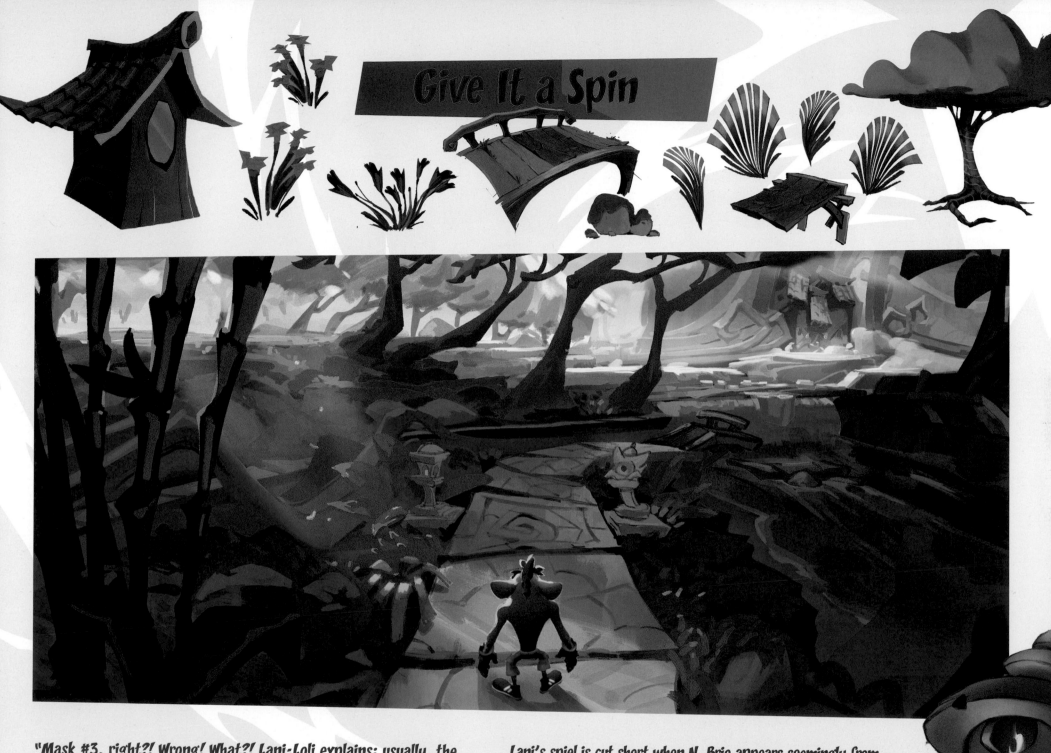

"Mask #3, right?! Wrong! What?! Lani-Loli explains: usually, the Quantum Masks have the power to open and close rifts as they please, but because those bozos are opening all these unnatural rifts, their powers don't work. So they're stuck taking the long way - hopping through dimensions until they hit the right one. Fortunately, the masks can generally sense each other, and Kupuna-Wa appears to be just one dimension away. But where's the rift?

Lani's spiel is cut short when N. Brio appears seemingly from nowhere. N. Brio is excited to see his "friends" because he's created a "fun game" for them to play, with a "reward" at the end. Oookay. It seems like N. Brio's been brewing up a new potion (one he hopes will finally be the one that allows him to mutiny against his master) and has run out of test subjects. He's transformed all of the inhabitants of this realm into beings that are a lot more... murder-y (that's "deadly diabolical creations" in N. Brio-speak.)"—Mandy Benanav

"Crash makes his way through what was once a serene riverside village to the gates of the mountain temple. Looks like N. Brio's brought the stone guardians of the village to life with his magic potions. As Crash makes his way through the village he encounters a giant impenetrable Dragon Gate. It seems like he's stuck when (huh???) the door suddenly opens! (On Tawna's Timeline she opens the door for Crash...) Crash is introduced to the power of 'Akano, the Dark Matter Mask, which allows him to perform his quantum spin and float far across the water and easily destroy even metal crates. Again, this level makes great use of the big vistas to show the village in the distance and the temple where Crash is headed..." —Josh Nadelberg

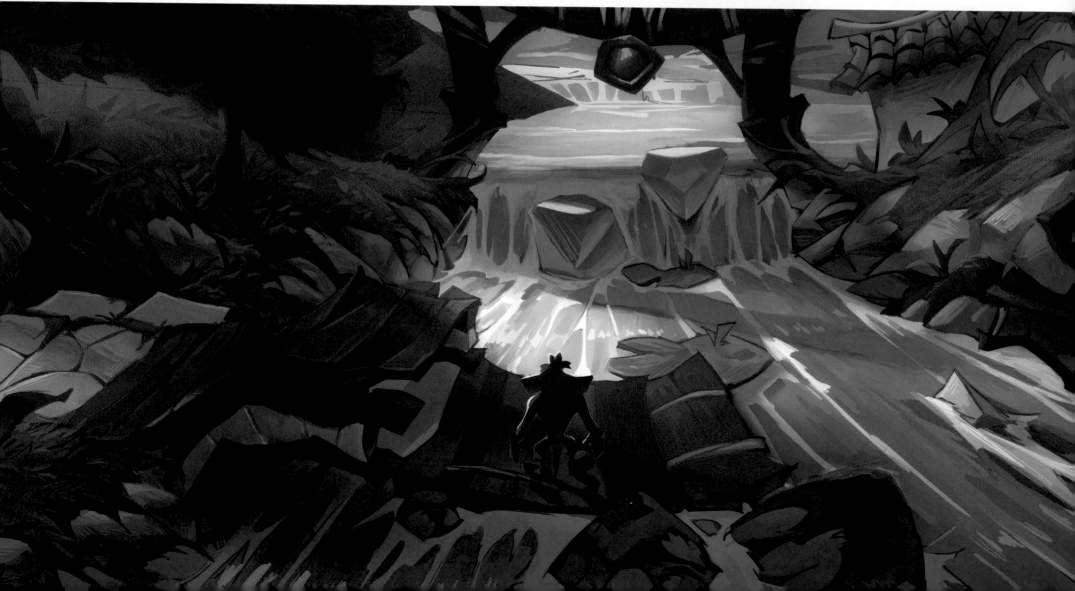

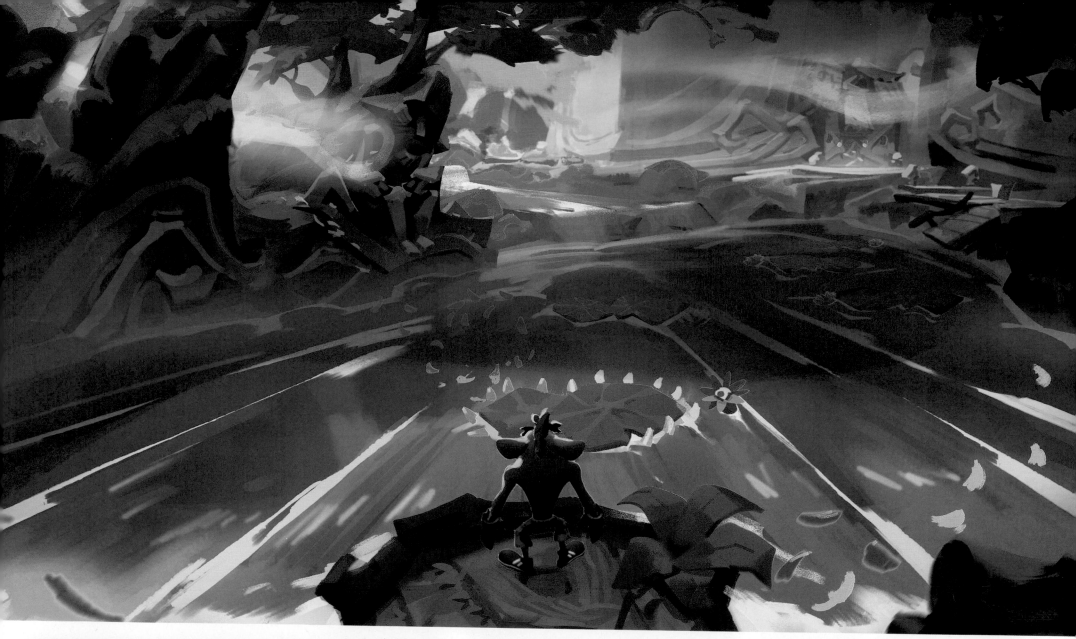

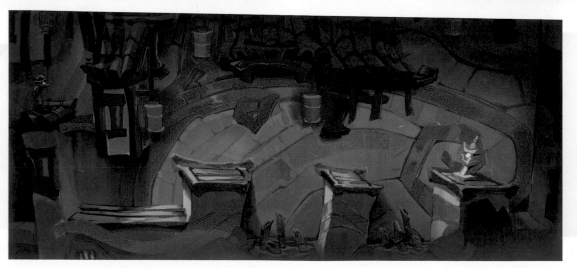

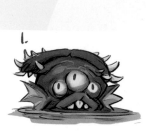
1.

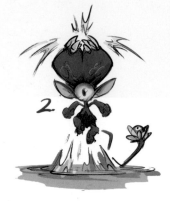
2.

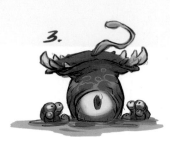
3.

4.

5.

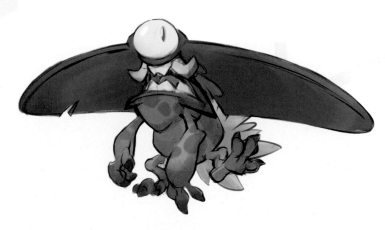

"A Yokai is a spirit that can go into anything, so there can be a Yokai for a door. I was like, 'Okay, so then it can be a lily pad.'" —Vinod Rams

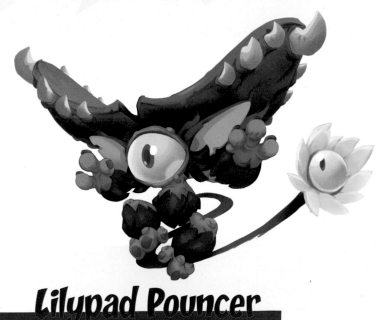

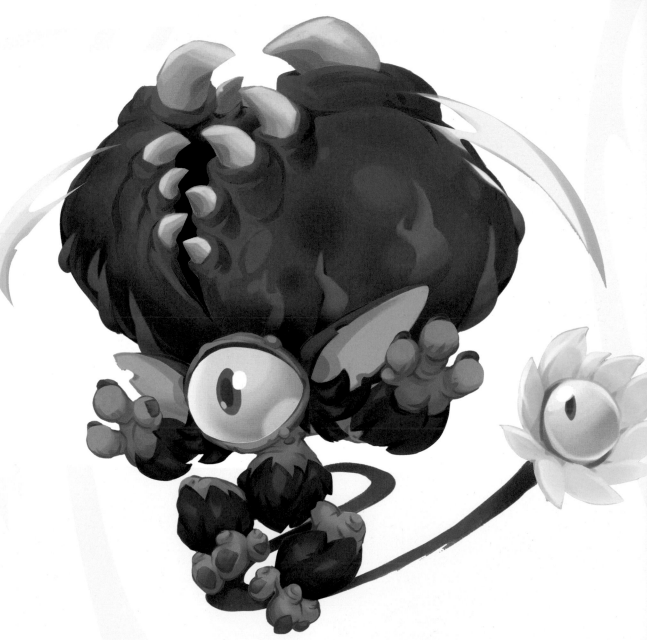

Lilypad Pouncer

TRANQUILITY FALLS

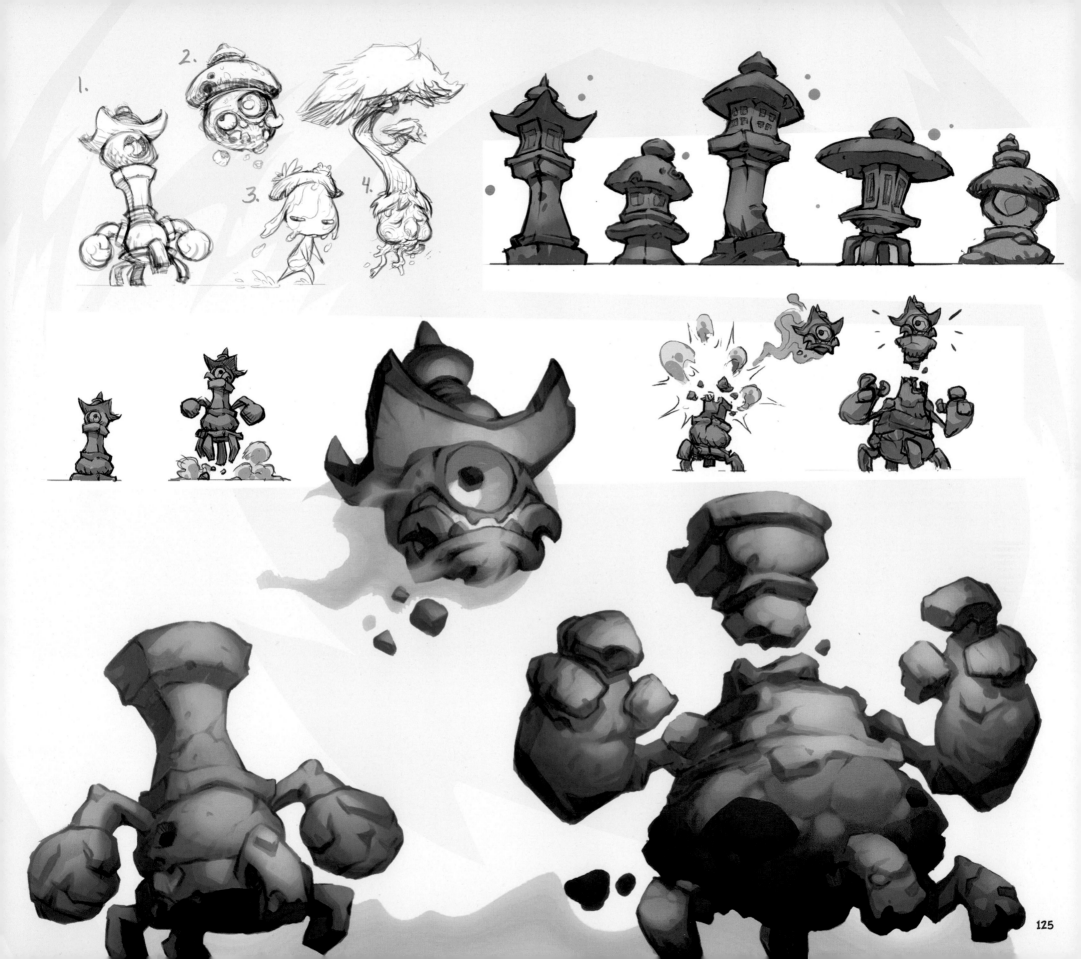

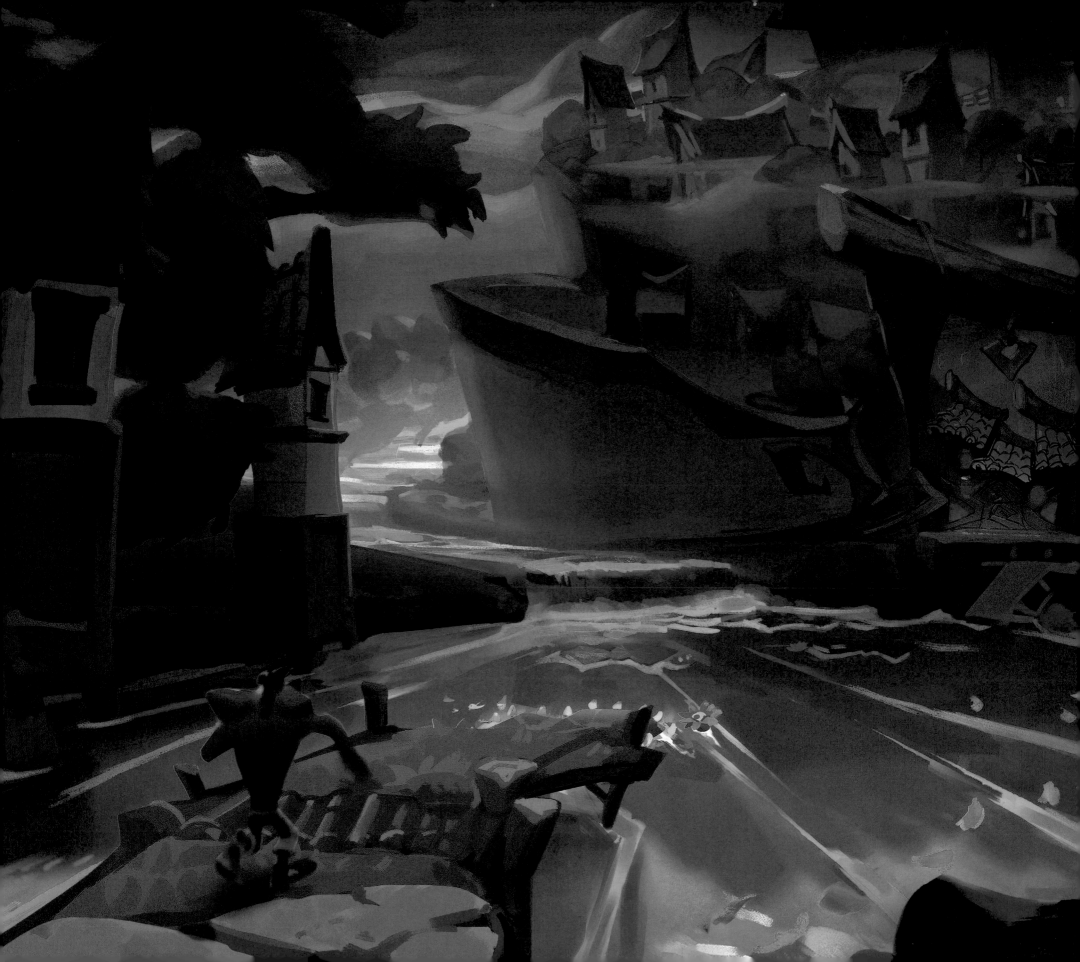

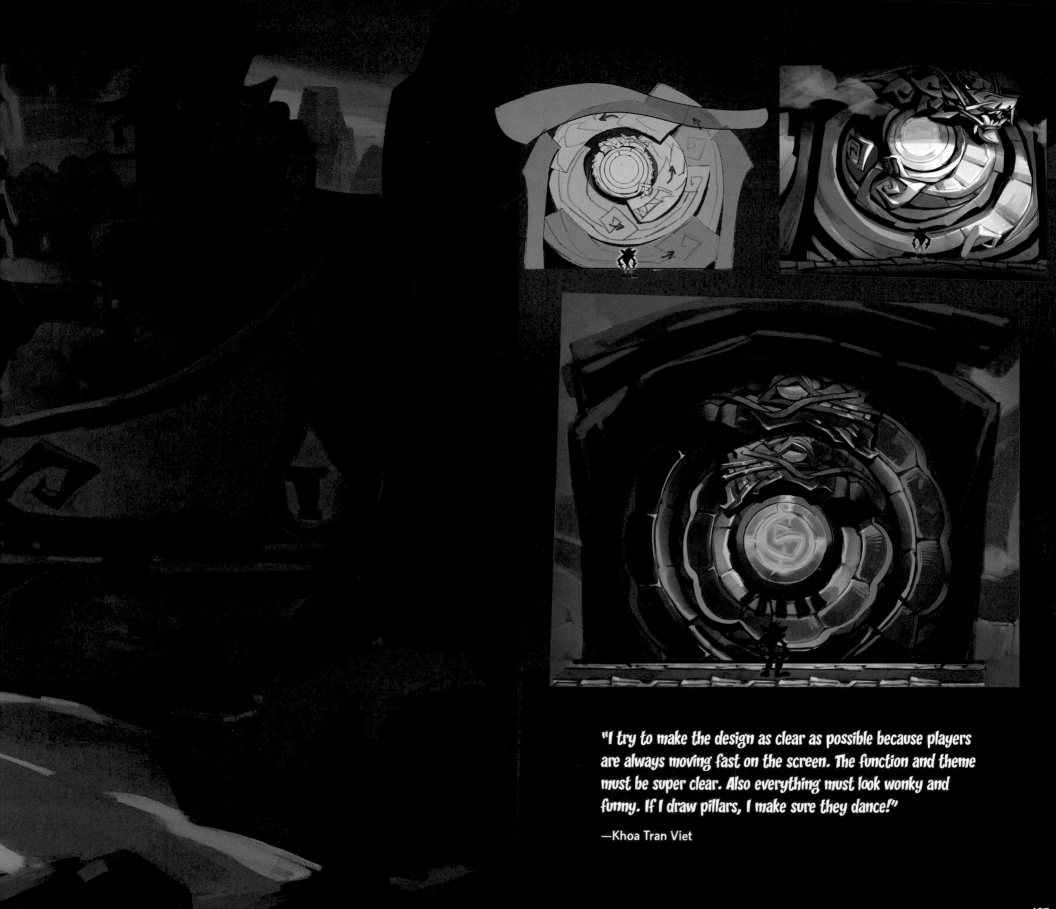

"I try to make the design as clear as possible because players are always moving fast on the screen. The function and theme must be super clear. Also everything must look wonky and funny. If I draw pillars, I make sure they dance!"

—Khoa Tran Viet

Draggin' On

"Night falls and Crash crosses a bridge to the first of the temple buildings. Enchanted stone dragons loop around the path, and statues come to life and bang their gongs trying to knock Crash off the edge with sonic blasts. At the top of the temple, Crash finds a beautiful magical tree bathed in moonlight shining through the temple's roof. We had originally planned on this tree having a magical pollen that made Crash have a hallucinatory experience in the next level, but that story beat was changed, and now it's just a cool tree…"

—Josh Nadelberg

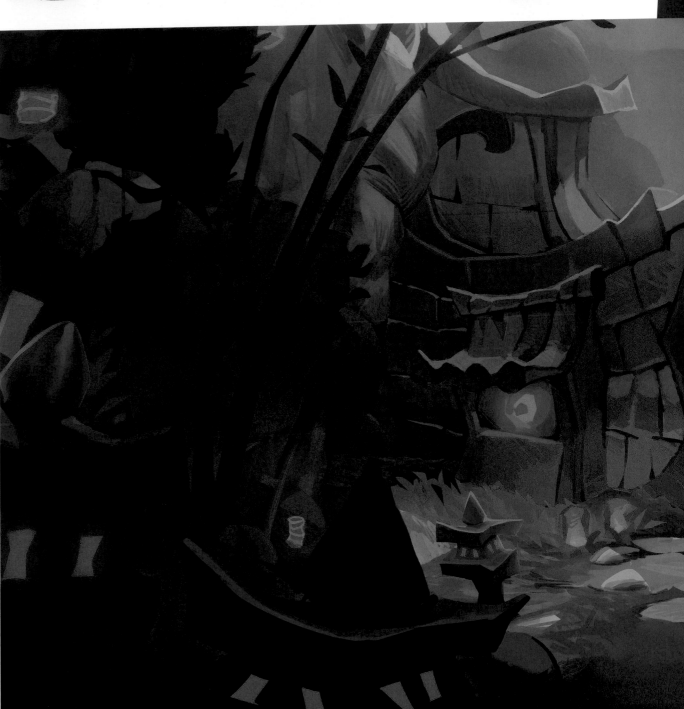

"It was cool to explore on these images. The important thing was the mood of it. We were exploring colors and moods and lightings, and the shapes, the shapes are crazy. I always have to have in mind that it has to be wonky and crazy and shape-y because it needs to not look like a casual, a normal platformer. It has to be really crazy just like Crash."

—Didier Nguyen

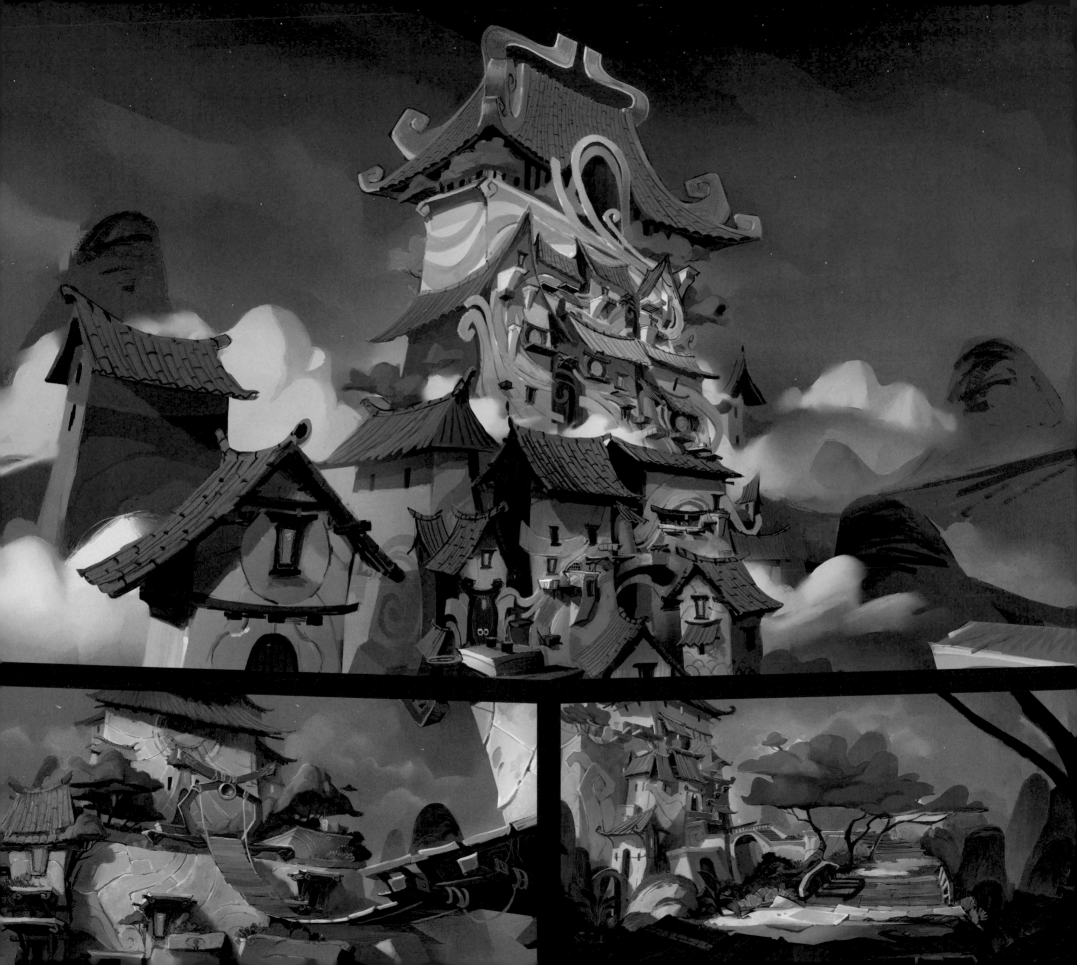

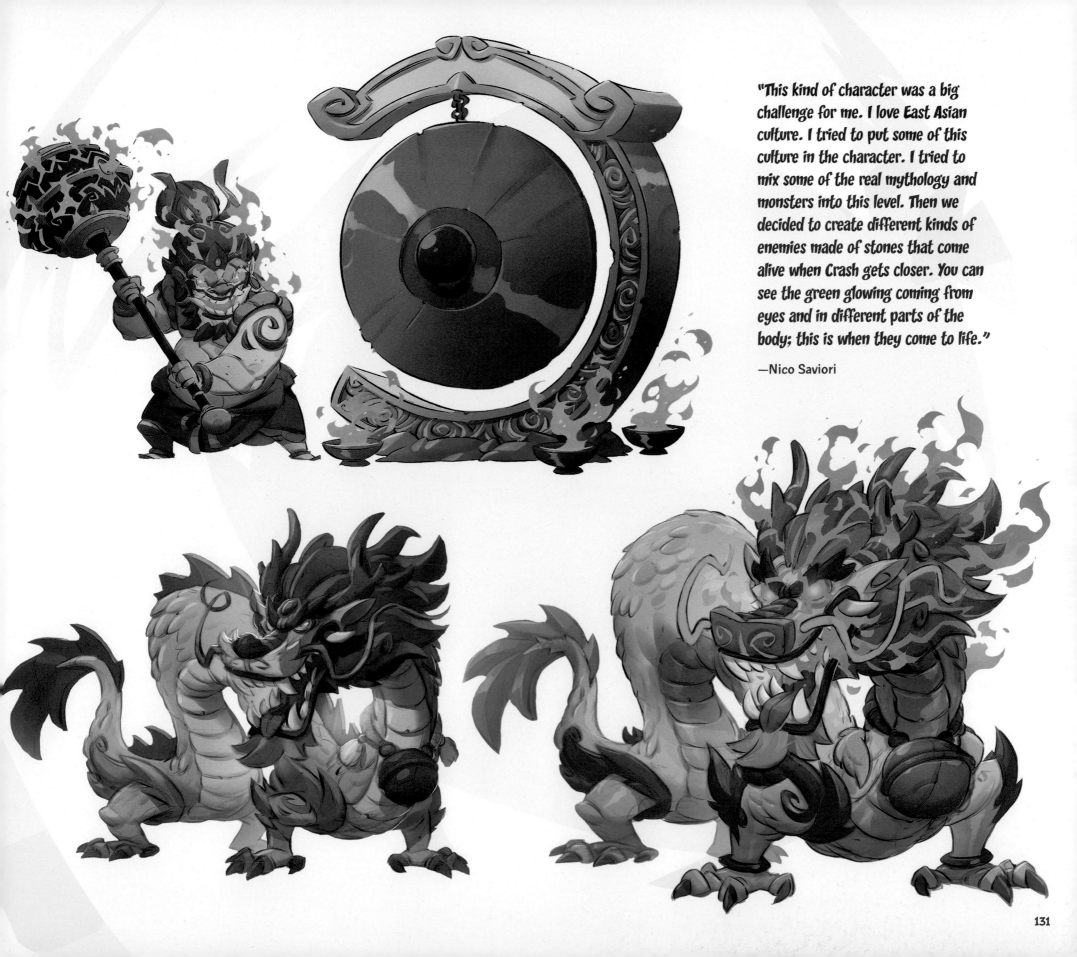

"This kind of character was a big challenge for me. I love East Asian culture. I tried to put some of this culture in the character. I tried to mix some of the real mythology and monsters into this level. Then we decided to create different kinds of enemies made of stones that come alive when Crash gets closer. You can see the green glowing coming from eyes and in different parts of the body; this is when they come to life."

—Nico Saviori

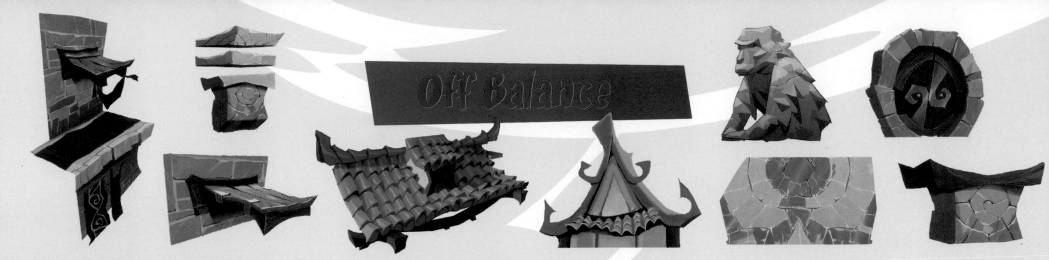

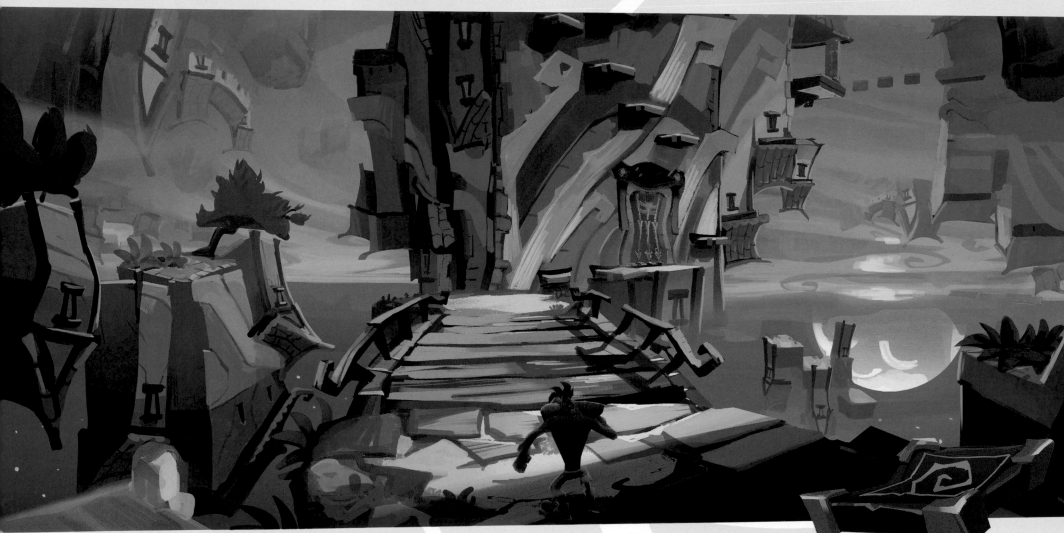

"As Crash walks past the tree, a dense fog clears and he finds himself in a surreal cloud temple. Guess the pollen still had its effect, even if we didn't highlight it in the story! Lol... Crash cruises over falling floating platforms, through upside-down waterfalls and twisting spiraling bridges to a small arena floating in the sky where he finds..." —Josh Nadelberg

TRANQUILITY FALLS

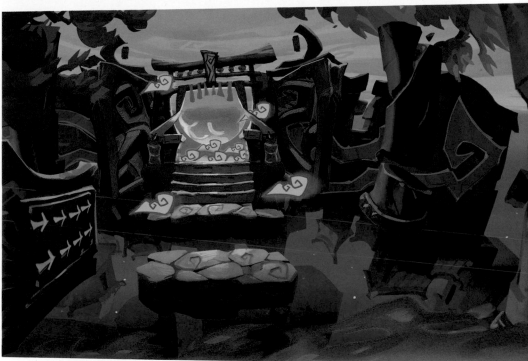

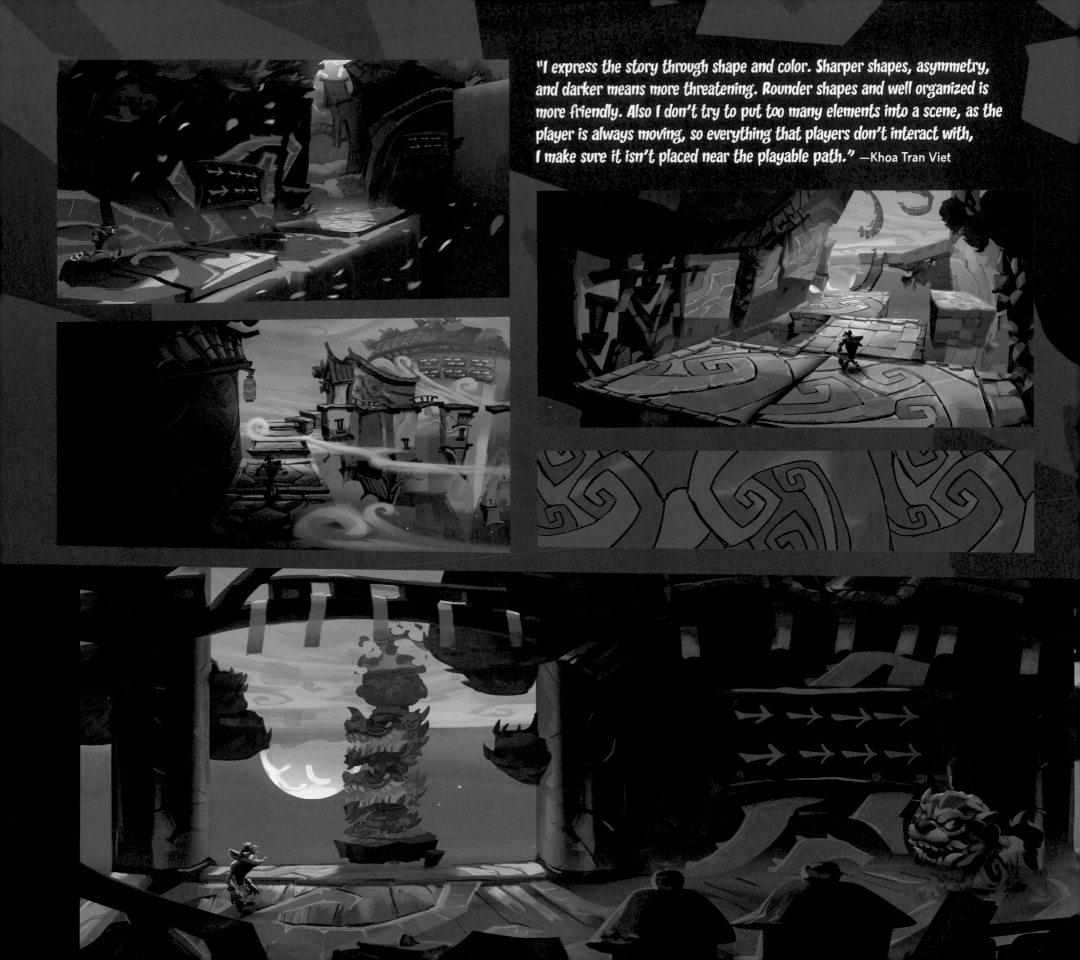

"I express the story through shape and color. Sharper shapes, asymmetry, and darker means more threatening. Rounder shapes and well organized is more friendly. Also I don't try to put too many elements into a scene, as the player is always moving, so everything that players don't interact with, I make sure it isn't placed near the playable path." —Khoa Tran Viet

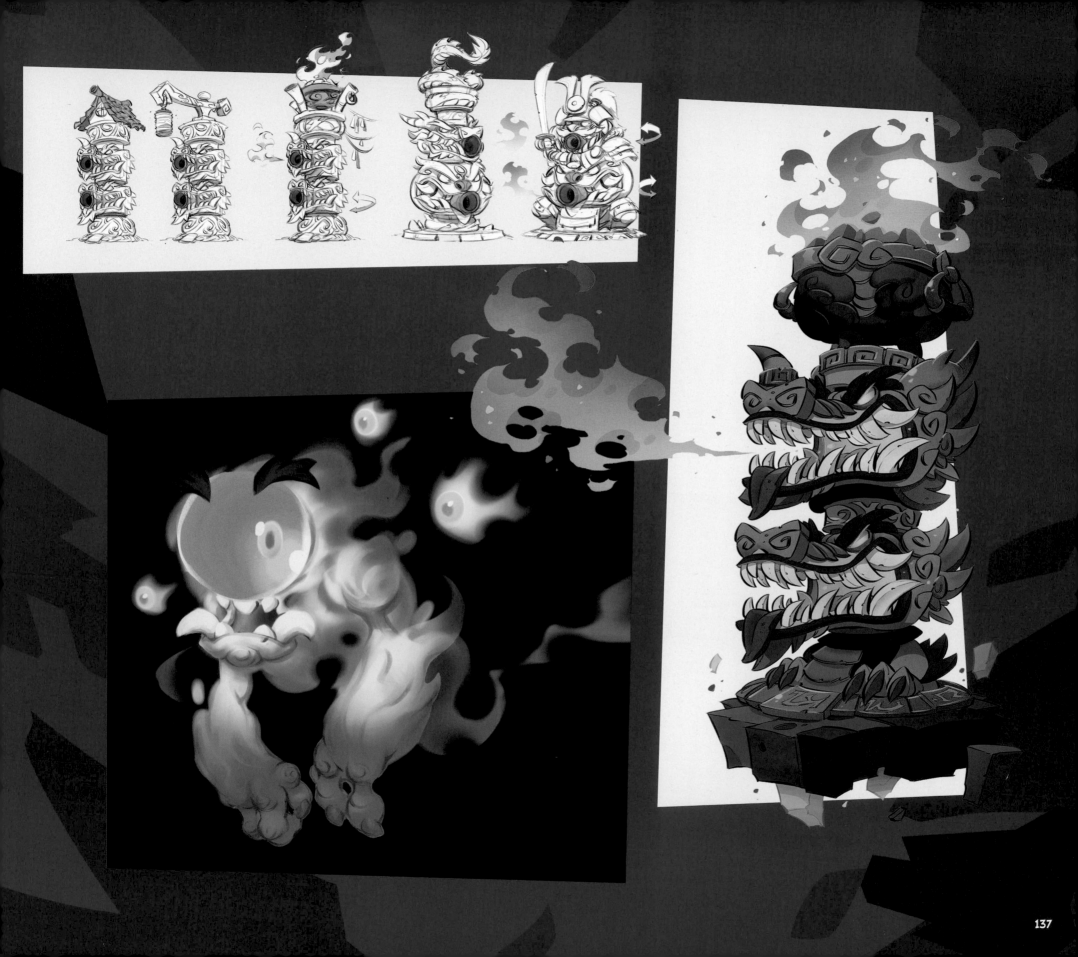

Trouble Brewing

"N. Brio has a throwback boss battle with Crash reminiscent of Crash 1, but... he has new potions, and whenever he throws one of these it transforms the level into a mode which flips the world side to side and causes everything to be rendered through wild and crazy filters! This is a tease for what we call N. Verted Mode, which allows you to replay all the games levels backward with these cool visual filters/effects. The fight culminates when he transforms himself into a hulking monster, and our heroes edge him off the arena, sumo style.. He falls to a platform below and is hit by another potion.

When he returns to his testing grounds, he's transformed yet again into a... some kind of... pterodactyl... thing. This is it—his final form—wait, WHAT?! N. Brio just laid an EGG? Crazy! N. Brio pathetically flies off, moaning, confused, and more than a little embarrassed. Crash and Coco say sayonara to this dimension and hop through the next rift." —Mandy Benanav

Dr. N. Brio

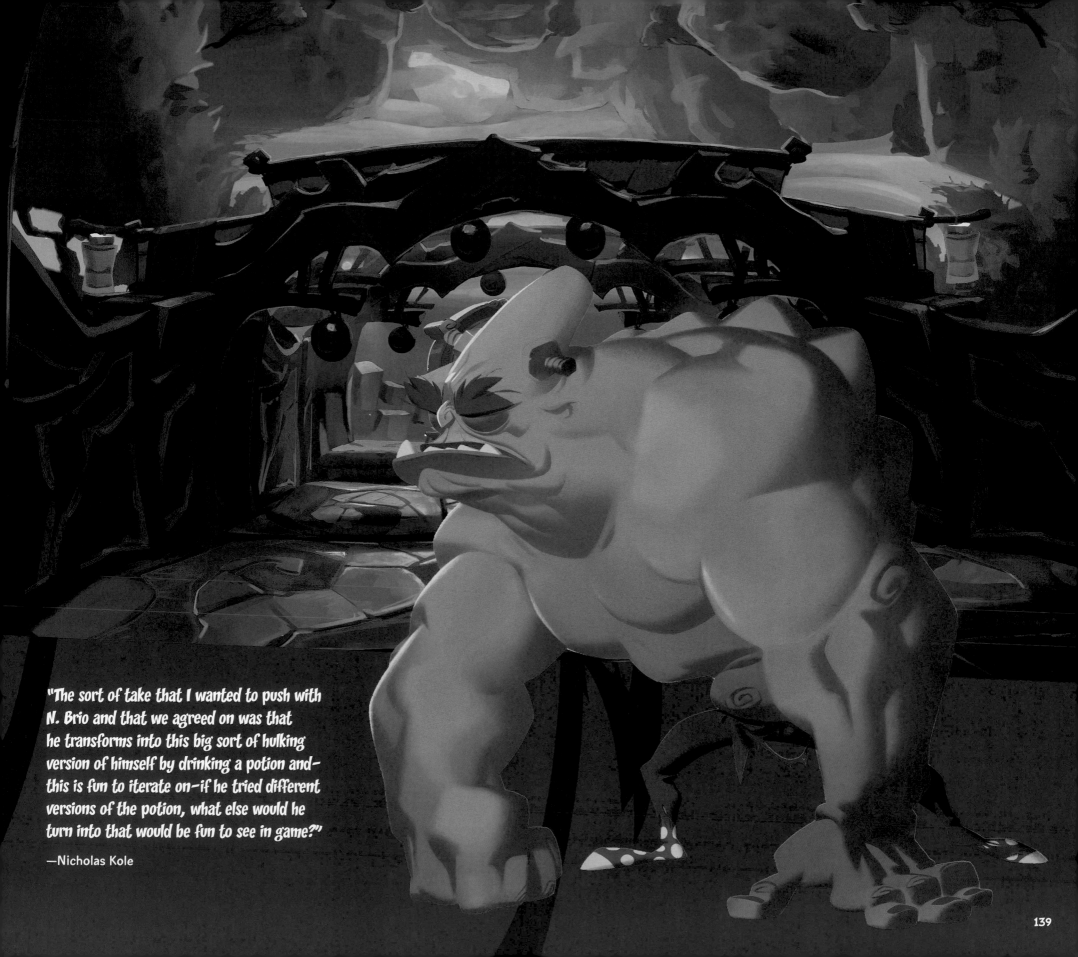

"The sort of take that I wanted to push with N. Brio and that we agreed on was that he transforms into this big sort of hulking version of himself by drinking a potion and—this is fun to iterate on—if he tried different versions of the potion, what else would he turn into that would be fun to see in game?"

—Nicholas Kole

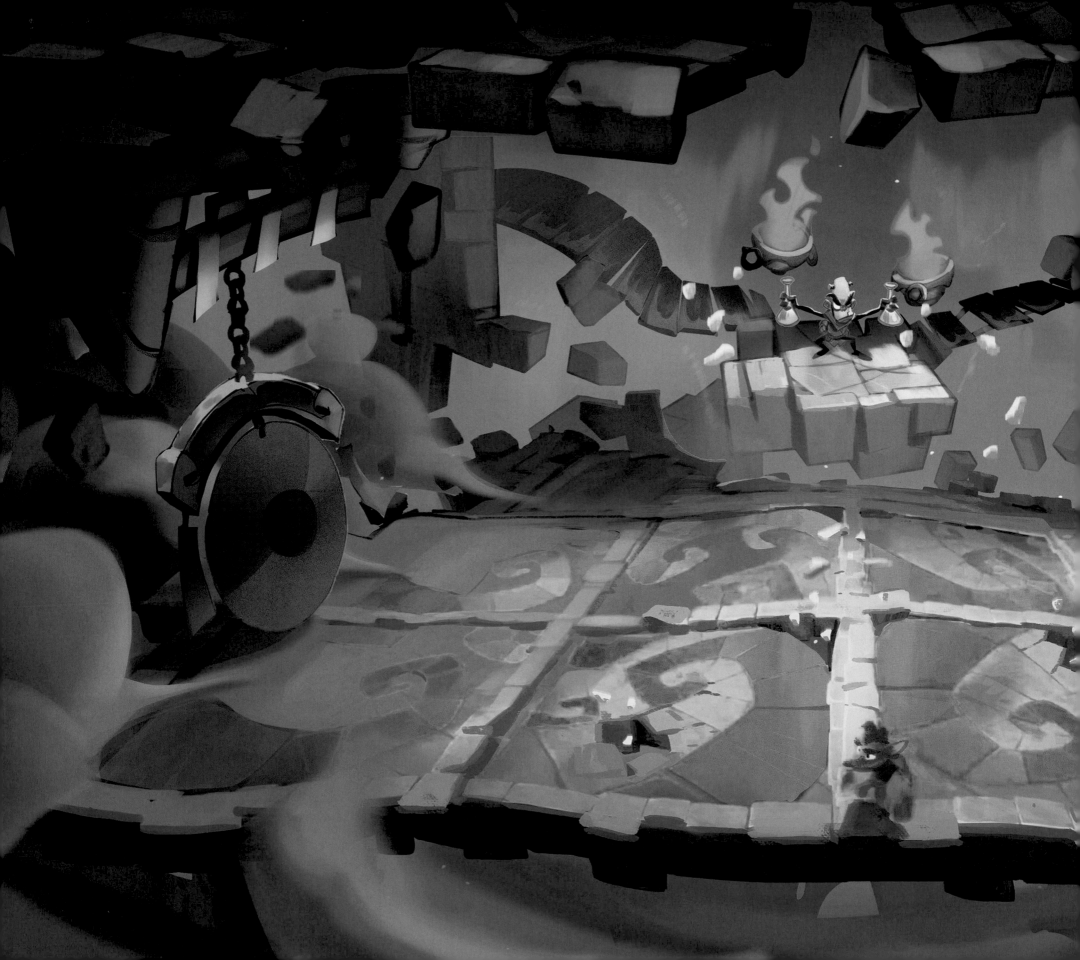

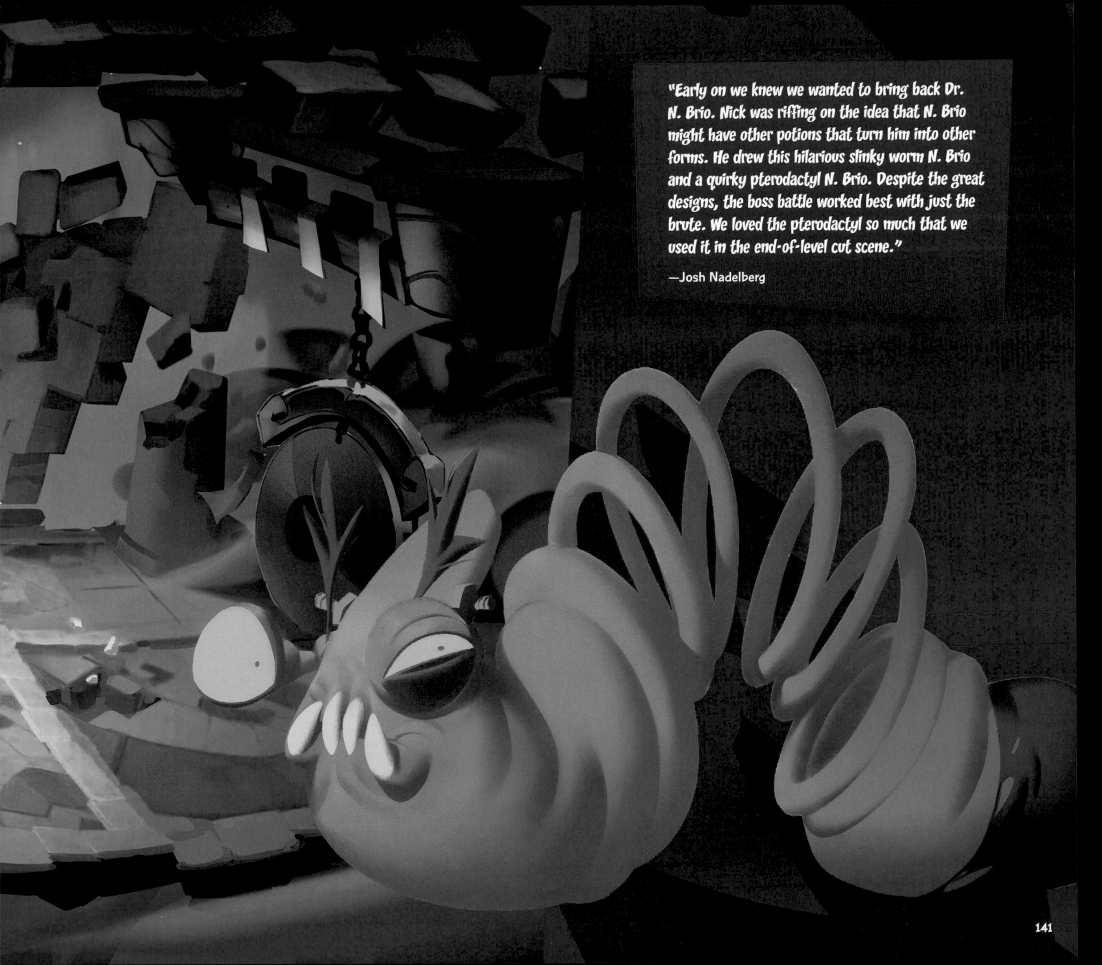

"Early on we knew we wanted to bring back Dr. N. Brio. Nick was riffing on the idea that N. Brio might have other potions that turn him into other forms. He drew this hilarious slinky worm N. Brio and a quirky pterodactyl N. Brio. Despite the great designs, the boss battle worked best with just the brute. We loved the pterodactyl so much that we used it in the end-of-level cut scene."

—Josh Nadelberg

"With Crash, for me, all the other projects I've worked on, they've ranged, but it's never gone this far into humorous. I tend to design things that are cute or cool. To design something that gets a laugh, just to look at it or to think about it, that was very new on Crash for me, so N. Brio's take sort of exemplifies some of that thinking, where it's just like, 'How zany can this go?, And I think by the time I got to him I felt pretty comfortable with the level of humor in the designs. But I learned a lot. It was a new sort of skill set to pick up."

—Nicholas Kole

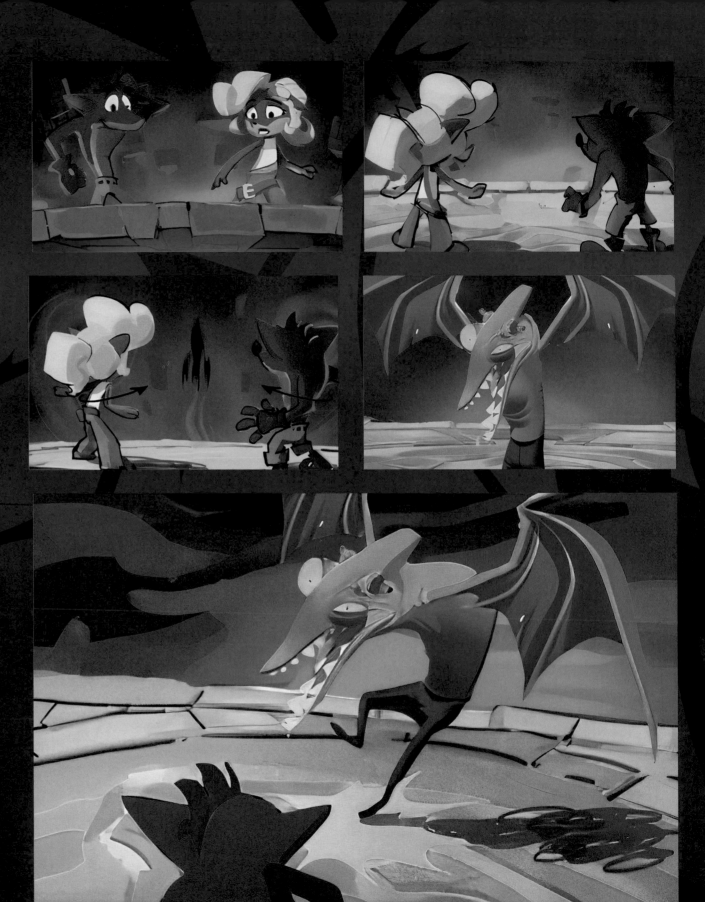

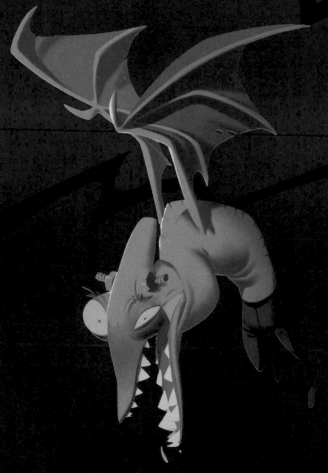

Dr. N. Brio

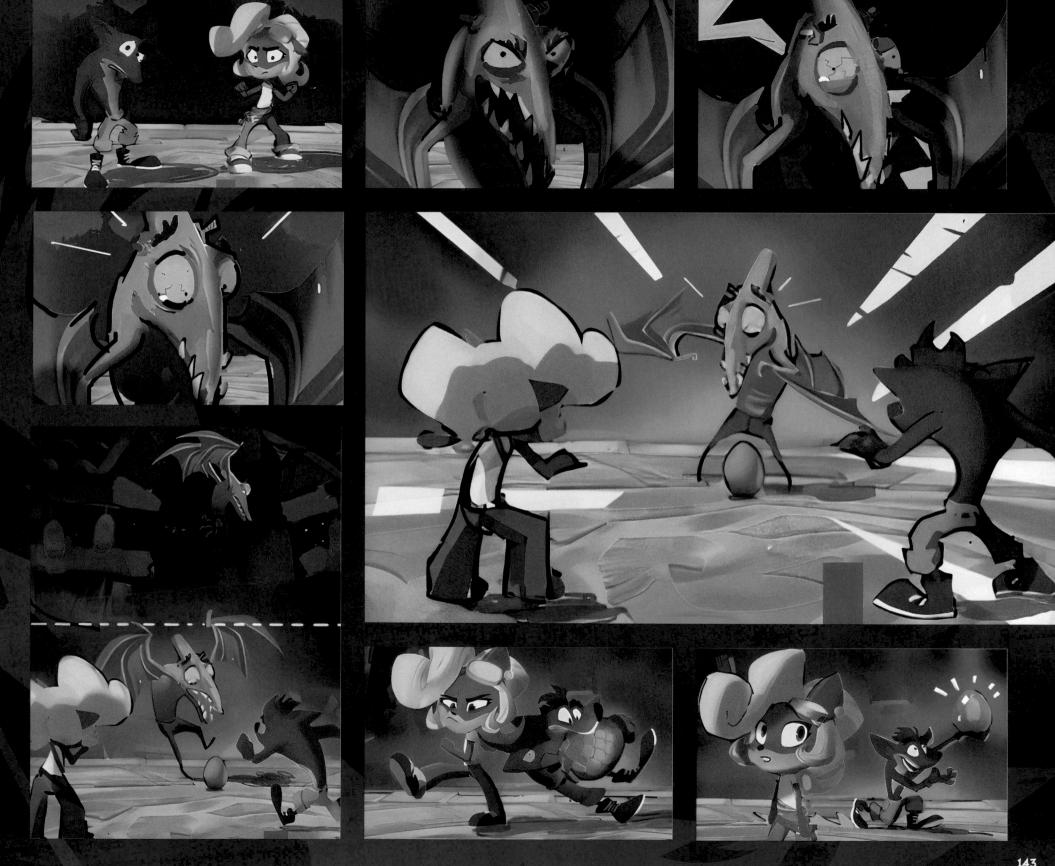

MOSQUITO MARSH

(A FEW DAYS AGO)

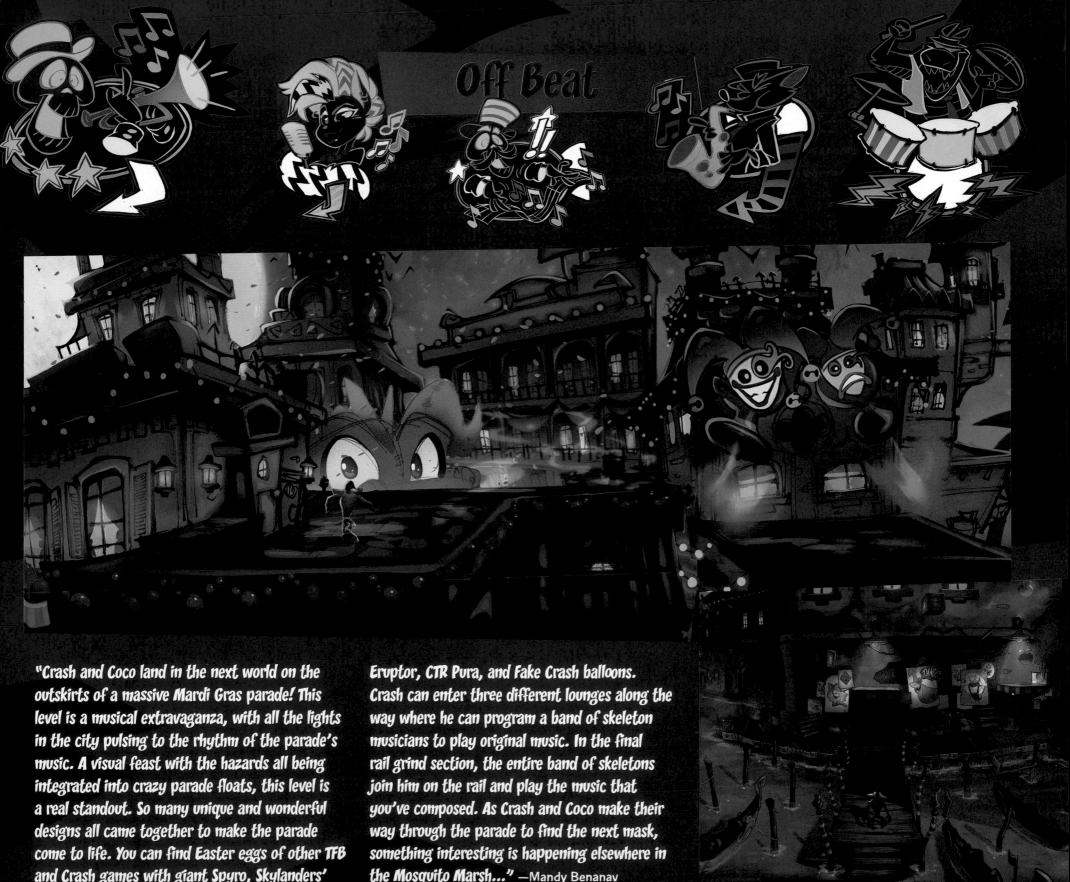

Off Beat

"Crash and Coco land in the next world on the outskirts of a massive Mardi Gras parade! This level is a musical extravaganza, with all the lights in the city pulsing to the rhythm of the parade's music. A visual feast with the hazards all being integrated into crazy parade floats, this level is a real standout. So many unique and wonderful designs all came together to make the parade come to life. You can find Easter eggs of other TFB and Crash games with giant Spyro, Skylanders'

Eruptor, CTR Pura, and Fake Crash balloons. Crash can enter three different lounges along the way where he can program a band of skeleton musicians to play original music. In the final rail grind section, the entire band of skeletons join him on the rail and play the music that you've composed. As Crash and Coco make their way through the parade to find the next mask, something interesting is happening elsewhere in the Mosquito Marsh..." —Mandy Benanav

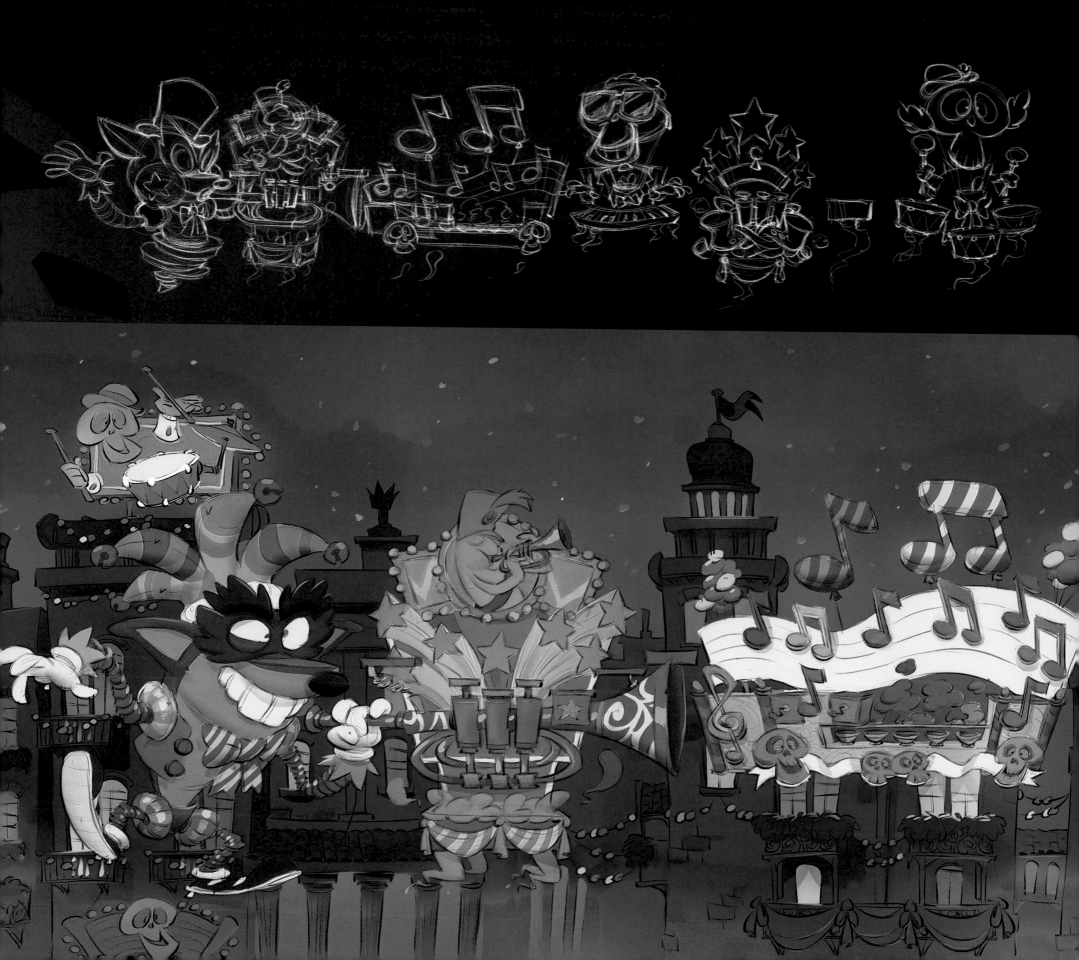

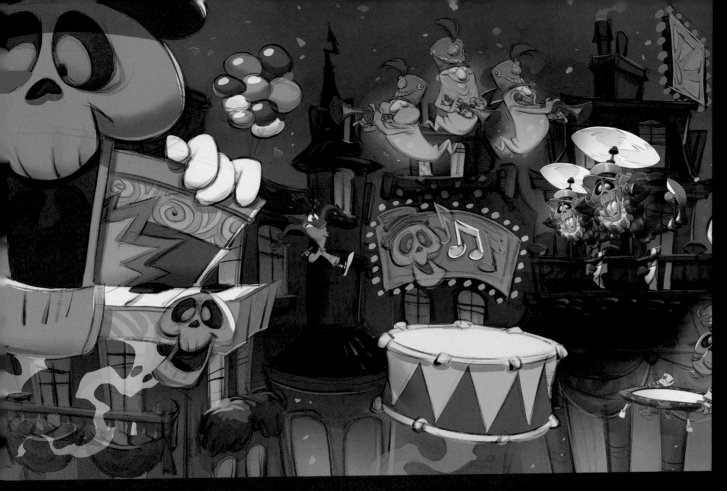

"Three months of my life I spent on this area, the New Orleans area. It's a mix between New Orleans and Venice, where there is this big carnival, and me and other character artists took a break from the characters and focused on the environments. We decided the looks of the buildings, the look of the area, the colors, and we made a lot of sketches."

—Nico Saviori

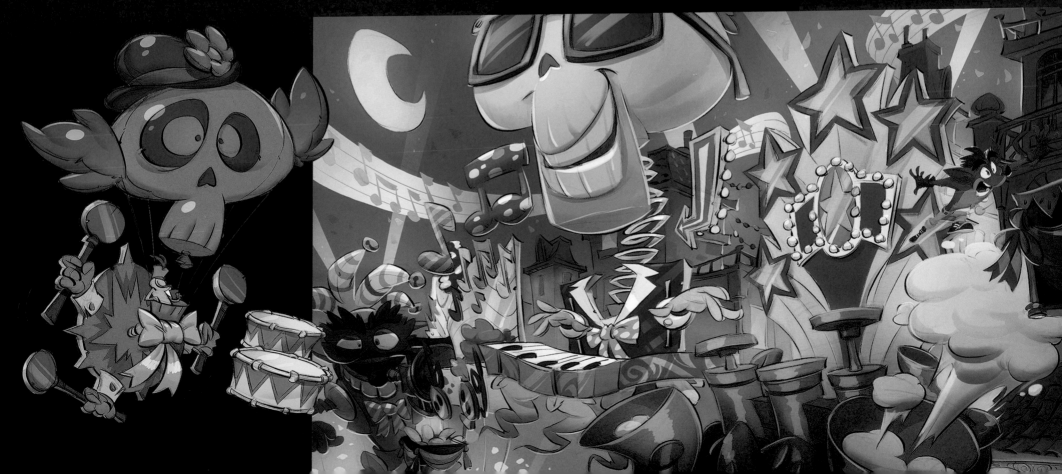

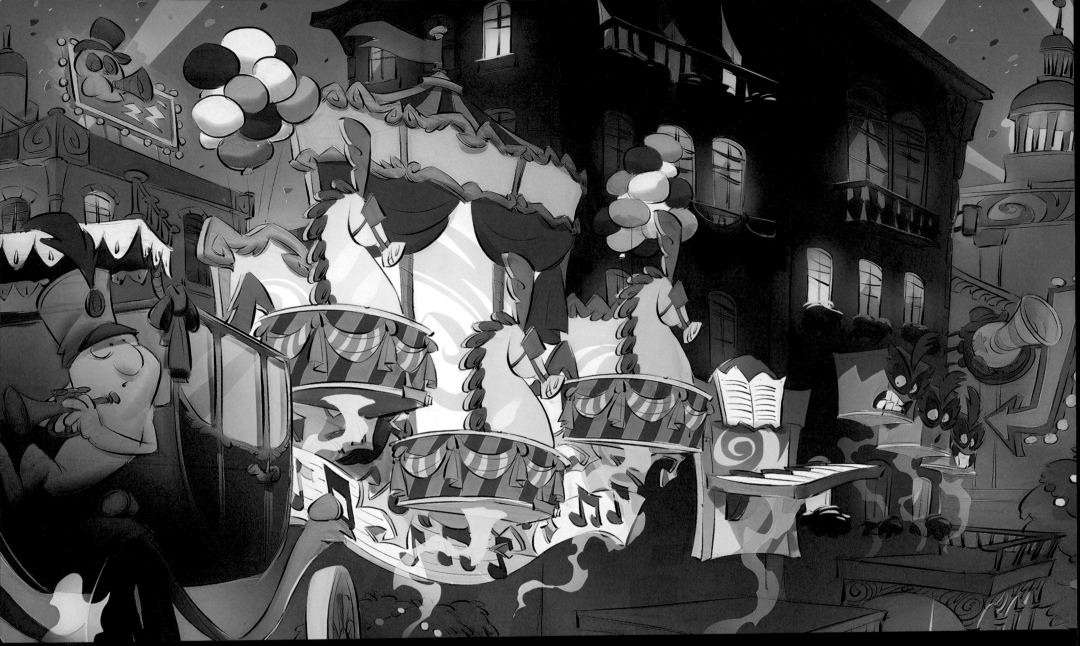

GHOSTLY SMOKE HOLDS THE 3D STRUCTURES

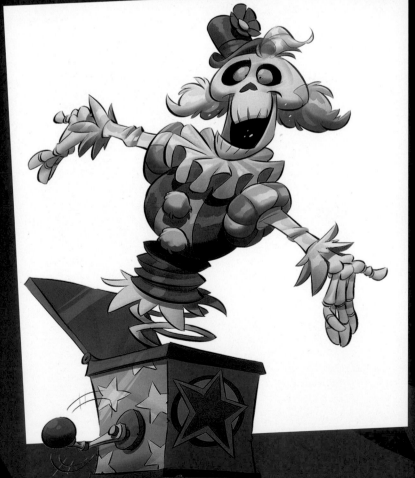

"I looked up a lot of old reference of New Orleans during the turn of the century and older photos of Mardi Gras parades. You start to look and you realize that the New Orleans architecture is a lot of wrought iron, balconies, everything is lit in a beautiful way, so we just took the lighting and made it spooky with that green glow and all the wrought iron balconies and stuff—we just made them cartoony and bent them in fun ways so they felt like they were all are kind of animated." —Vinod Rams

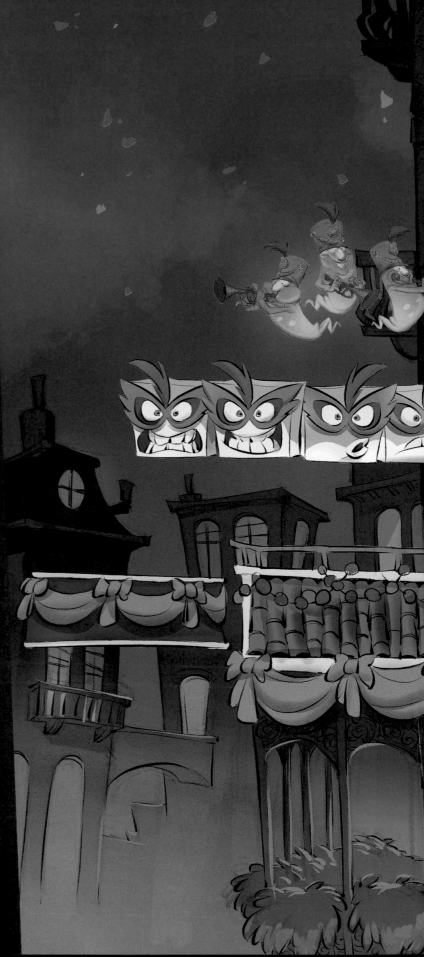

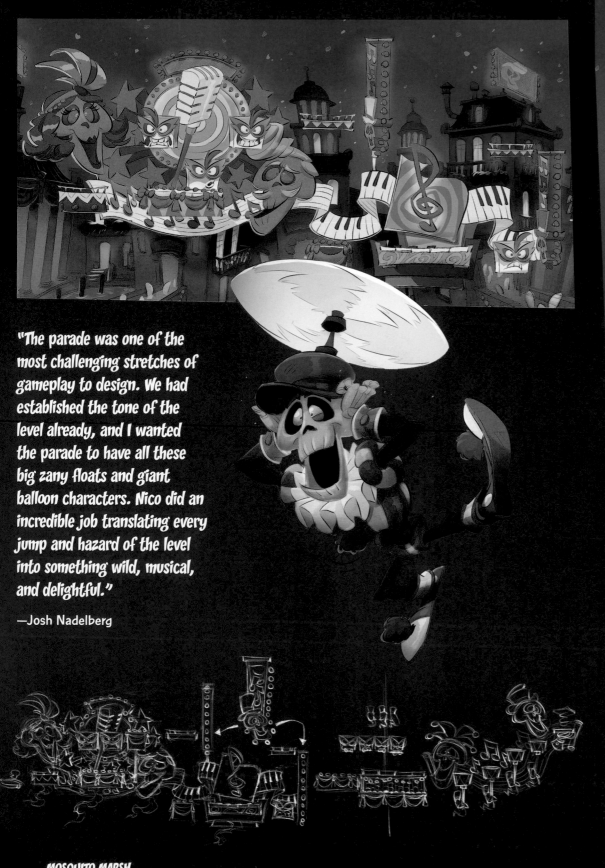

"The parade was one of the most challenging stretches of gameplay to design. We had established the tone of the level already, and I wanted the parade to have all these big zany floats and giant balloon characters. Nico did an incredible job translating every jump and hazard of the level into something wild, musical, and delightful."

—Josh Nadelberg

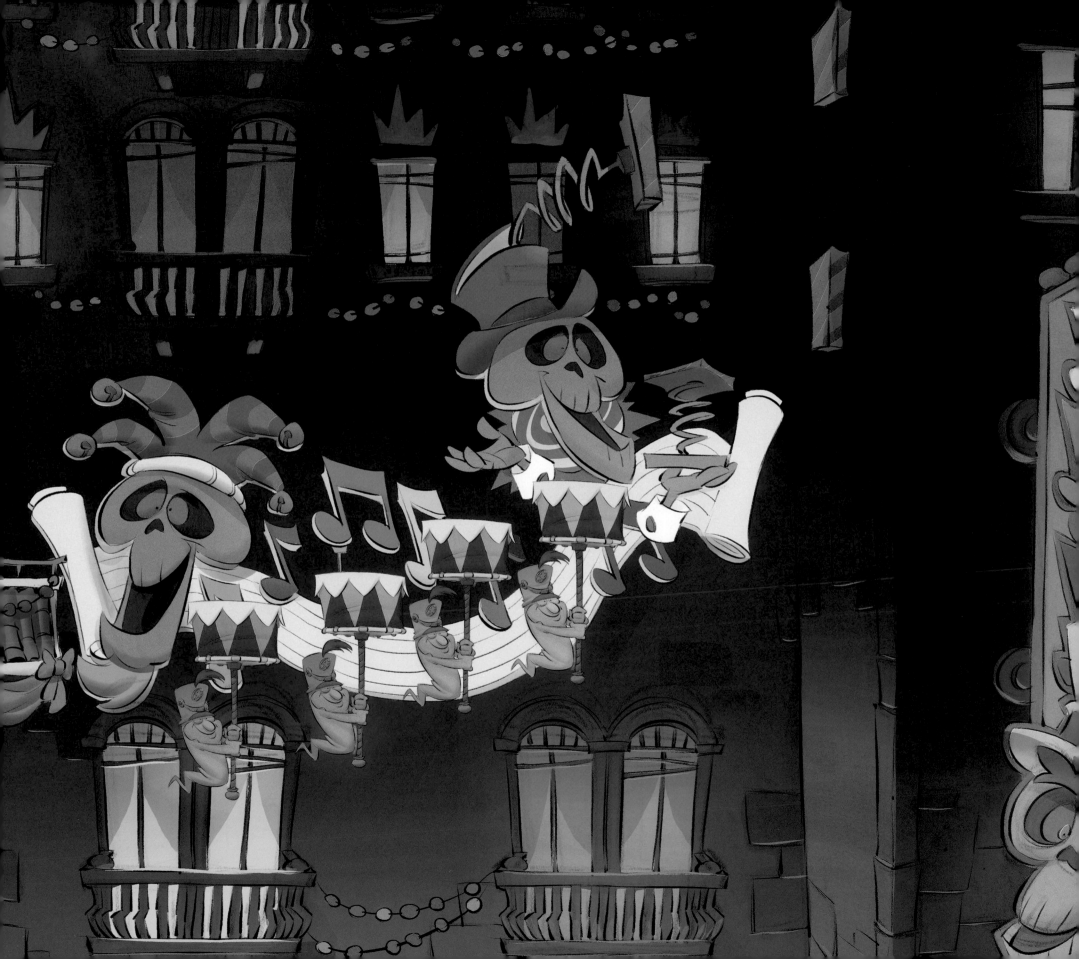

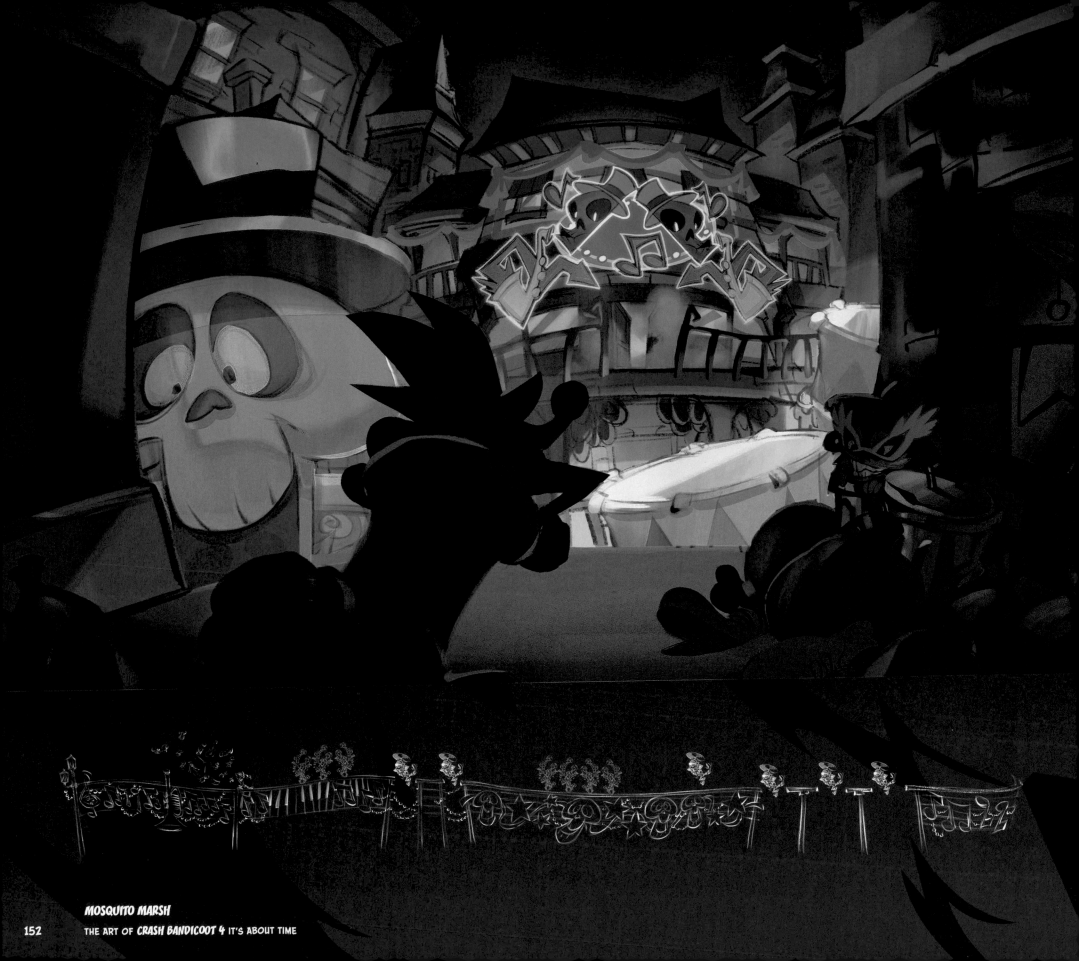

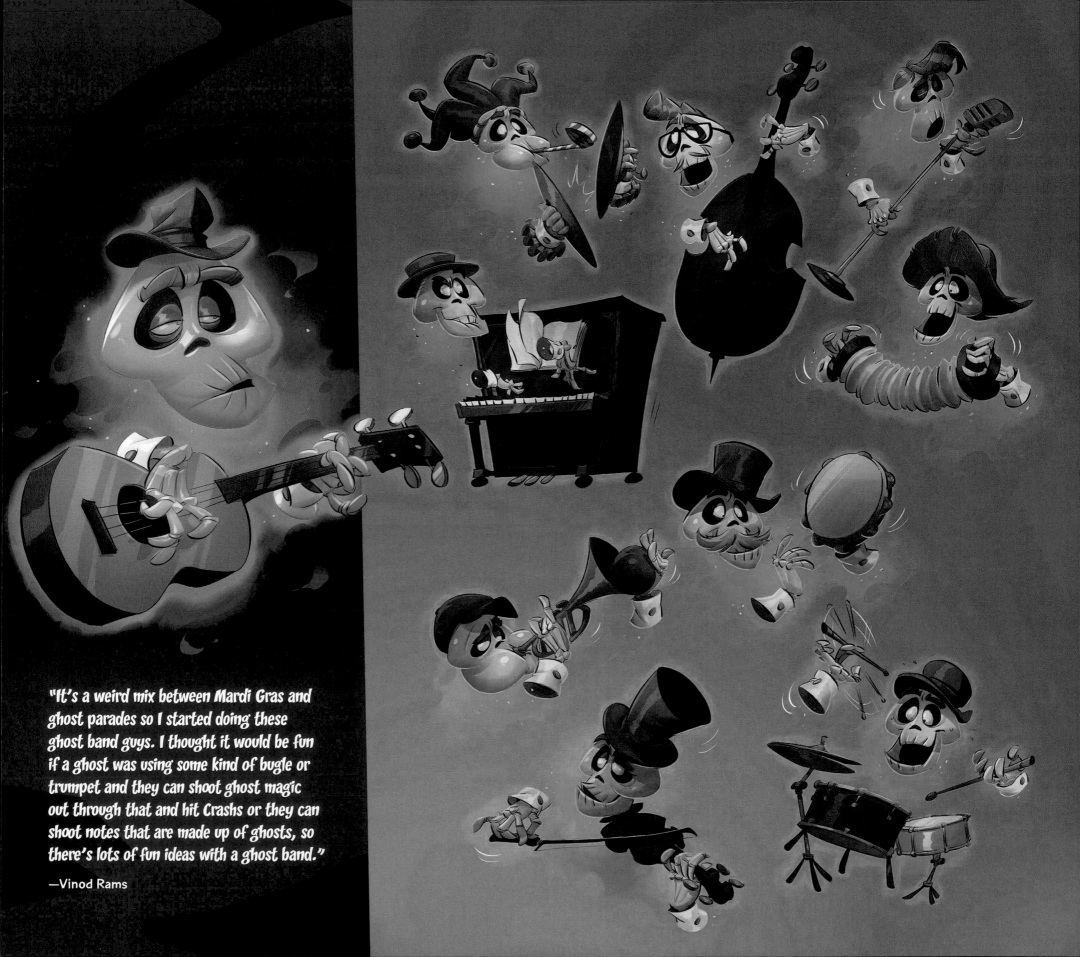

"It's a weird mix between Mardi Gras and ghost parades so I started doing these ghost band guys. I thought it would be fun if a ghost was using some kind of bugle or trumpet and they can shoot ghost magic out through that and hit Crashs or they can shoot notes that are made up of ghosts, so there's lots of fun ideas with a ghost band."

—Vinod Rams

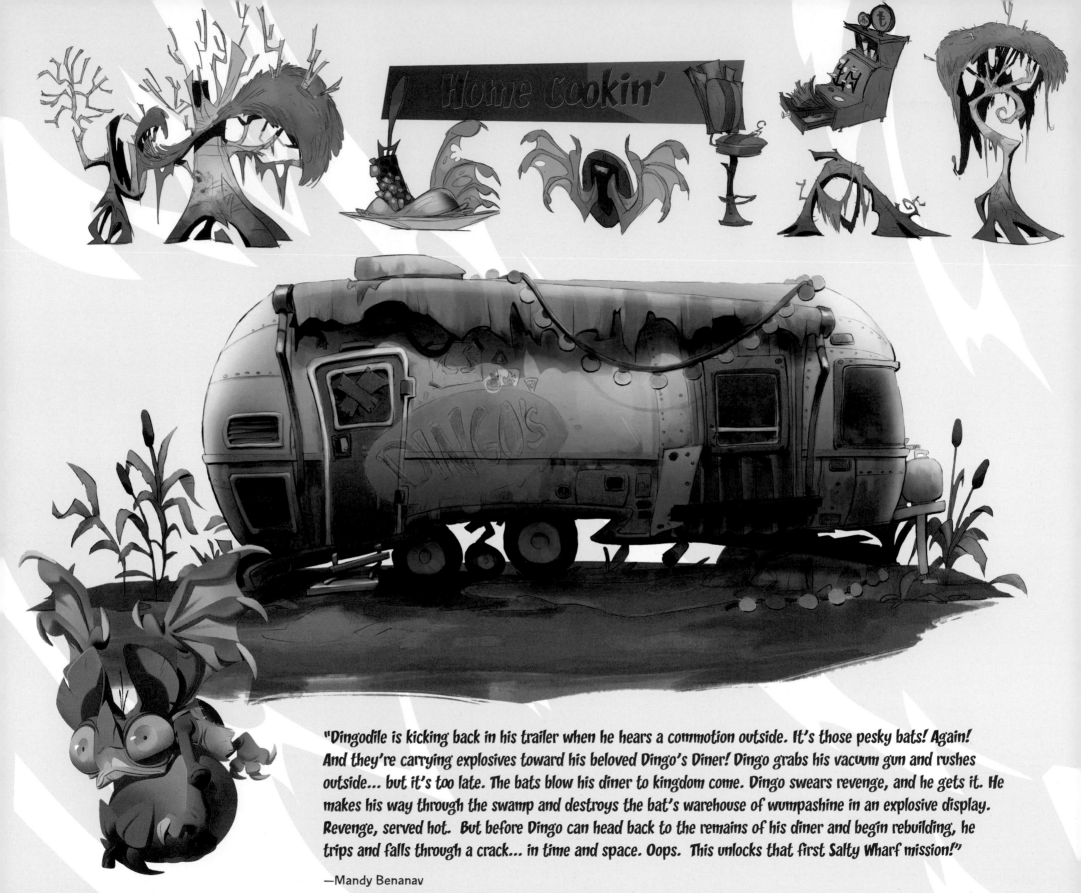

"Dingodile is kicking back in his trailer when he hears a commotion outside. It's those pesky bats! Again! And they're carrying explosives toward his beloved Dingo's Diner! Dingo grabs his vacuum gun and rushes outside... but it's too late. The bats blow his diner to kingdom come. Dingo swears revenge, and he gets it. He makes his way through the swamp and destroys the bat's warehouse of wumpashine in an explosive display. Revenge, served hot. But before Dingo can head back to the remains of his diner and begin rebuilding, he trips and falls through a crack... in time and space. Oops. This unlocks that first Salty Wharf mission!"

—Mandy Benanav

MOSQUITO MARSH

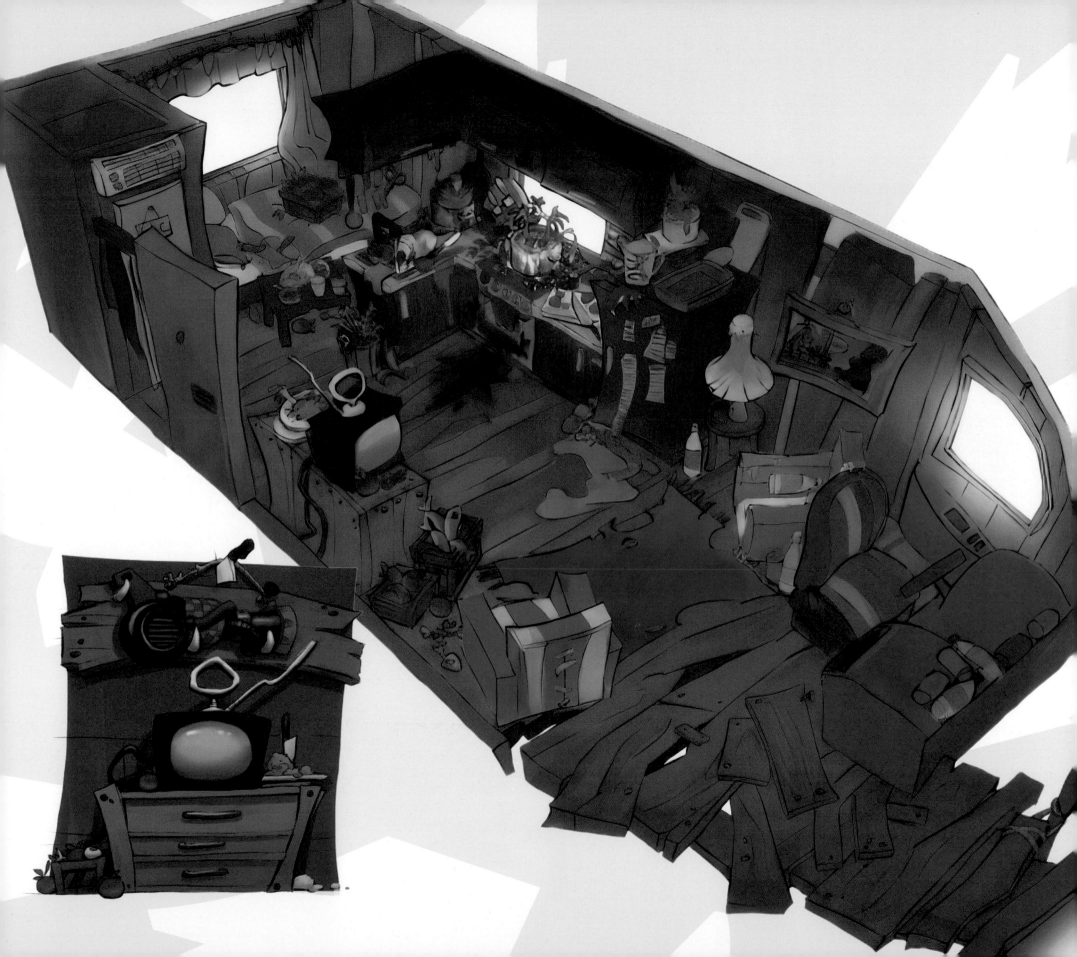

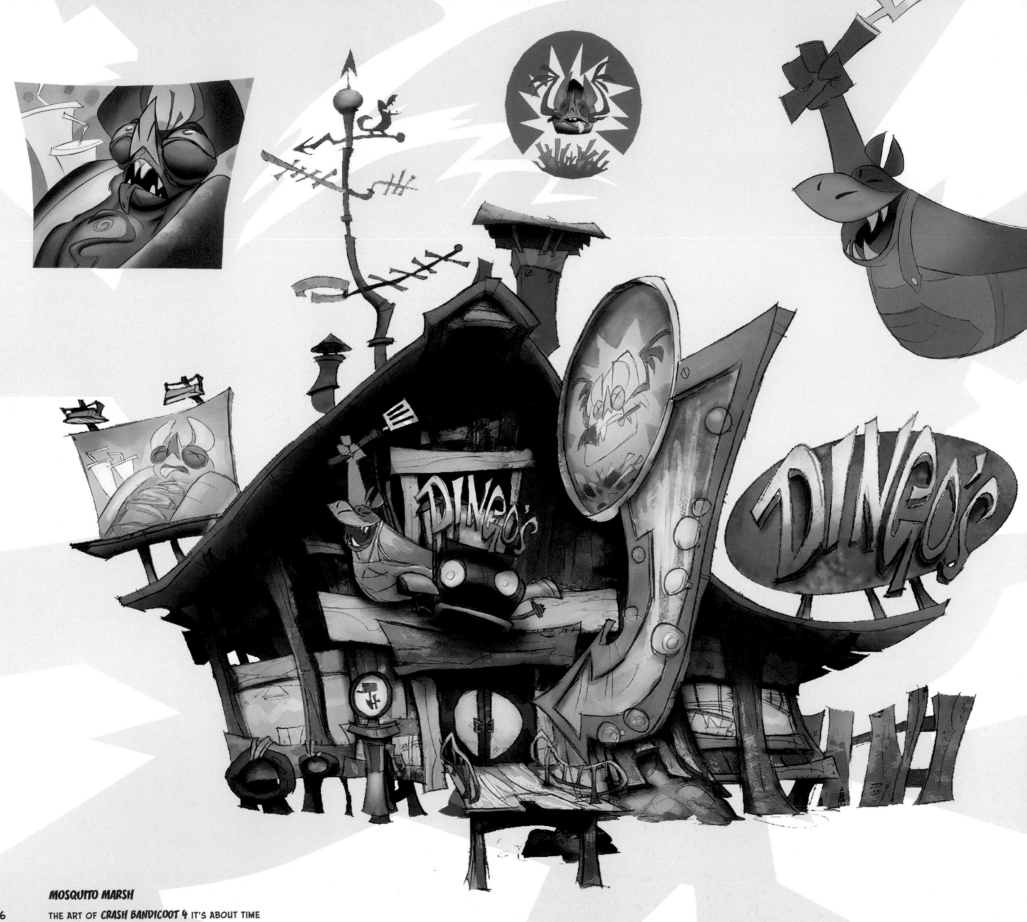

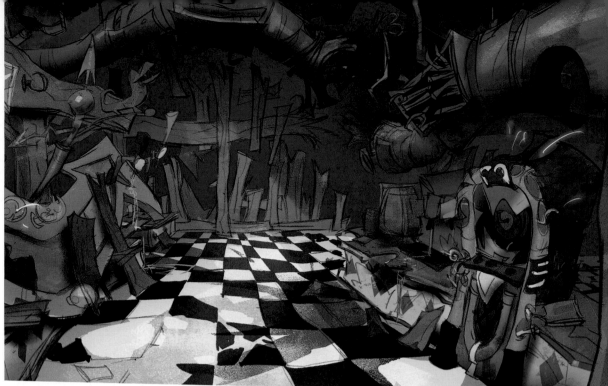

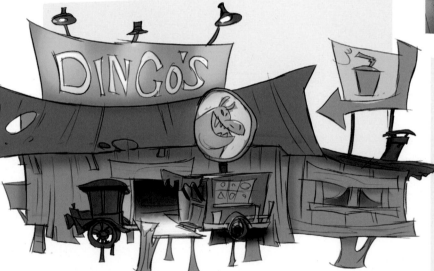

"I live in the Czech Republic, but I'm from Missouri in America, and they have these really cheesy gift stores along the highways. That was the inspiration for the design of Dingo's Diner—these giant red barns that sold, like, rabbit's feet and candy and stuff."

—James Martin

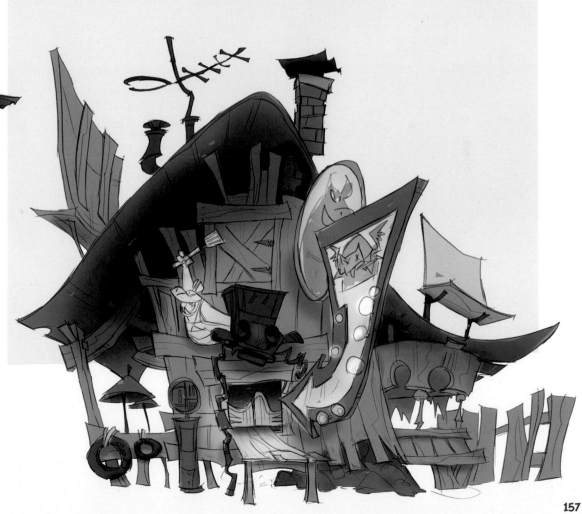

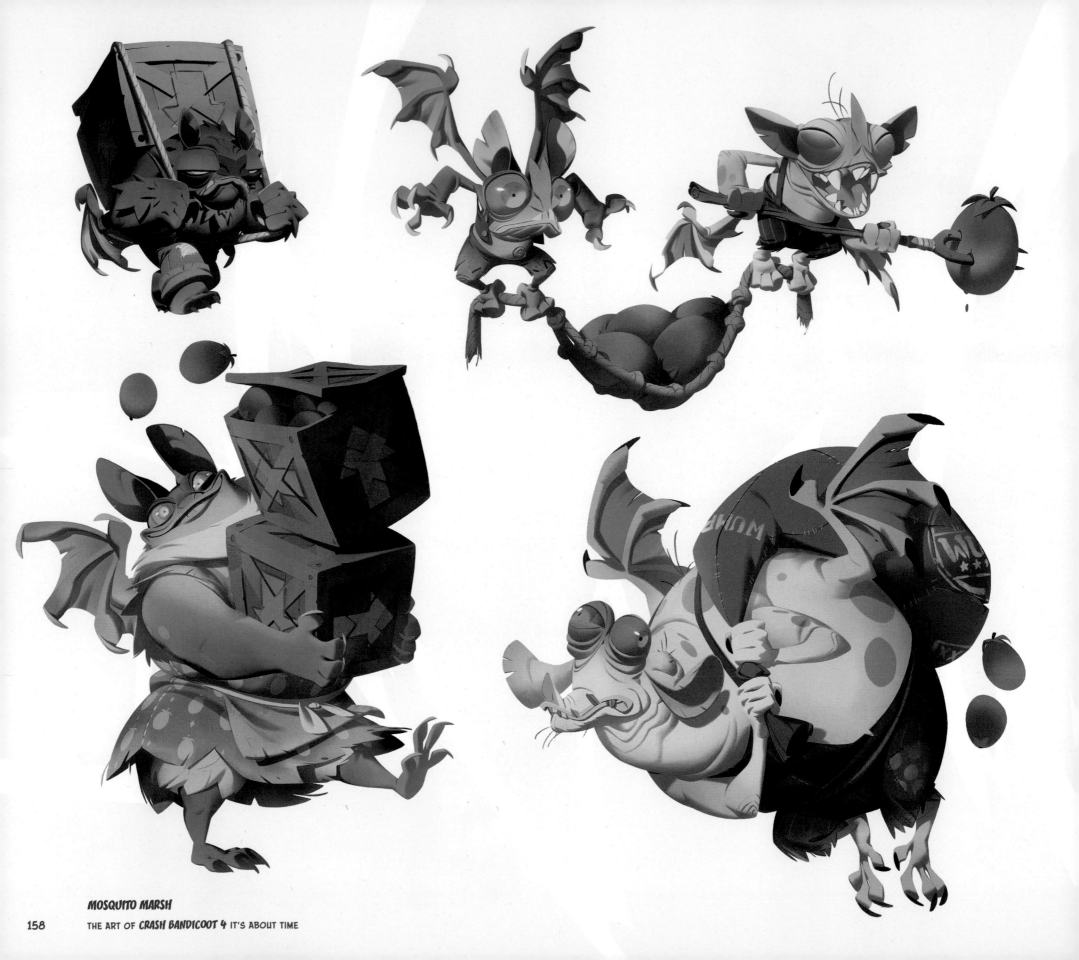

MOSQUITO MARSH

THE ART OF **CRASH BANDICOOT** 4 IT'S ABOUT TIME

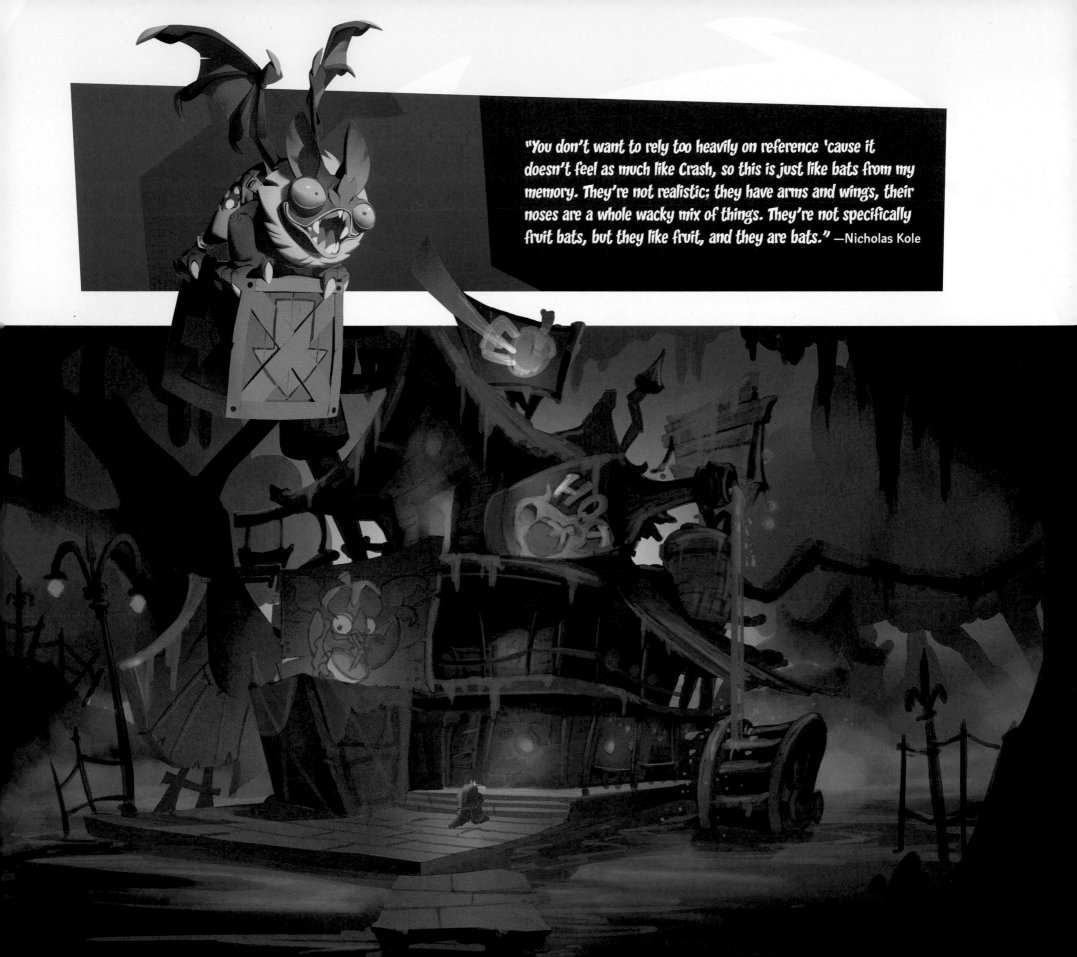

"You don't want to rely too heavily on reference 'cause it doesn't feel as much like Crash, so this is just like bats from my memory. They're not realistic; they have arms and wings, their noses are a whole wacky mix of things. They're not specifically fruit bats, but they like fruit, and they are bats." —Nicholas Kole

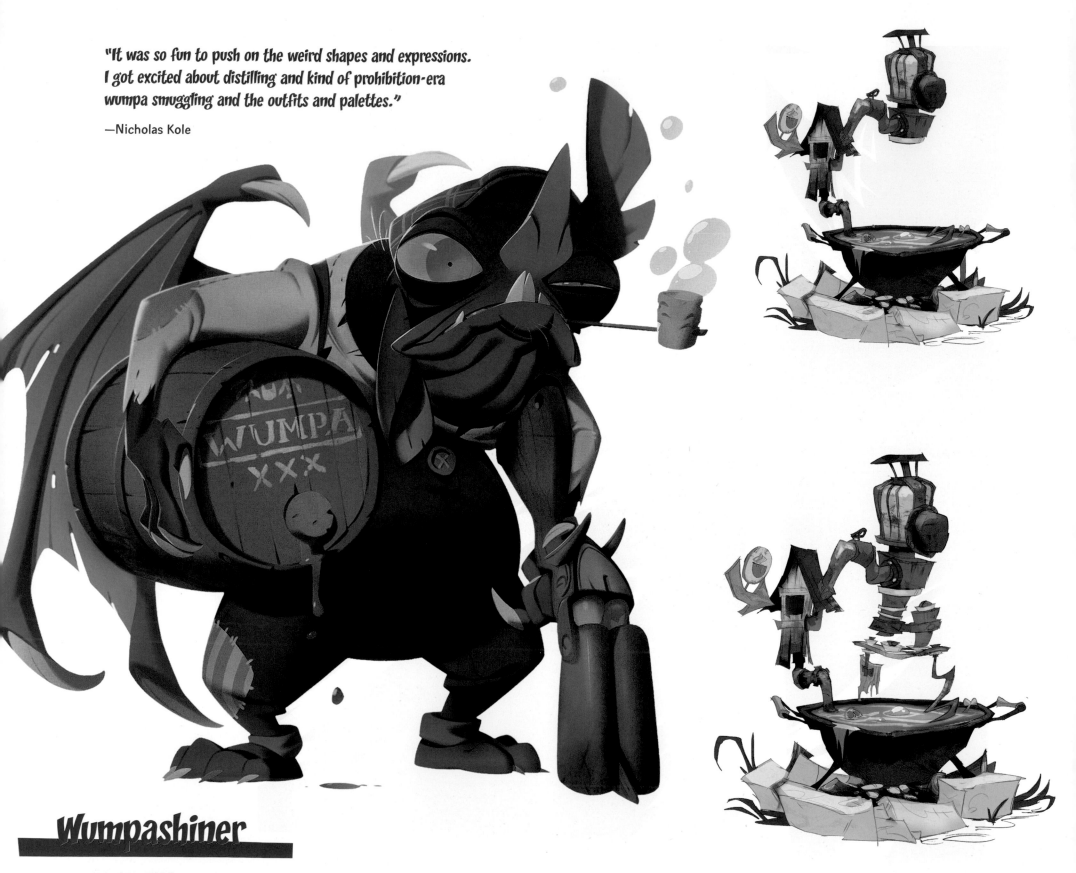

"It was so fun to push on the weird shapes and expressions. I got excited about distilling and kind of prohibition-era wumpa smuggling and the outfits and palettes."

—Nicholas Kole

Wumpashiner

MOSQUITO MARSH

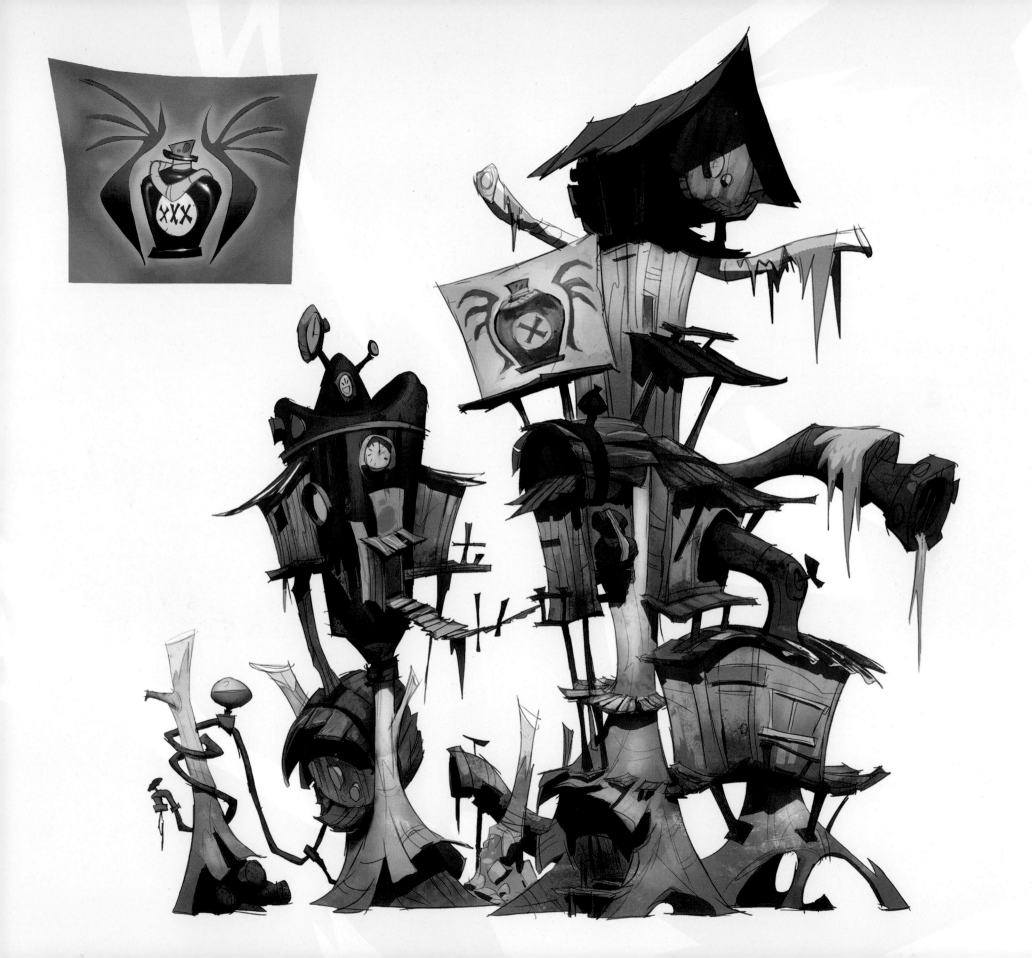

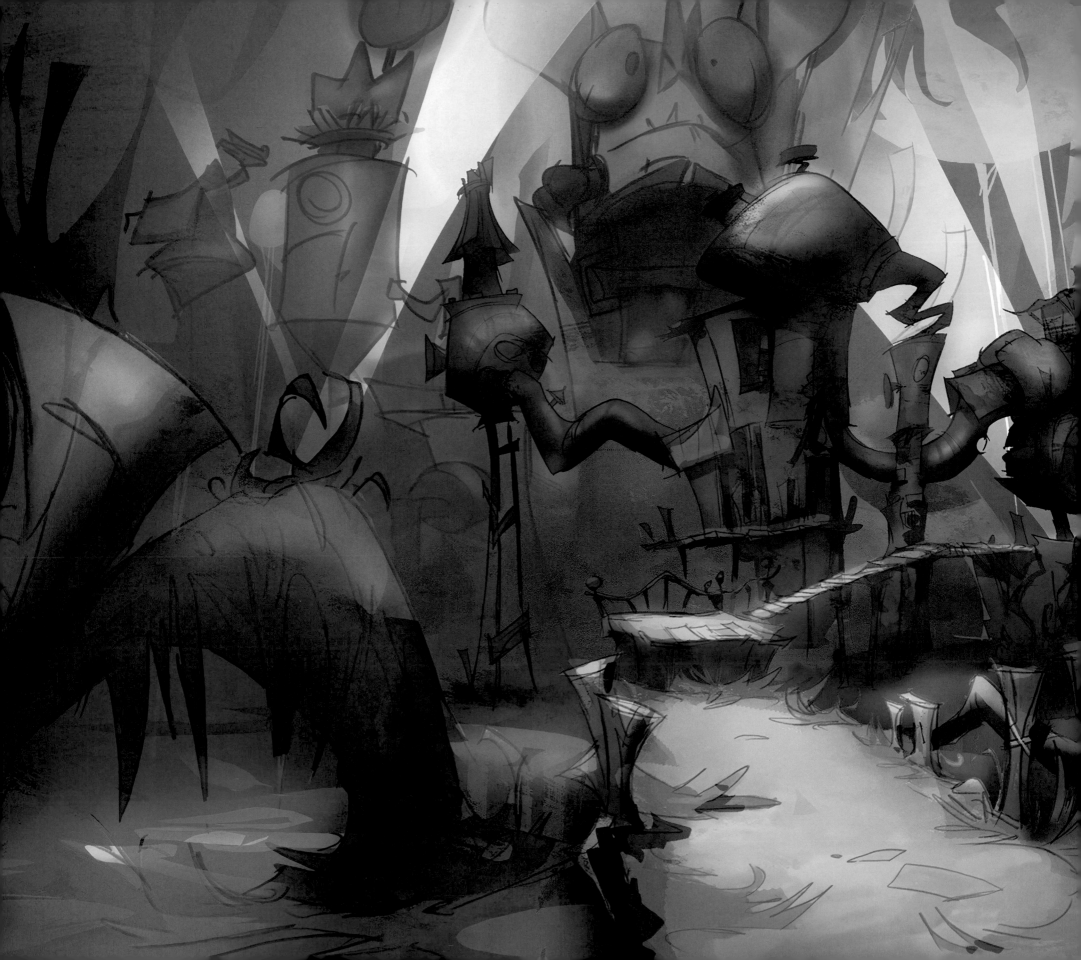

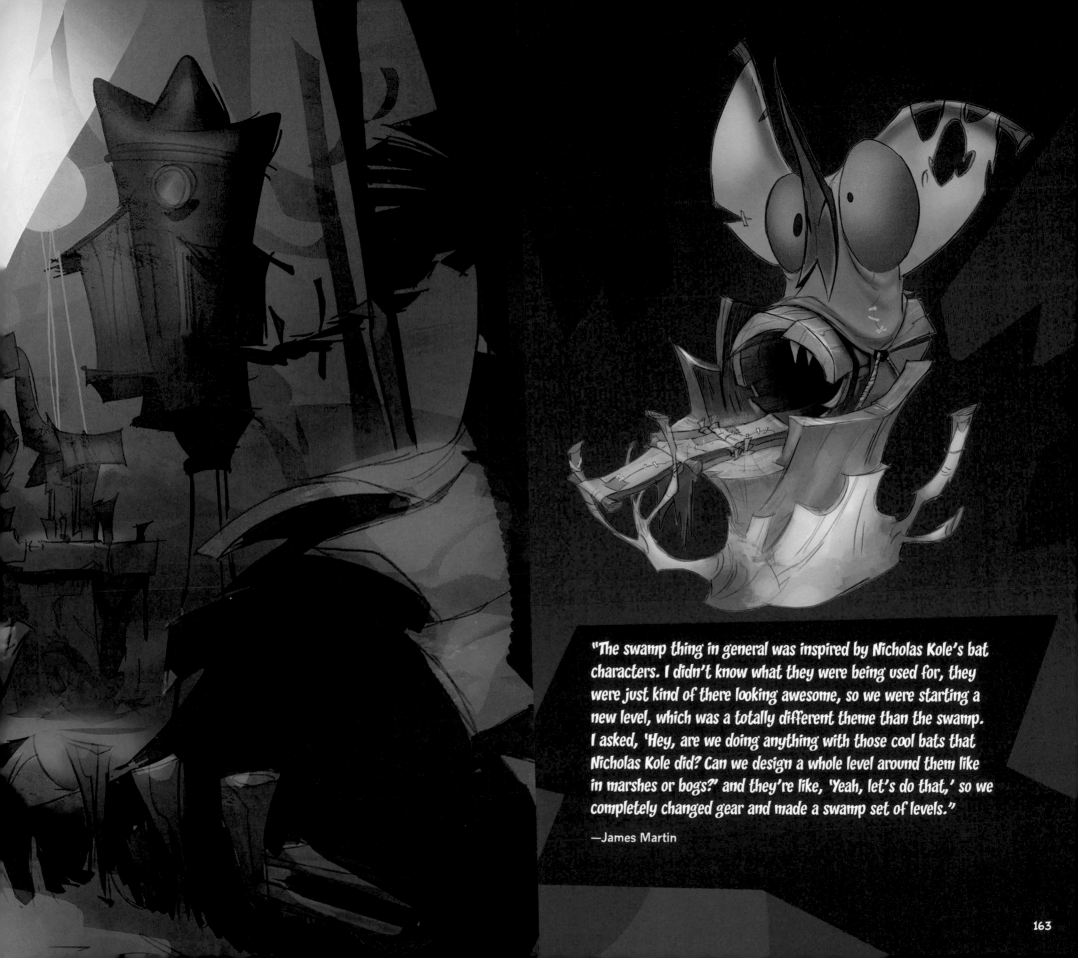

"The swamp thing in general was inspired by Nicholas Kole's bat characters. I didn't know what they were being used for, they were just kind of there looking awesome, so we were starting a new level, which was a totally different theme than the swamp. I asked, 'Hey, are we doing anything with those cool bats that Nicholas Kole did? Can we design a whole level around them like in marshes or bogs?' and they're like, 'Yeah, let's do that,' so we completely changed gear and made a swamp set of levels."

—James Martin

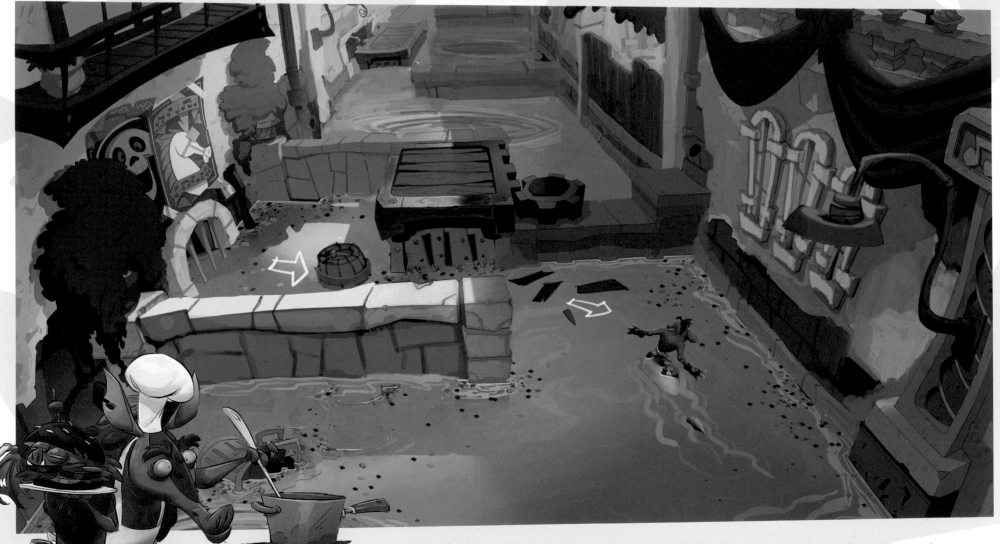

"*Crash and Coco find themselves on the edge of the canal, the morning after the parade. Crash jumps on a hoverboard and makes his way through the swamp to find the mask. On his way he must escort a Dingo's Diner food boat through the swamp, dodge deadly mines, and finally destroy Ripper Roo, who's preventing him from making his way to the third mask.*"

—Josh Nadelberg

MOSQUITO MARSH

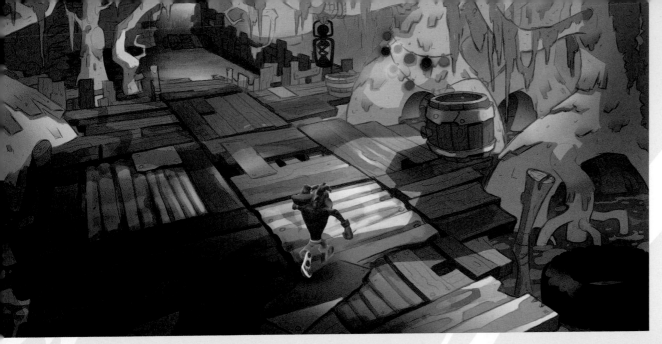

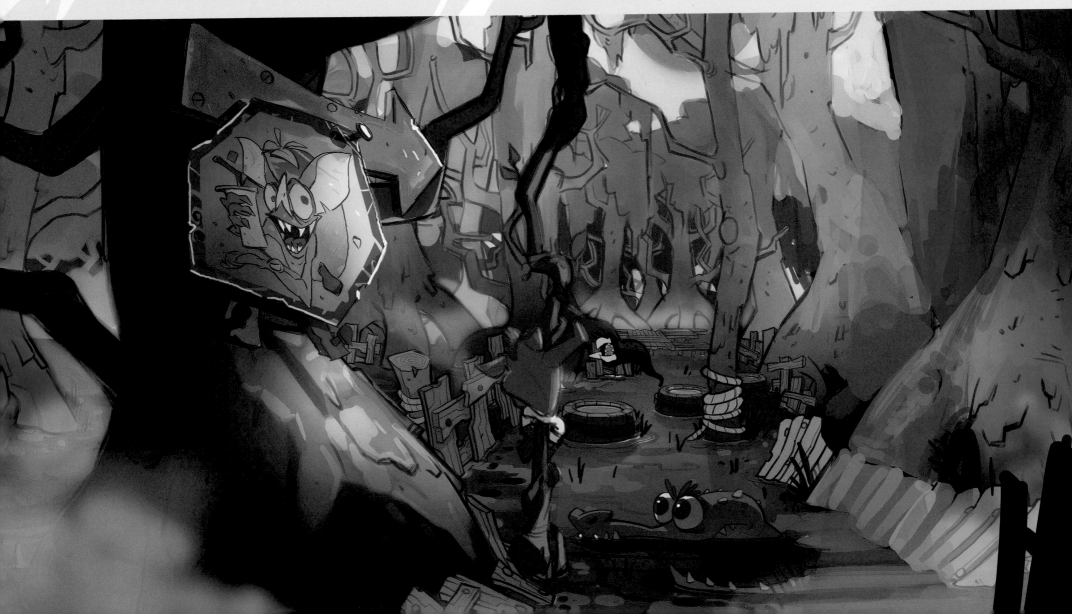

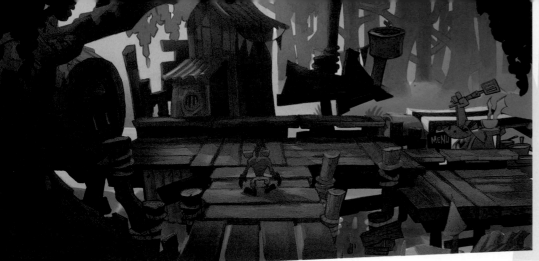

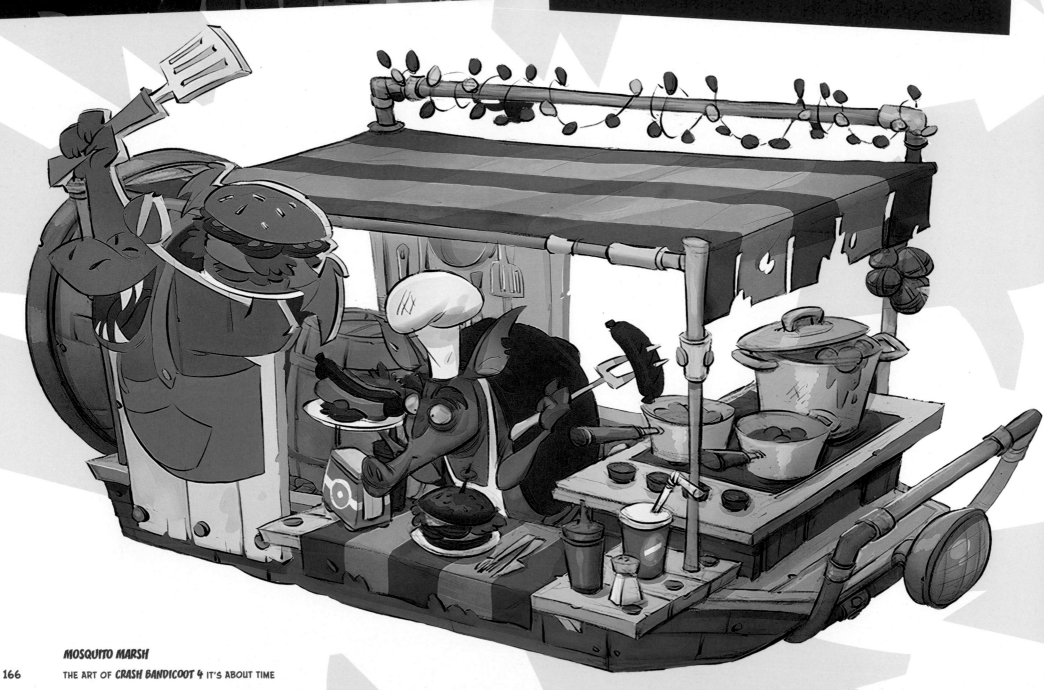

MOSQUITO MARSH

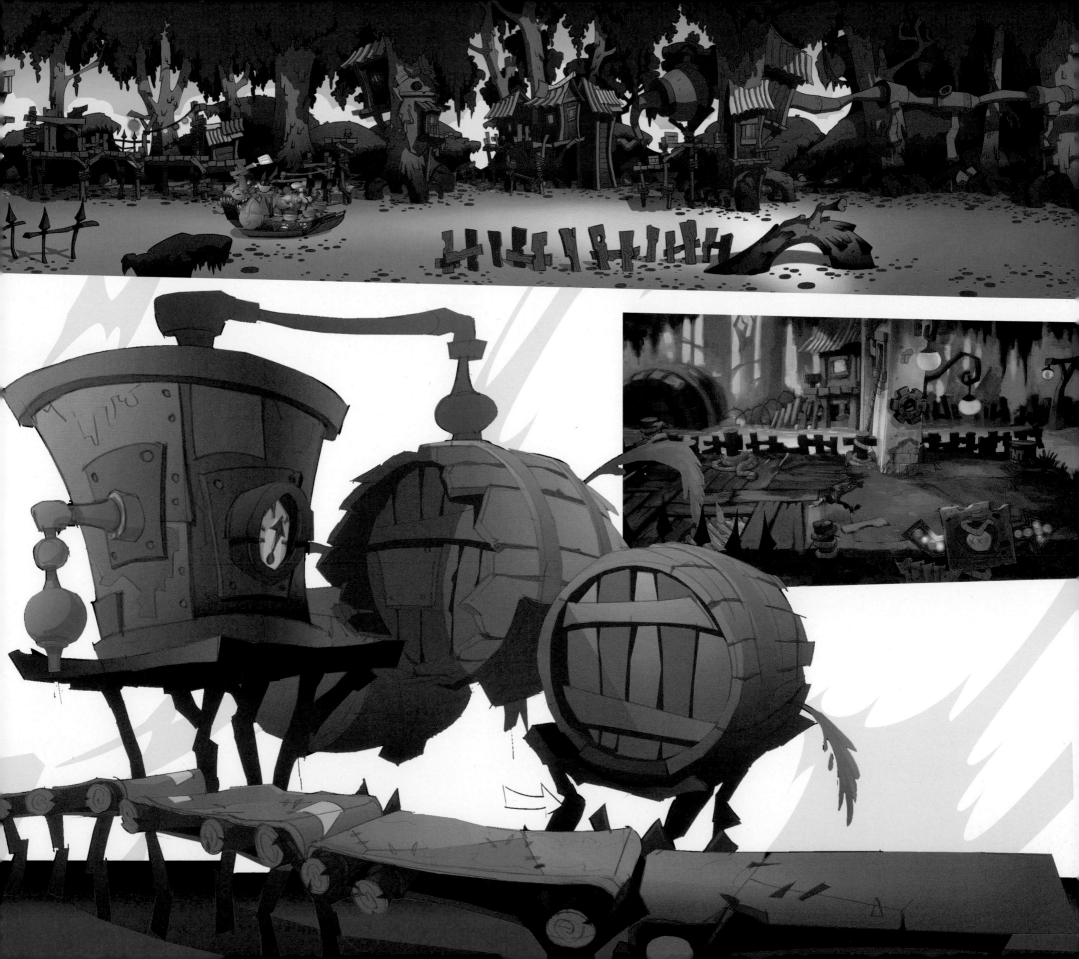

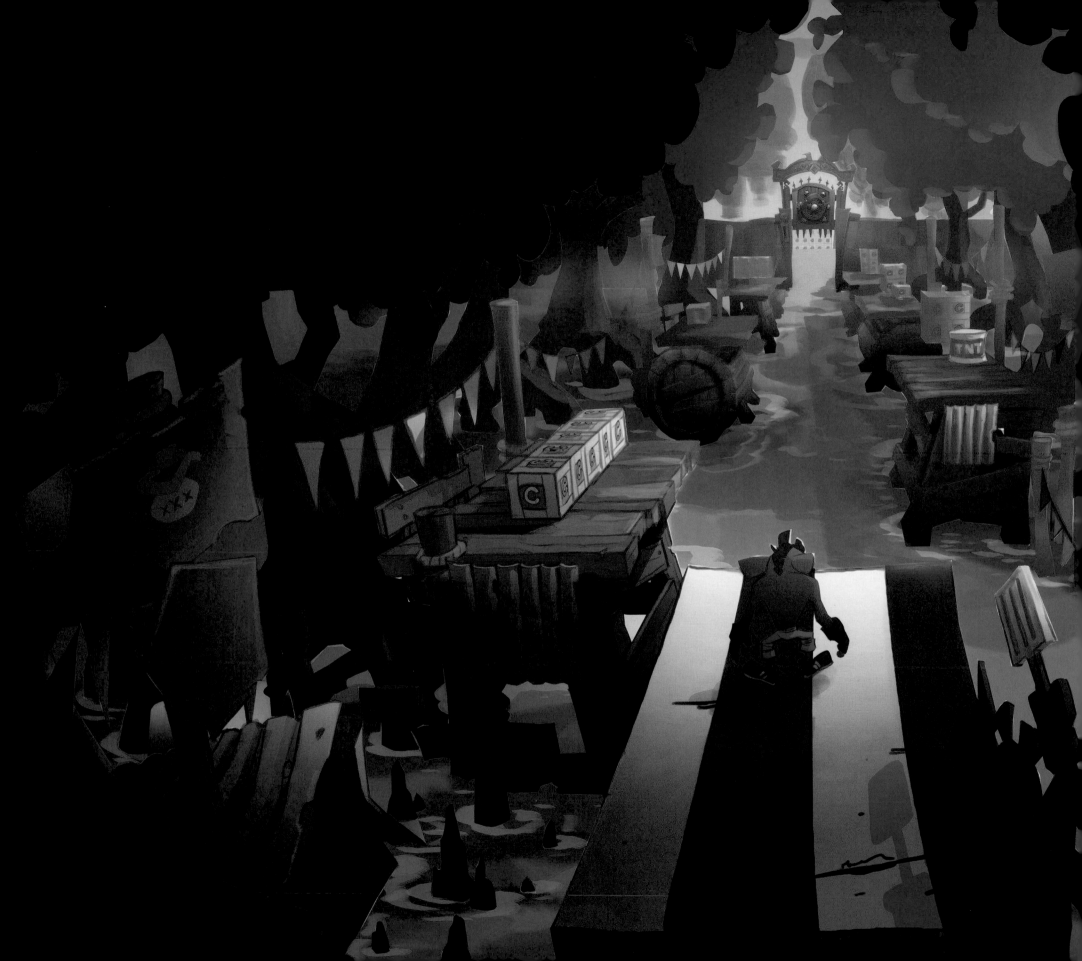

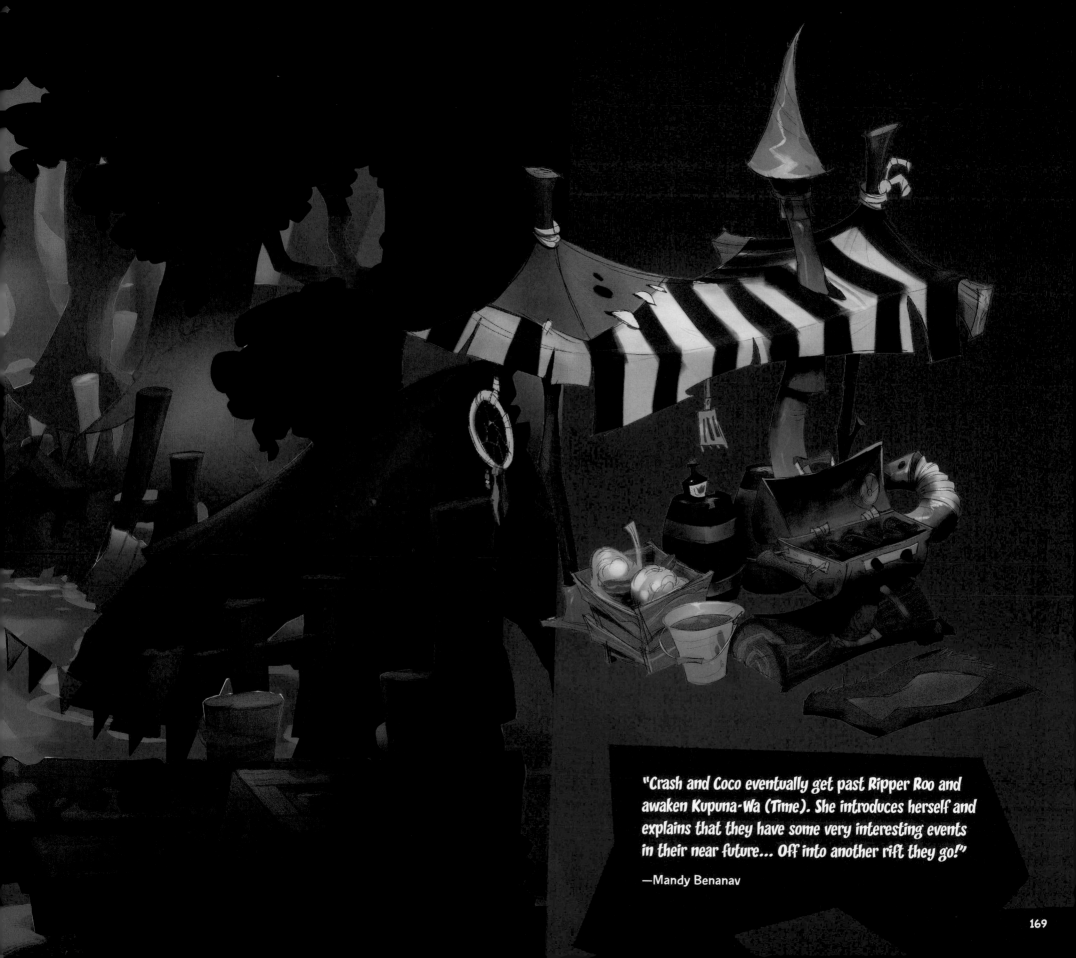

"Crash and Coco eventually get past Ripper Roo and awaken Kupuna-Wa (Time). She introduces herself and explains that they have some very interesting events in their near future... Off into another rift they go!"

—Mandy Benanav

169

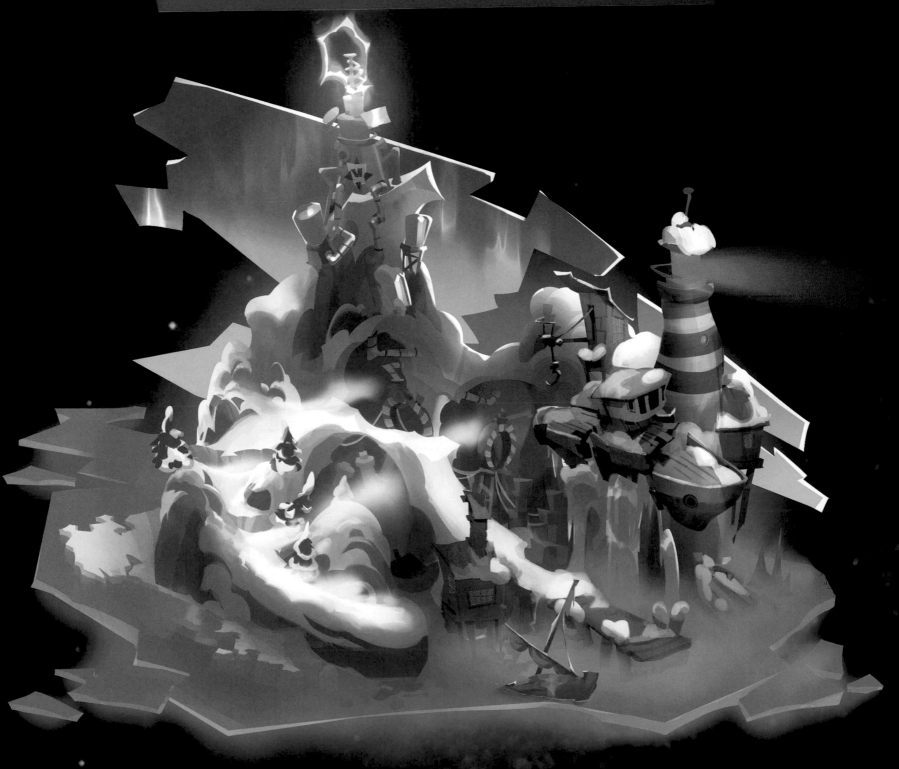

Snow Way Out

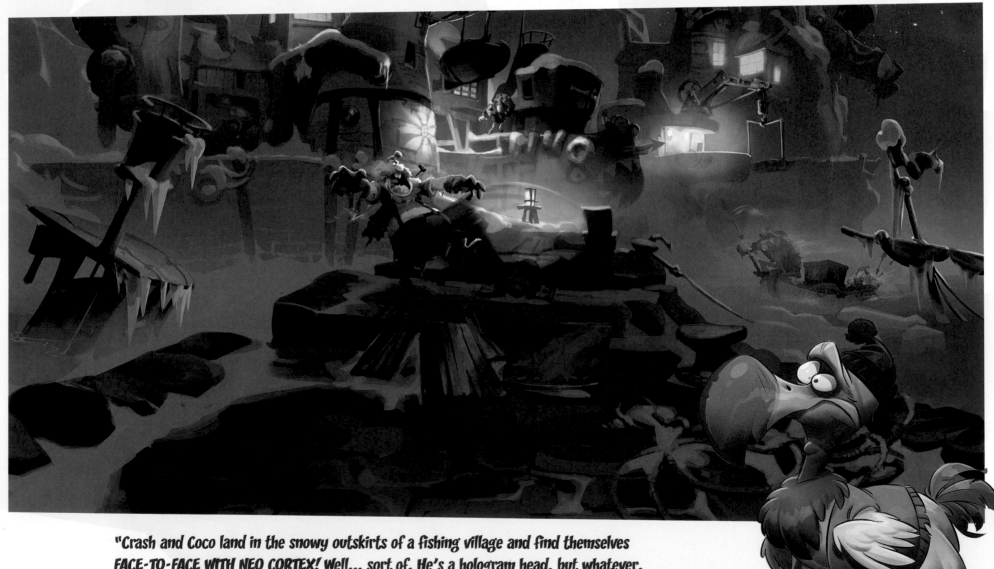

"Crash and Coco land in the snowy outskirts of a fishing village and find themselves FACE-TO-FACE WITH NEO CORTEX! Well... sort of. He's a hologram head, but whatever. Details. He does The Usual—threaten them to a fight if they can find him without freezing on the way up. Oh, and of course, he's guarding the next rift. Great!"

—Mandy Benanav

ATAKS

TOP VIEW

"In the first level, Crash makes his way through an 'abandoned' fishing village. Thing is, it's actually full of frozen zombie fishermen. When we started designing the 11th Dimension level we wanted to come up with some fun new enemies, and we fell in love with these designs. In my head canon, they're part of a strange new experiment that Neo Cortex is performing. You can even see a few of them placed in vats of Nitro later on in the world. It's not explicit in the story, but for the interested observer they may pick up on stuff like that... At one point, Crash is approaching a giant boat frozen into an ice wall when it suddenly explodes (huh???), removing a clear path for Crash. (Turns out this was Neo Cortex, and at the end of his Timeline he tried to blow up Crash with TNT but mistimed the explosion). Crash uses the time-slow mask to make his way across falling ice floes instead! At the end of this level Crash enters the tunnels that will lead him to Cortex's Nitro lab."

—Josh Nadelberg

Frozen Fisherman

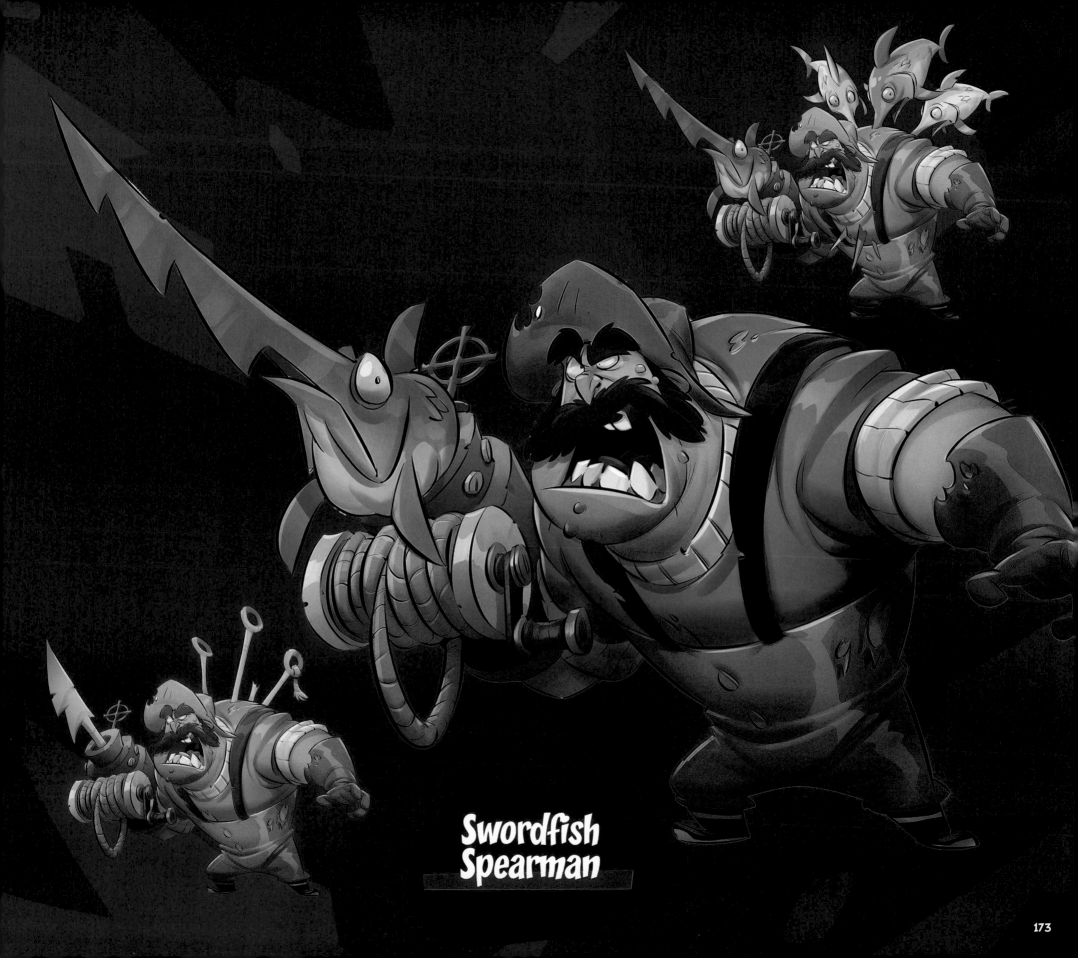

Swordfish Spearman

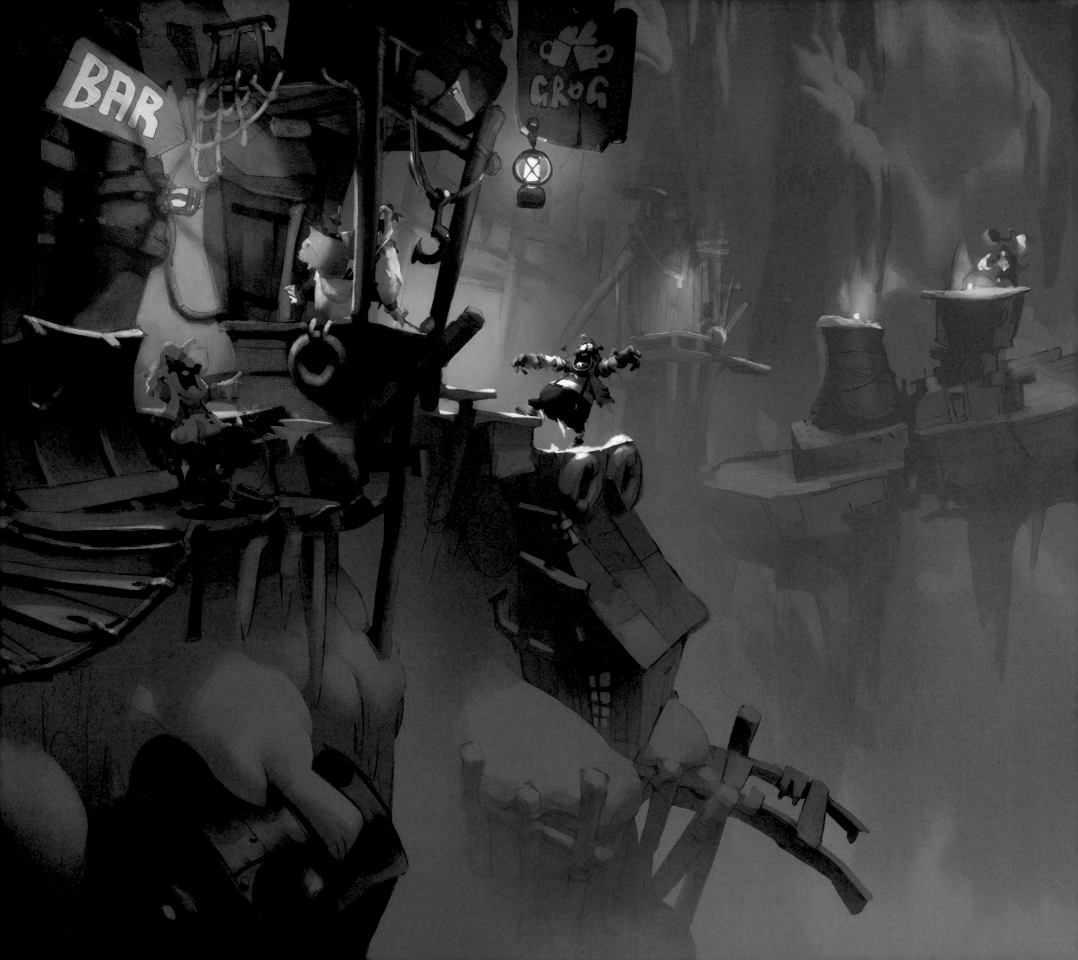

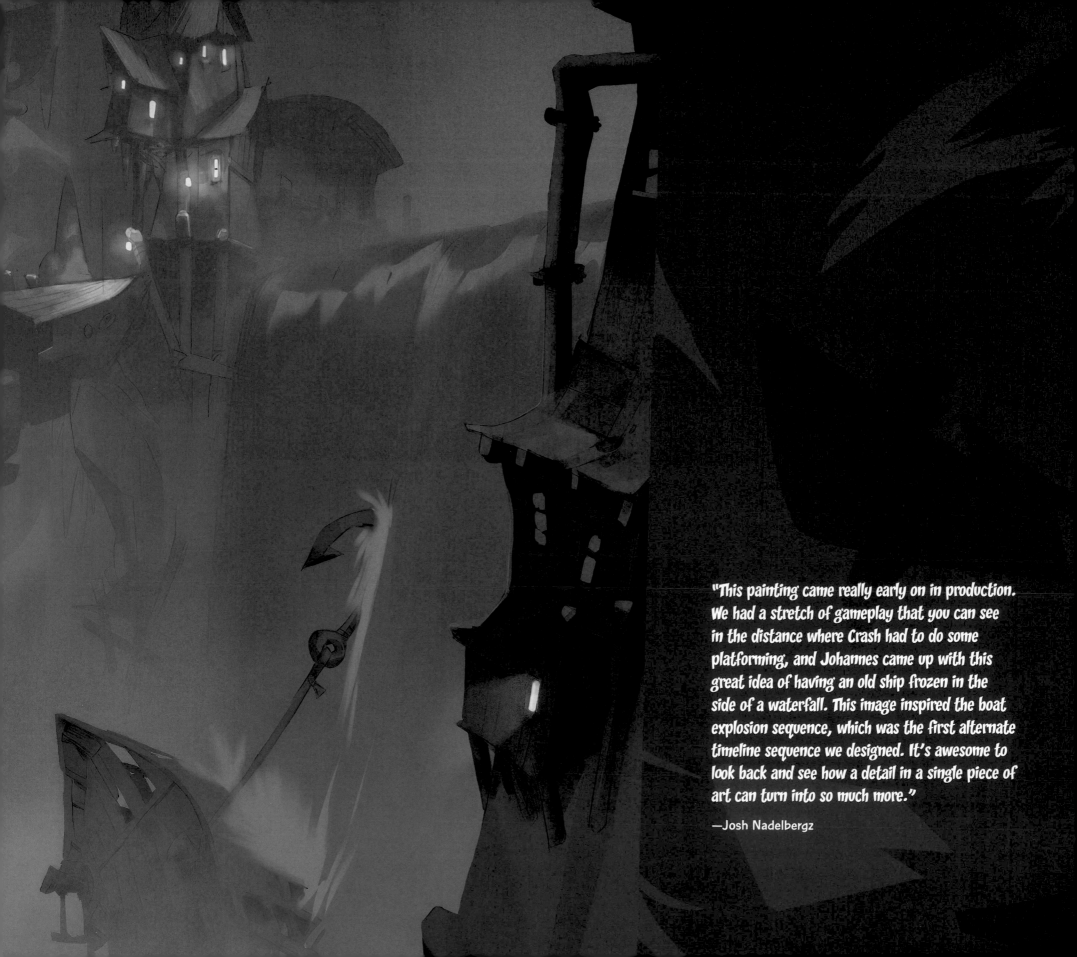

"This painting came really early on in production. We had a stretch of gameplay that you can see in the distance where Crash had to do some platforming, and Johannes came up with this great idea of having an old ship frozen in the side of a waterfall. This image inspired the boat explosion sequence, which was the first alternate timeline sequence we designed. It's awesome to look back and see how a detail in a single piece of art can turn into so much more."

—Josh Nadelbergz

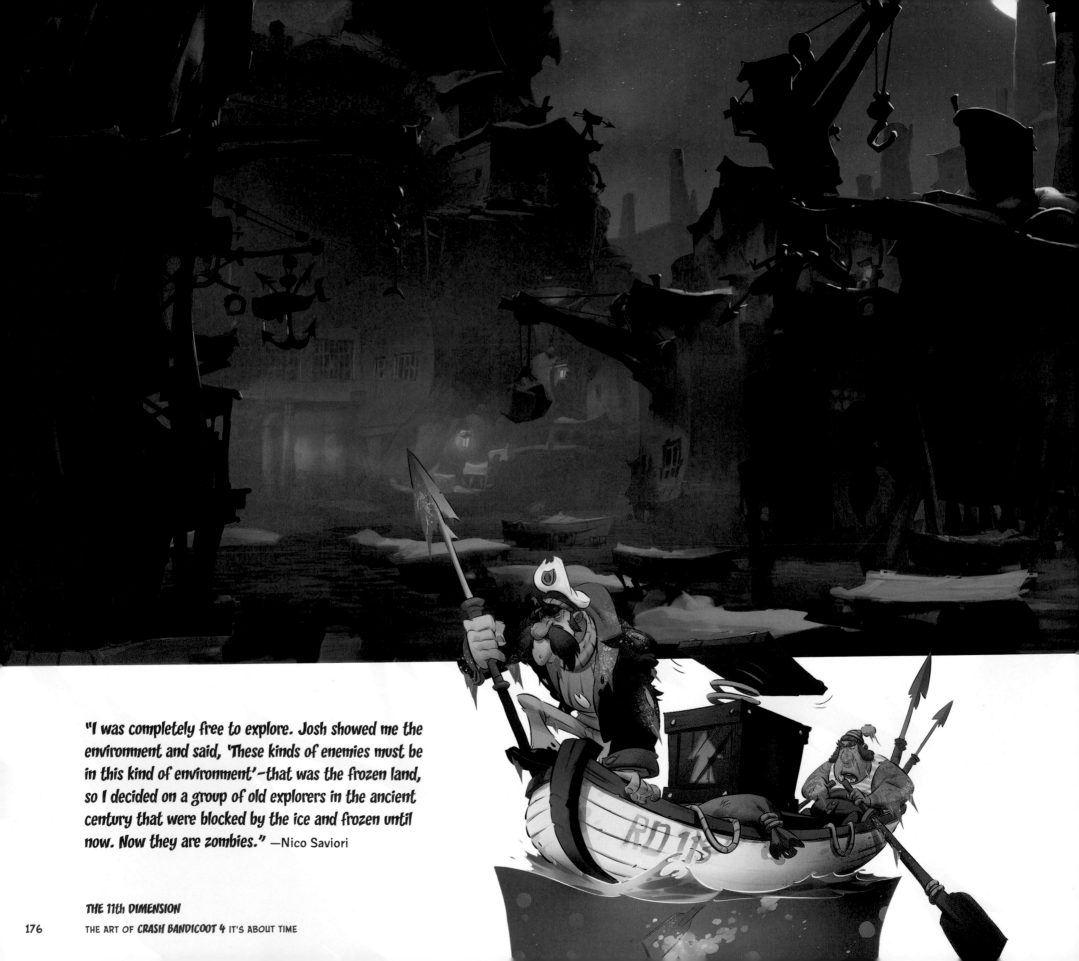

"I was completely free to explore. Josh showed me the environment and said, 'These kinds of enemies must be in this kind of environment'—that was the frozen land, so I decided on a group of old explorers in the ancient century that were blocked by the ice and frozen until now. Now they are zombies." —Nico Saviori

THE 11th DIMENSION

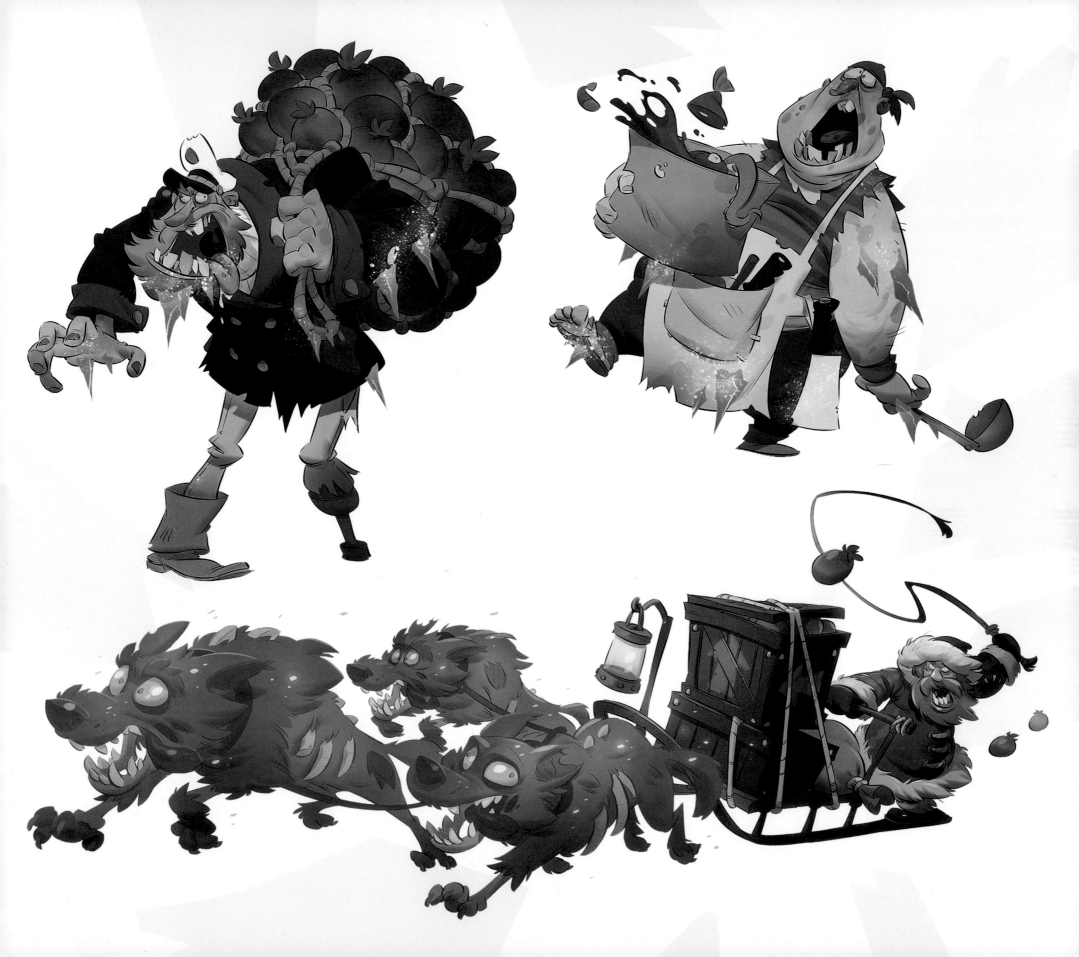

Stay Frosty

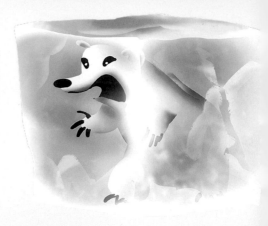

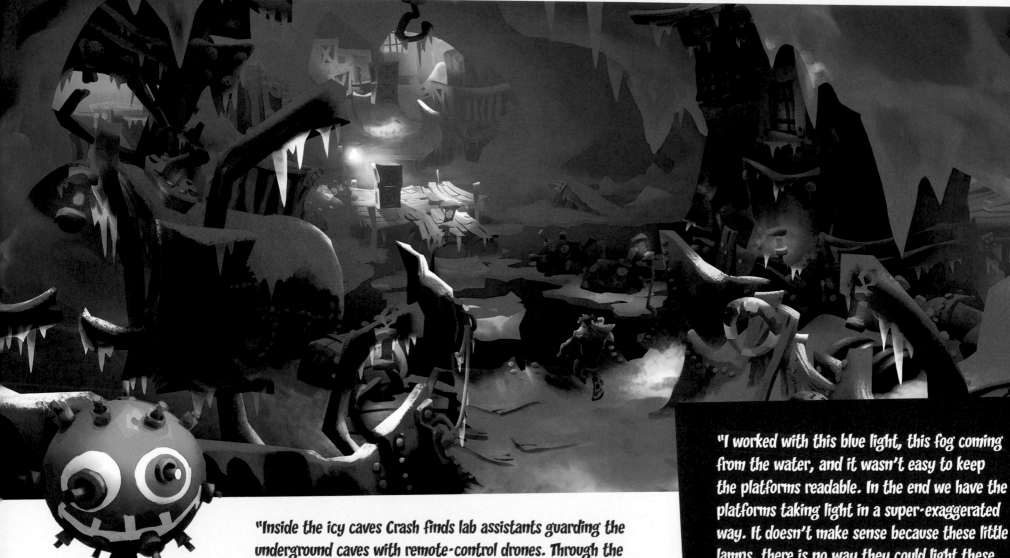

"Inside the icy caves Crash finds lab assistants guarding the underground caves with remote-control drones. Through the tunnels he finds glowing pipes of Nitro that lead him through the level and out the other side of the caves where we find Cortex's factory/lab in the distance." —Josh Nadelberg

"I worked with this blue light, this fog coming from the water, and it wasn't easy to keep the platforms readable. In the end we have the platforms taking light in a super-exaggerated way. It doesn't make sense because these little lamps, there is no way they could light these platforms like that, but we had to do that so the pathway is always clear for the players."

—JB Dugait

THE 11th DIMENSION

Sinister
Sea Dog

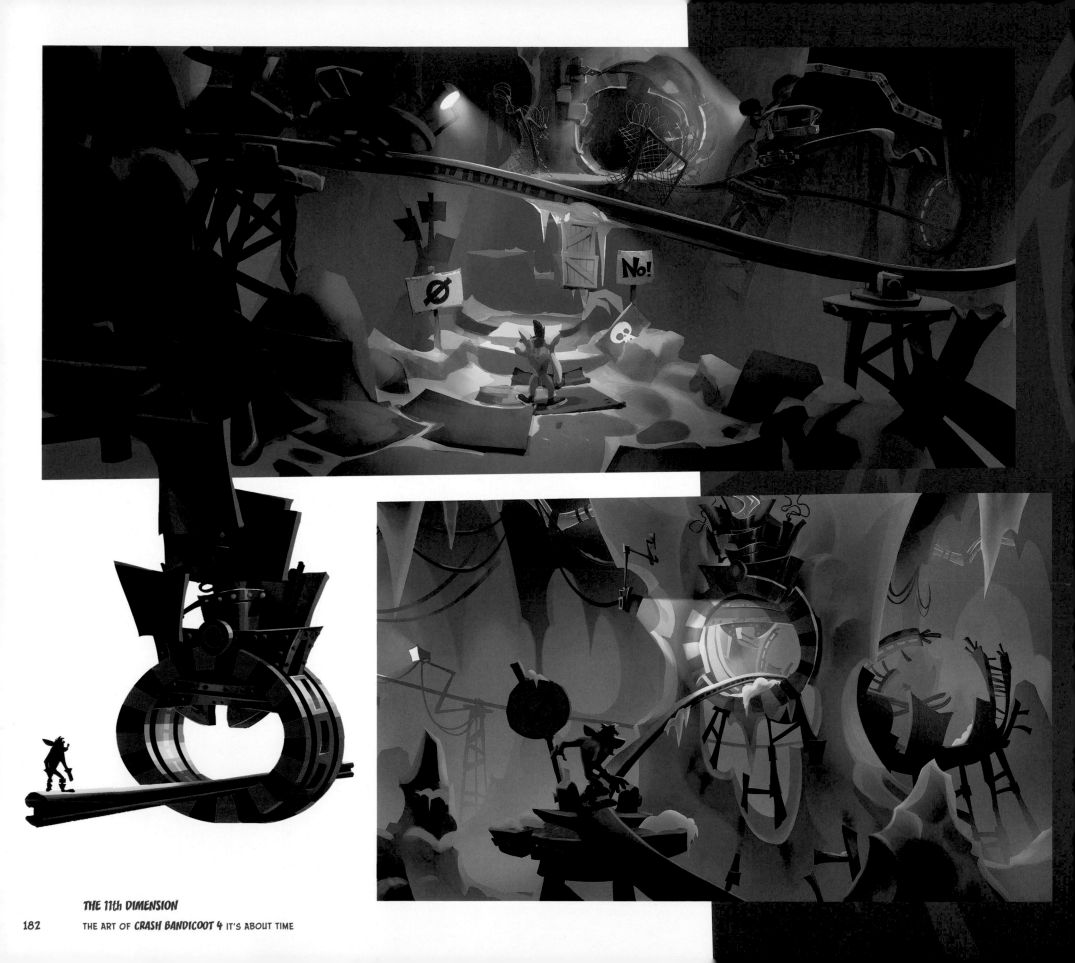

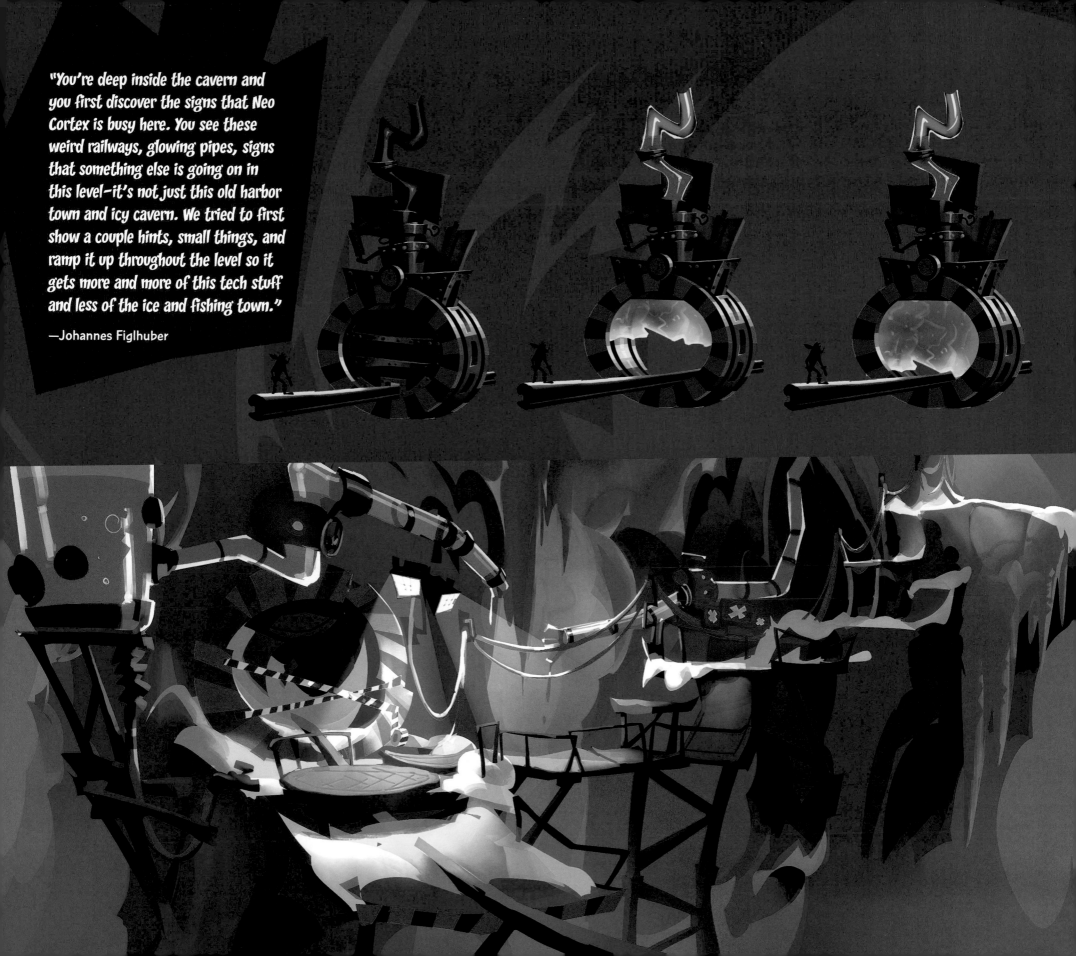

"You're deep inside the cavern and you first discover the signs that Neo Cortex is busy here. You see these weird railways, glowing pipes, signs that something else is going on in this level—it's not just this old harbor town and icy cavern. We tried to first show a couple hints, small things, and ramp it up throughout the level so it gets more and more of this tech stuff and less of the ice and fishing town."

—Johannes Figlhuber

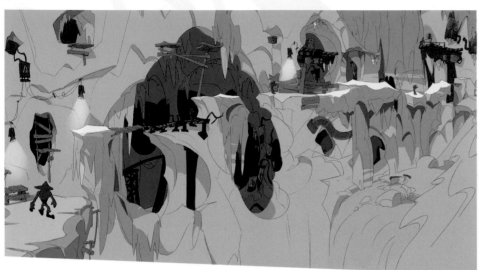
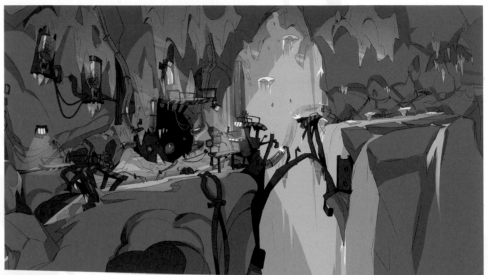
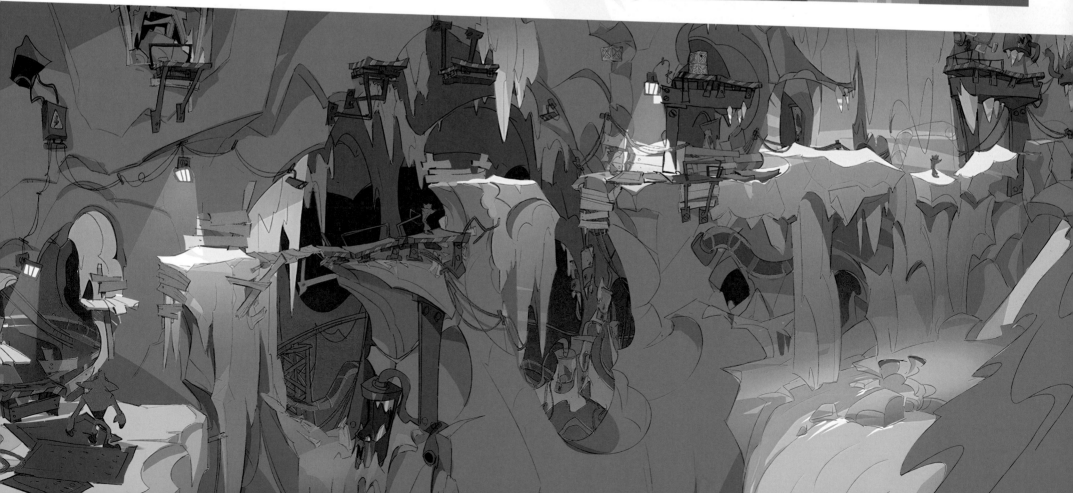

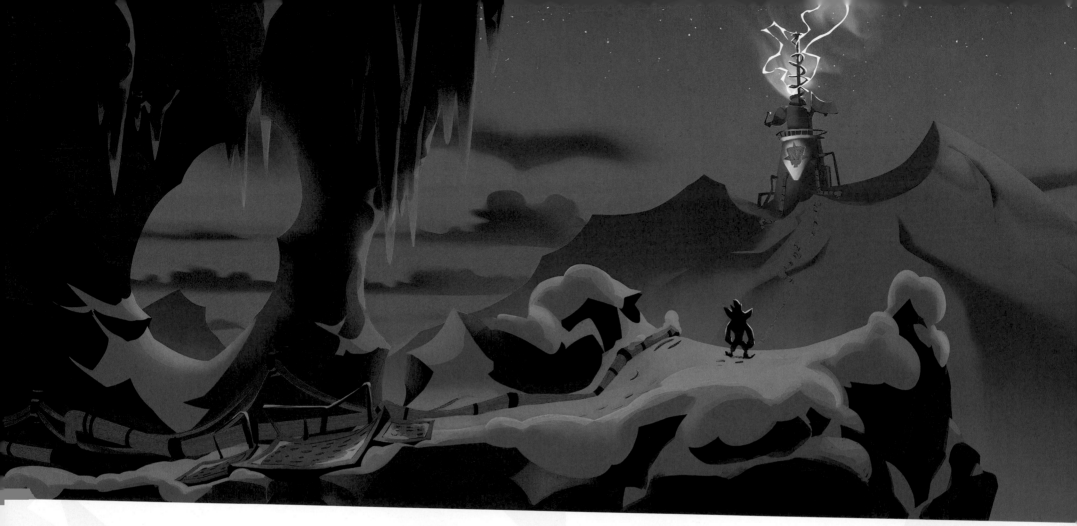

"We wanted to have a versatile enemy for the ice lab, so Nico designed this hovering drone that could have different attachments making him either ranged melee, or even something that could deliver crates. At some point as we were iterating on the design, someone came up with the idea that they were invincible and the only way to destroy them would be to take out a lab assistant with a remote control!"

—Josh Nadelberg

Electric Buzzer

Bears Repeating

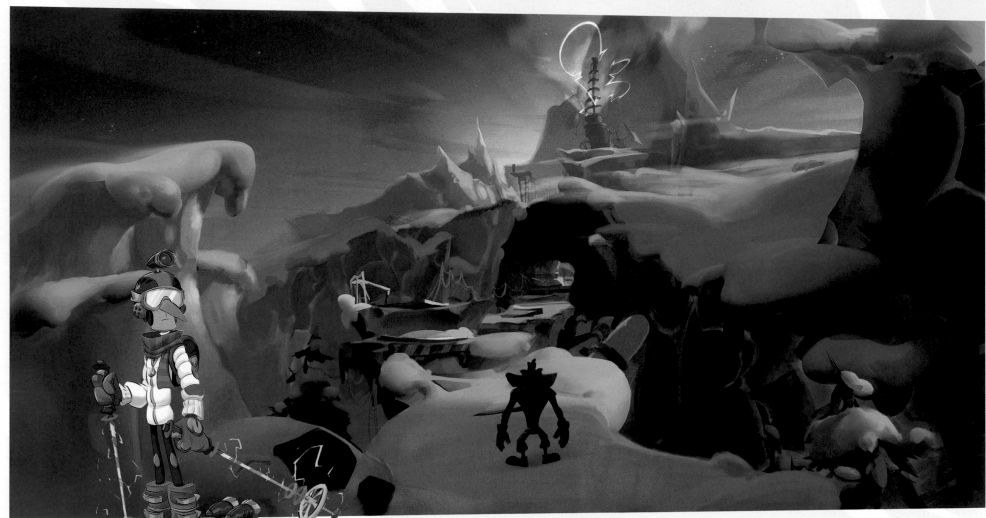

"Crash infiltrates Neo's Nitro plant. He uses the time-slow mask to survive as he runs across dangerous exploding Nitro crates that conveniently (huh???) are set up to cause a chain reaction that blows up the factory. Tawna's Timeline ends with her moving the crates into position right as Crash is about to run across them, setting them off… as the factory explodes, Neo Cortex jumps on skis and flees down the mountain to his awaiting blimp. Crash gives chase on Polar, his old friend…" —Josh Nadelberg

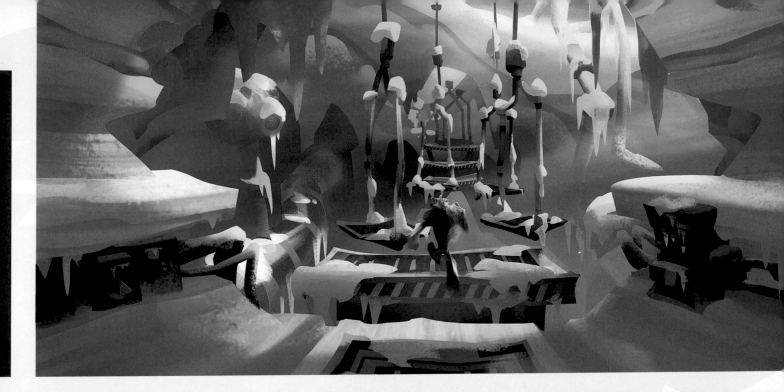

"It was a bit of a struggle to find a balance between lighting the direction the player should go and not getting too much attention stolen by the green pipes 'cause they are glowing and it attracts the eye. So I tried to use the pipes in a way that it's obvious that the player should go upwards."

—Brun Croes

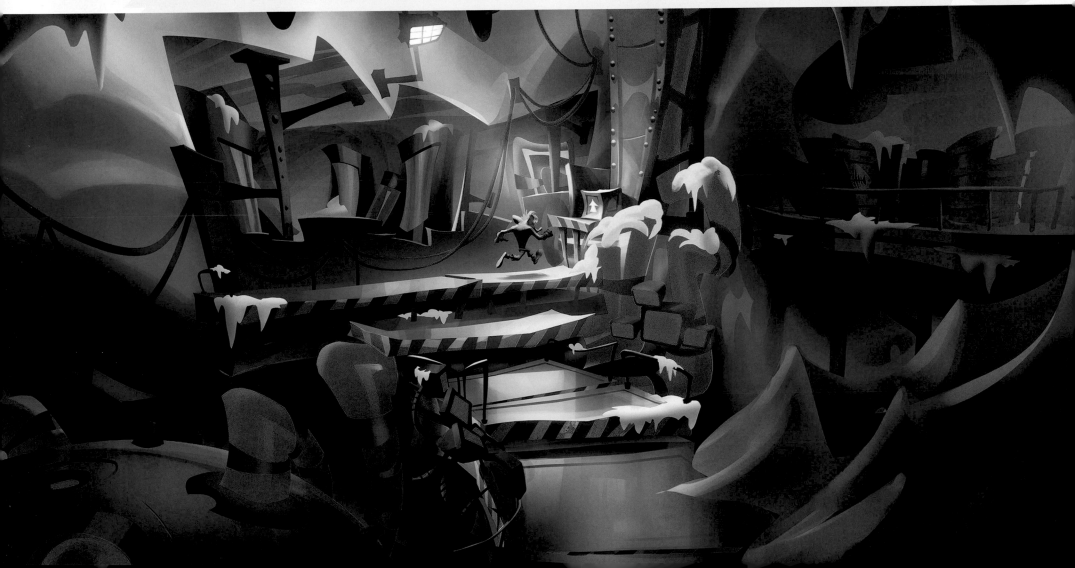

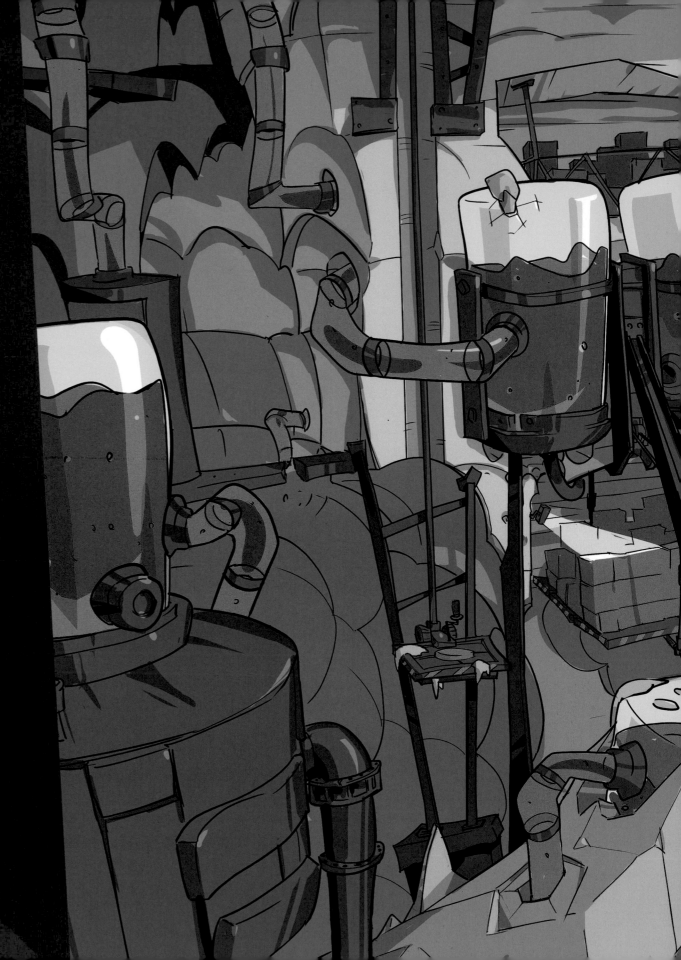

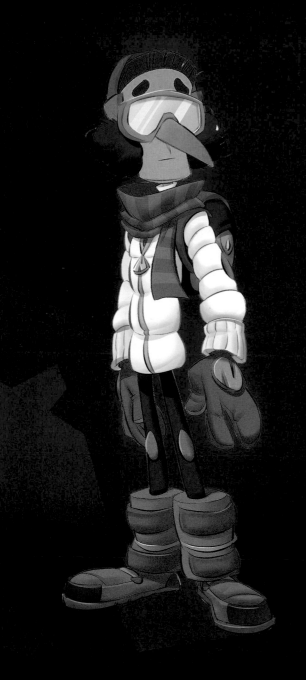

"This is what we thought would be the main storage area for the Nitro. It's just basically some sort of factory. We tried to bring in elements like those floodlights to give you the feeling you're under surveillance the whole time by Neo Cortex or his minions." —Max Degen

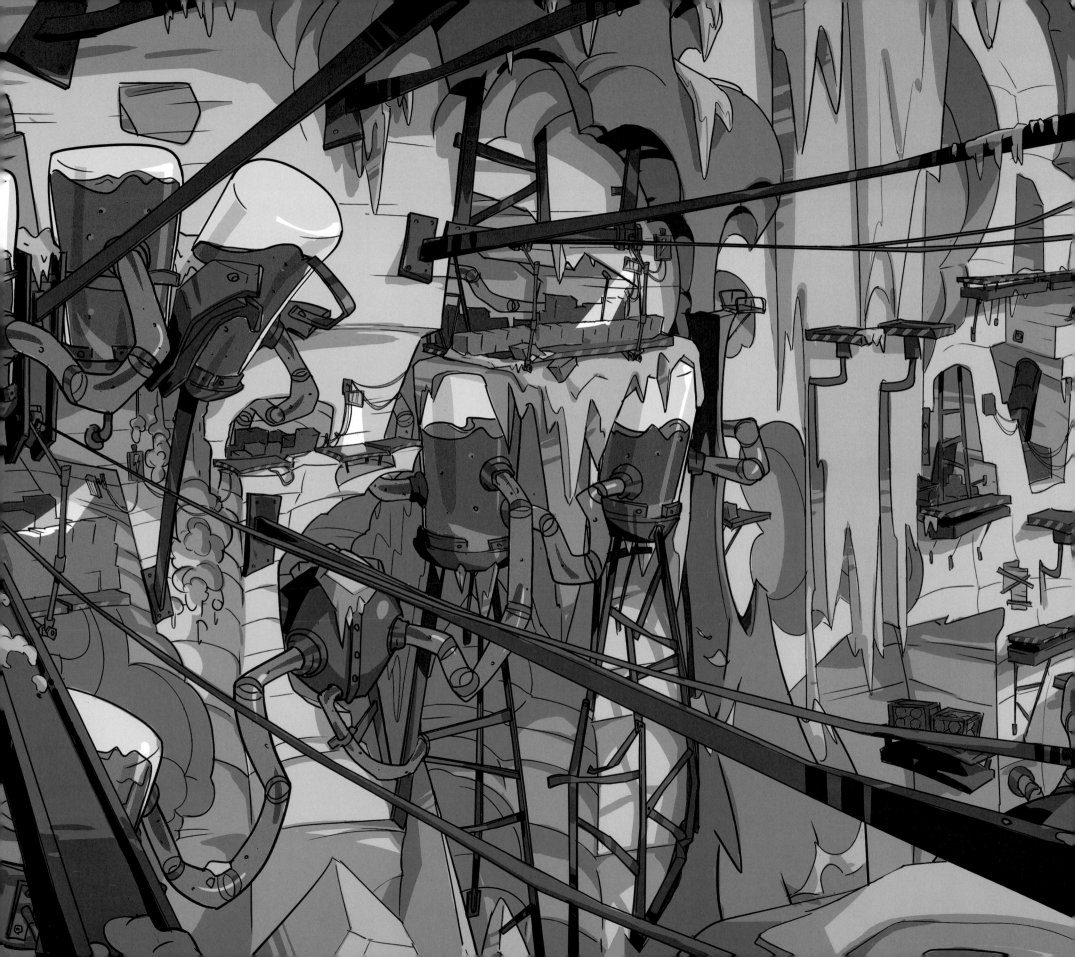

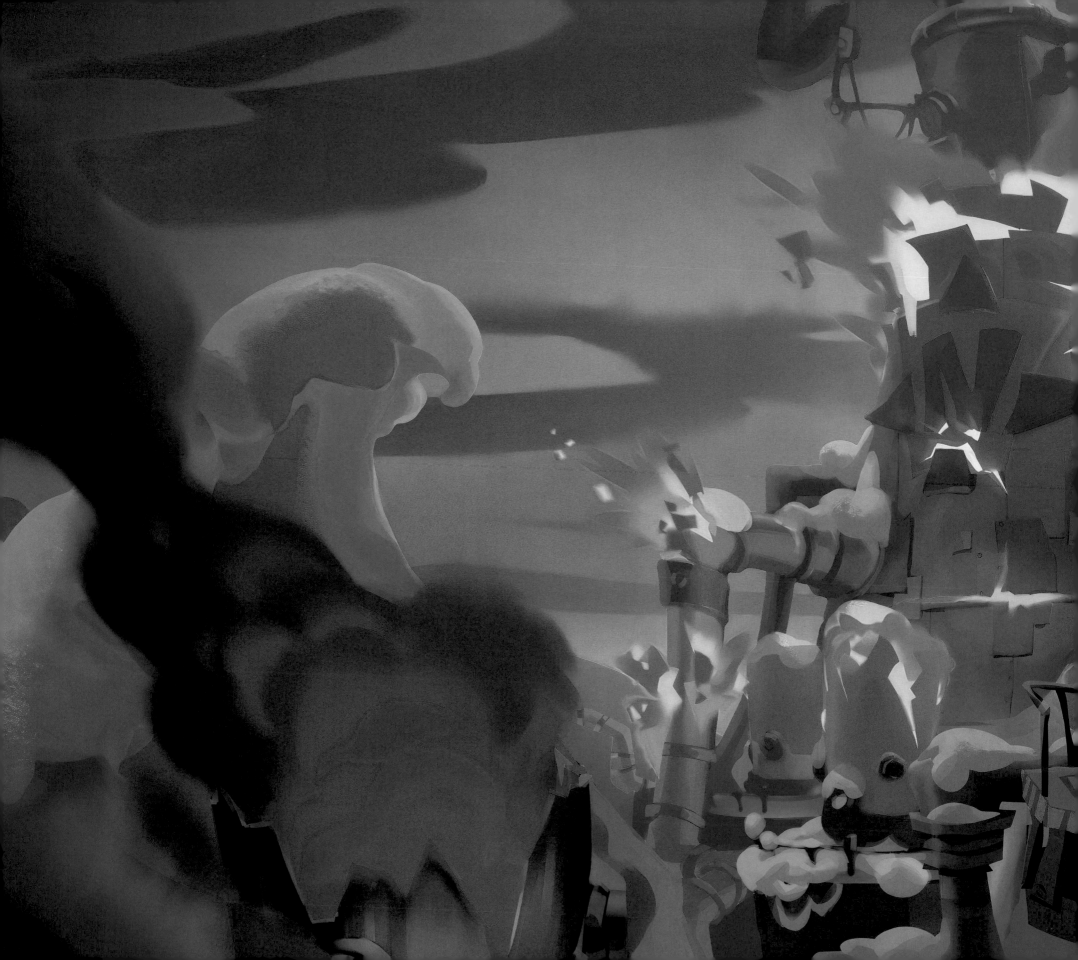

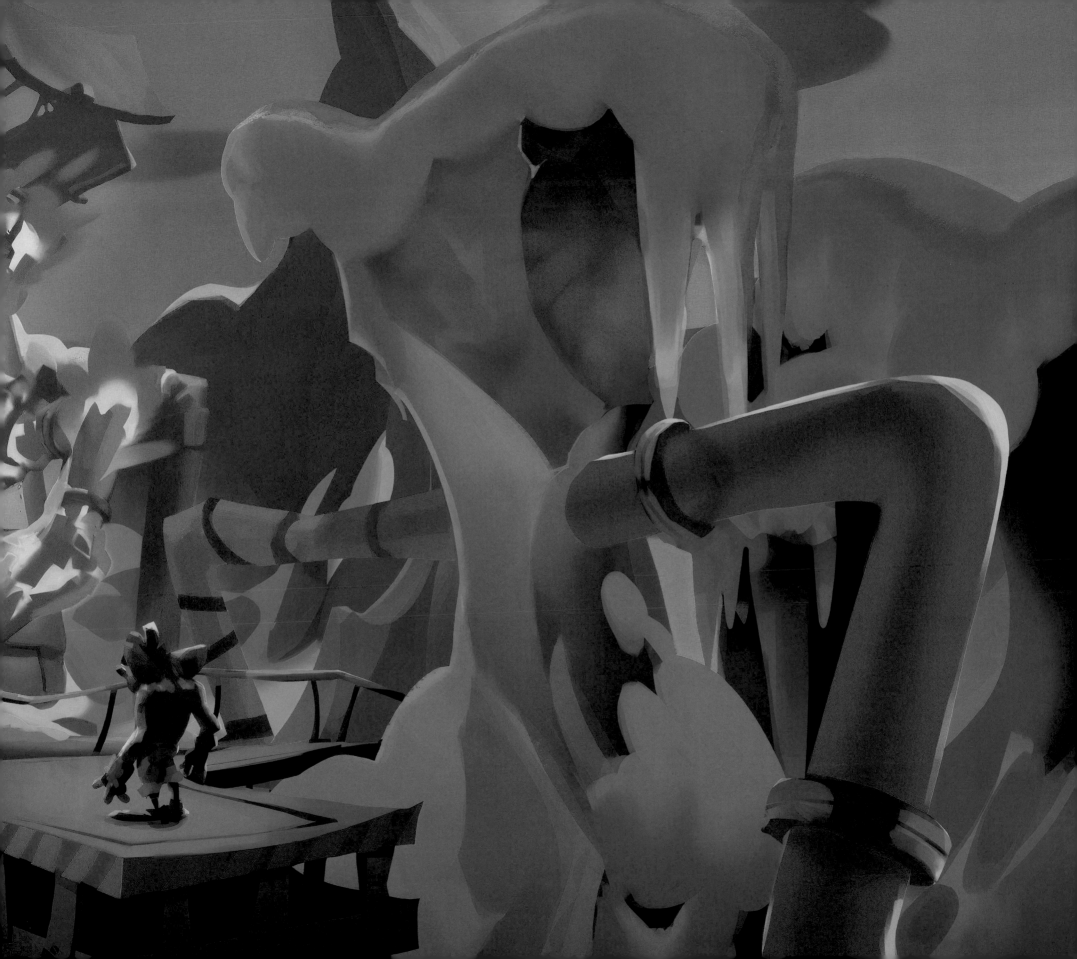

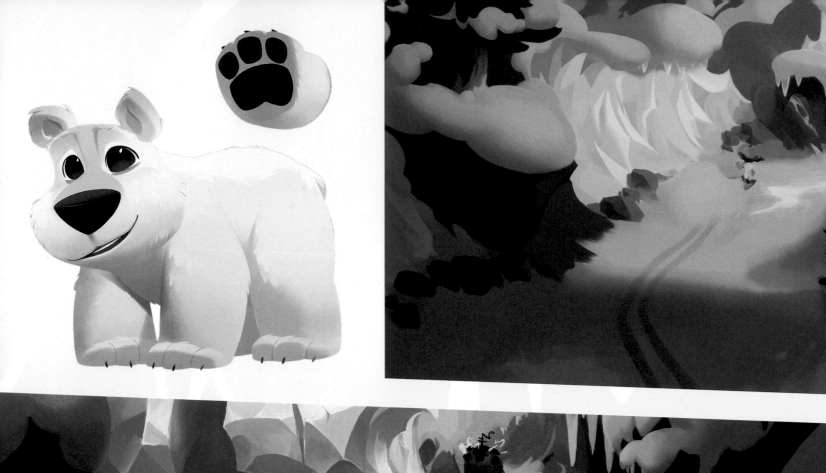
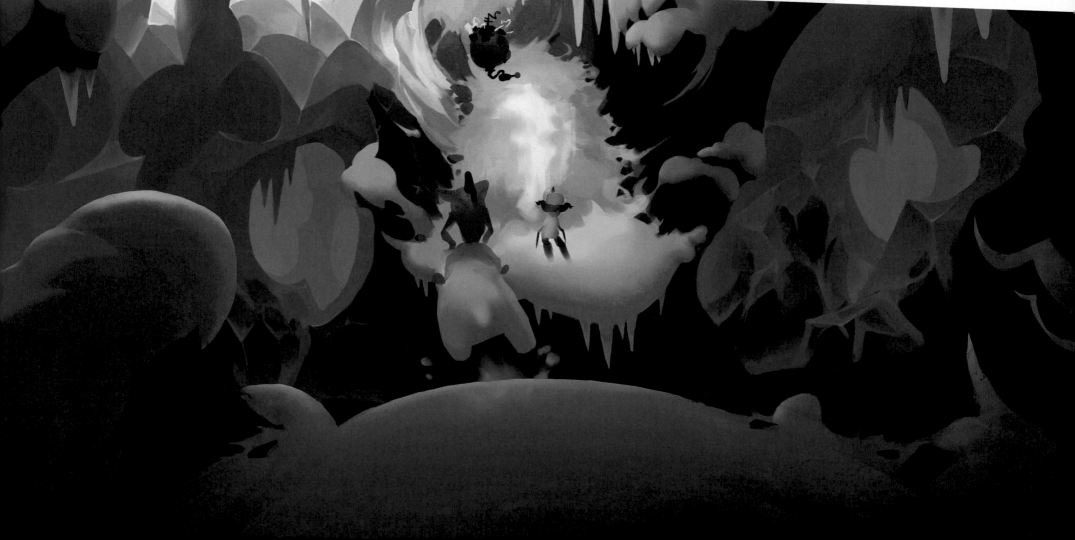

"It was pretty hard to make the beginning readable because the whole environment is white, and also the ice floe the player has to walk on is white. We decided that this level would be at sunrise and at the end of the level would also be this blimp that is going to fly away. It was pretty important and would be a nice scene at sunrise."

—Ilka Hesche

Fourth Time's a Charm

"Our heroes make their way to Cortex's blimp, hop aboard, and do what they do best: kick Cortex butt in a big boss battle involving punching one-wheeled robots, rocket launchers, and electric blasts on a constantly shifting playfield in the sky.

At the end of the battle, instead of running away swearing revenge like usual, Cortex just slumps, defeated. He's tired of the cycle, and his heart just isn't in it anymore. He spent decades planning this while imprisoned, and for what?

Just when Cortex thinks he can't sink any lower, the hologram head of N. Tropy appears. After rubbing some salt into Cortex's wounds, he hits him with a twist: he's been secretly scheming behind Cortex's back all along. The Rift Generator is capable of so much more than he was letting on—and now the time is right. He's going to reset the Timeline in every dimension so he can rule over all of creation from the start, effectively becoming a god. See you never, Neo Bore-tex.

Cortex is incensed. To lose to his hated foe is bad enough. To be betrayed by his at-best-tolerated ex-prison mate all the more... but to be wiped from existence by him?! Cortex won't stand for it. It appears Cortex and Crash have a common enemy... which makes them... friends?!

Coco is skeptical, but Crash welcomes him with open arms. Cortex has joined the party. And off they go to find the final mask..."

—Mandy Benanav

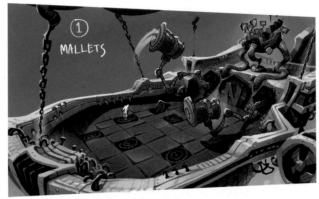
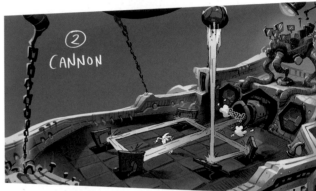
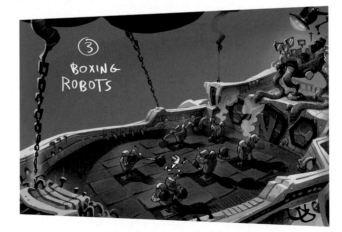
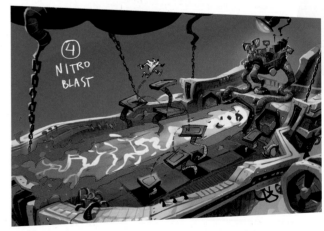
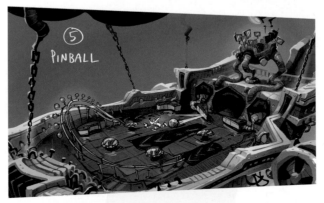
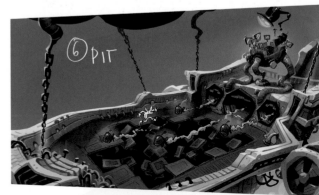

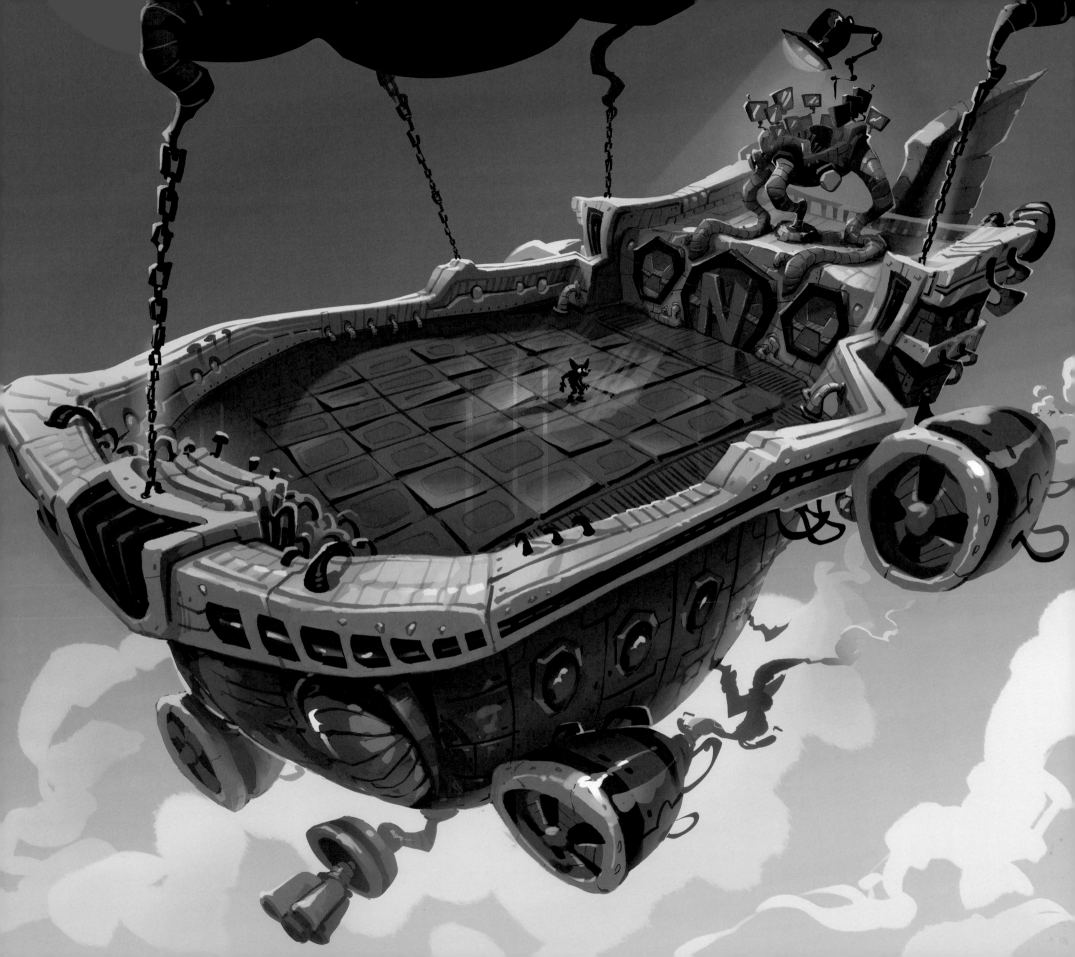

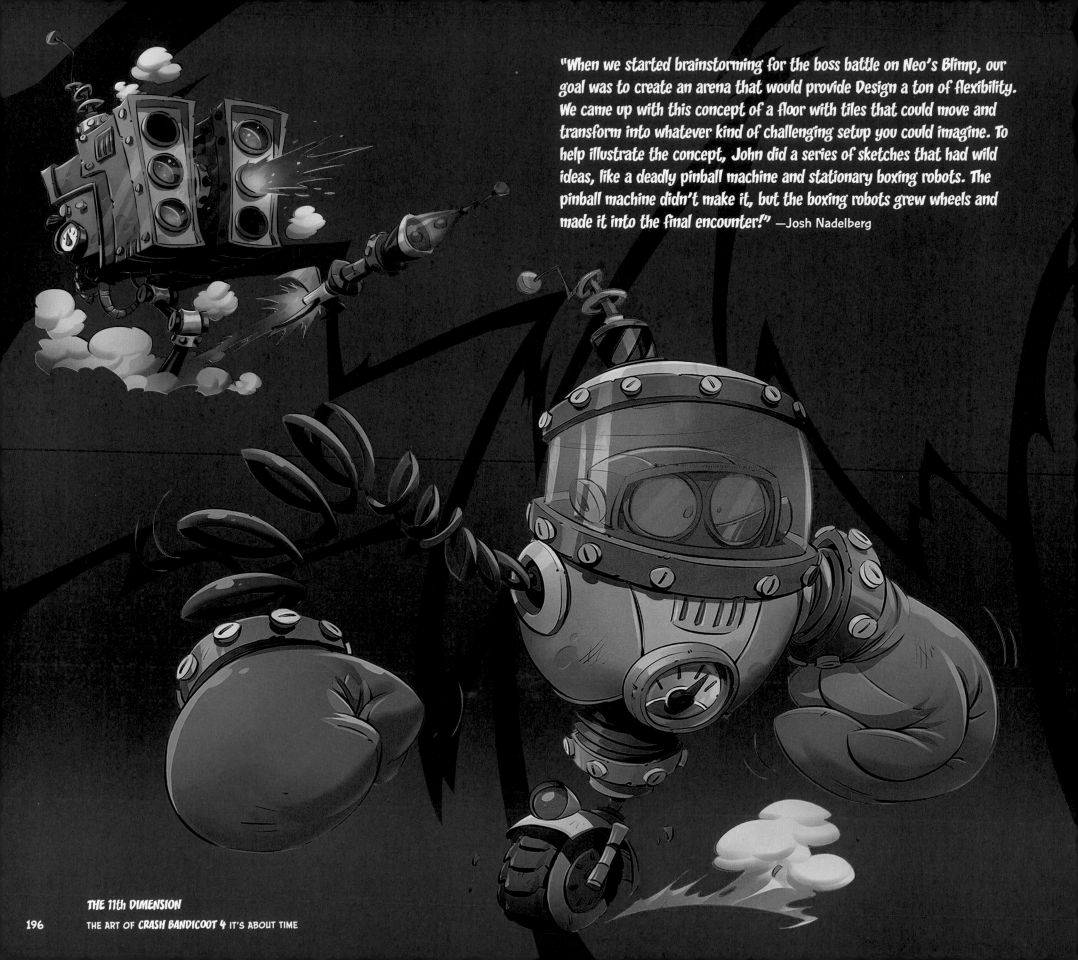

"When we started brainstorming for the boss battle on Neo's Blimp, our goal was to create an arena that would provide Design a ton of flexibility. We came up with this concept of a floor with tiles that could move and transform into whatever kind of challenging setup you could imagine. To help illustrate the concept, John did a series of sketches that had wild ideas, like a deadly pinball machine and stationary boxing robots. The pinball machine didn't make it, but the boxing robots grew wheels and made it into the final encounter!" —Josh Nadelberg

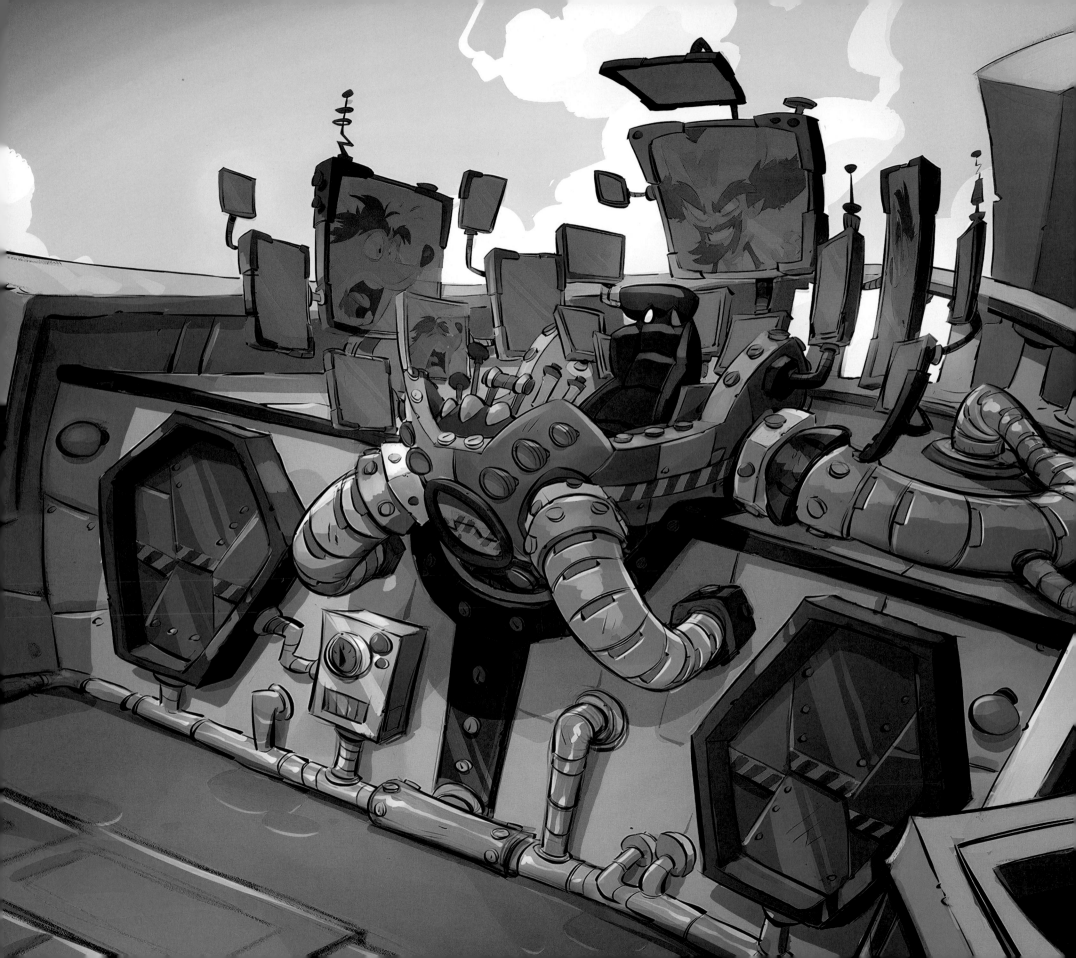

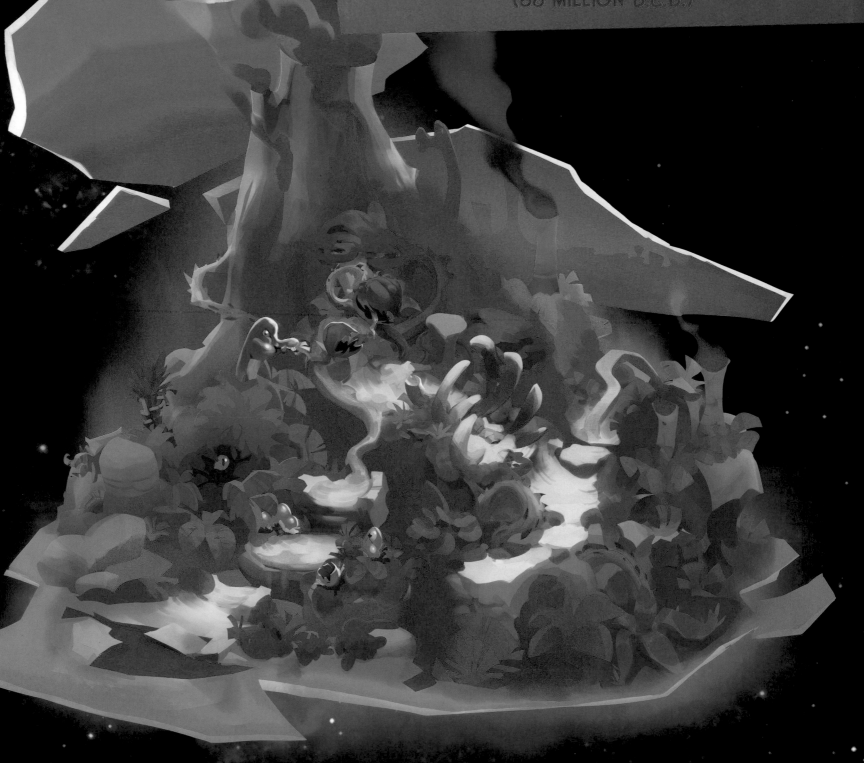

EGGIPUS DIMENSION
(88 MILLION B.C.B.)

Blast to the Past

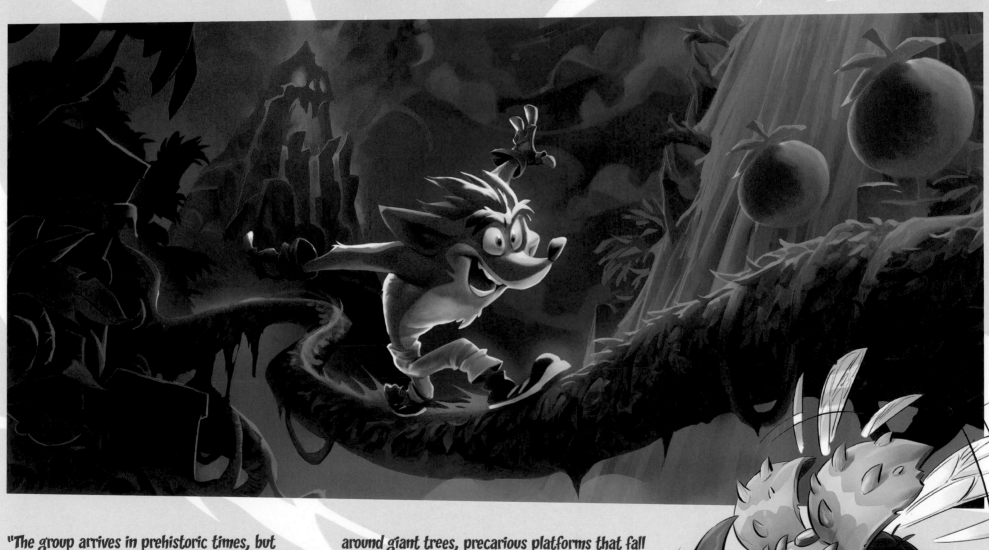

"The group arrives in prehistoric times, but Cortex doesn't stick the landing from the rift and winds up separated from the group.

In the first level Crash makes his way through a prehistoric valley with wild rail grinds wrapping around giant trees, precarious platforms that fall into hot lava, and thwacking vines that whip their thorny tongues in all directions... all of these prehistoric levels really nail the scope of this big new Crash game." —Mandy Benanav

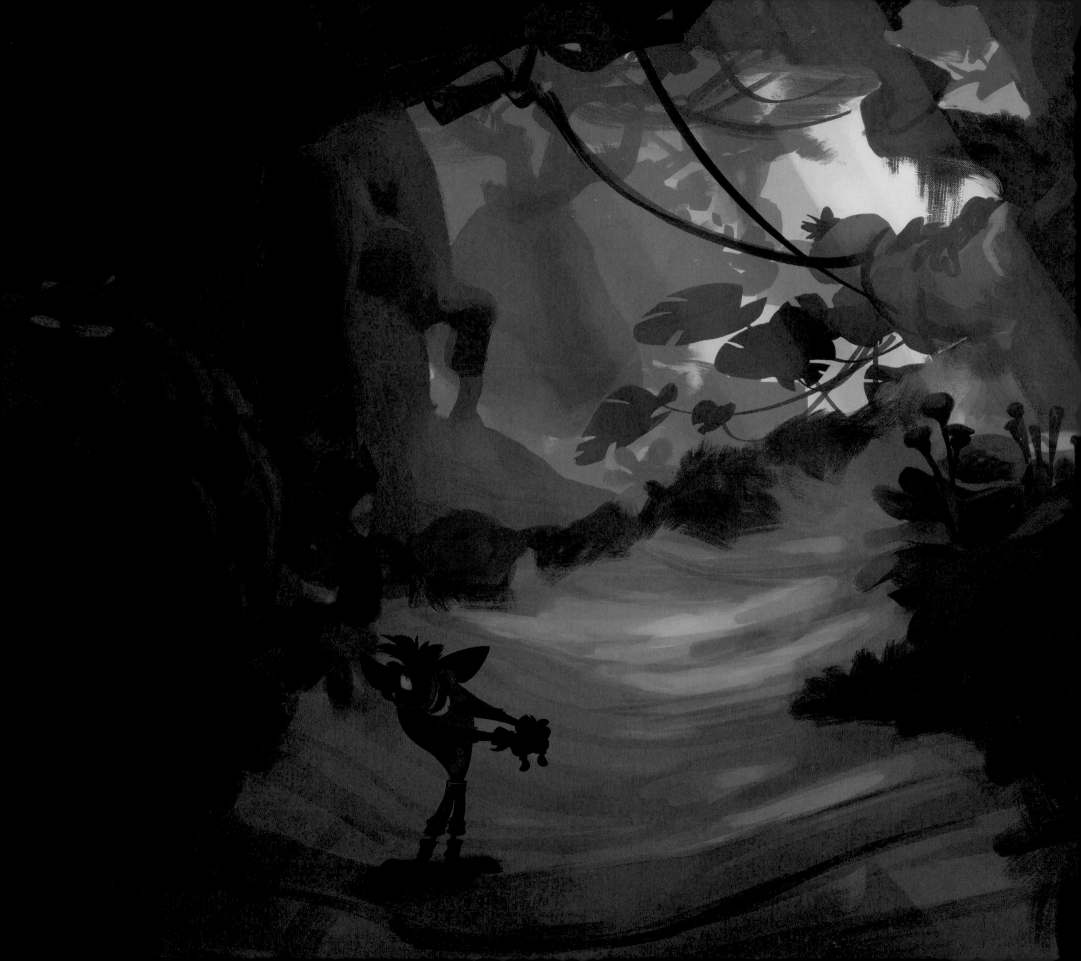

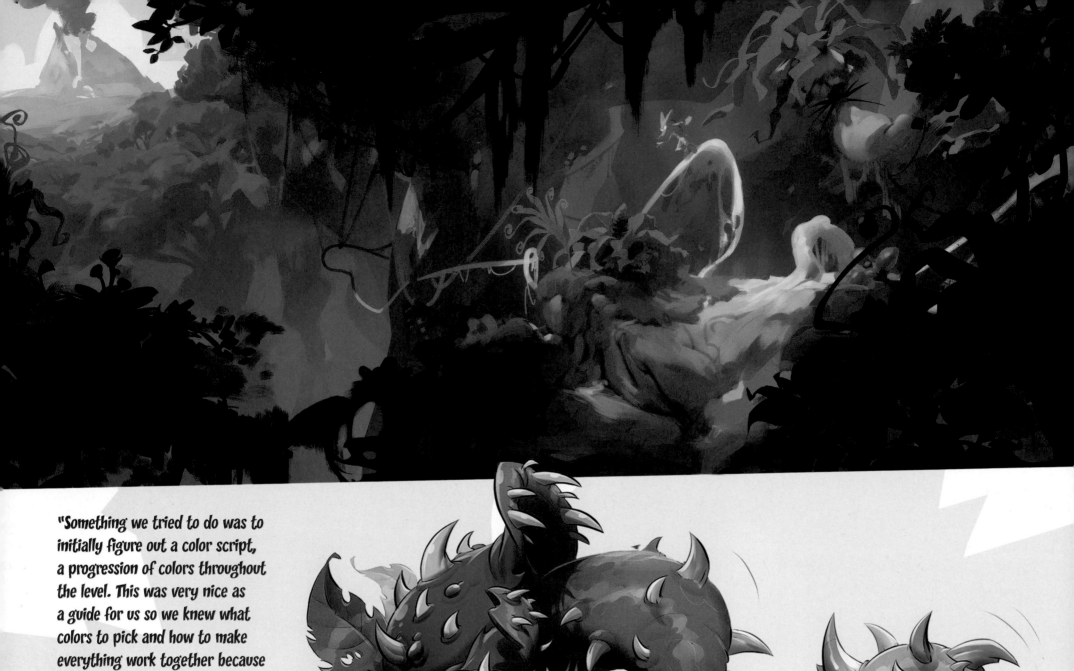

"Something we tried to do was to initially figure out a color script, a progression of colors throughout the level. This was very nice as a guide for us so we knew what colors to pick and how to make everything work together because usually there were three to five artists working on one map, and it's tricky to make everything cohesive."

—Johannes Figlhuber

Vicious Viner

EGGIPUS DIMENSION

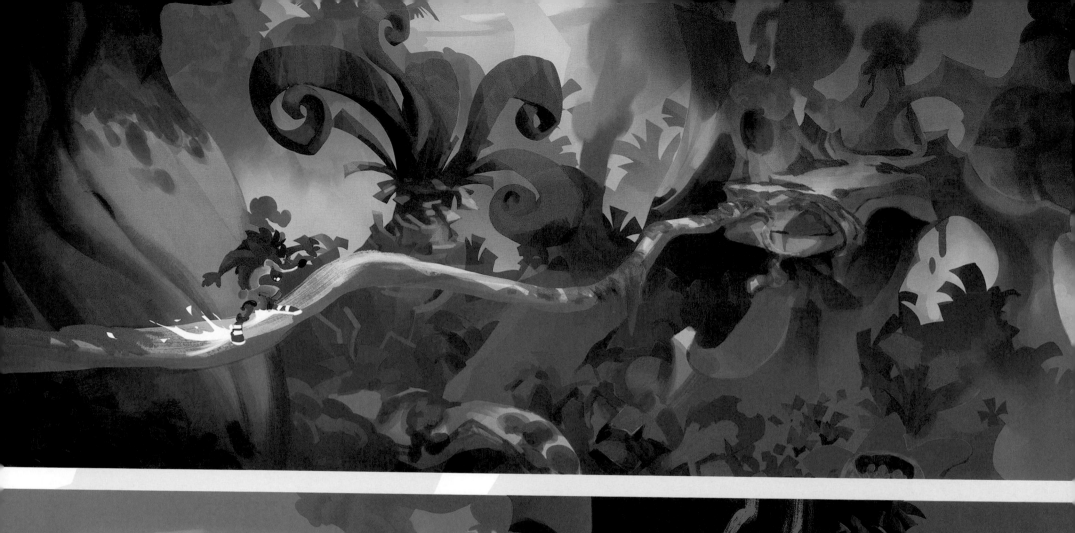
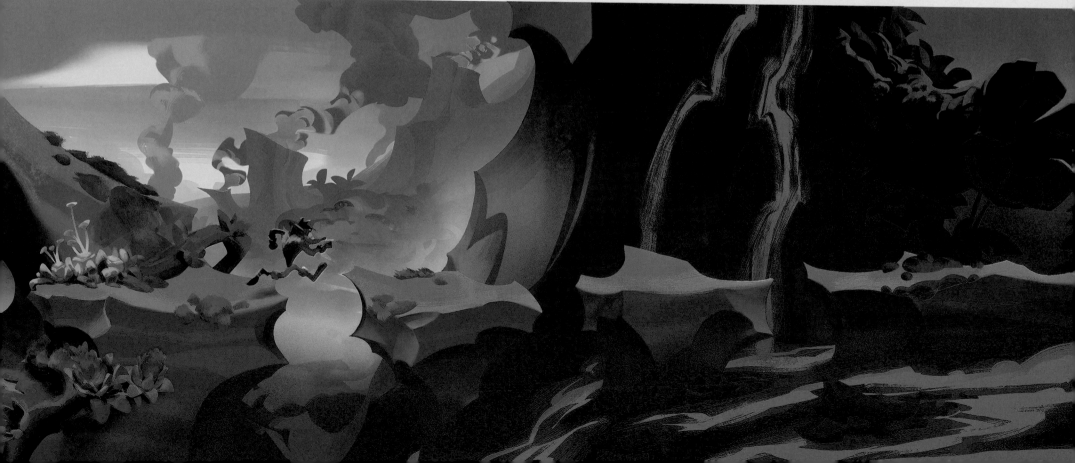

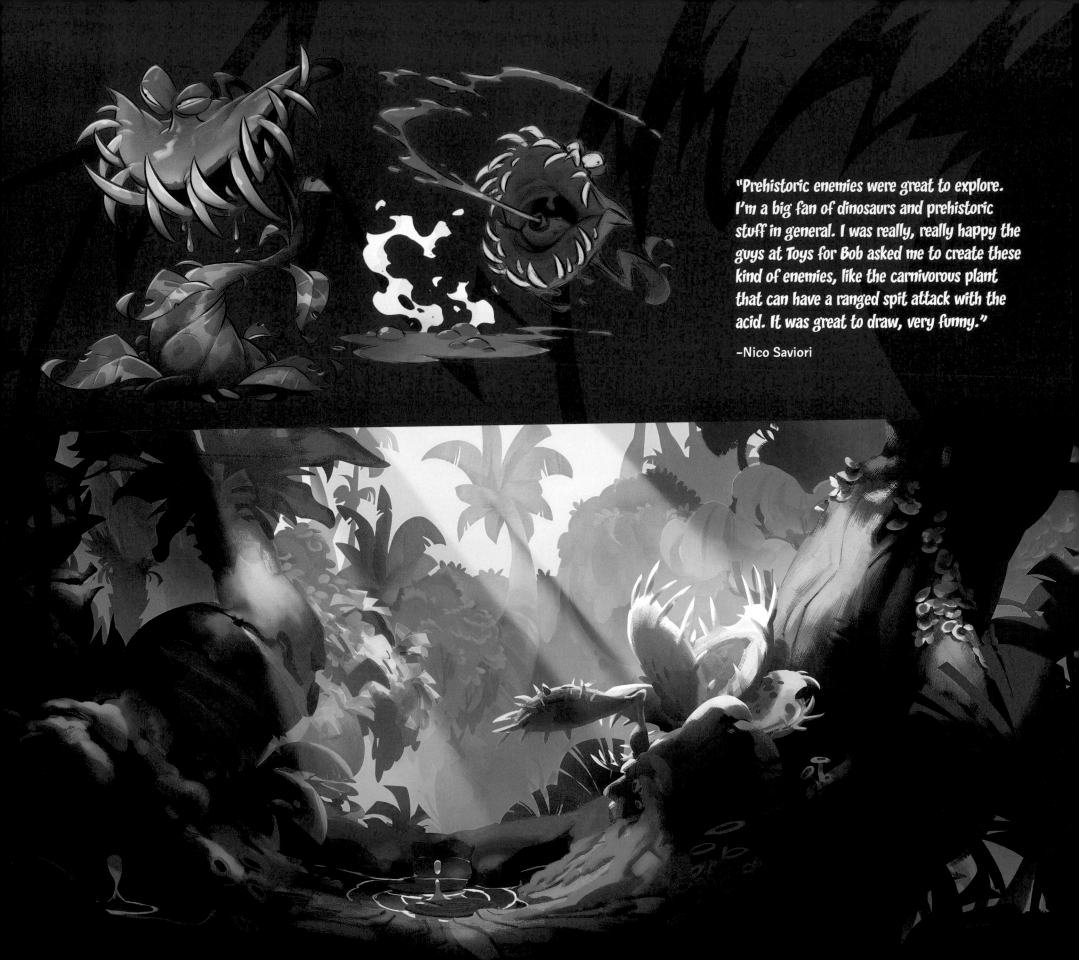

"Prehistoric enemies were great to explore. I'm a big fan of dinosaurs and prehistoric stuff in general. I was really, really happy the guys at Toys for Bob asked me to create these kind of enemies, like the carnivorous plant that can have a ranged spit attack with the acid. It was great to draw, very funny."

–Nico Saviori

Fossil Fueled

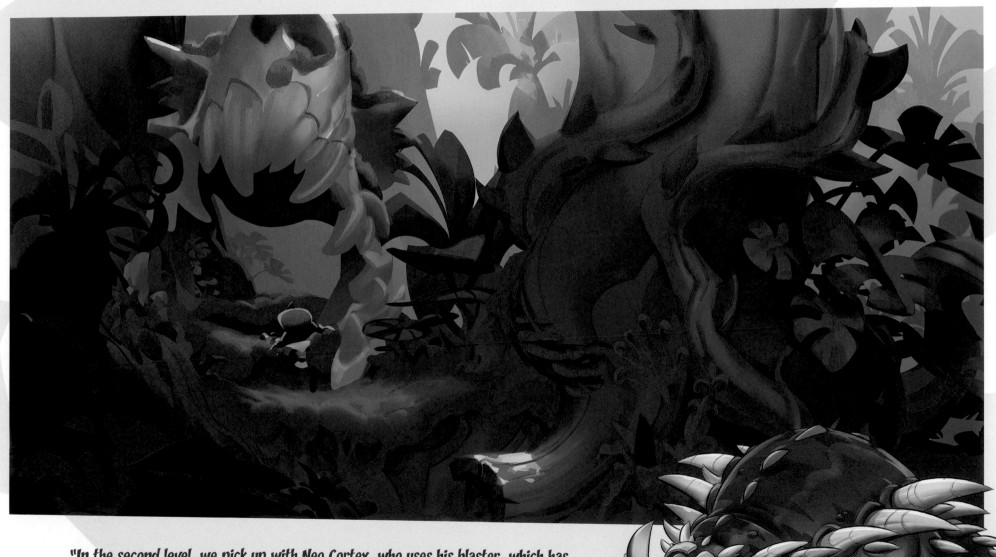

"In the second level, we pick up with Neo Cortex, who uses his blaster, which has the ability to turn organic matter into bouncy jelly pads and story platforms, as he tries to find the mask himself. He makes his way through the skeletons of giant dinosaurs, up cliffs full of fossils and bones, and across deadly lava fields before finding himself in a magical glowing prehistoric jungle." –Josh Nadelberg

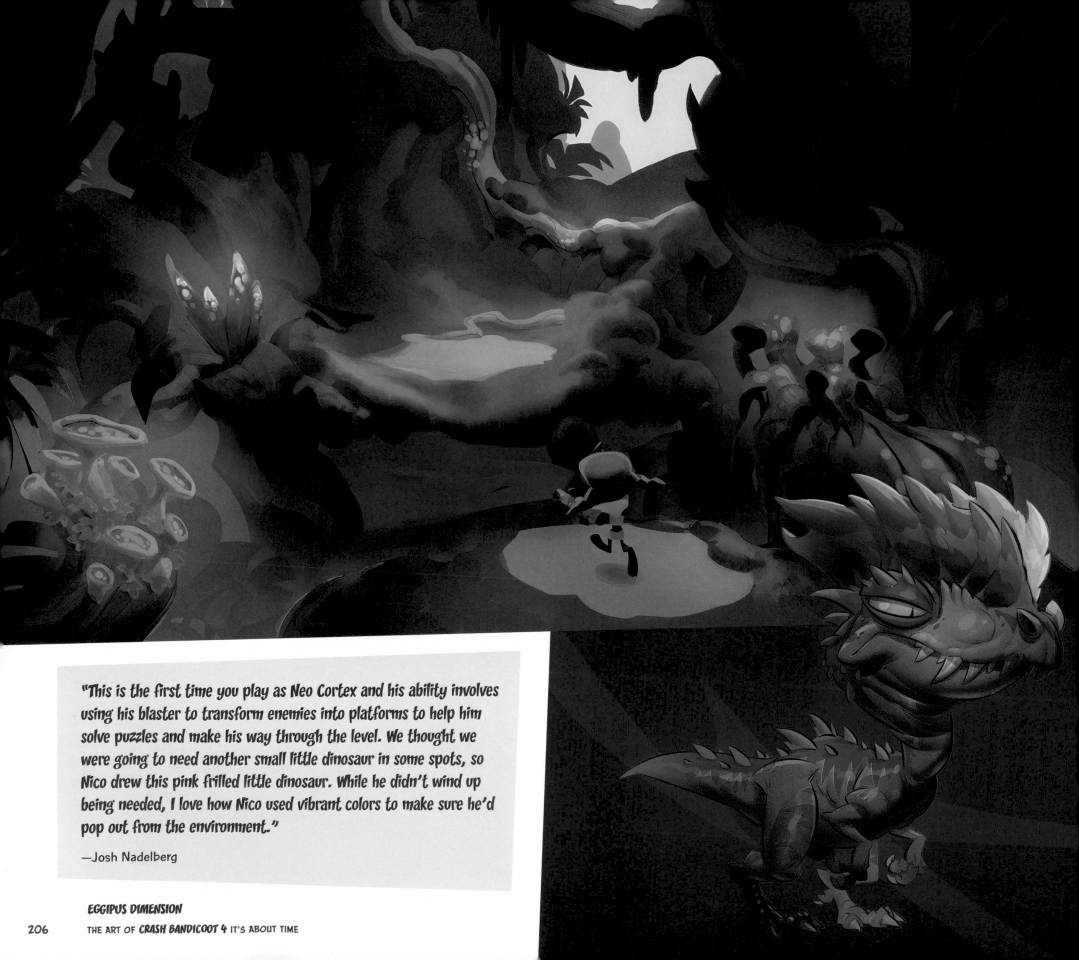

"This is the first time you play as Neo Cortex and his ability involves using his blaster to transform enemies into platforms to help him solve puzzles and make his way through the level. We thought we were going to need another small little dinosaur in some spots, so Nico drew this pink frilled little dinosaur. While he didn't wind up being needed, I love how Nico used vibrant colors to make sure he'd pop out from the environment."

—Josh Nadelberg

EGGIPUS DIMENSION

"Close-up paintings can help to tell the 3D artists 'this is the vibe or the feeling that we want to achieve,' or 'this is the atmosphere,' or 'this is how the lighting should be.'"

—Brun Croes

EGGIPUS DIMENSION

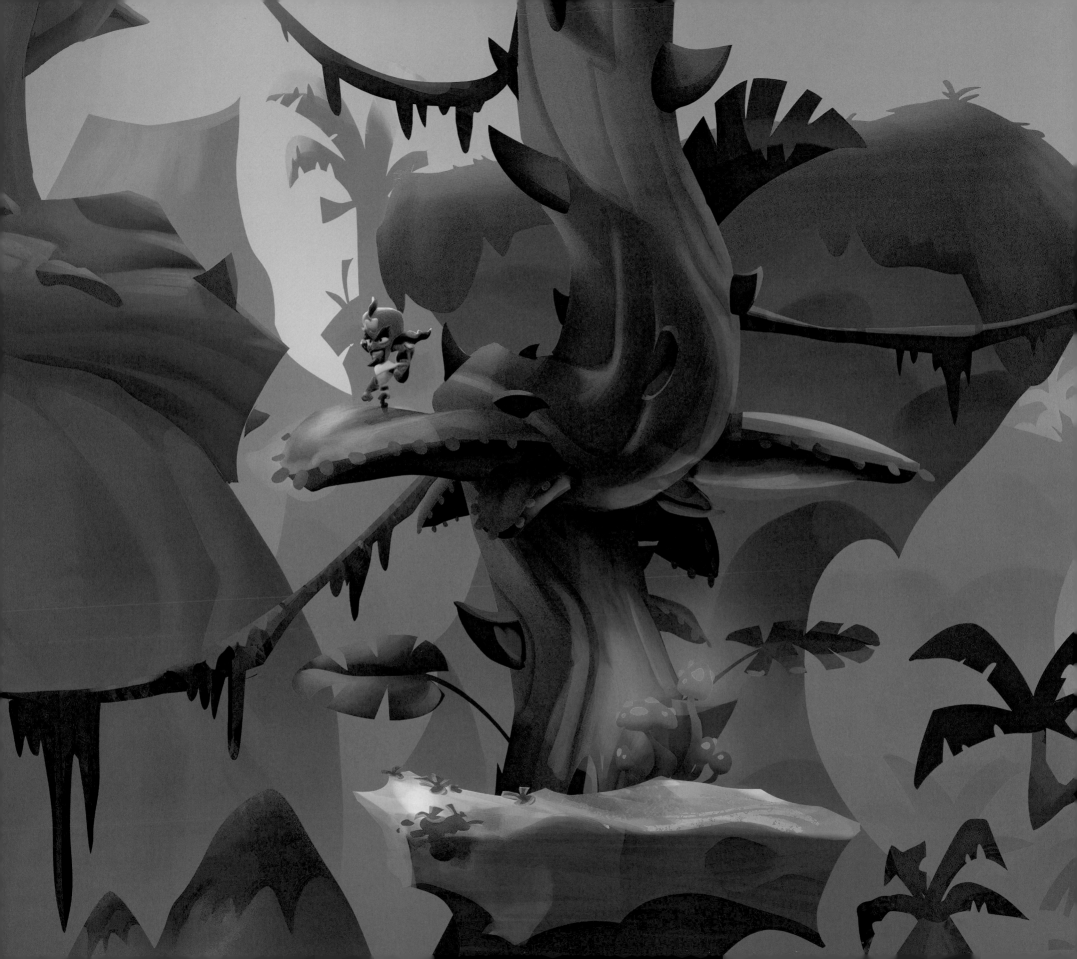

Dino Dash

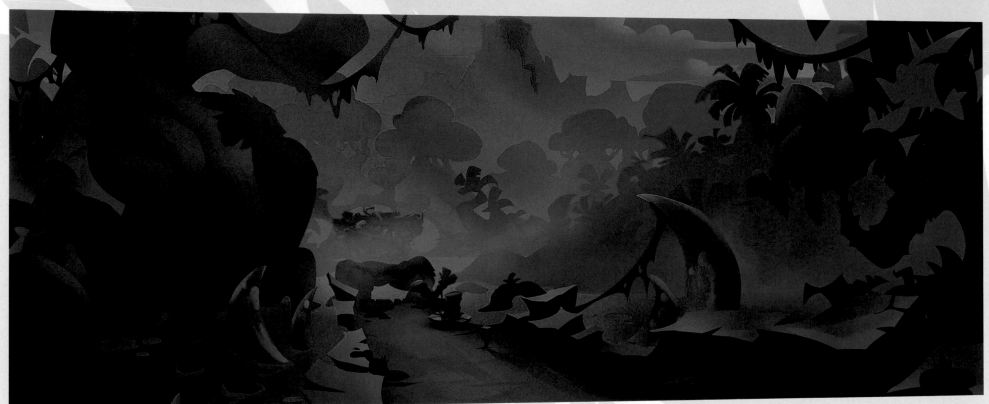

"As the sun sets, Crash is getting closer to the mask but winds up drawing the eye of a giant T-Rex who gives chase in the last of the three big chase scenes. Just before Crash is about to get chomped a stone archway crumbles on the head of the T-Rex, allowing Crash a breather (huh???). Turns out this was Dingo's doing once again on his Timeline as he sets the arch tumbling while he's attempting to make his way to a rift of his own. The T-Rex chase finally comes to a climax when Crash makes his way over crumbling platforms, and the T-Rex falls to his doom in the lava. Neo Cortex comes running in through the jungle to meet them just in time to find the final mask: Ika-Ika (Gravity).

With all four masks together, there's only one thing left to do: track down N. Tropy, destroy his machine, and seal the rifts. Easy, right? Off they go through a final rift that takes them to…"

—Mandy Benanav

EGGIPUS DIMENSION

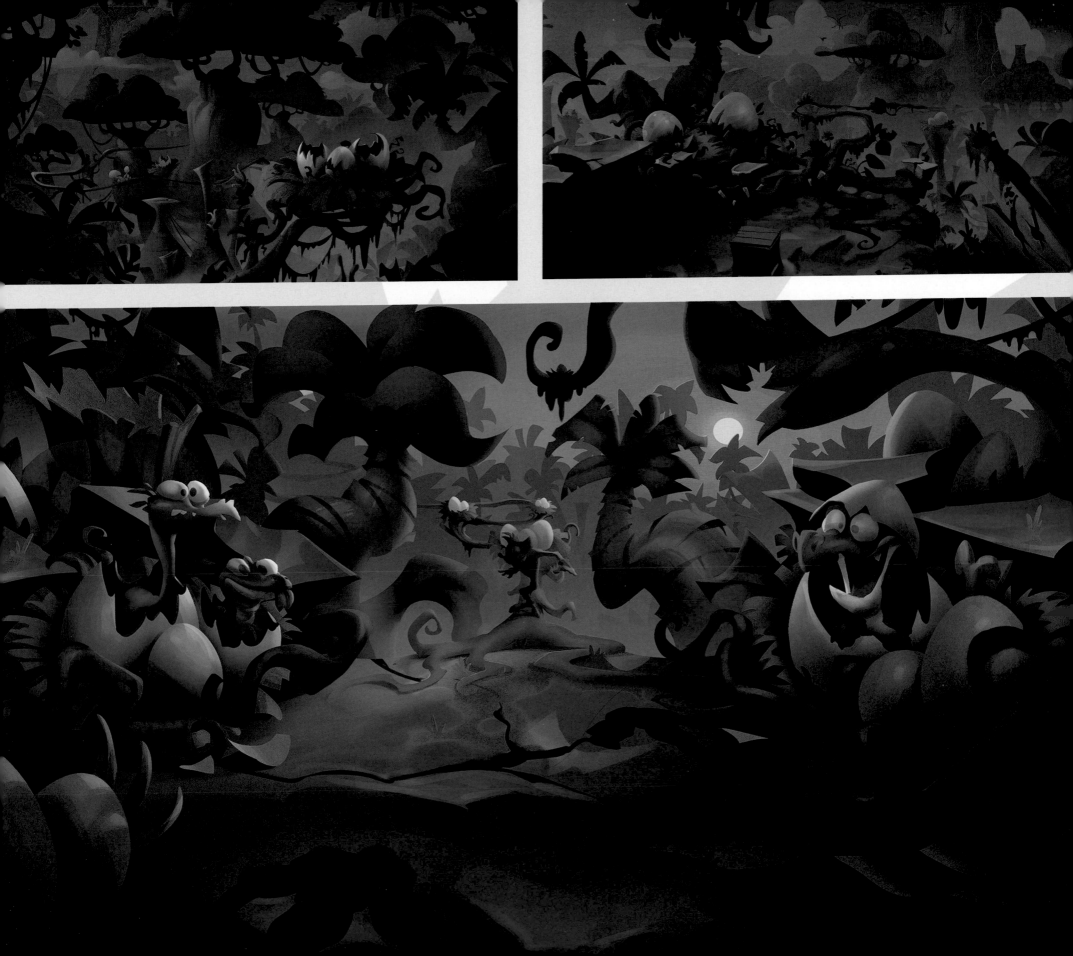

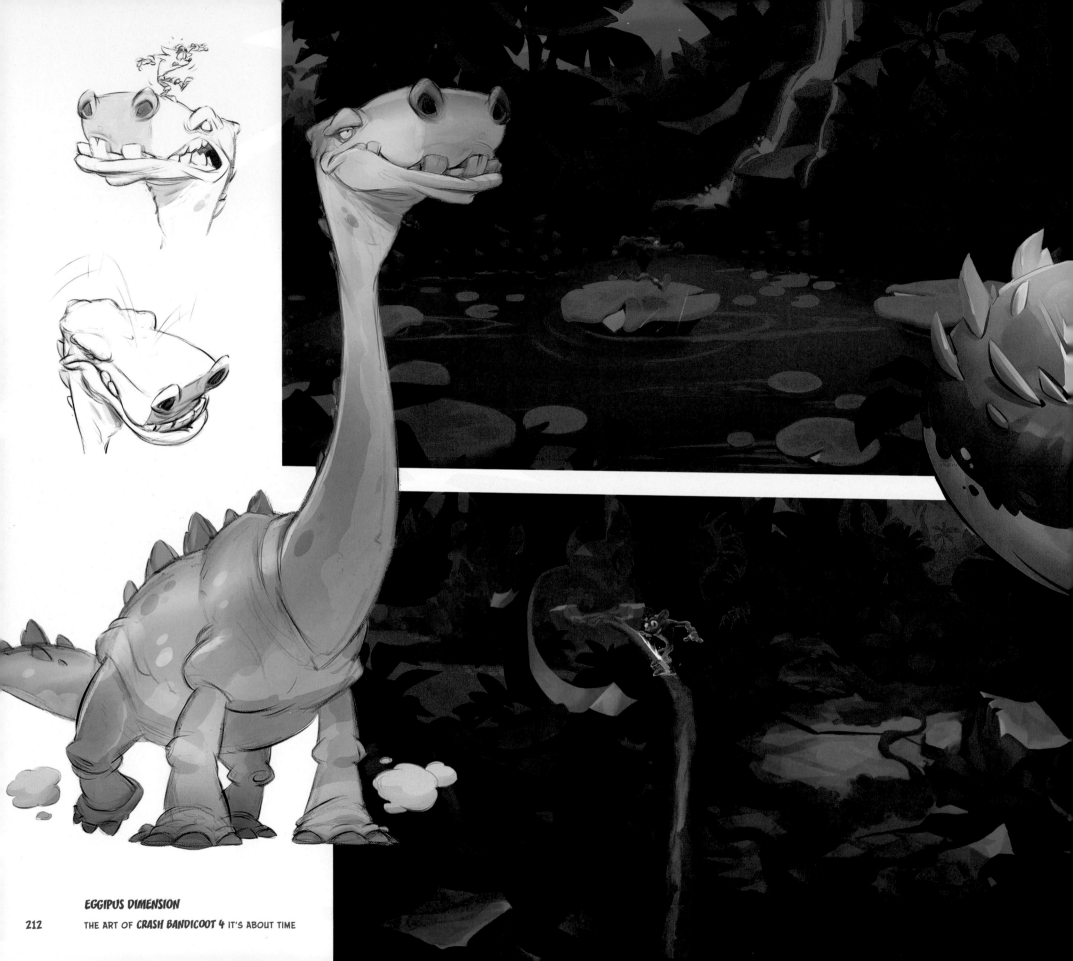

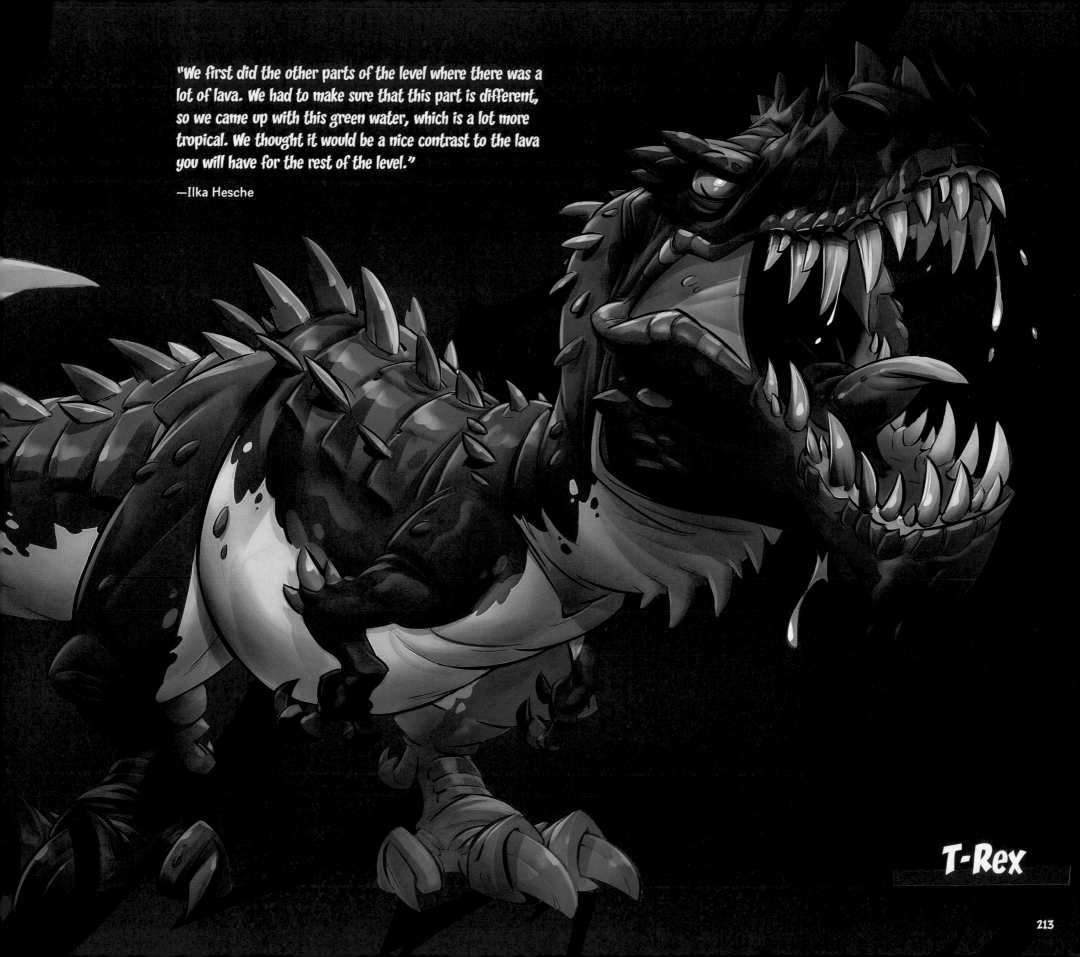

"We first did the other parts of the level where there was a lot of lava. We had to make sure that this part is different, so we came up with this green water, which is a lot more tropical. We thought it would be a nice contrast to the lava you will have for the rest of the level."

—Ilka Hesche

T-Rex

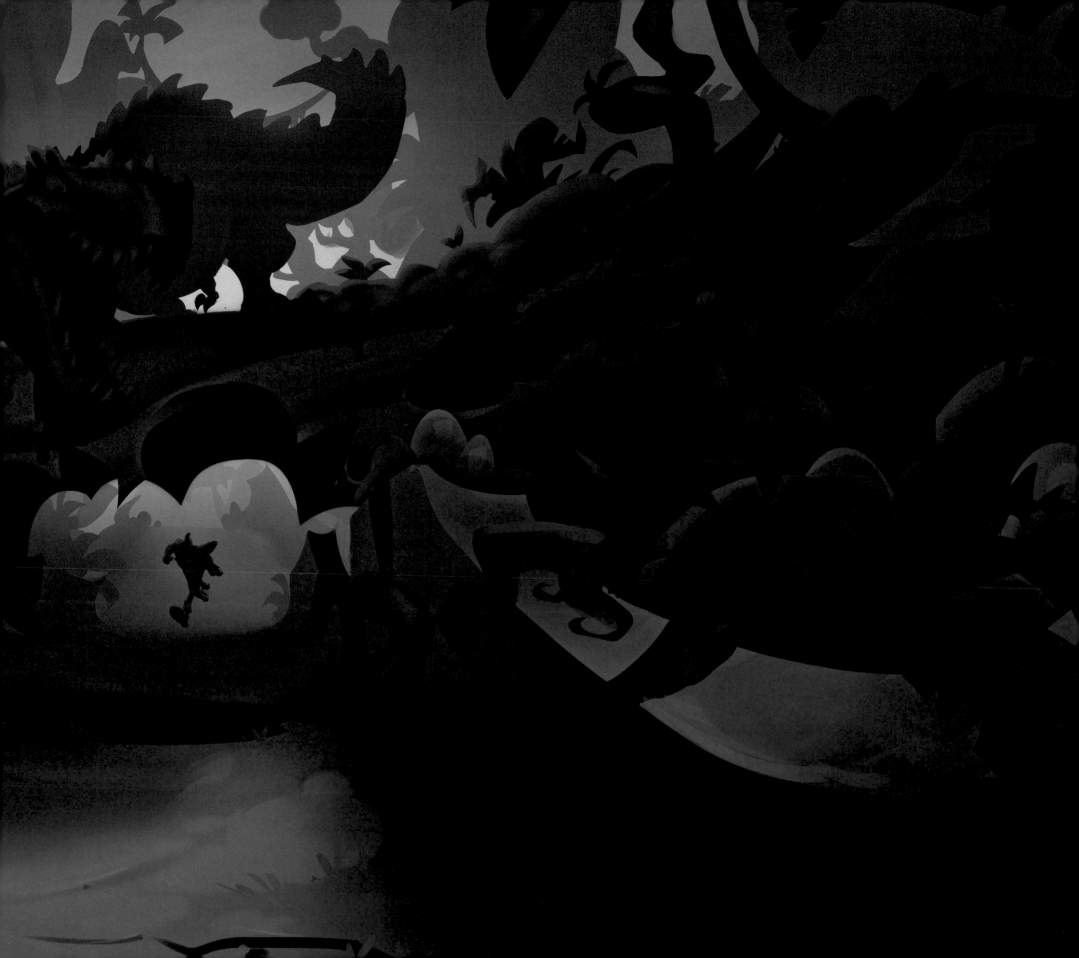

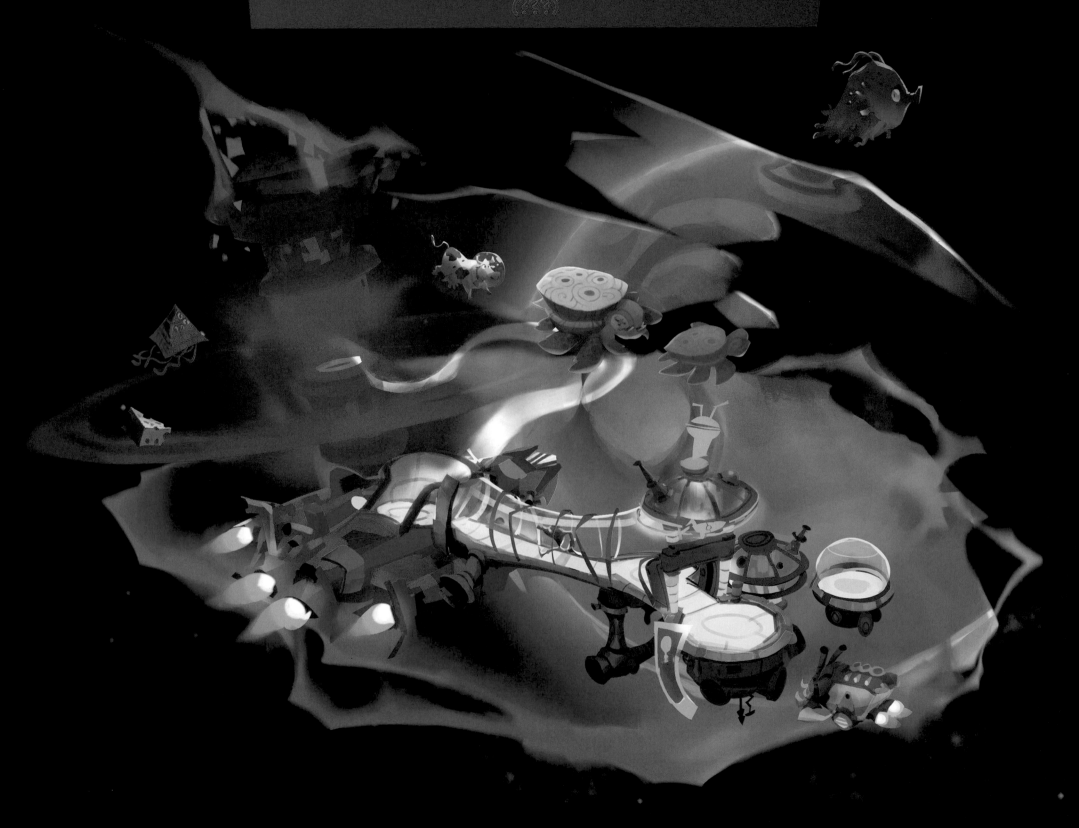

BERMUGULA'S ORBIT

(???)

Out for Lunch

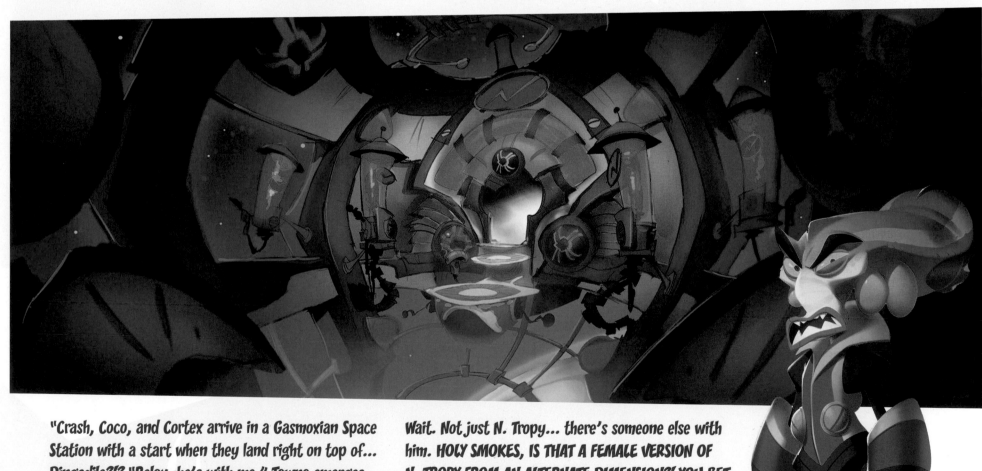

"Crash, Coco, and Cortex arrive in a Gasmoxian Space Station with a start when they land right on top of... Dingodile?!? "Relax—he's with me." Tawna emerges from behind the hulking hybrid. Seems sometime since we saw her last she found poor Dingo hopping his way through dimensions, looking for the leap home.

Suddenly the gang overhears a familiar voice on a nearby monitor... Nitros Oxide? The alien kart-racing champion and villain of CTR?! But he's being awfully demure. Is he giving in to N. Tropy? Looks like it.

Wait. Not just N. Tropy... there's someone else with him. HOLY SMOKES, IS THAT A FEMALE VERSION OF N. TROPY FROM AN ALTERNATE DIMENSION?! YOU BET YOUR SWEET JORTS IT IS. Tawna appears to recognize her—from the same universe, perhaps?

Looks like our heroes arrived just in the nick of time—the Tropies are preparing to enact the final stage of their plan and order Oxide to take his ship to the rift generator. Looks like it's time to hitch a ride." —Mandy Benanav

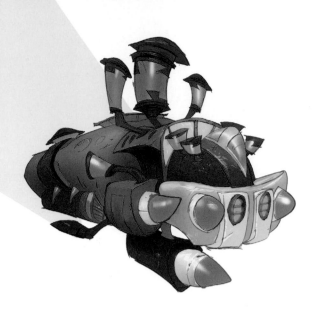

"At this point, it was kind of hard to find what Gasmoxian is. That was the biggest challenge because it's not really a clearly defined thing. I did a lot of sketches that were too alien, too crazy, so I tried to find the right balance between something that looks alien and something that looks familiar."

—James Martin

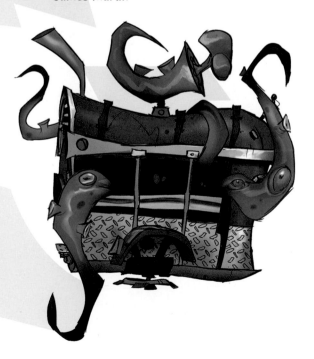

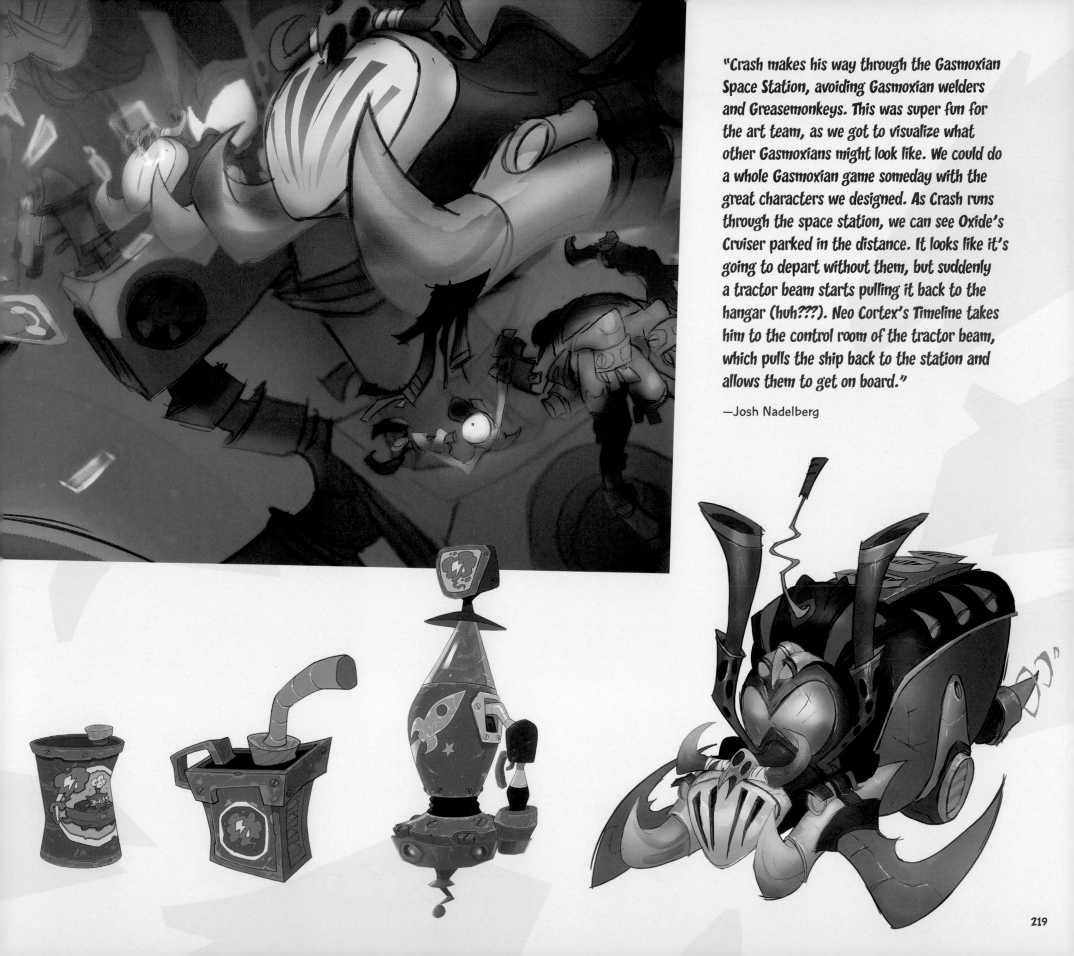

"Crash makes his way through the Gasmoxian Space Station, avoiding Gasmoxian welders and Greasemonkeys. This was super fun for the art team, as we got to visualize what other Gasmoxians might look like. We could do a whole Gasmoxian game someday with the great characters we designed. As Crash runs through the space station, we can see Oxide's Cruiser parked in the distance. It looks like it's going to depart without them, but suddenly a tractor beam starts pulling it back to the hangar (huh???). Neo Cortex's Timeline takes him to the control room of the tractor beam, which pulls the ship back to the station and allows them to get on board."

—Josh Nadelberg

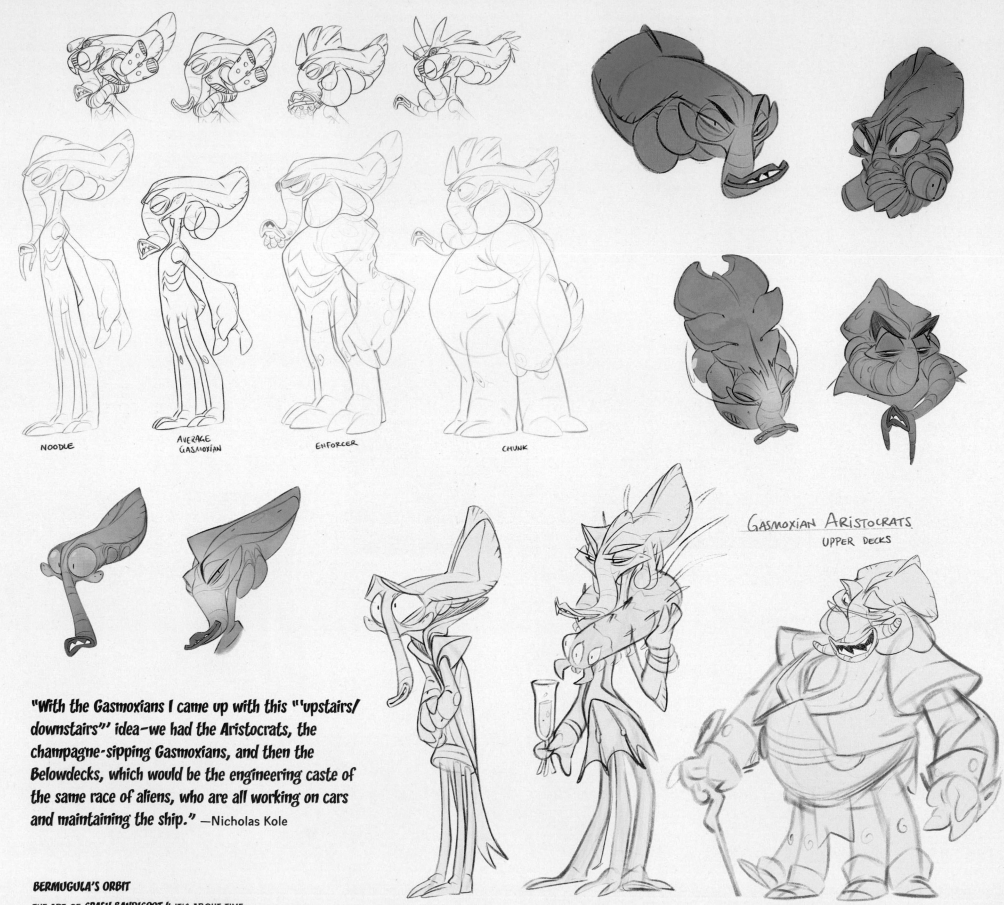

NOODLE

AVERAGE GASMOXIAN

ENFORCER

CHUNK

GASMOXIAN ARISTOCRATS
UPPER DECKS

"With the Gasmoxians I came up with this "'upstairs/downstairs'" idea—we had the Aristocrats, the champagne-sipping Gasmoxians, and then the Belowdecks, which would be the engineering caste of the same race of aliens, who are all working on cars and maintaining the ship." —Nicholas Kole

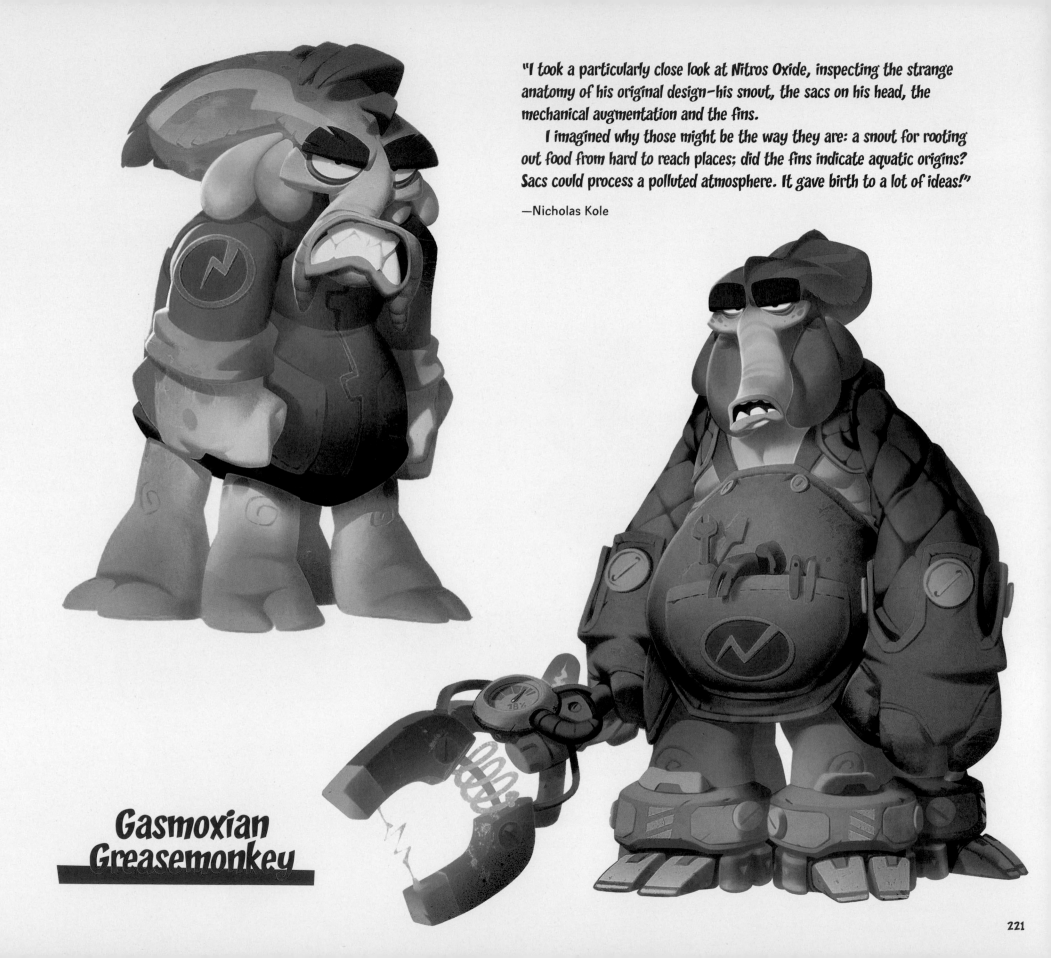

"I took a particularly close look at Nitros Oxide, inspecting the strange anatomy of his original design—his snout, the sacs on his head, the mechanical augmentation and the fins.

I imagined why those might be the way they are: a snout for rooting out food from hard to reach places; did the fins indicate aquatic origins? Sacs could process a polluted atmosphere. It gave birth to a lot of ideas!"

—Nicholas Kole

Gasmoxian Greasemonkey

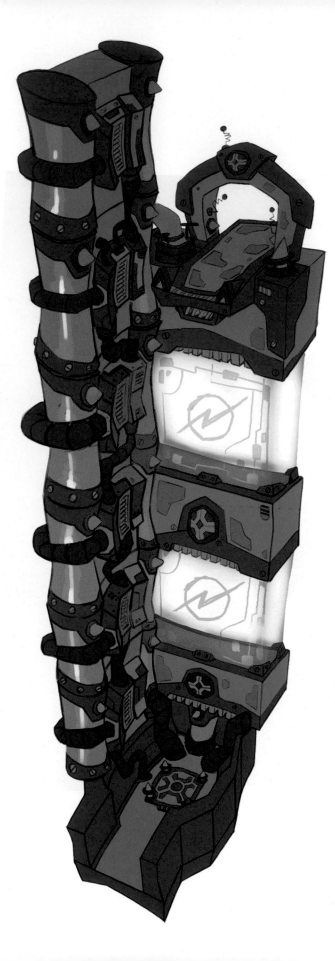

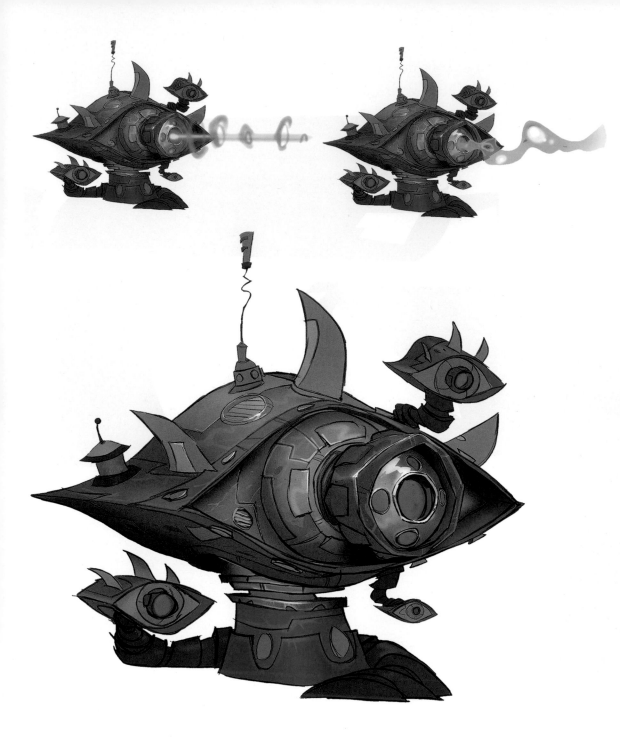

"Tractor beam—it's an eyeball theme. I don't know why. There was definitely a reason... oh, I know what it was: It was hard to come up with ideas of what a Gasmoxian is, so I was being completely random; I did sketches of organic things like a big hand as a tractor beam, or a face."

—James Martin

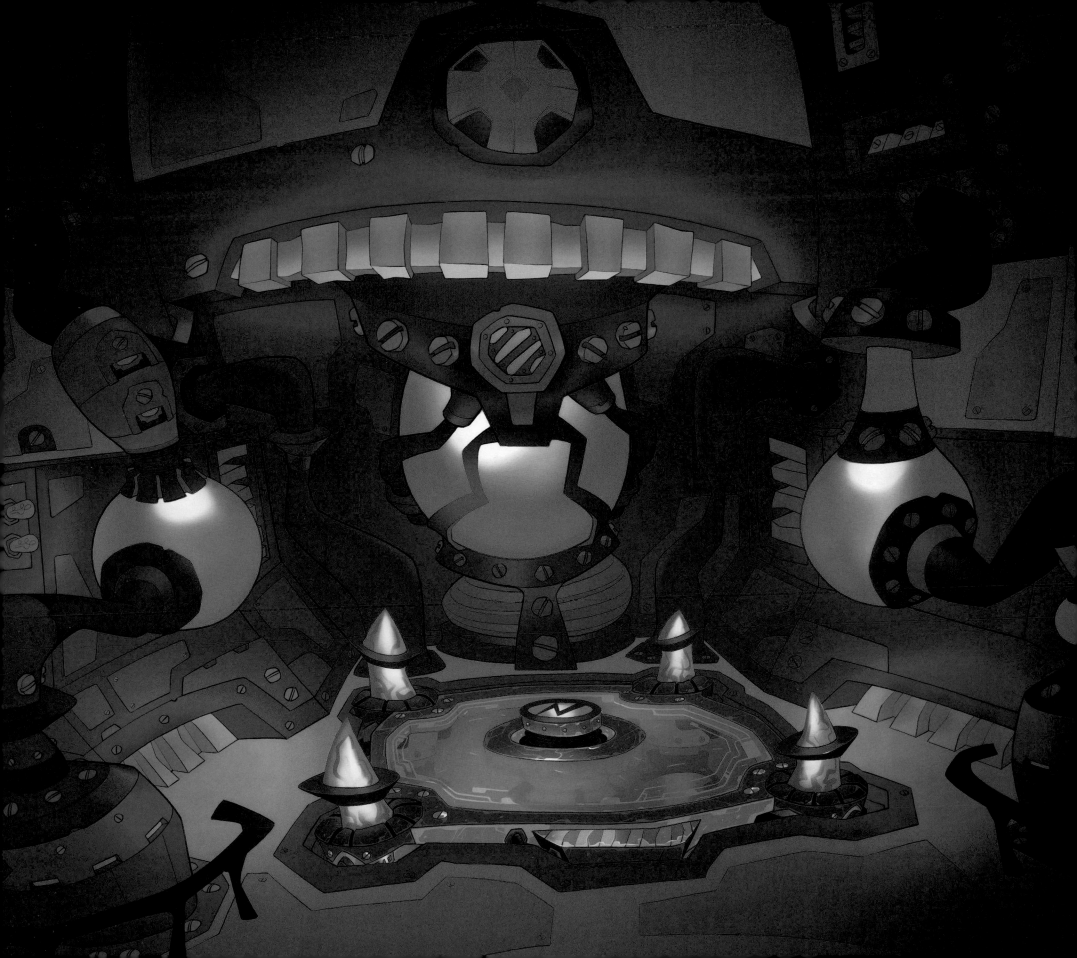

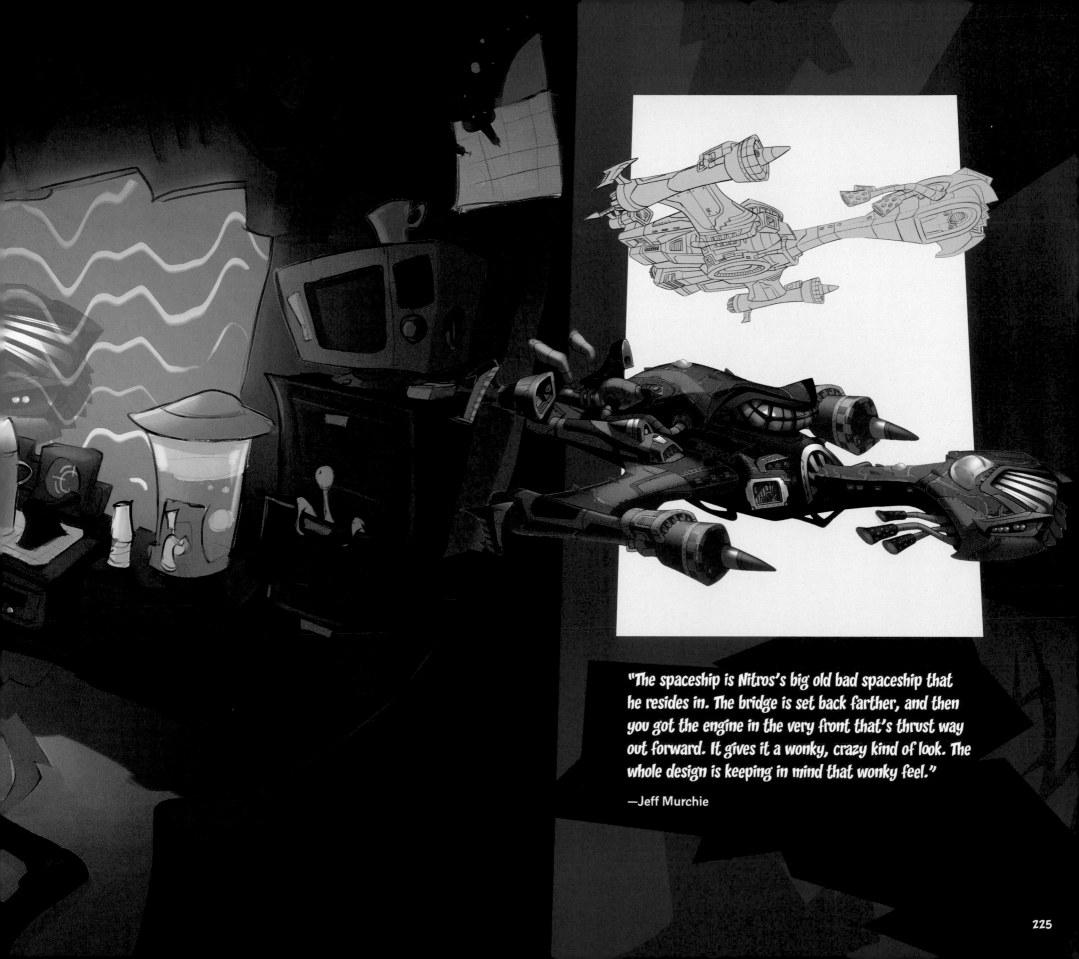

"The spaceship is Nitros's big old bad spaceship that he resides in. The bridge is set back farther, and then you got the engine in the very front that's thrust way out forward. It gives it a wonky, crazy kind of look. The whole design is keeping in mind that wonky feel."

—Jeff Murchie

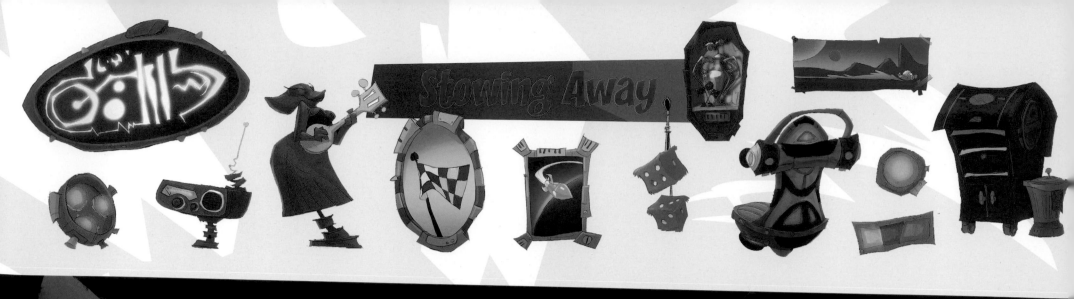

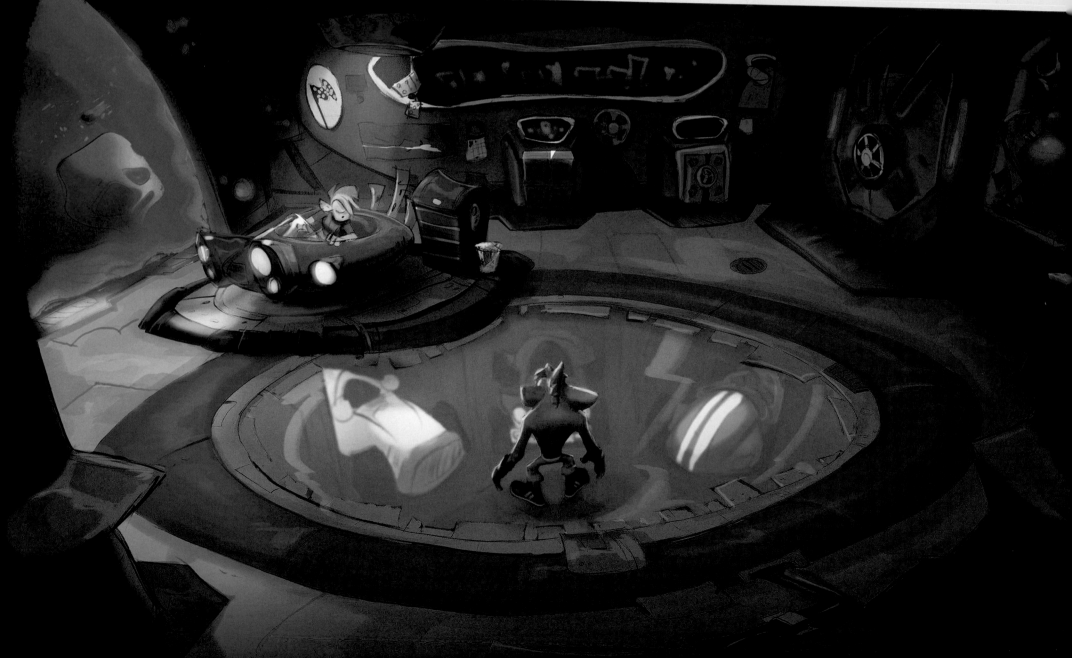

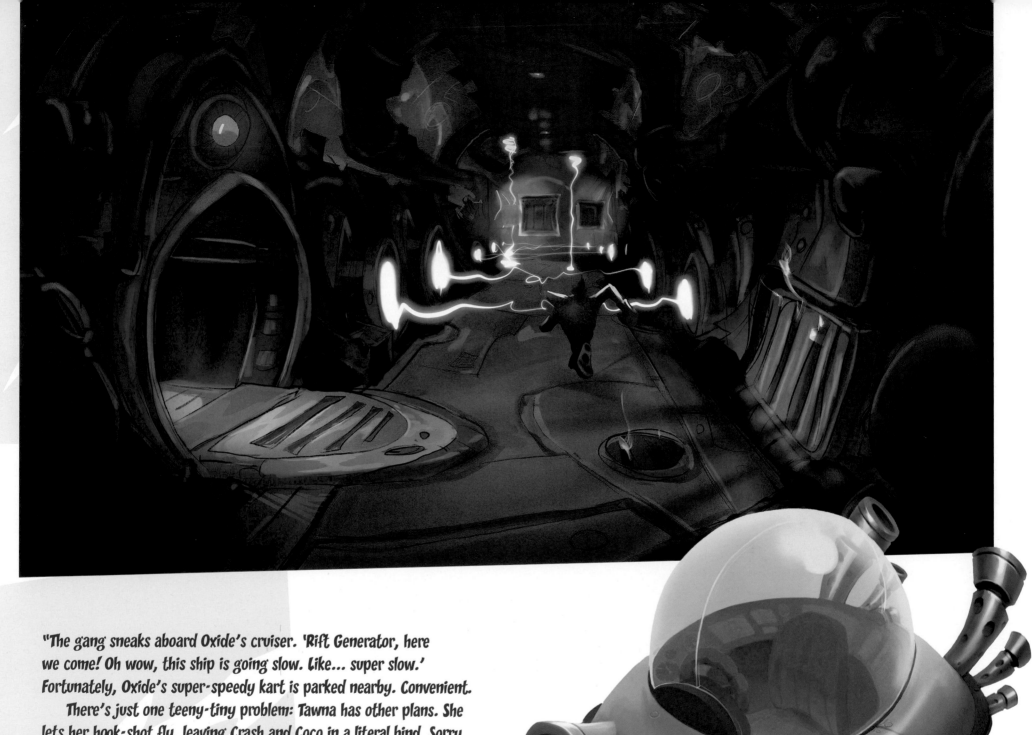

"The gang sneaks aboard Oxide's cruiser. 'Rift Generator, here we come! Oh wow, this ship is going slow. Like... super slow.' Fortunately, Oxide's super-speedy kart is parked nearby. Convenient.

There's just one teeny-tiny problem: Tawna has other plans. She lets her hook-shot fly, leaving Crash and Coco in a literal bind. Sorry, she says, she won't lose Crash and Coco in this dimension too. Despite Coco's protests, Tawna takes off.

Having been out surveying the ship, Dingo and Cortex appear just in time to see Tawna leaving. They free Crash and Coco, but it's too late. Tawna is on her way to face the Big Bads all by herself."

—Mandy Benanav

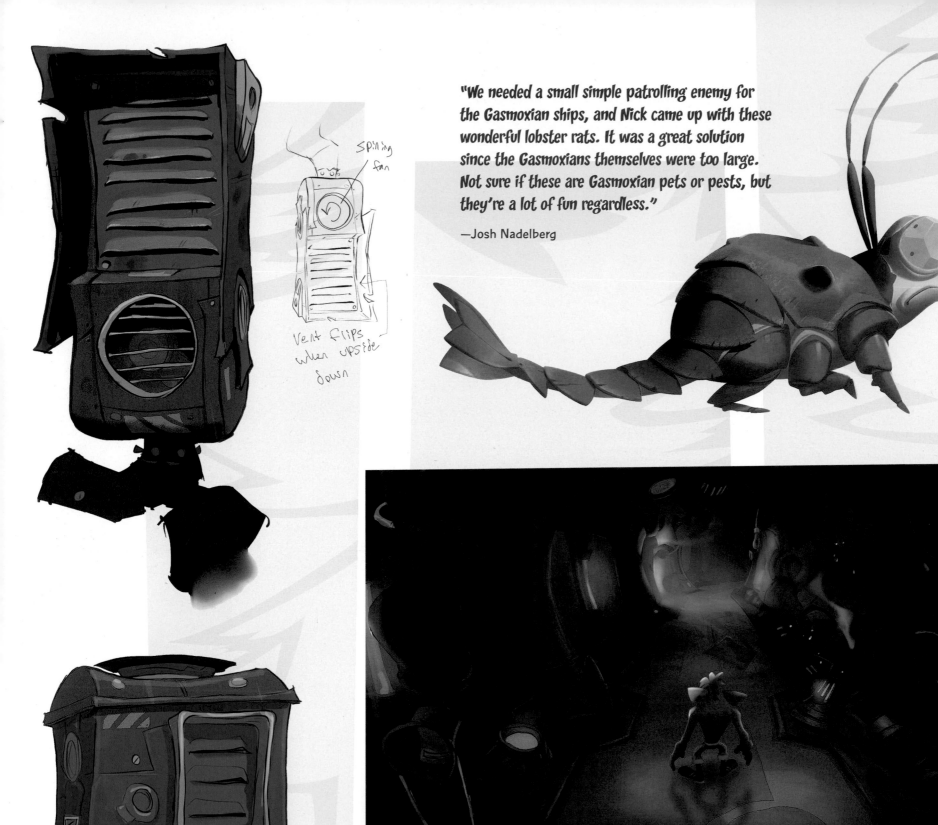

Spining fan

Vent flips when upside down

"We needed a small simple patrolling enemy for the Gasmoxian ships, and Nick came up with these wonderful lobster rats. It was a great solution since the Gasmoxians themselves were too large. Not sure if these are Gasmoxian pets or pests, but they're a lot of fun regardless."

—Josh Nadelberg

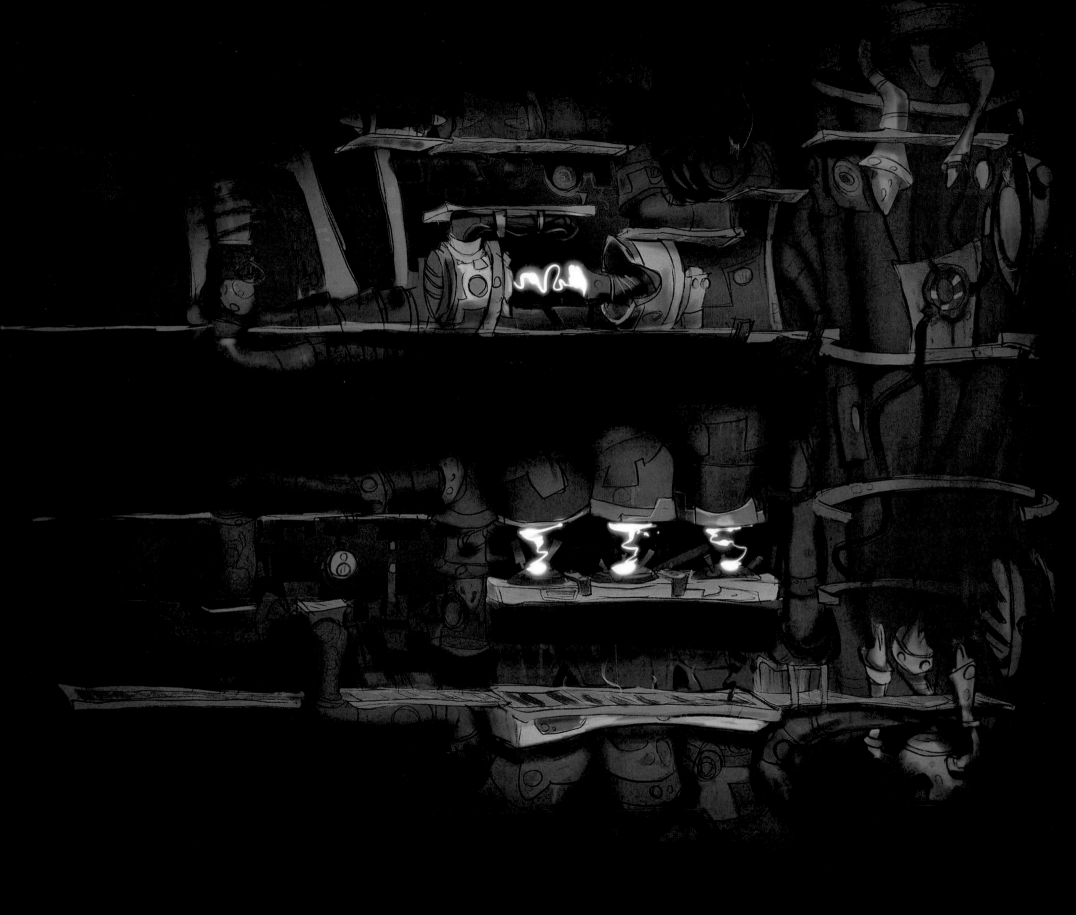

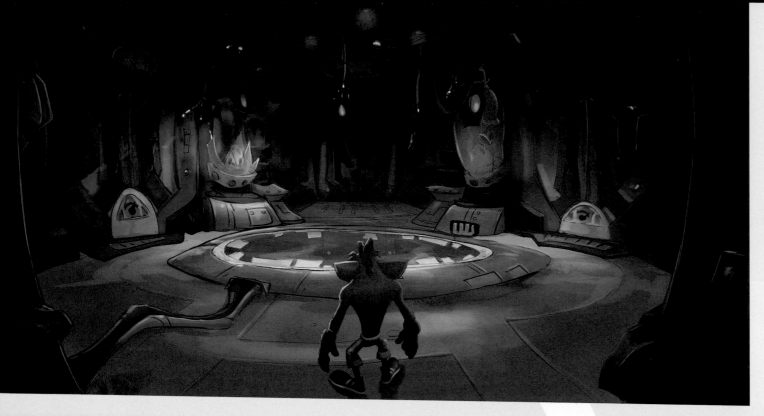

"The escape pod room, I thought of an airplane, so I had a gas mask hanging from the ceiling, the emergency exit... it's taking airplane visual language, and boats. Off to the left, hiding behind a pillar is a life buoy... which would be totally useless in space."

—James Martin

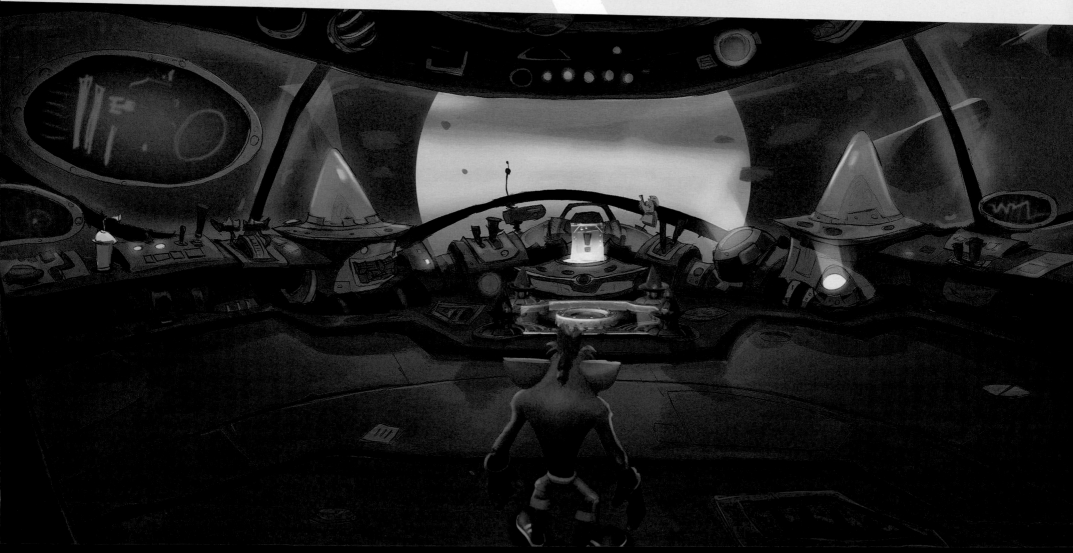

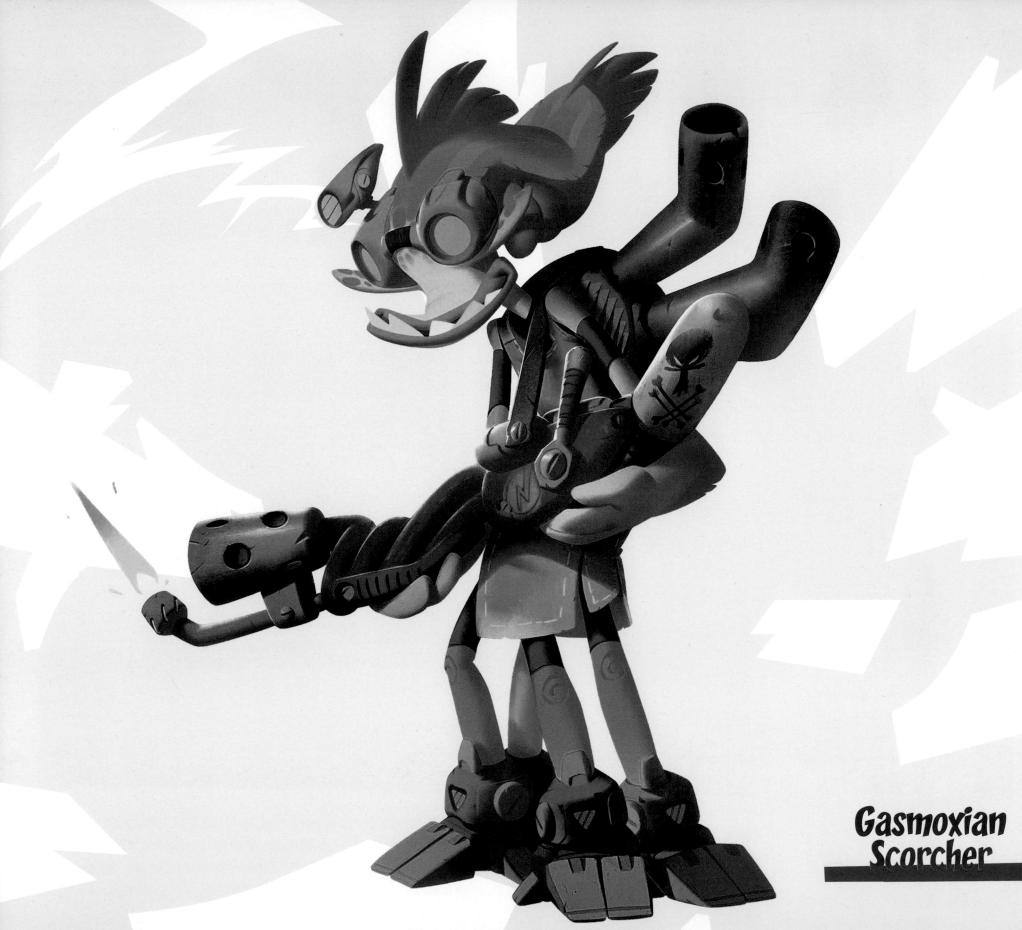

Gasmoxian
Scorcher

Crash Landed

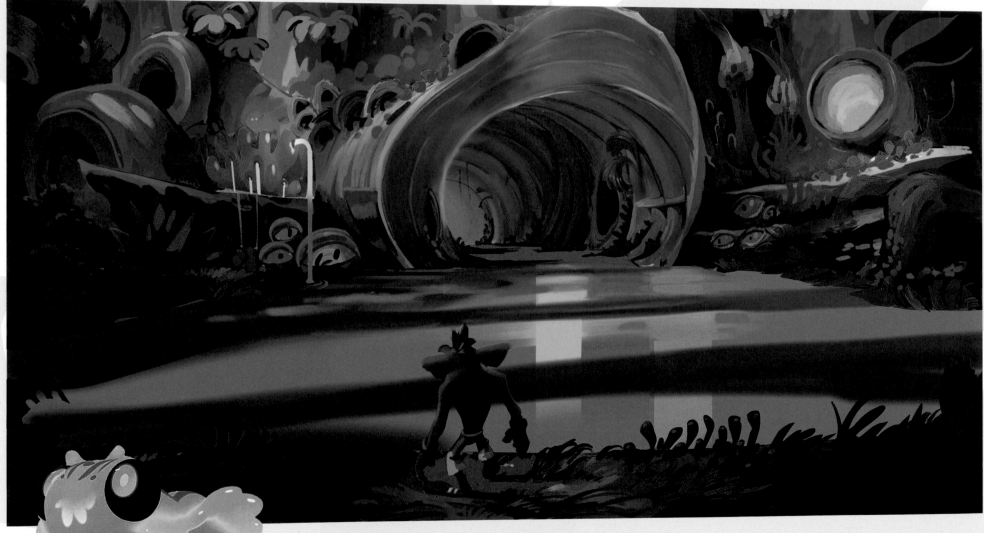

"Fortunately, this is the planet that contains a massive rift leading directly to the Rift Generator... on the other side of the planet. They make their way through an amazing alien landscape full of amazing flora and fauna. Crash jumps on the back of a tiny little alien friend, a shnurgle, and rides him across bales of flying space turtles and through dark caverns full of spooky mole-eels." —Josh Nadelberg

BERMUGULA'S ORBIT

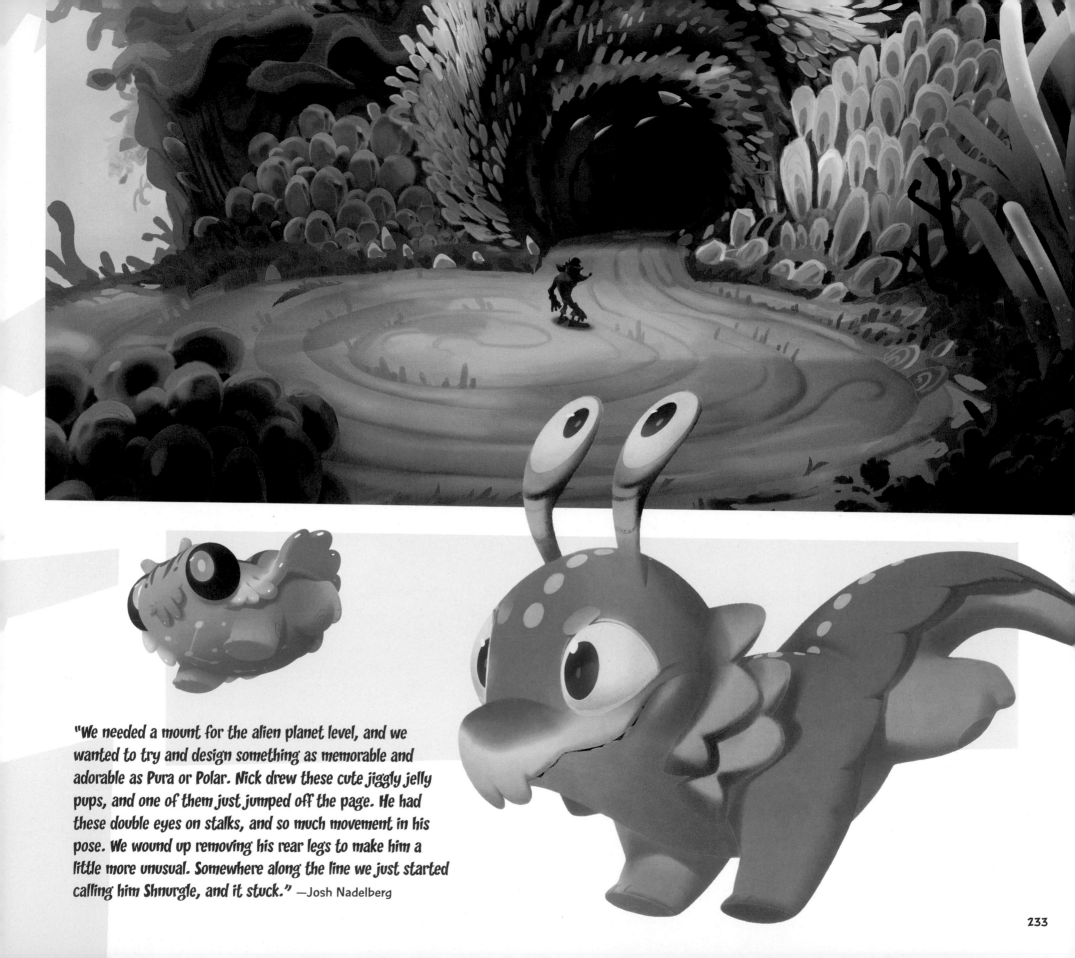

"We needed a mount for the alien planet level, and we wanted to try and design something as memorable and adorable as Pura or Polar. Nick drew these cute jiggly jelly pups, and one of them just jumped off the page. He had these double eyes on stalks, and so much movement in his pose. We wound up removing his rear legs to make him a little more unusual. Somewhere along the line we just started calling him Shnurgle, and it stuck." —Josh Nadelberg

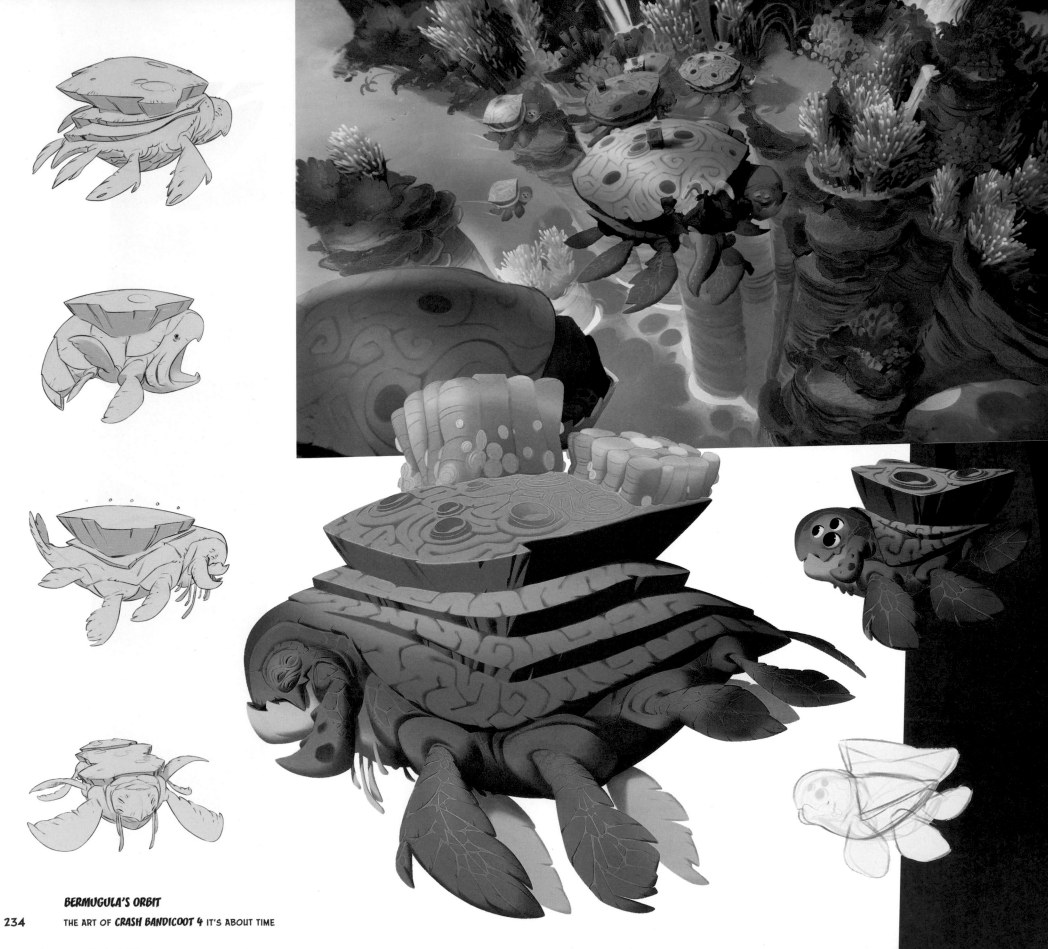

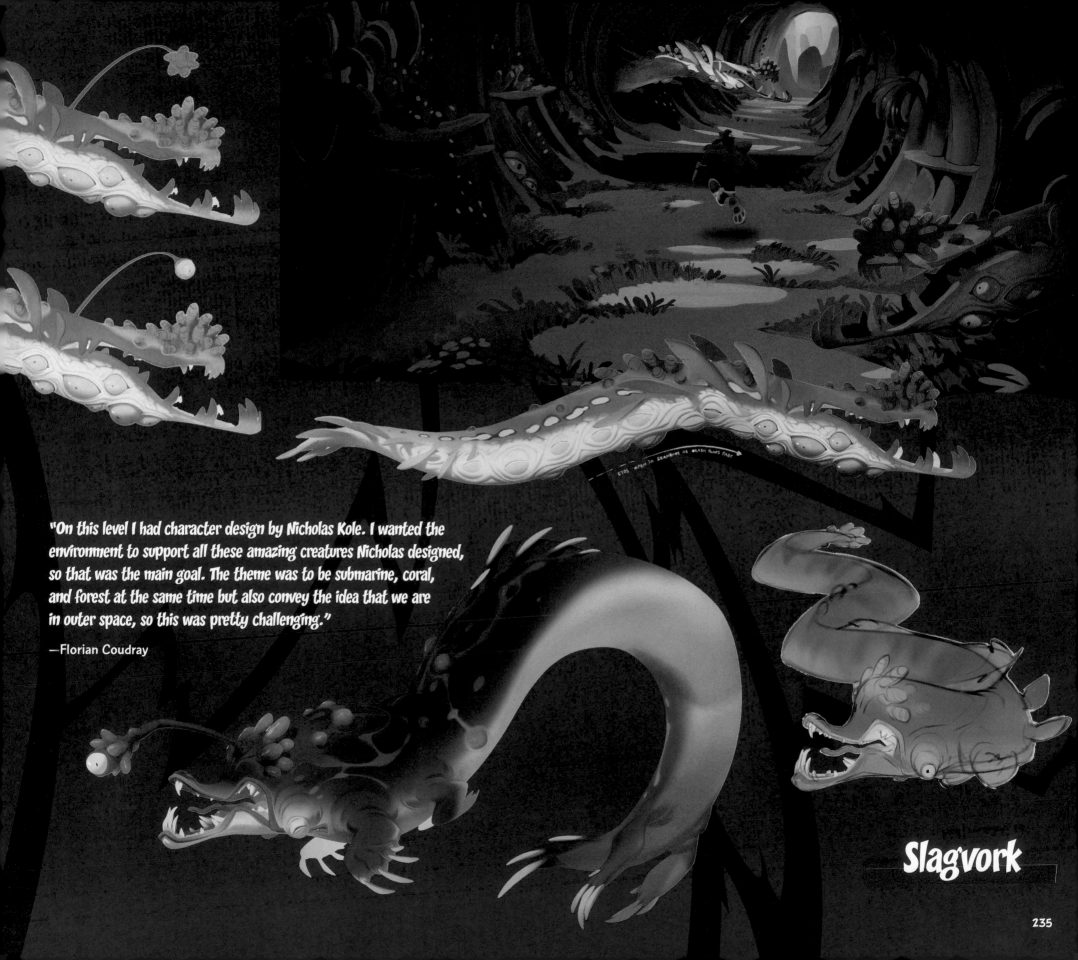

"On this level I had character design by Nicholas Kole. I wanted the environment to support all these amazing creatures Nicholas designed, so that was the main goal. The theme was to be submarine, coral, and forest at the same time but also convey the idea that we are in outer space, so this was pretty challenging."

—Florian Coudray

Slagvork

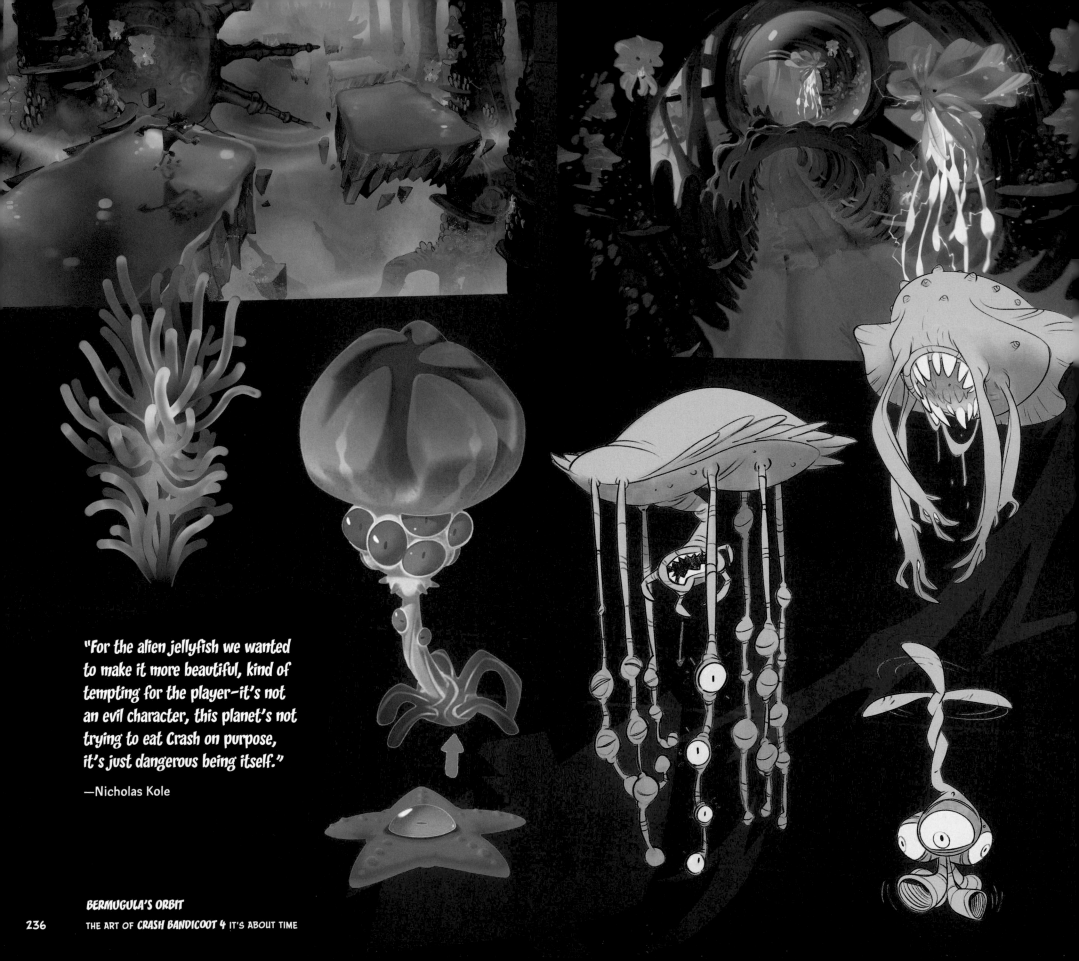

"For the alien jellyfish we wanted to make it more beautiful, kind of tempting for the player—it's not an evil character, this planet's not trying to eat Crash on purpose, it's just dangerous being itself."

—Nicholas Kole

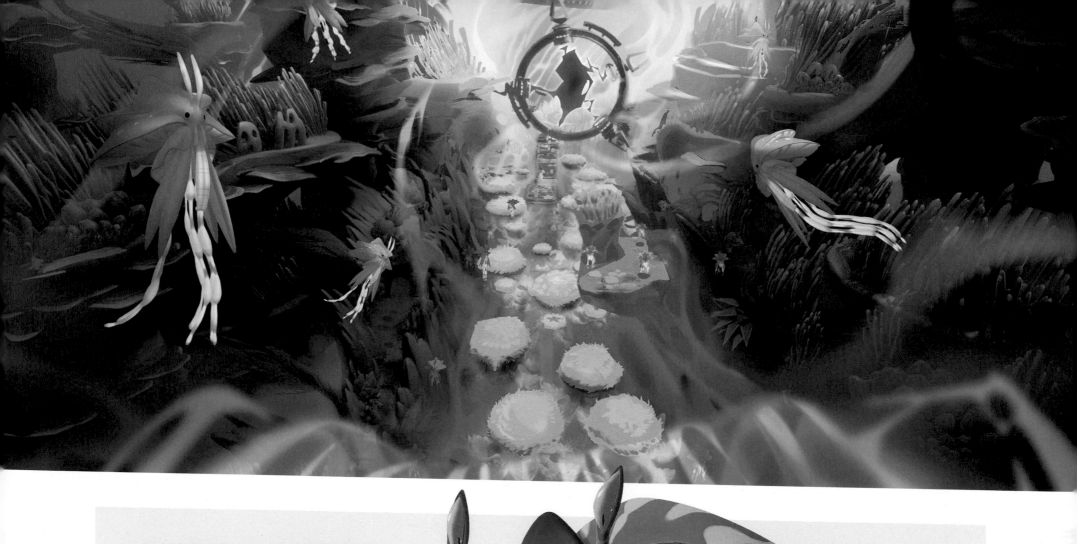

"We had already concepted Shnurgle when Design told us that they needed a huge stampeding character. We thought it would be fun if they were the elder versions of Crash's new buddy. They think Crash is a very bad influence on their little boy…"

—Josh Nadelberg

Mama Shnurgle



Dr. N. Tropy

BERMUGULA'S ORBIT

"After they make their way across the planet and through the rift it's finally here:
SHOWDOWN TIME. Crash, Coco, Dingo, and Cortex arrive to see Tawna fighting back against the Tropies, but FemTropy has her on the ropes. FemTropy is taunting Tawna when... oooh, what's this? Crash and Coco are here? Oh, how fun, she coos, she's never gotten to kill someone twice before.

That's right—the Crash and Coco from Tawna's universe are dead—and FemTropy killed them, right in front of Tawna's eyes.

Content to draw out their deaths like a cat playing with a mouse, the Tropies release Tawna and start the machine. BOOM! Our ragtag group is sent flying through the 'air', (we're in space, remember) as the machine rips open enormous rift after enormous rift."

—Mandy Benanav

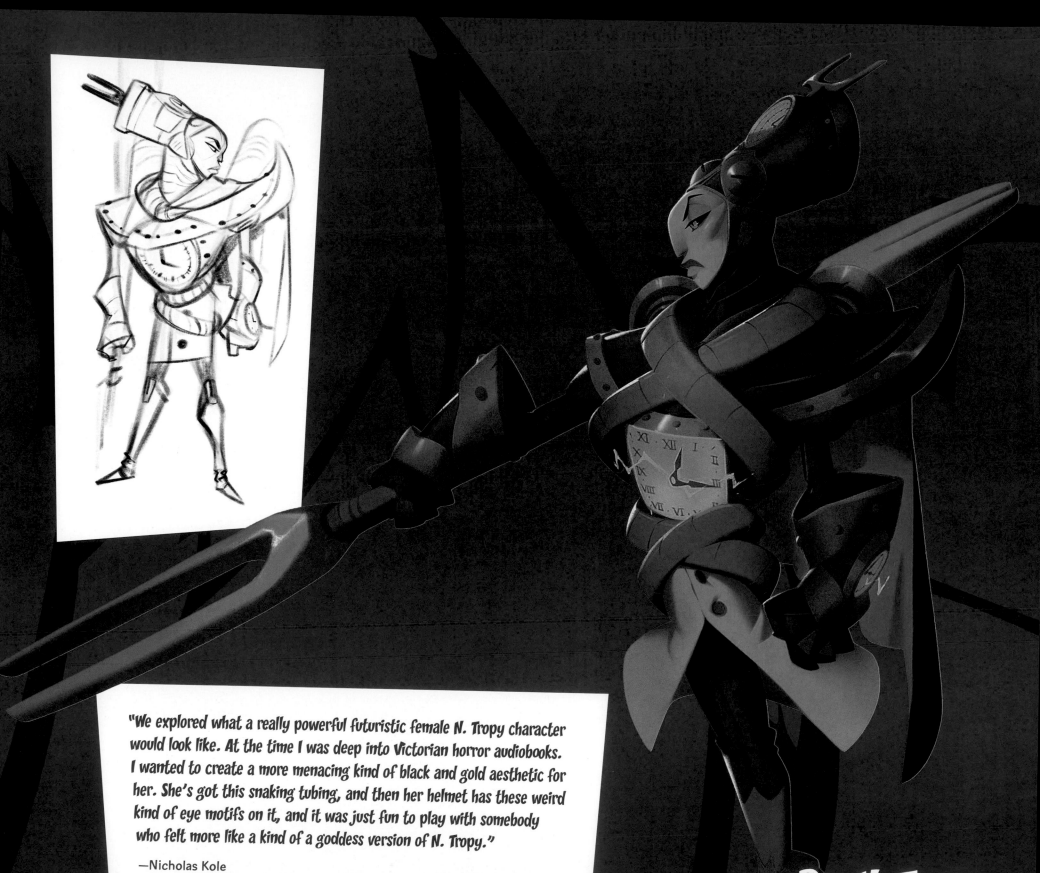

"We explored what a really powerful futuristic female N. Tropy character would look like. At the time I was deep into Victorian horror audiobooks. I wanted to create a more menacing kind of black and gold aesthetic for her. She's got this snaking tubing, and then her helmet has these weird kind of eye motifs on it, and it was just fun to play with somebody who felt more like a kind of a goddess version of N. Tropy."

—Nicholas Kole

Dr. N. Tropy
(Tawnaverse)

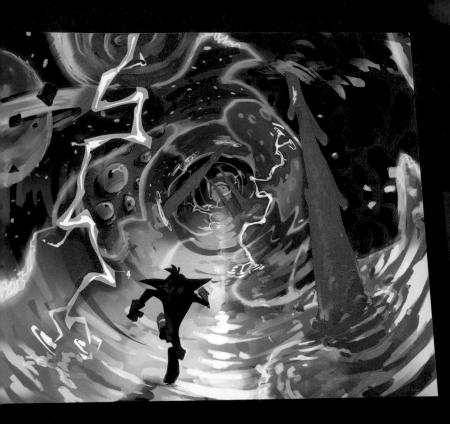

"The reality tunnel sequence was one of the most ambitious in the game. We wanted to create a surreal transition that showed Crash literally traveling through space and time. Inspired by a piece of inspirational key art by Nico and a wild, colorful sketch by John, Johannes crystalized the idea of Crash riding the reality rails through shards that revealed worlds that he's explored throughout the game. We loved the visual and worked really hard to capture that experience in game.

Sometimes you'll design something that everyone loves, but for some reason or another, whether it presents unwieldy technical challenges or something makes it incredibly difficult to implement, you have to let it go and come up with something new. This was almost one of those ideas, but I'm so proud of everyone that worked on it because it feels really fresh and exciting. At one point there were hazards along the rail, but as we iterated on the entire boss battle, we felt like this was better as a safe and fun transitional section before you get to the really challenging orbiting rock section. Audio added all of these great echoing pieces of dialogue, and it just turned into this wonderfully bizarre and surreal breath of fresh air." —Josh Nadelberg

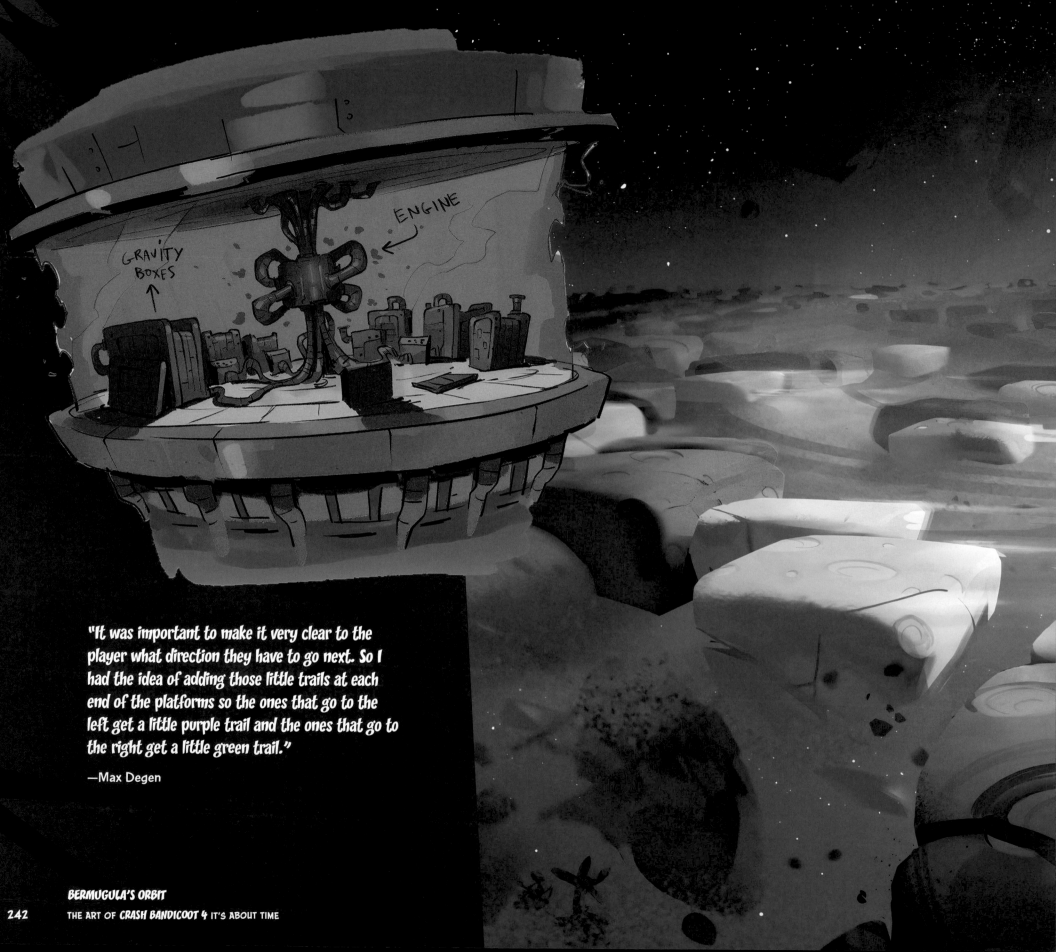

GRAVITY
BOXES

ENGINE

"It was important to make it very clear to the player what direction they have to go next. So I had the idea of adding those little trails at each end of the platforms so the ones that go to the left get a little purple trail and the ones that go to the right get a little green trail."

—Max Degen

BERMUGULA'S ORBIT

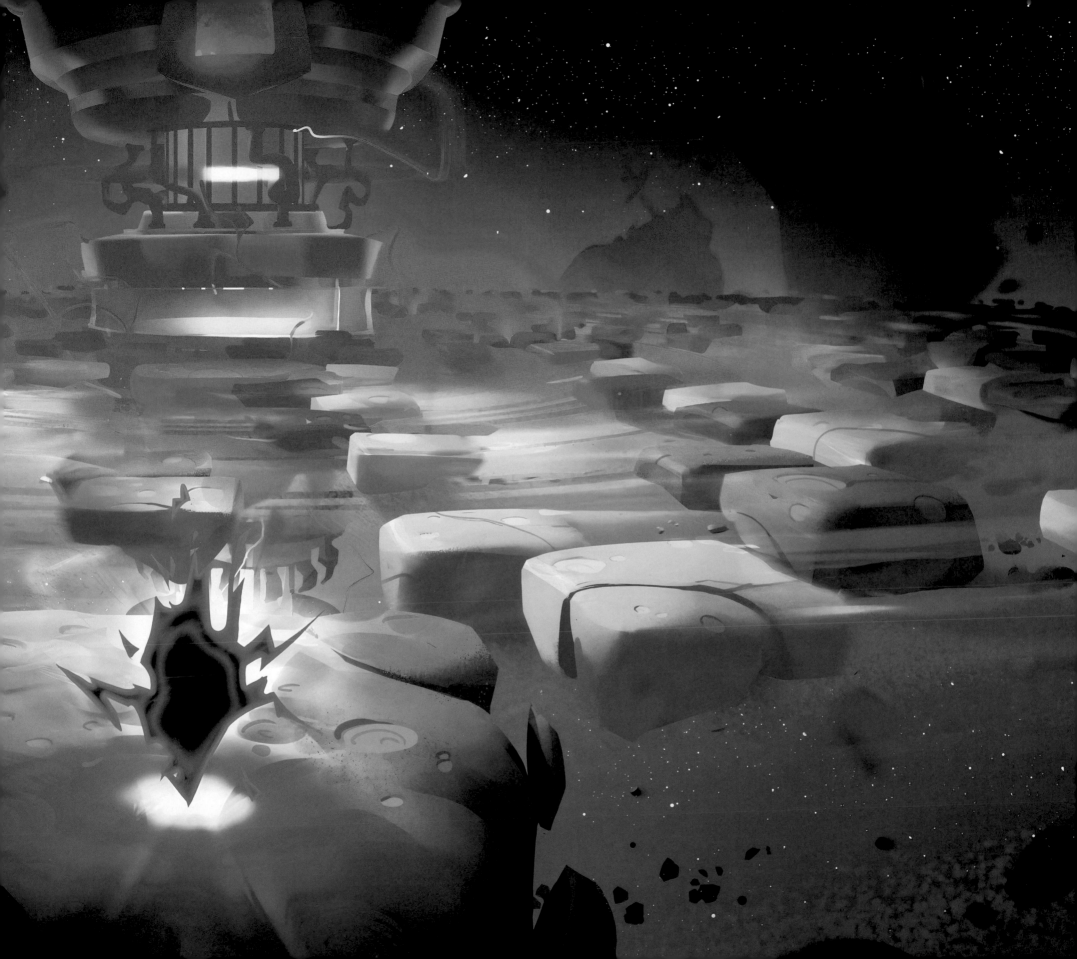

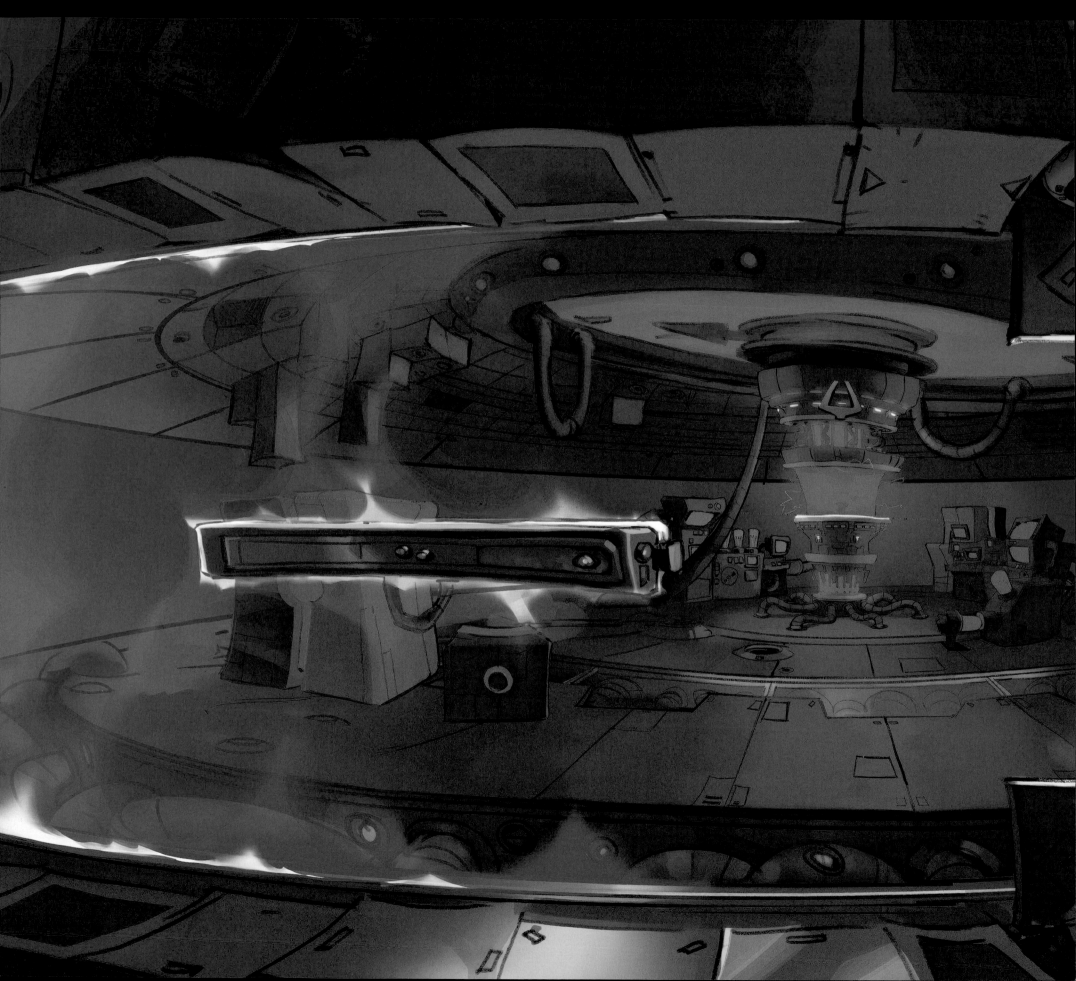

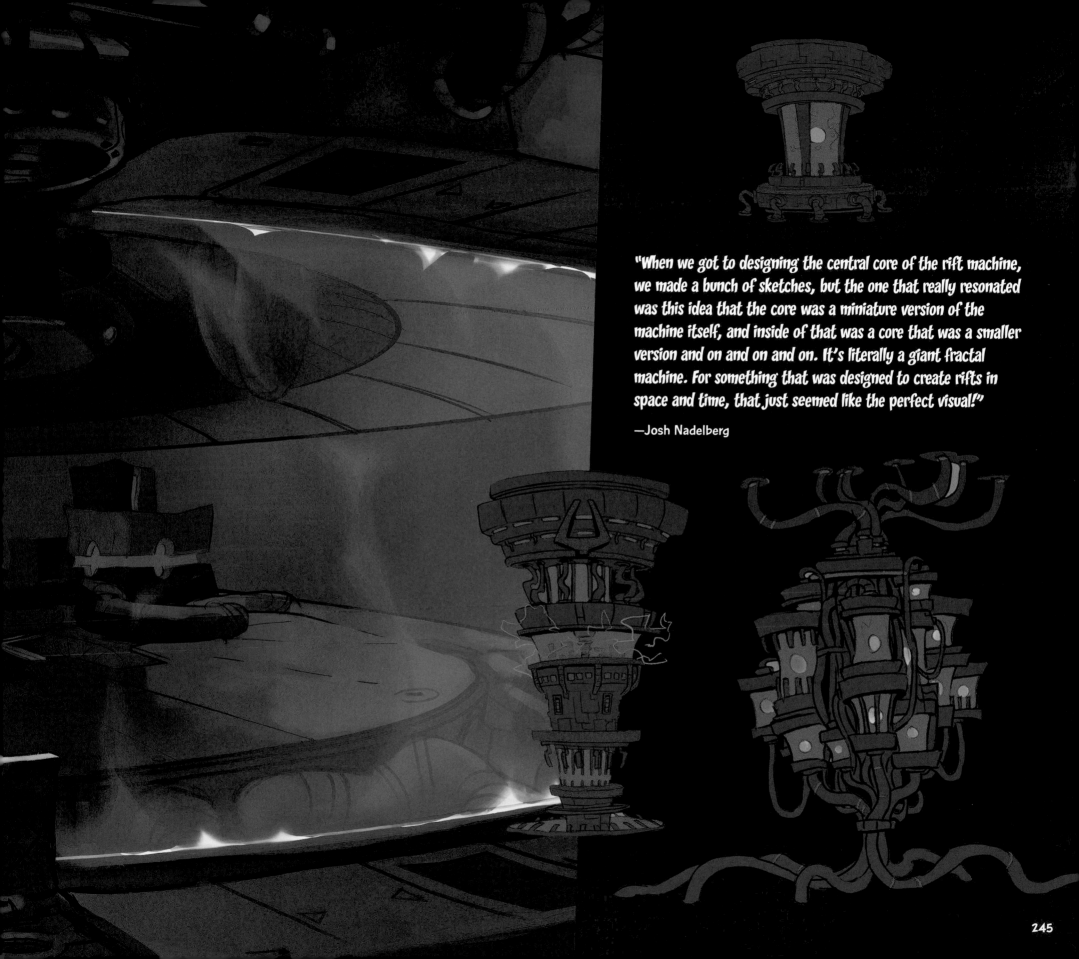

"When we got to designing the central core of the rift machine, we made a bunch of sketches, but the one that really resonated was this idea that the core was a miniature version of the machine itself, and inside of that was a core that was a smaller version and on and on and on. It's literally a giant fractal machine. For something that was designed to create rifts in space and time, that just seemed like the perfect visual!"

—Josh Nadelberg

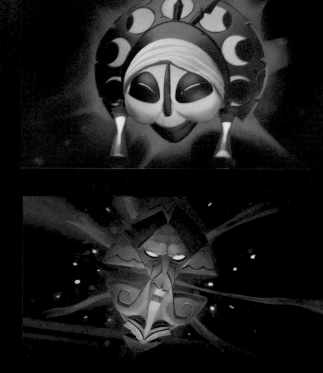

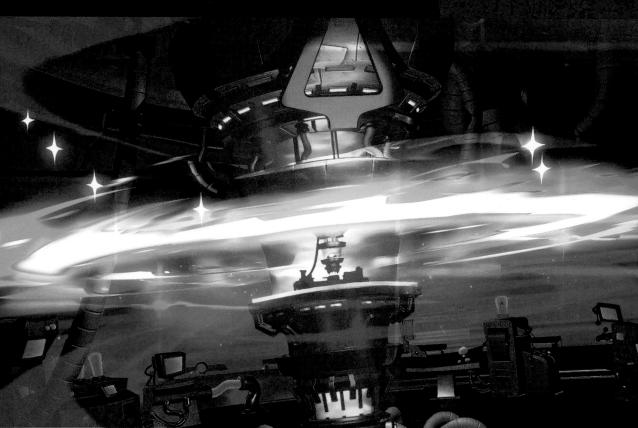
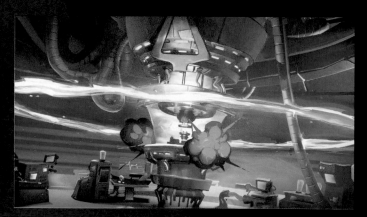

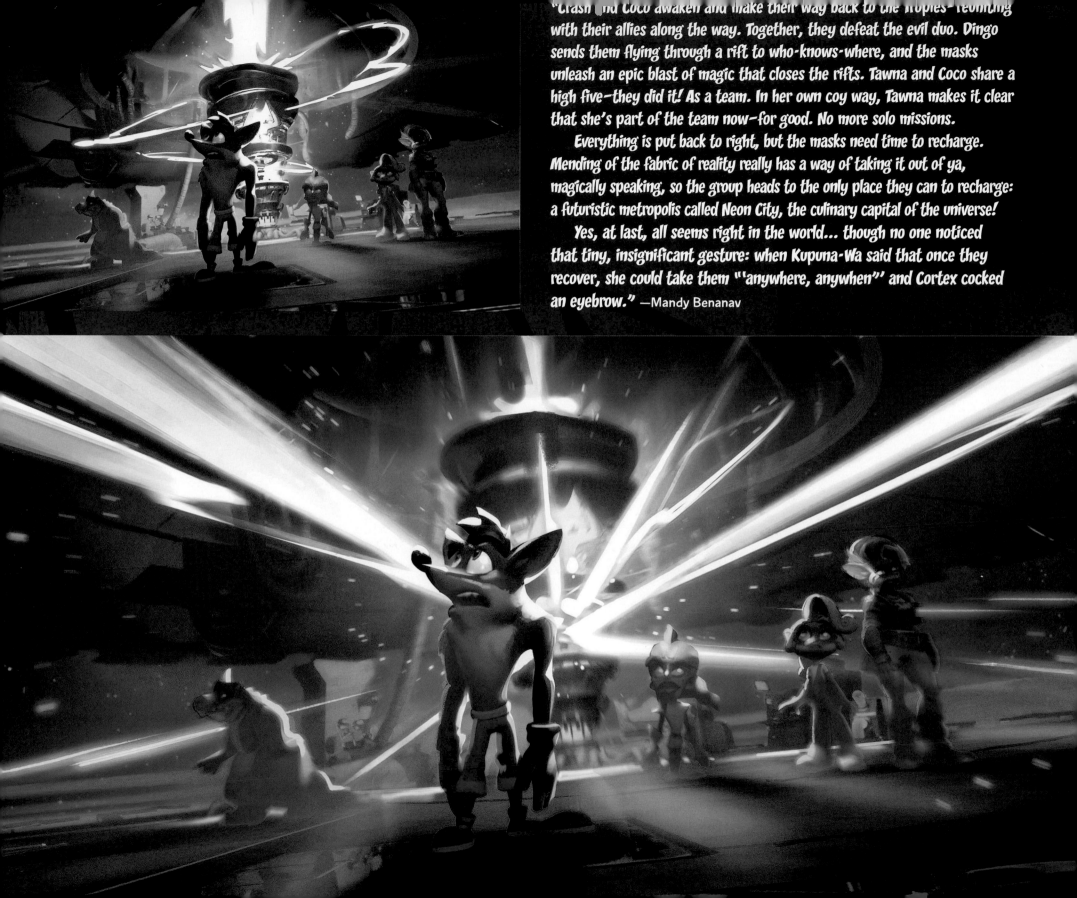

"Crash and Coco awaken and make their way back to the Ropies-reuniting with their allies along the way. Together, they defeat the evil duo. Dingo sends them flying through a rift to who-knows-where, and the masks unleash an epic blast of magic that closes the rifts. Tawna and Coco share a high five—they did it! As a team. In her own coy way, Tawna makes it clear that she's part of the team now—for good. No more solo missions.

Everything is put back to right, but the masks need time to recharge. Mending of the fabric of reality really has a way of taking it out of ya, magically speaking, so the group heads to the only place they can to recharge: a futuristic metropolis called Neon City, the culinary capital of the universe!

Yes, at last, all seems right in the world... though no one noticed that tiny, insignificant gesture: when Kupuna-Wa said that once they recover, she could take them "'anywhere, anywhen'' and Cortex cocked an eyebrow." —Mandy Benanav

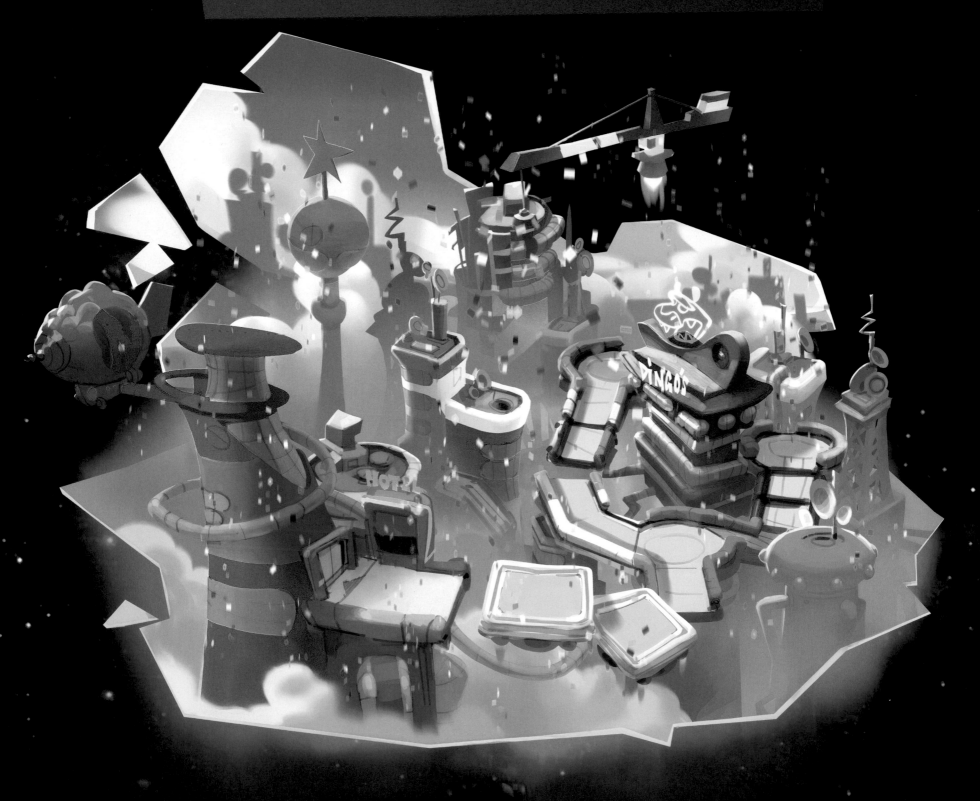

THE SN@XX DIMENSION
(3032)

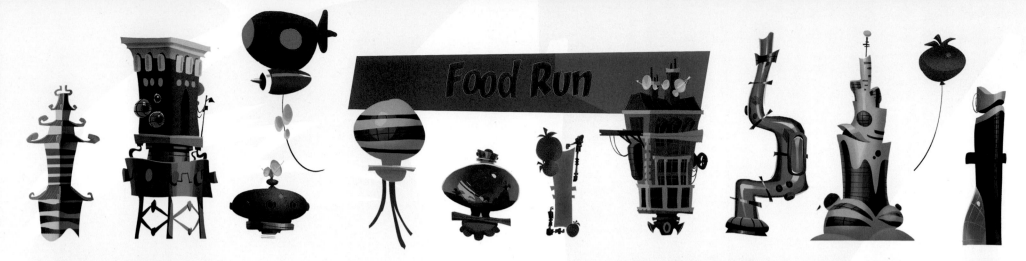

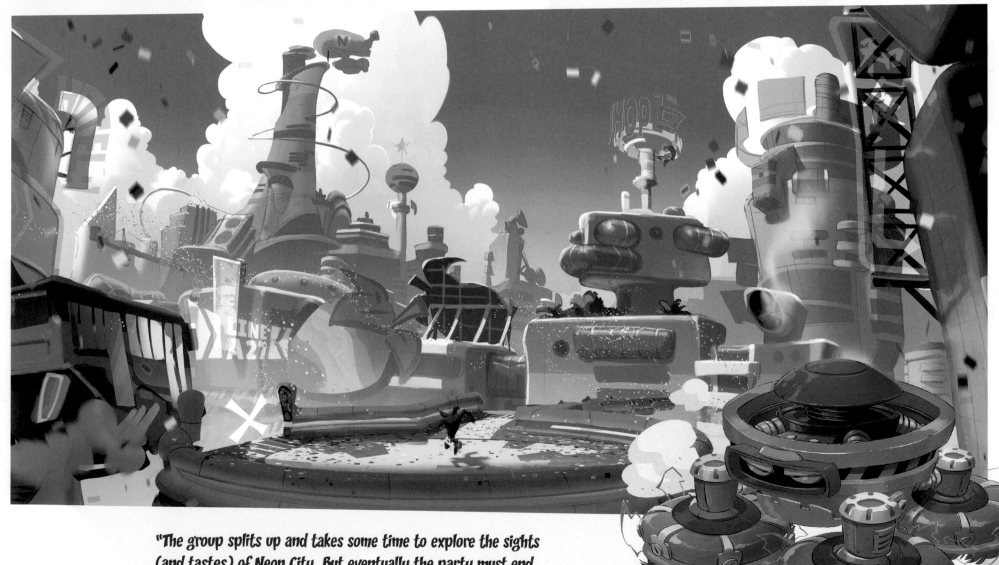

"The group splits up and takes some time to explore the sights (and tastes) of Neon City. But eventually the party must end. Once they've all been sated, they return to the blimp..."

—Josh Nadelberg

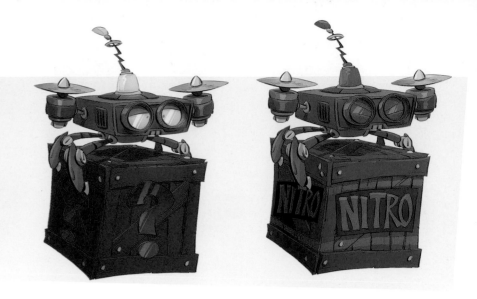

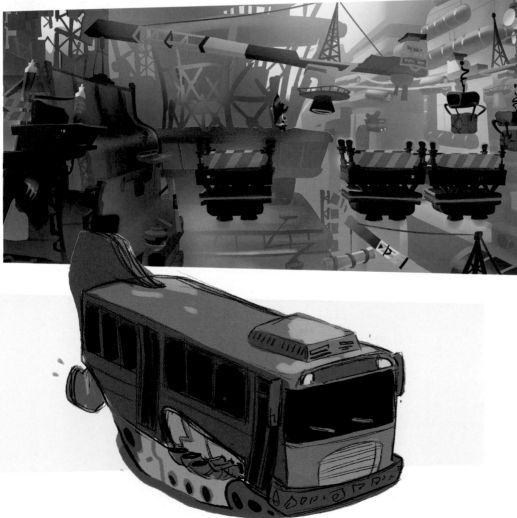

"After defeating N. Tropy we wanted the city to feel super colorful, fun, and refreshing. There weren't originally any enemies in the city, and it was all about challenging platforming. We designed all these wonderful robots just to bring the world to life, and as Design iterated on the gameplay, a bunch of them wound up becoming baddies, like these little delivery drones."

—Josh Nadelberg

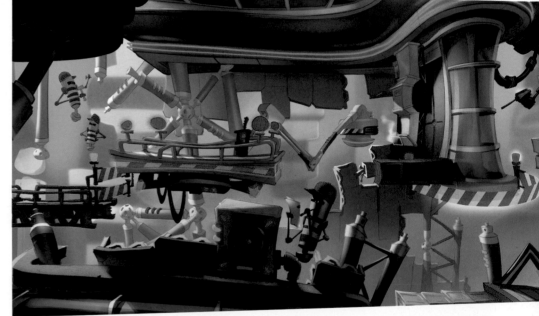

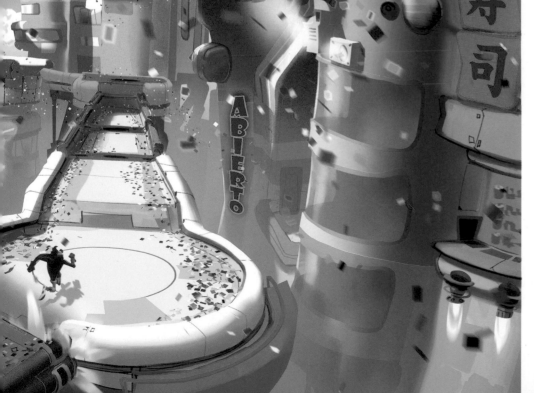

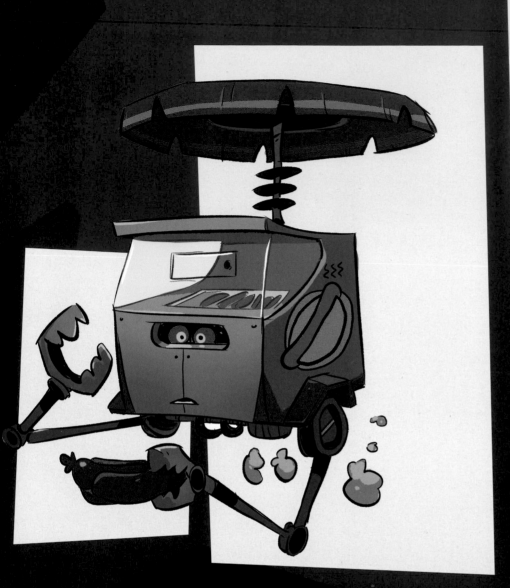

"In the far background is Dingo's Diner, and Crash is trying to get there. This is a takeout where cars drive through, and Crash is jumping between the cars that are having their orders taken. It was fun to combine Dingo's Diner with the futuristic element, to have those cars flying with the city down below... and a little hint at Spyro."

—Brun Croes

Frank's Plump Wieners Kioskbot

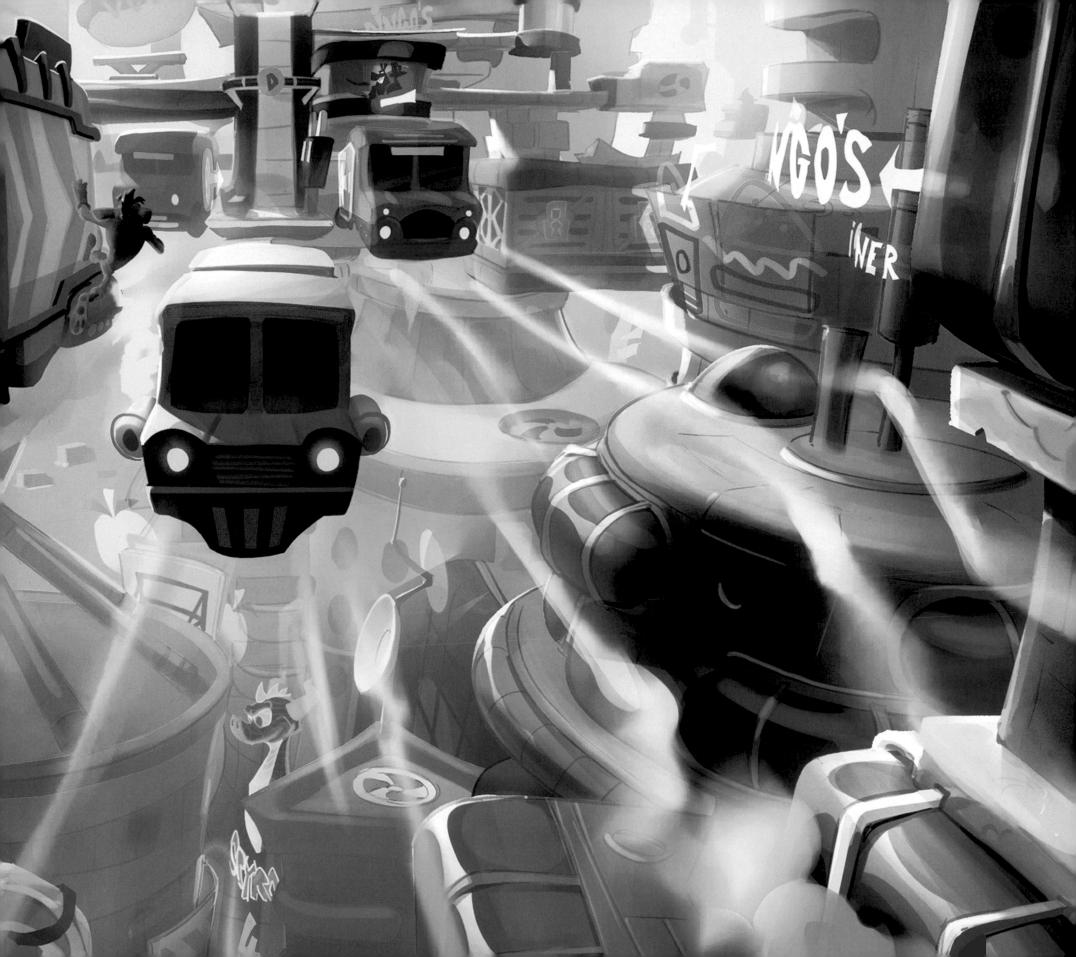

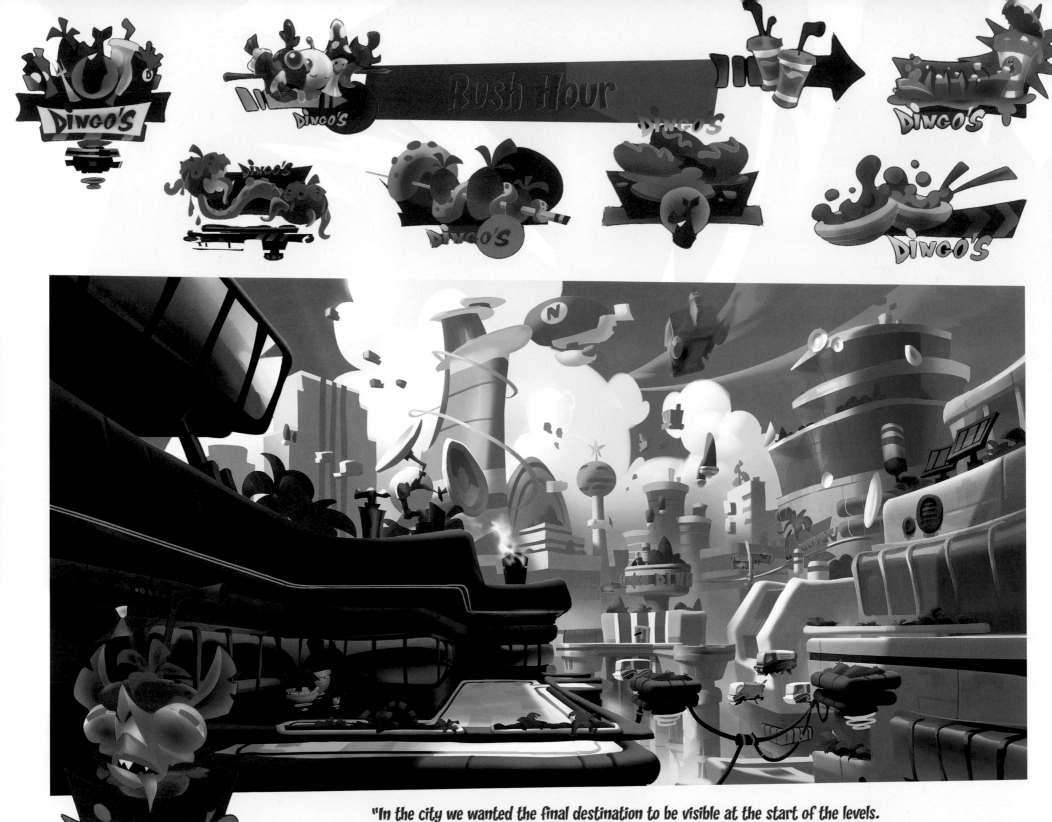

"In the city we wanted the final destination to be visible at the start of the levels. Here you can see Neo's blimp parked atop the building in the distance. This landmark is present in all 3 levels even though the heroes are all starting from different locations throughout the city. It's really incredible how huge this city is." —Josh Nadelberg

THE SN@XX DIMENSION

"We created lots of different signs in different languages. The reference we used for that were all the languages that the game would be translated into."

—Johannes Figlhuber

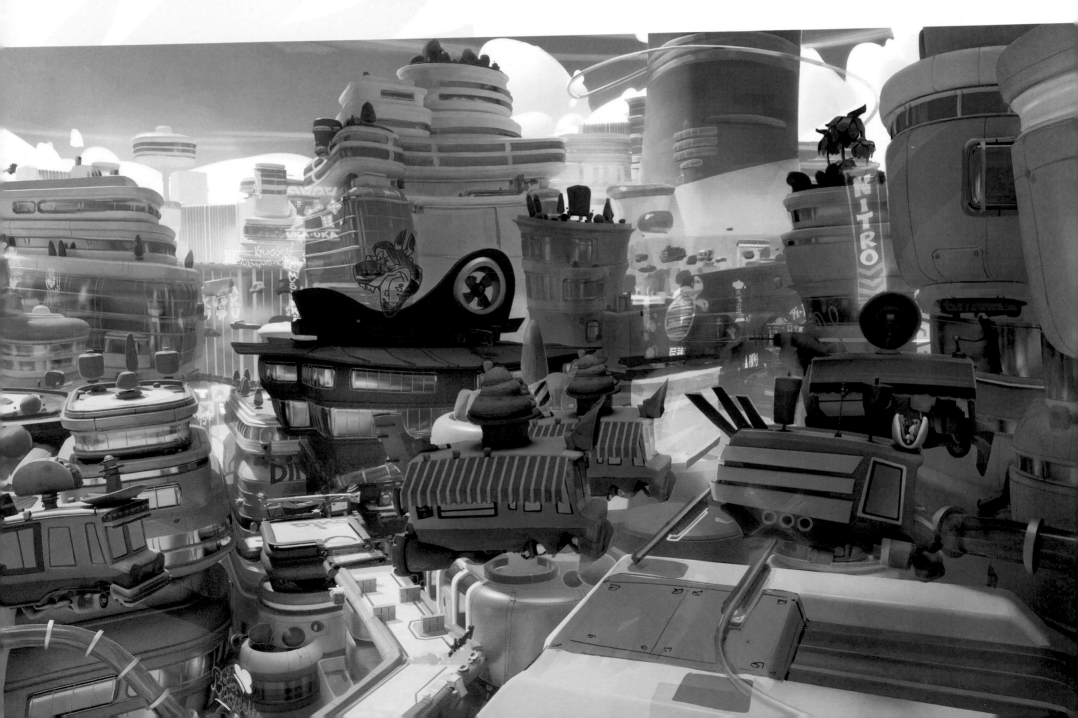

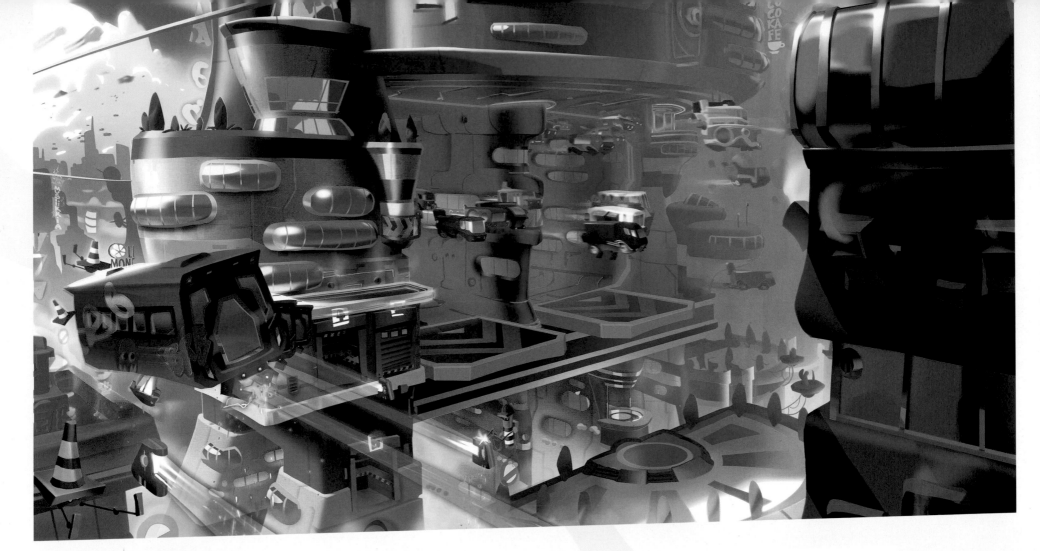

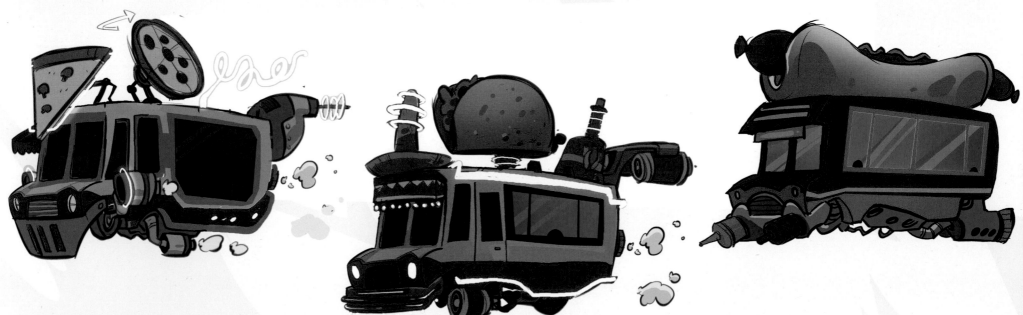

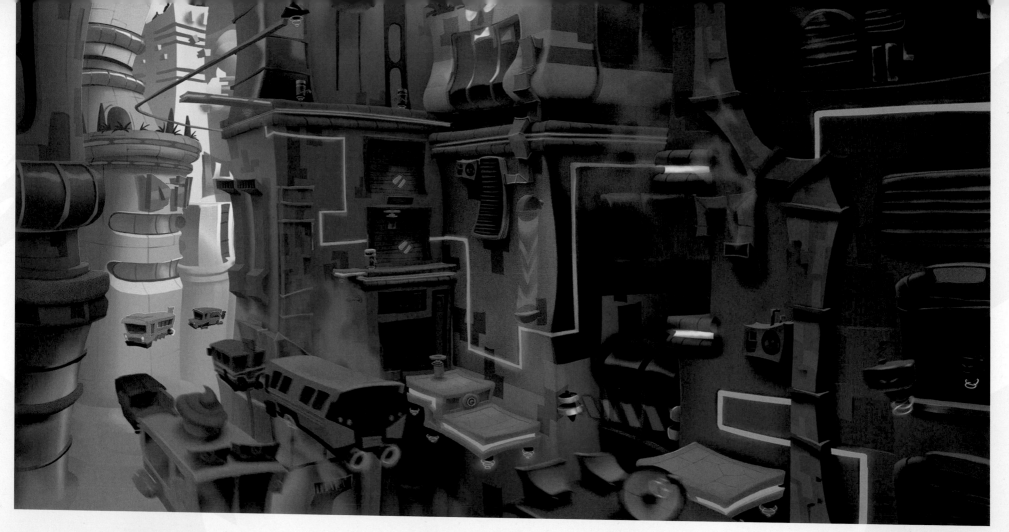

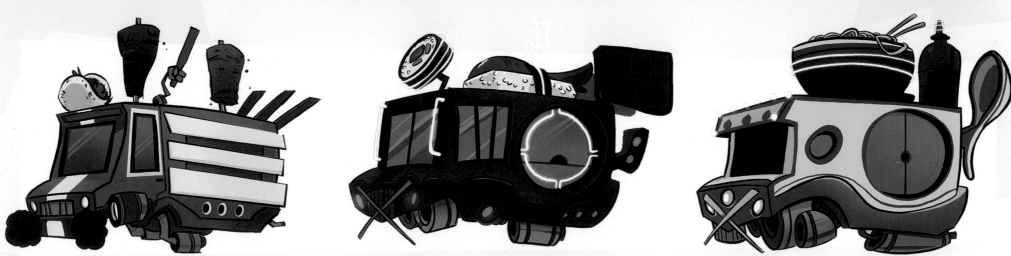

"Brett drew a food truck at one point with a big ice cream cone on top. We loved that and asked him to make a whole slew of variants that would add to this multicultural future city. The ketchup and mustard headlights on the hot dog truck are hilarious, and I love that Brett added a bottle of hot sauce next to the noodles. These little details add so much character to the world." —Josh Nadelberg

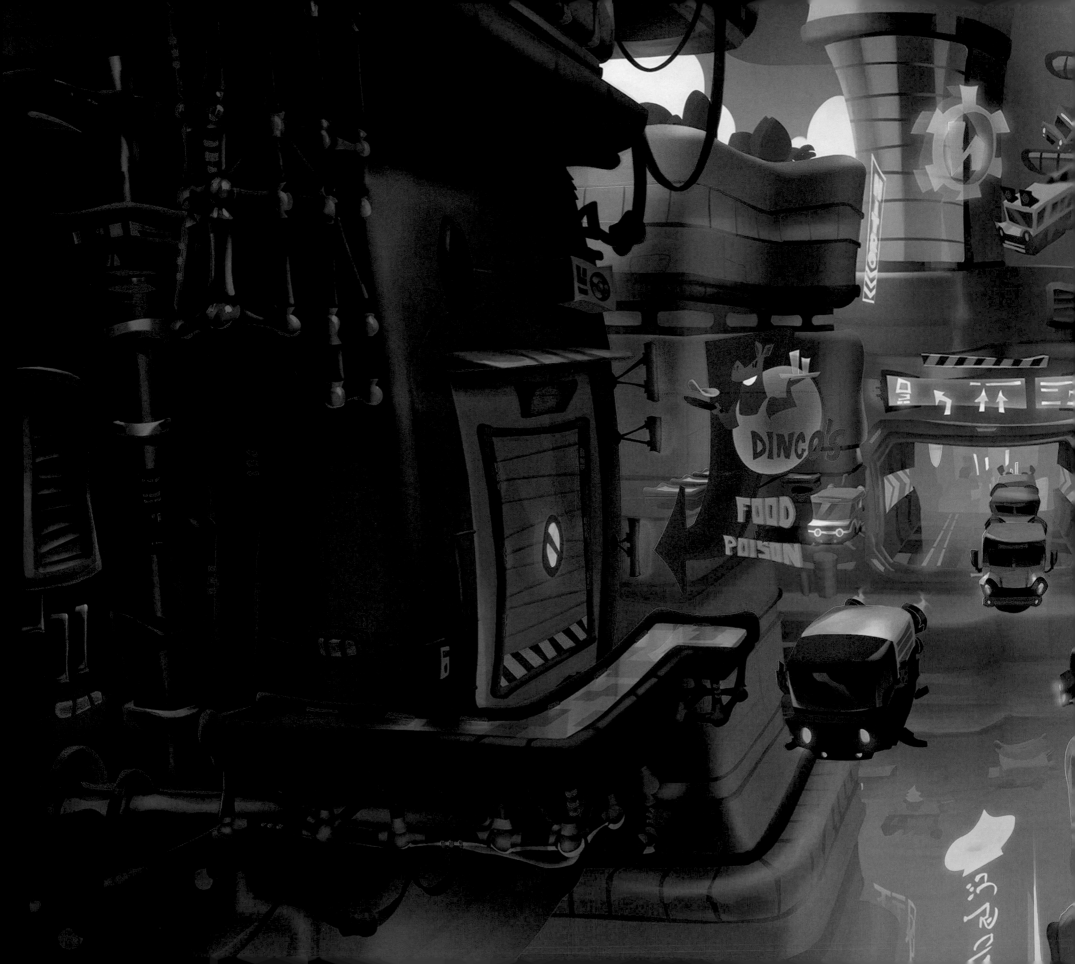

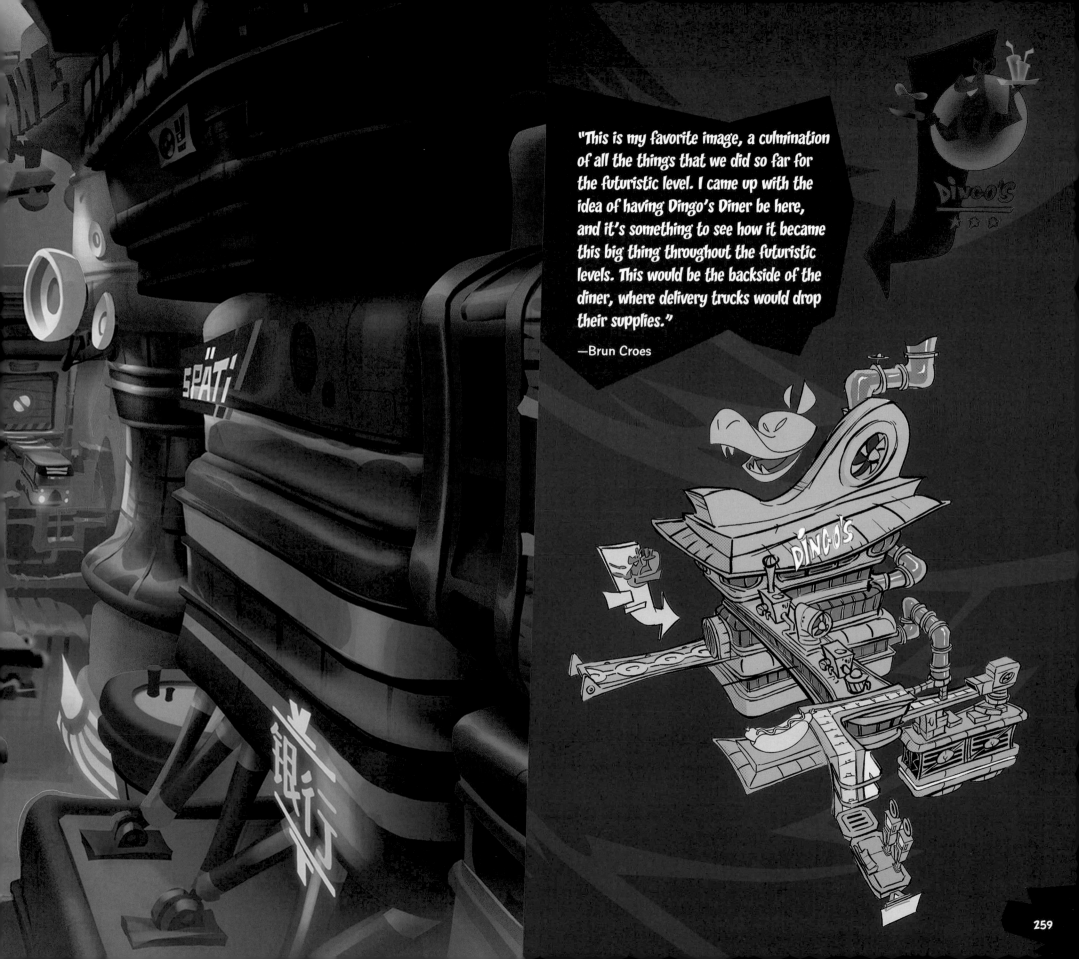

"This is my favorite image, a culmination of all the things that we did so far for the futuristic level. I came up with the idea of having Dingo's Diner be here, and it's something to see how it became this big thing throughout the futuristic levels. This would be the backside of the diner, where delivery trucks would drop their supplies."

—Brun Croes

The Crate Escape

"Cortex is the last to join the group, and he's unusually quiet. He's been replaying recent events in his head, and just as he reaches the others he's hit with an epiphany: there's **ANOTHER** way to break the cycle of losing to Crash, and it's not to join him—it's to prevent him from ever being '"born."' And he can use the masks to take him where he needs to go."

—Mandy Benanav

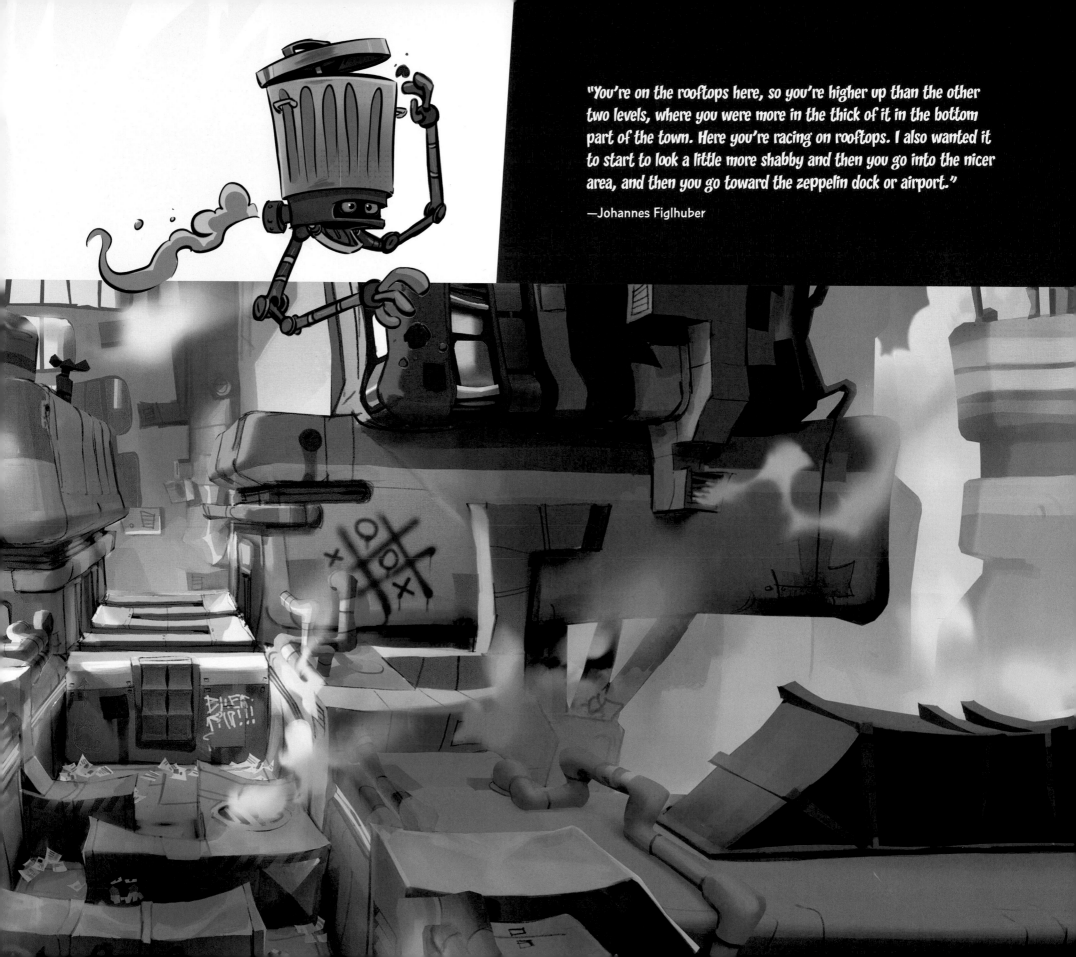

"You're on the rooftops here, so you're higher up than the other two levels, where you were more in the thick of it in the bottom part of the town. Here you're racing on rooftops. I also wanted it to start to look a little more shabby and then you go into the nicer area, and then you go toward the zeppelin dock or airport."

—Johannes Figlhuber

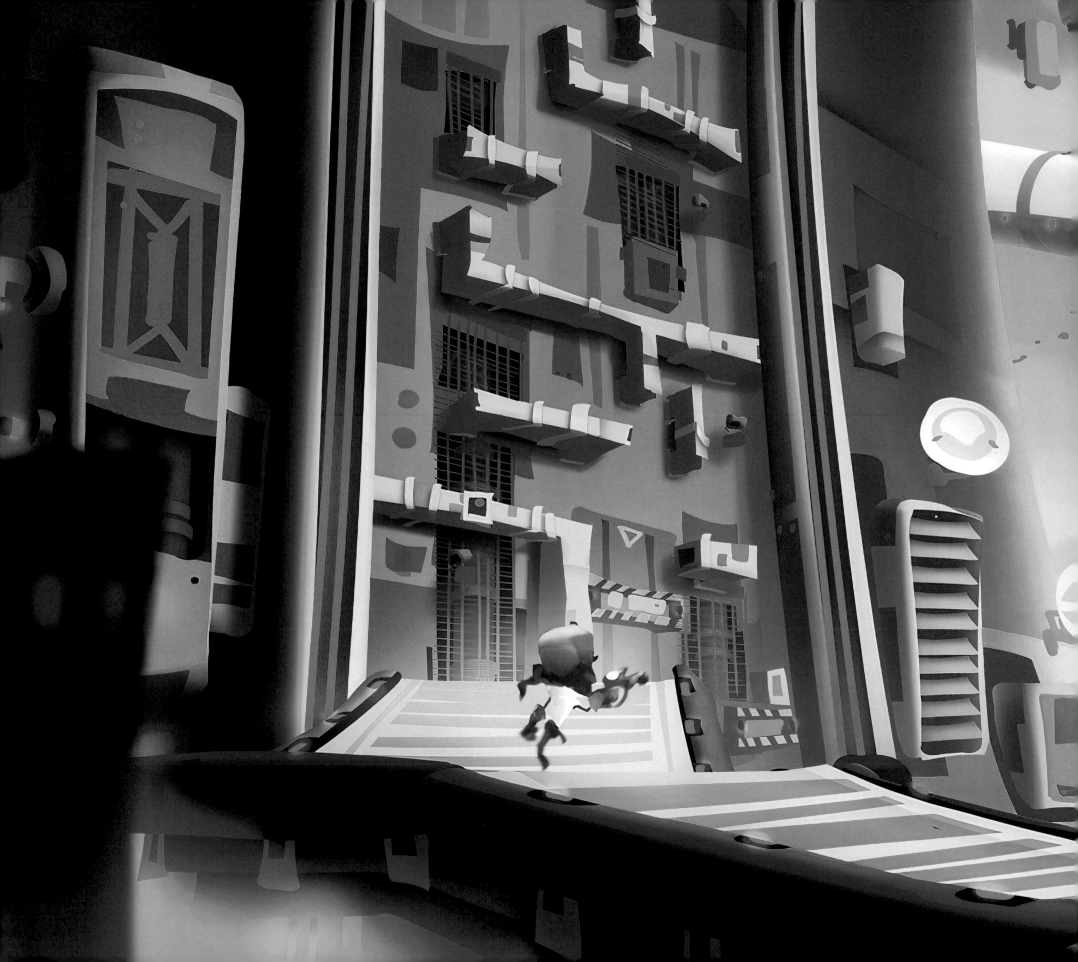

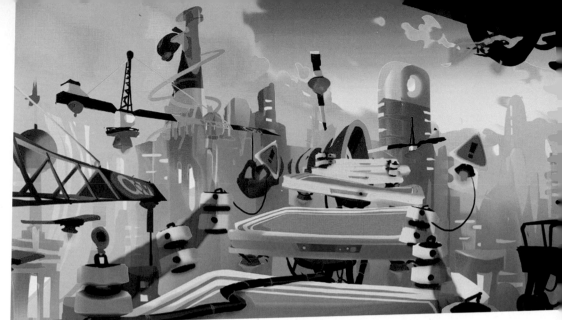

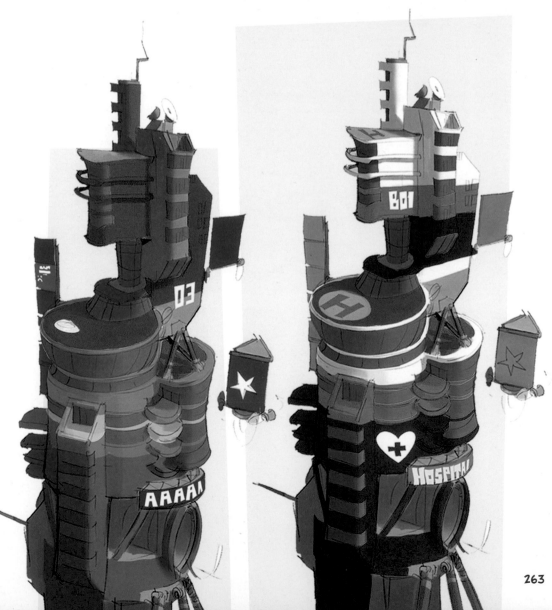

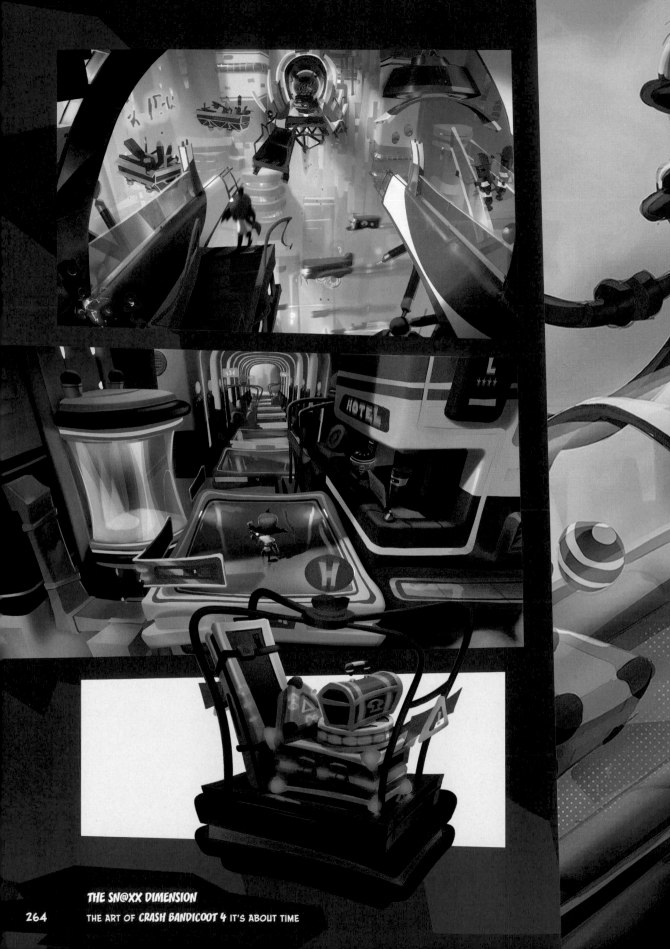

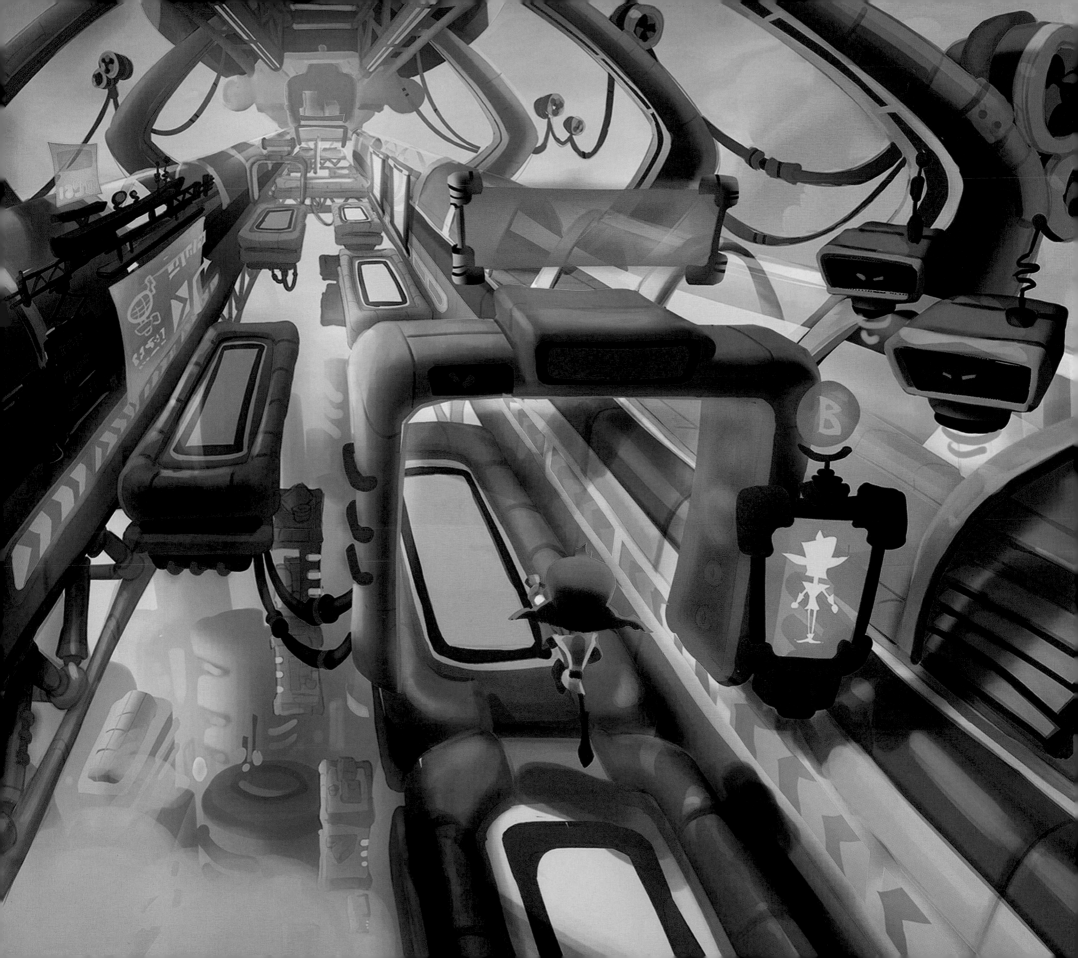

"Cortex kidnaps Kupuna-Wa and jumps into his blimp and flies away, leaving a trail of boxes and luggage falling out the back of the blimp. Crash jumps into the melee of falling crates and miraculously manages to make his way to the blimp. Neo opens a portal back to where it all began. Just as the bandicoots catch up with him (Tawna and Dingo get left behind when they clear the way for our leads), he opens a massive rift and steers his blimp through it, sending the bandicoots off the side. What he doesn't know is that they managed to grab the back of the blimp and are holding on tight."

—Mandy Benanav

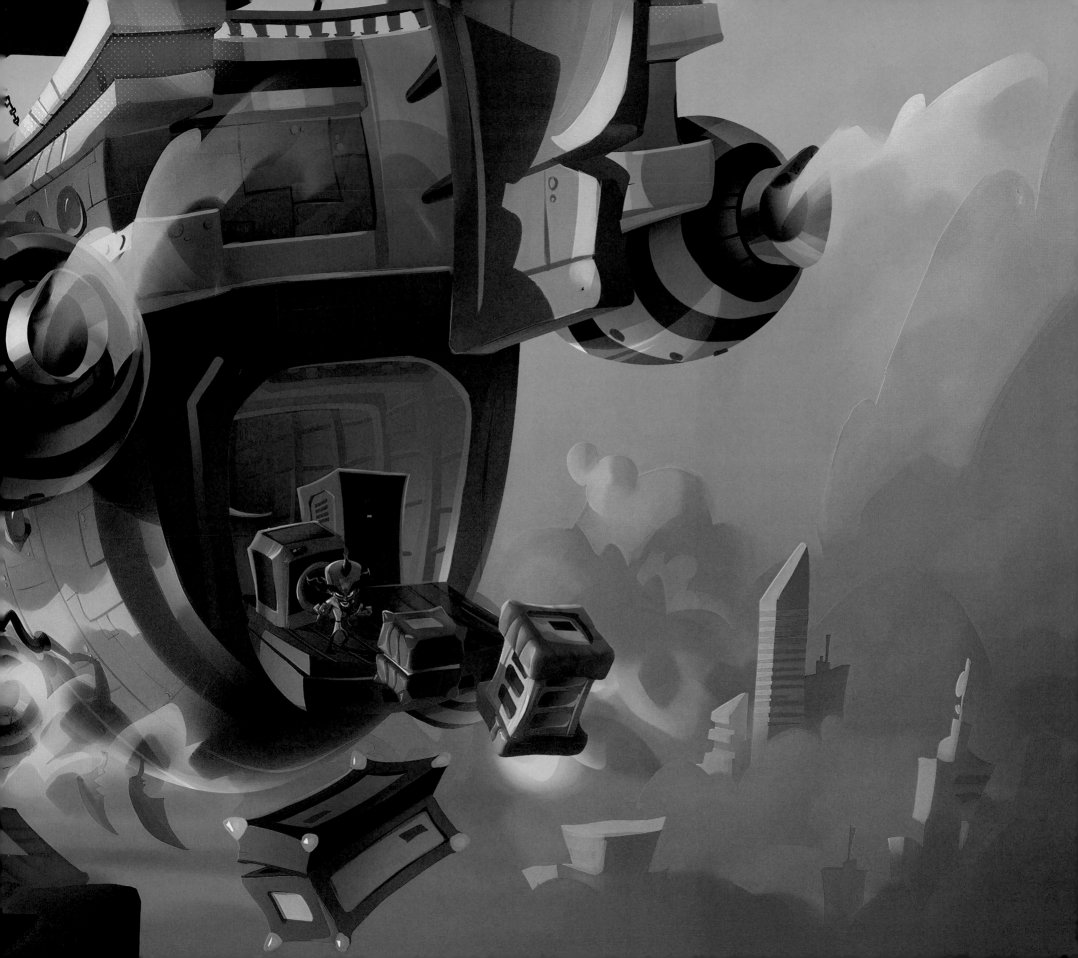

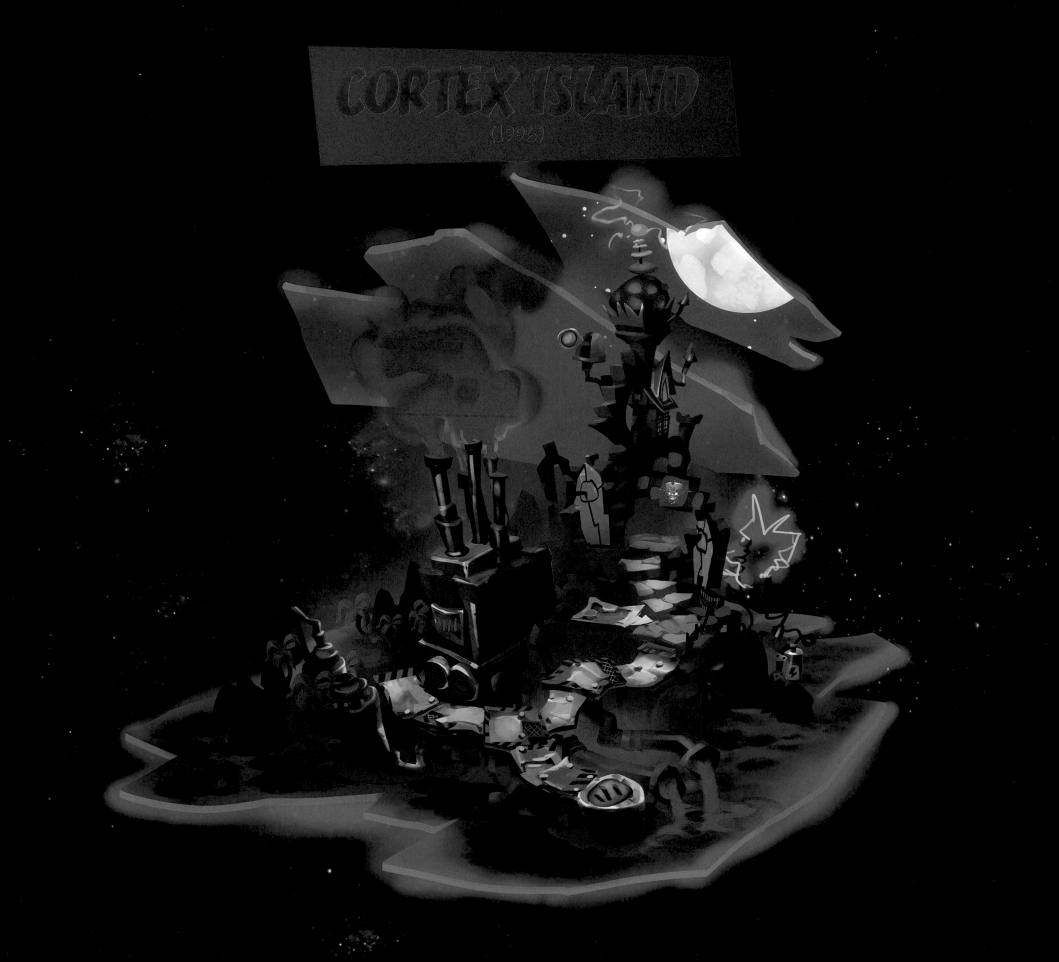

CORTEX ISLAND

(1996)

Nitro Processing

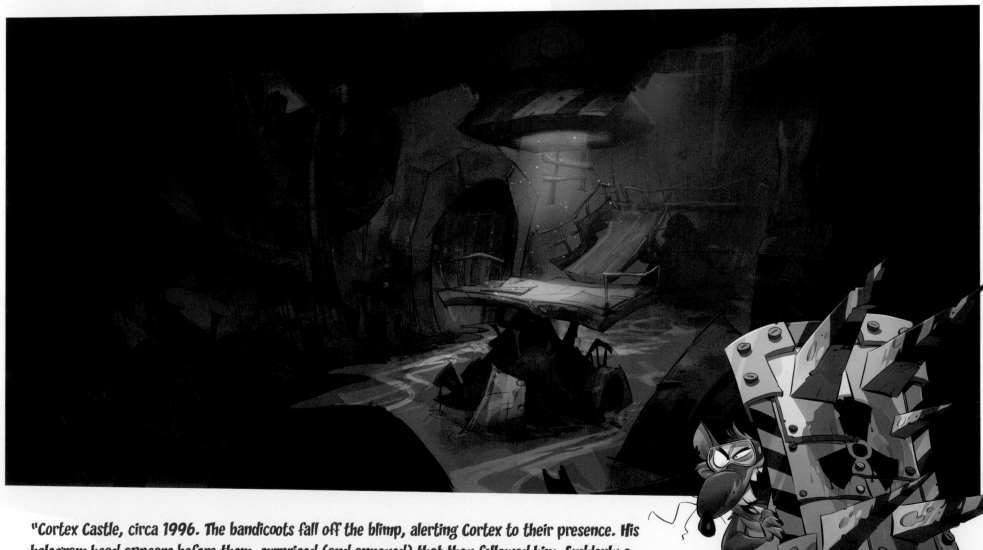

"Cortex Castle, circa 1996. The bandicoots fall off the blimp, alerting Cortex to their presence. His hologram head appears before them, surprised (and annoyed) that they followed him. Suddenly a second holo-head appears! A second Cortex holo-head. Cortex comes to the grim realization that his biggest obstacle to enacting his plan isn't Crash, it's... himself. Young Cortex refuses to believe what he's seeing and orders his lackeys to keep an eye out for this 'impostor.'" —Mandy Benanav

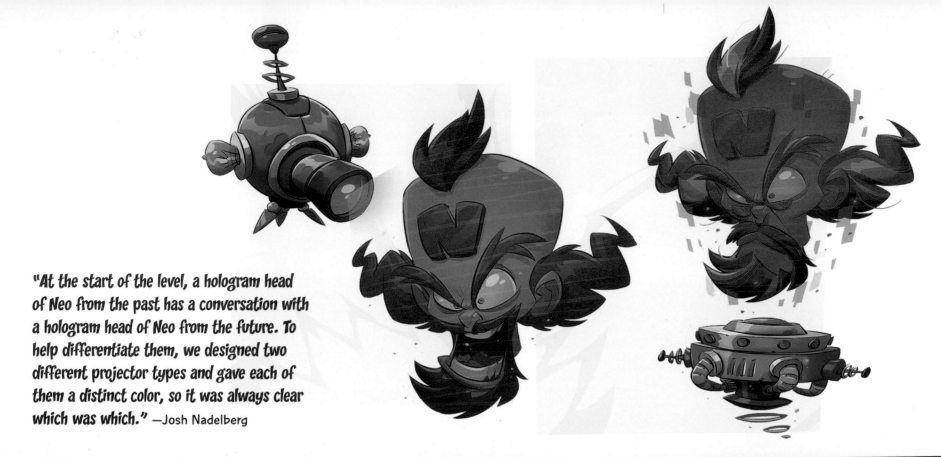

"At the start of the level, a hologram head of Neo from the past has a conversation with a hologram head of Neo from the future. To help differentiate them, we designed two different projector types and gave each of them a distinct color, so it was always clear which was which." —Josh Nadelberg

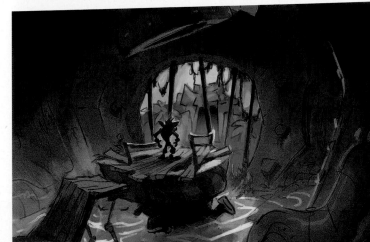

"I was trying to figure out what the feel of the sewer was. We didn't even know it was going to be a sewer when I drew some of this stuff, so some of these paintings were trying to figure that out. I was like, 'Okay, so there's a power plant that is polluting a sewer that is also a junkyard. The idea is that everything's coming downstream. Cortex Castle and all his contraptions are just polluting everything, and this is like the gunky place where all the garbage goes to collect from his crazy experiments."

—James Martin

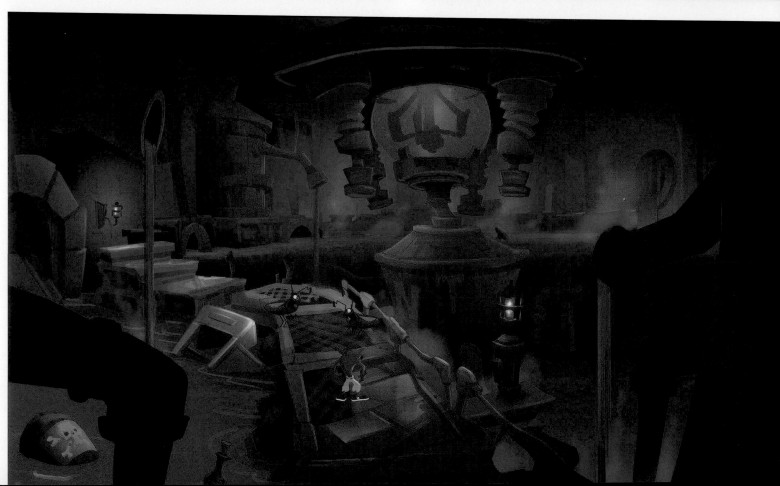

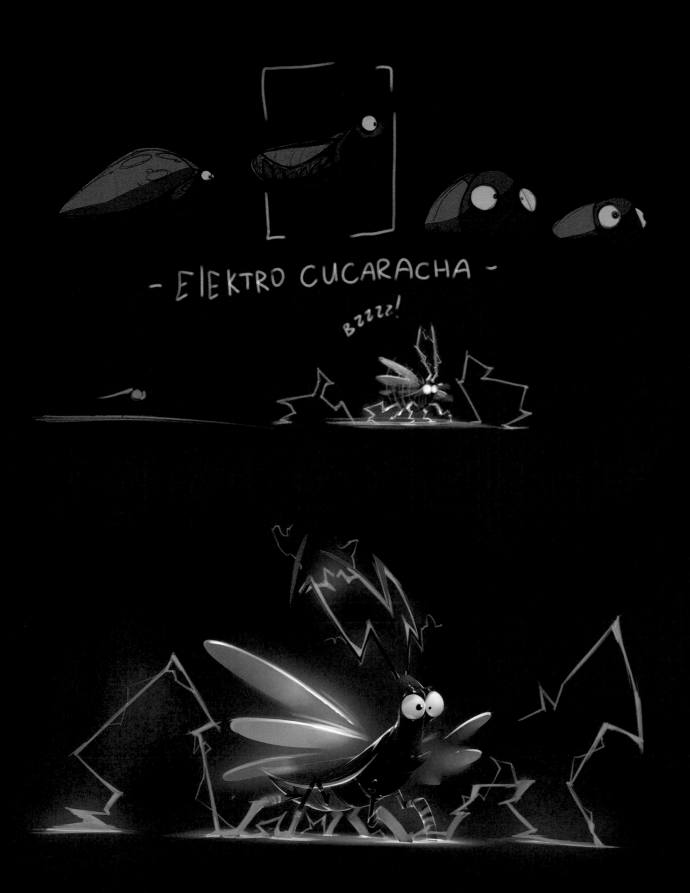

- ELEKTRO CUCARACHA -

BZZZZ!

"This was my concept. It's a simple character, a character that might live in this area, but it was too simple, so I made a little animation for him and called it 'electro cucaracha' and sent it to Josh. Everybody was laughing. We had fun and forgot about it. Two weeks later, Josh called me and said the team approved this character. Since then I make animations for everything."

—Oleg Yurkov

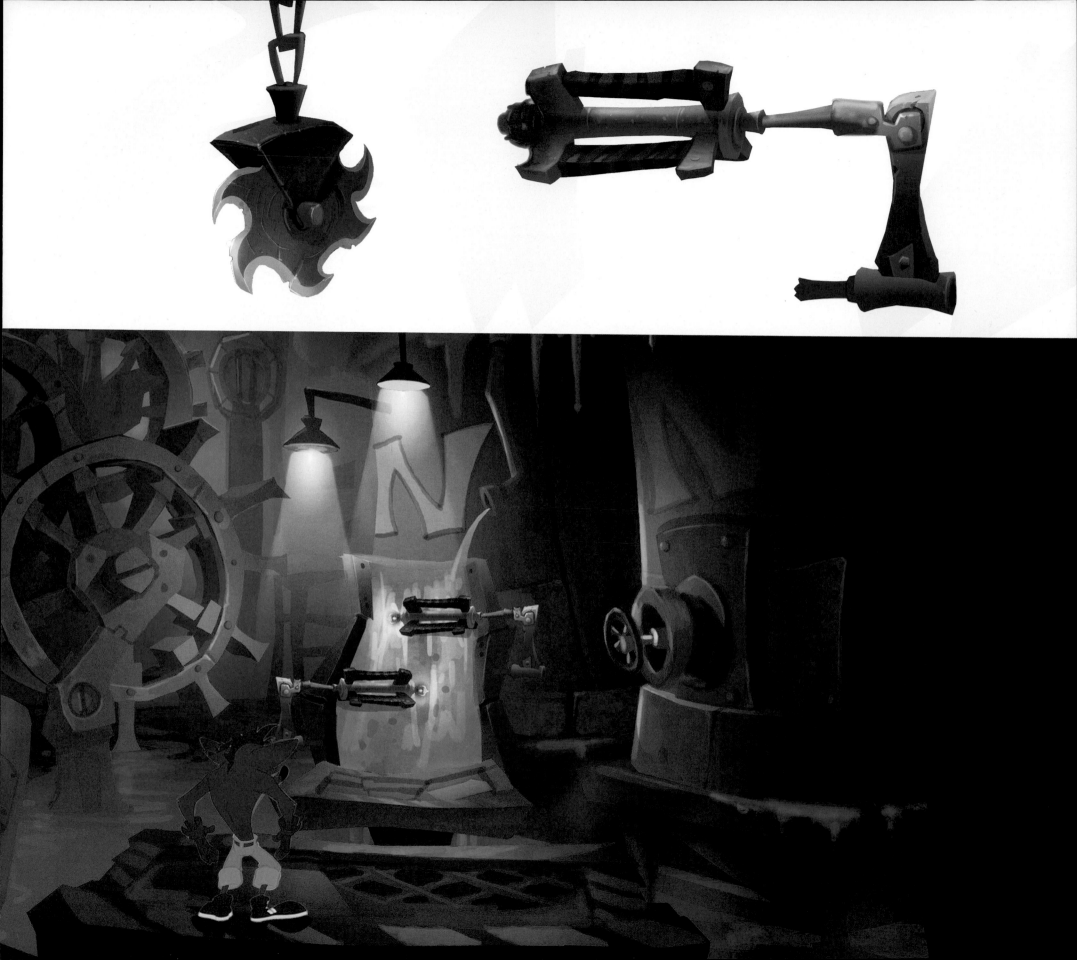

"From the Nitro plant, the bandicoots continue through the sewers and through the volcanic furnaces that power Neo's castle. Finally, at the end of the level, they get to the castle's 'back door.'"

—Josh Nadelberg

"Coming from drawing characters, it's all about the details. It's all about the costumes, the look and the feel. The mood and personality are definitely important but in an environment they're of huge importance. When you're running through an environment, the thing that you take away from it in most cases is the mood and the overall feeling."

—Jeff Murchie

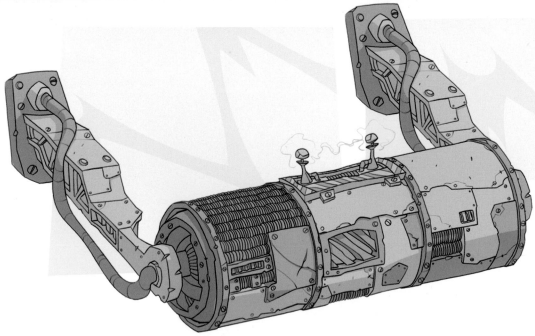

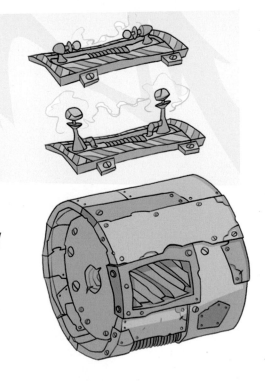

"We started out with this idea of toxic crystals, and then we decided to go in a different direction. The area is still toxic, but there's no crystals. It has a little more of the traditional greenish yellowish hues. I like the pipe work and the texturing. We added electricity for extra color and an extra sense of danger and just to show that that the area was really run down and kind of neglected."

—Jeff Murchie

CORTEX ISLAND

"I was working with a lot of shapes, trying to be wonky and trying to make things feel a little unstable in areas, make areas feel a little bit dangerous. That was something we were always trying to make you feel, even though the environments aren't moving, we wanted them to feel like they've been lived in and it's not a pristine world."

—Jeff Murchie

"For Neo Cortex's castle, that lower section is a design that I came up with. We wanted a way to enter the castle from below without having to change the design that had been established in past games. So we added this secret entrance. We wanted it to feel like when you're coming up from the toxic waste areas and the magma, you feel the verticality, like you're going up and it's big and overwhelming."

—Jeff Murchie

CORTEX ISLAND

Cortex Castle

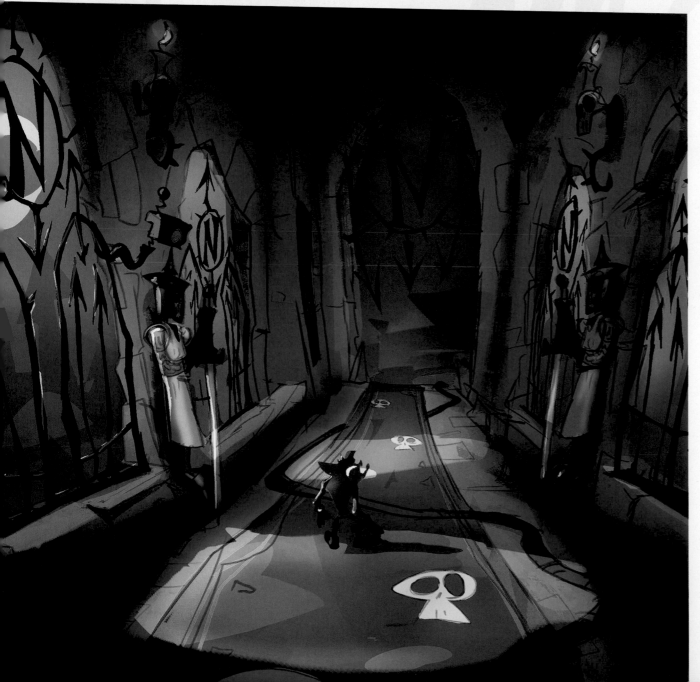

"Crash and Coco make their way through Neo's surreal castle, past paintings of Neo's parents and favorite family dog and tons of other fun little Easter eggs. At one point, the path seems blocked. A giant gap is before Crash, when suddenly a lab assistant comes tumbling down a chute and triggers a drawbridge to lower (huh???). In Neo's Timeline, he encounters his younger '90s self, and in the melee of that conflict sends a lab assistant down a book return chute in the library. Finally, Crash and Coco make it to the final chamber..." —Josh Nadelberg

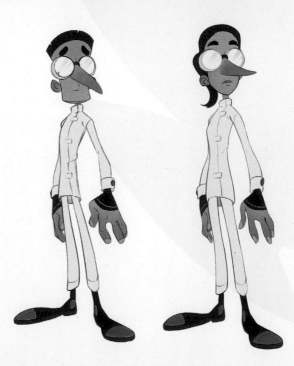

279

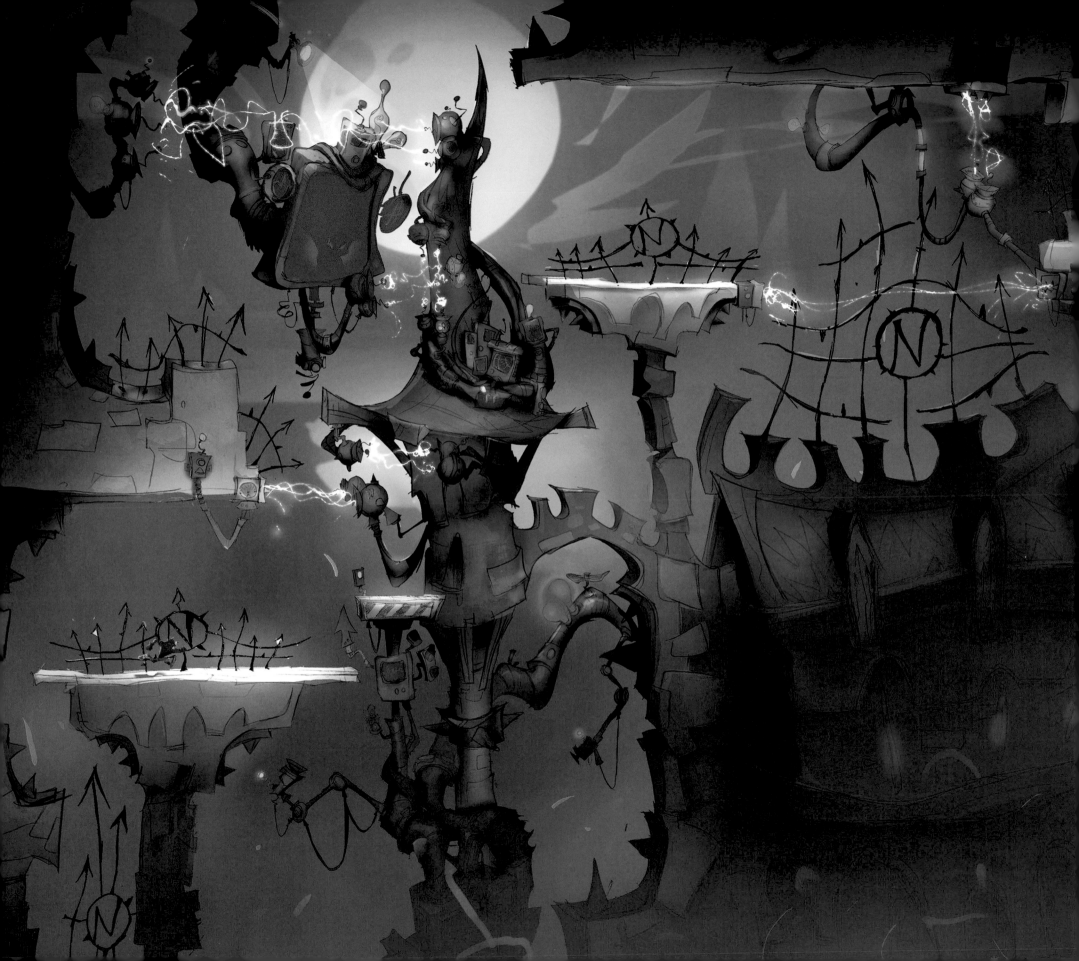

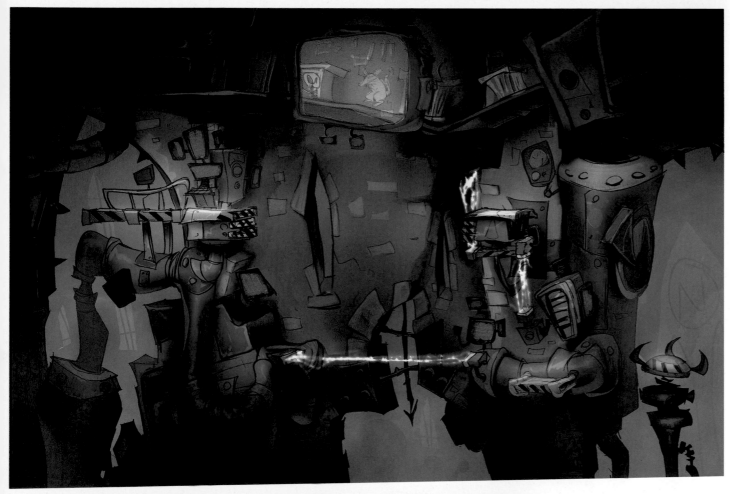

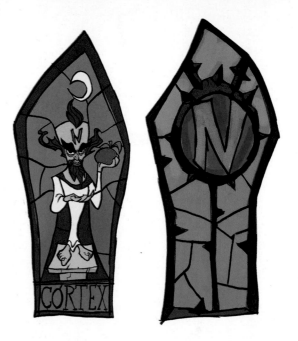

"You had this castle in the first game, and this is a different part of it. This is kind of a redesign of the final levels of the first game but with our team's take on it."

—James Martin

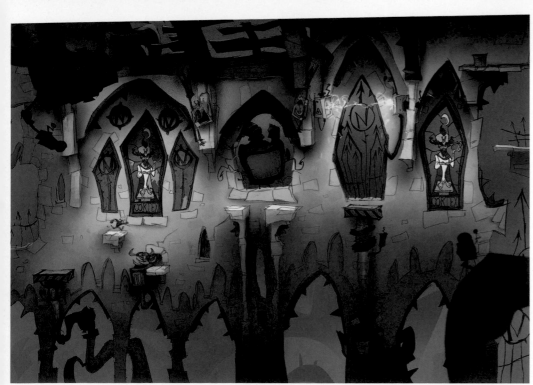

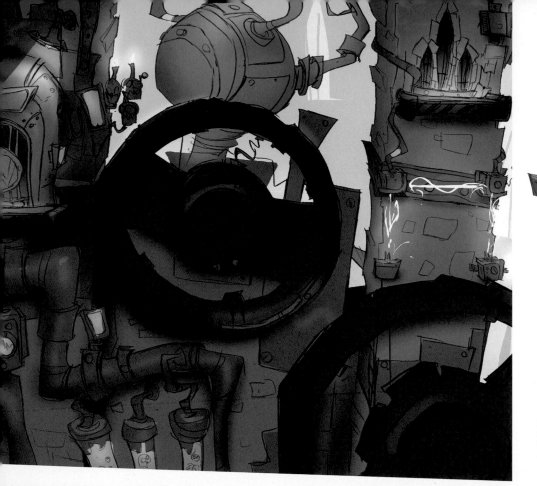
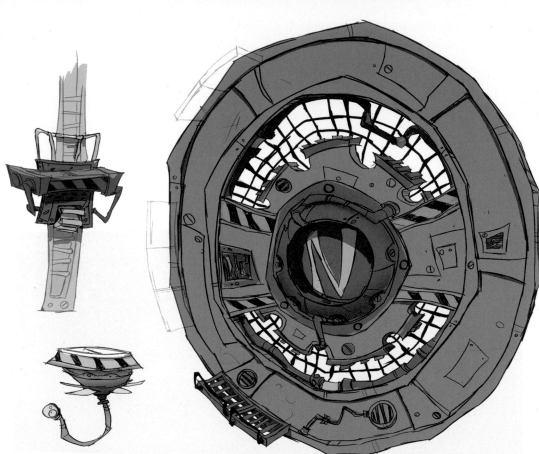
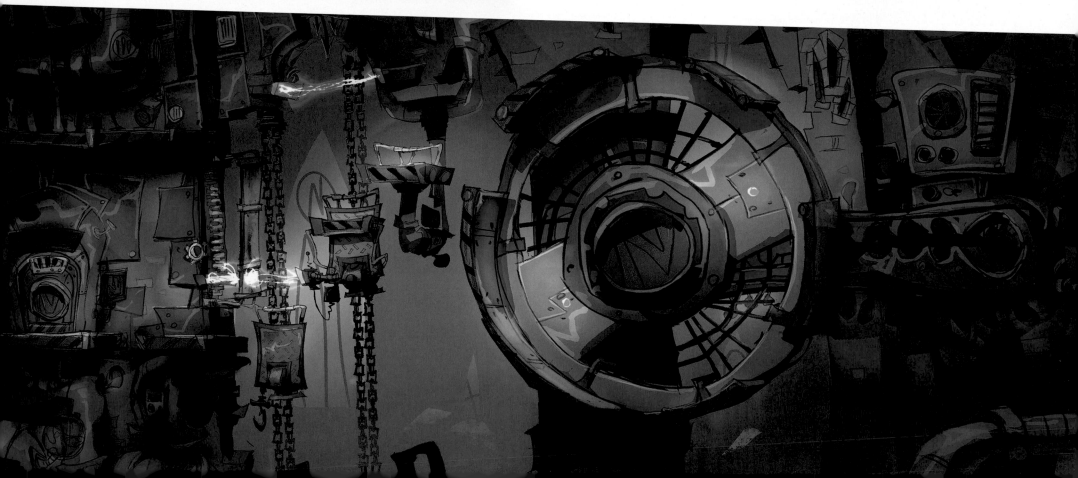

"*I tried to put a lot of cables, to indicate that there's no Wi-Fi, or anything, everything's plugged in like old cameras and stuff. And the knights, I wanted to tie in the old game so I put things like the knights from CRASH BANDICOOT 3 in the castle, they're skeletons.*"

—James Martin

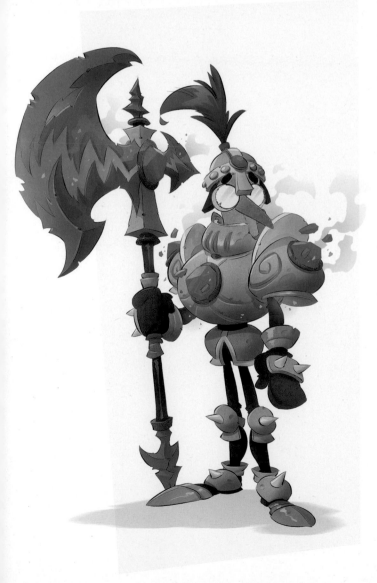

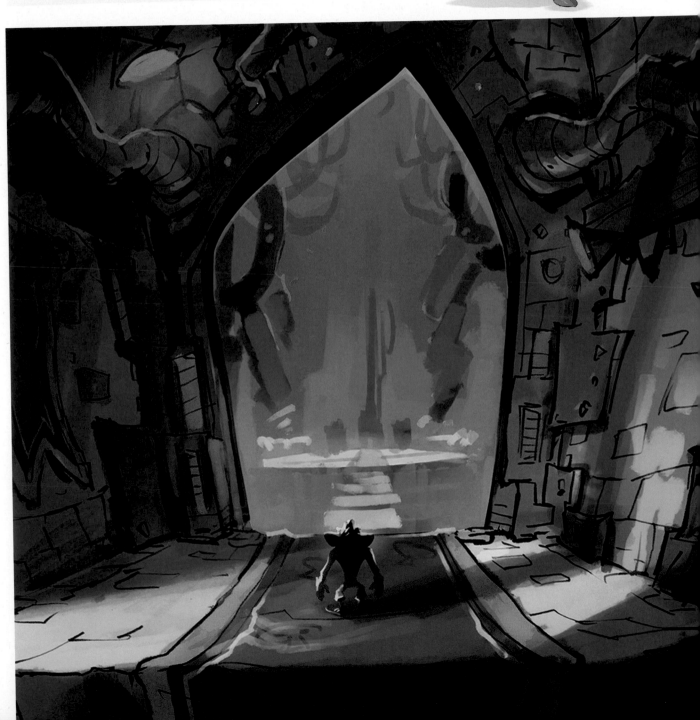

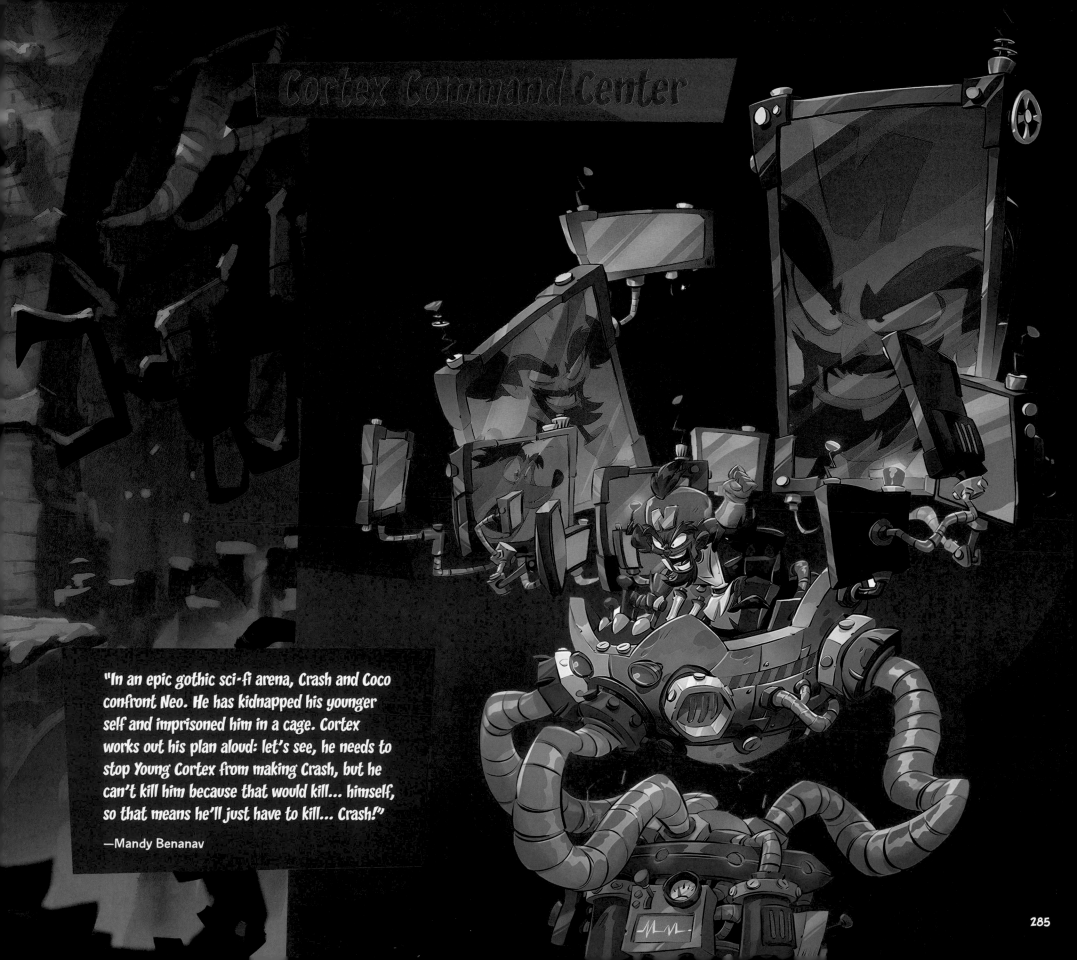

Cortex Command Center

"In an epic gothic sci-fi arena, Crash and Coco confront Neo. He has kidnapped his younger self and imprisoned him in a cage. Cortex works out his plan aloud: let's see, he needs to stop Young Cortex from making Crash, but he can't kill him because that would kill... himself, so that means he'll just have to kill... Crash!"

—Mandy Benanav

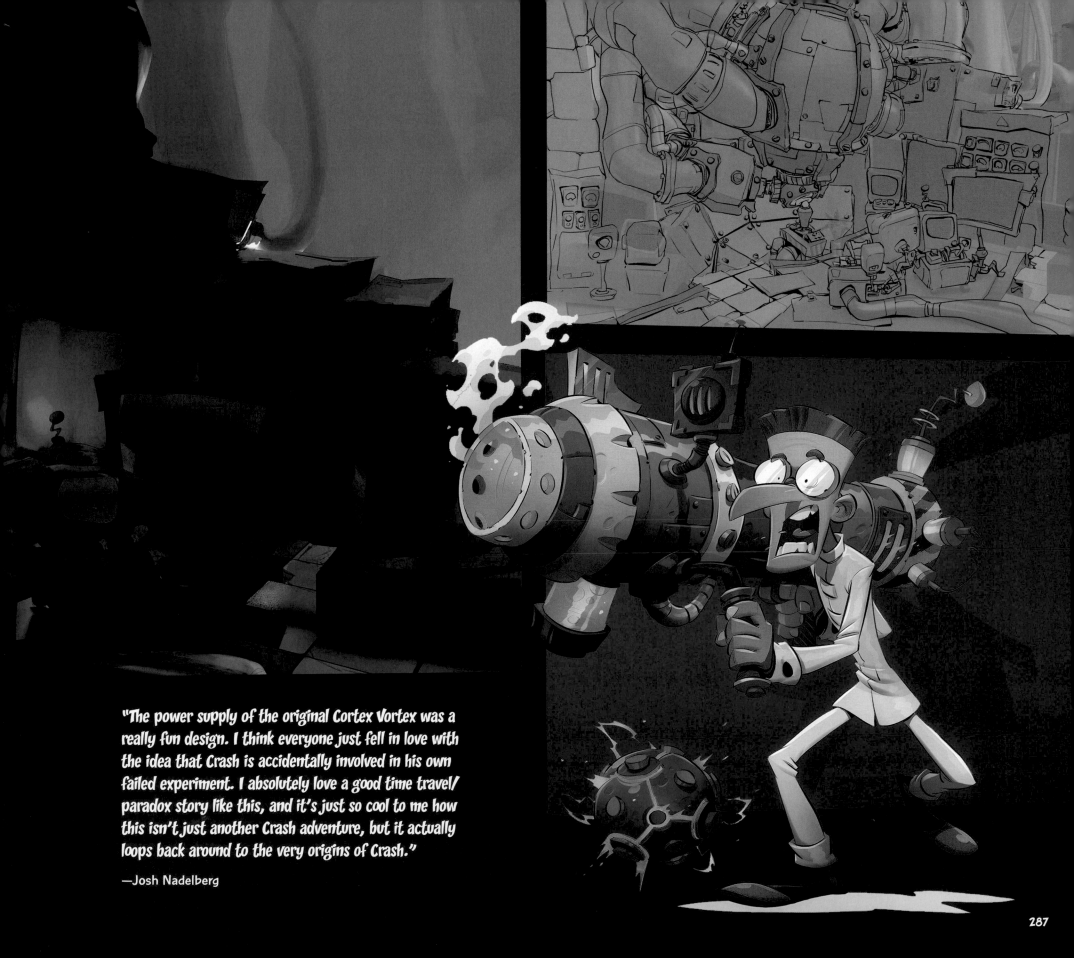

"The power supply of the original Cortex Vortex was a really fun design. I think everyone just fell in love with the idea that Crash is accidentally involved in his own failed experiment. I absolutely love a good time travel/ paradox story like this, and it's just so cool to me how this isn't just another Crash adventure, but it actually loops back around to the very origins of Crash."

—Josh Nadelberg

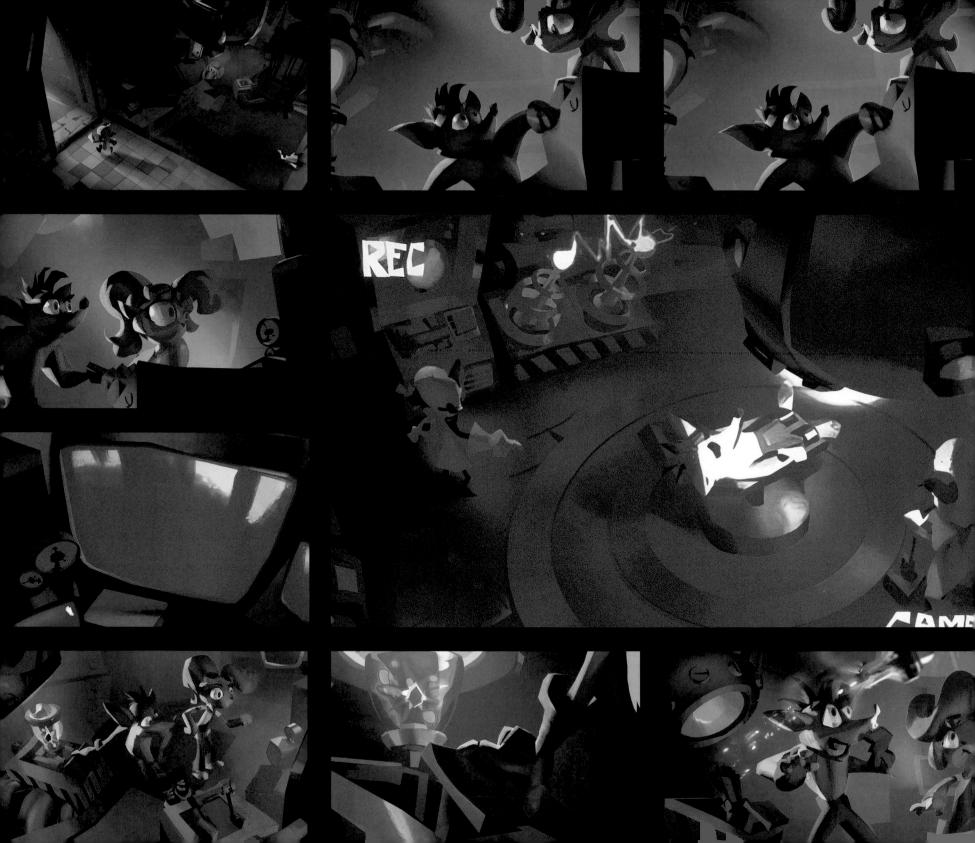

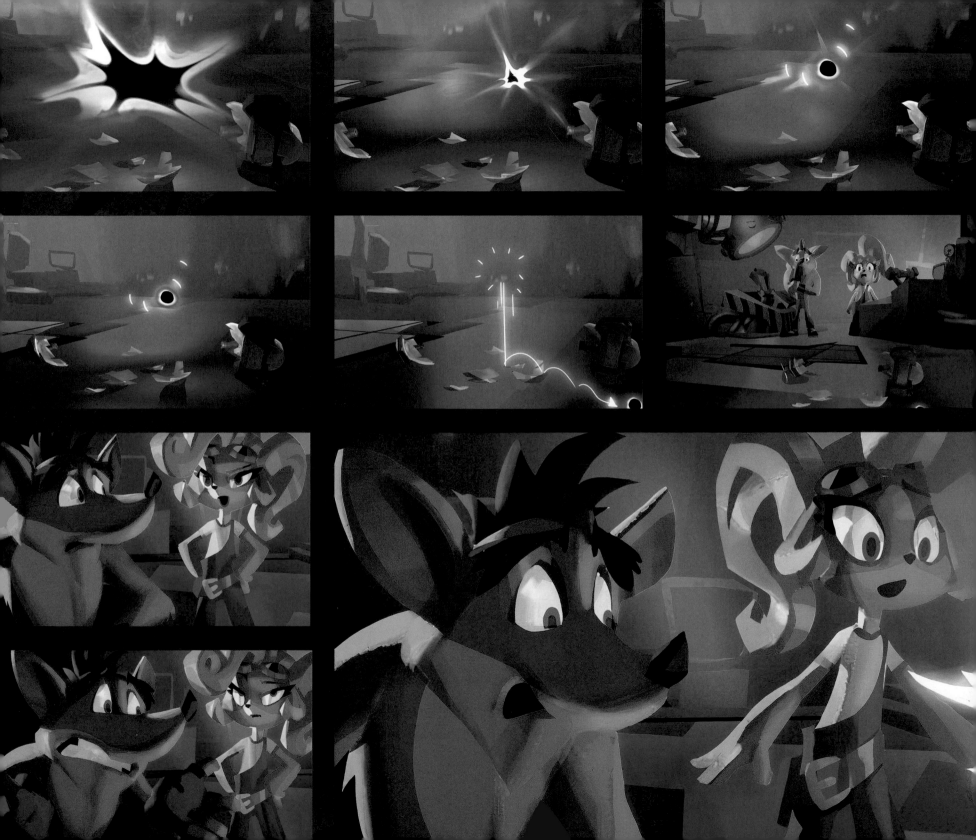

"Crash and Coco defeat Cortex once and for all. He lays in a daze as Young Cortex awakens in a stupor and puts the events together in his head... if the 'impostor' is lying dazed on the ground before him it can only mean one thing—they fought, and he won! Hooray, Cortex! He leaves on his merry way to create Crash Bandicoot. Or does he? At the crucial point where the Cortex Vortex rejects Crash Bandicoot... it seems our very own Crash accidentally caused the rejection. As in Crash 1, he escapes brainwashing and capture, and leaves to live his life on N. Sanity Island. If Crash hadn't gone back in time and caused the machine to reject him, would he exist as he does today? We'll never know.

Soon our Cortex's head begins to clear, and the masks have a particular punishment in mind: a time out... at the end of the universe.

Crash, Coco, and the masks head back home. It's about time."

—Mandy Benanav

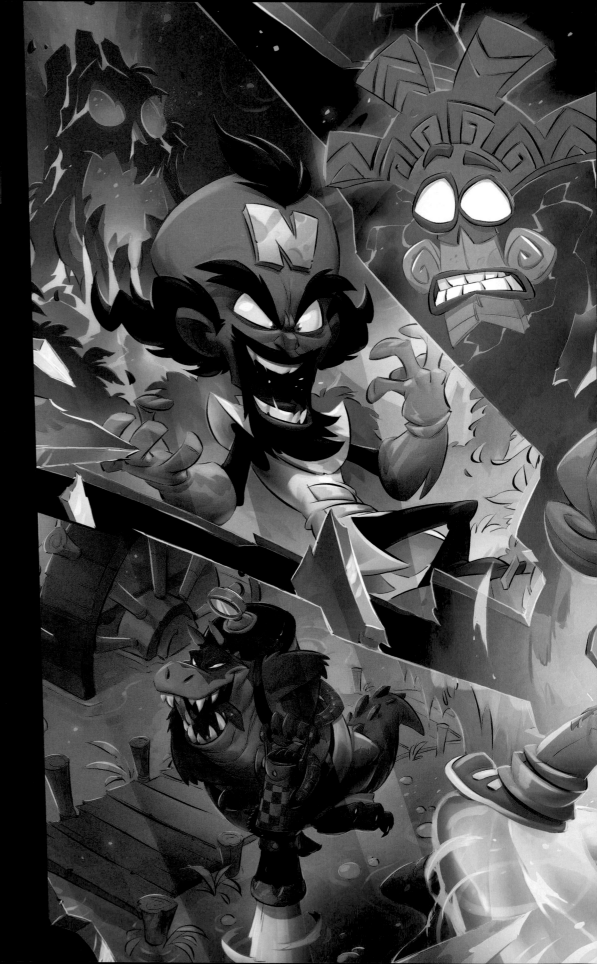

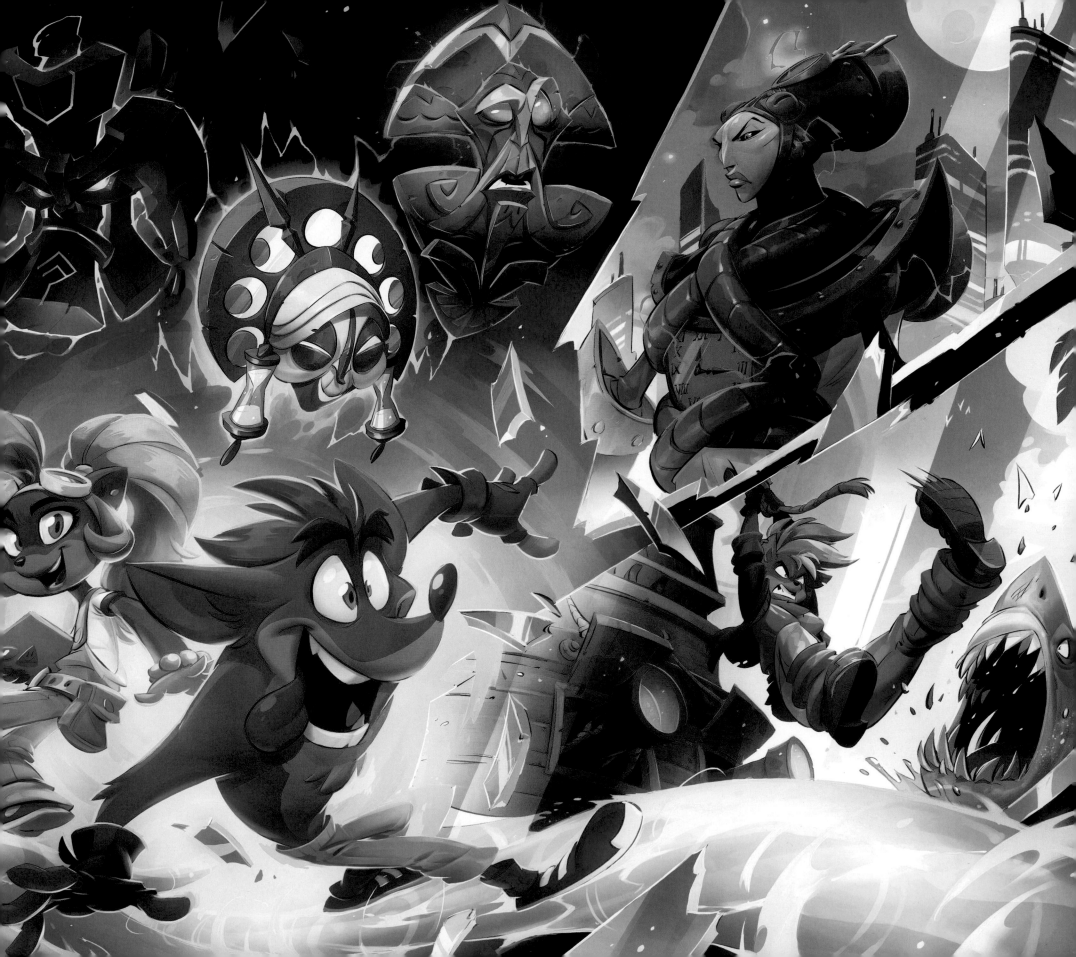

Memories/Flashback

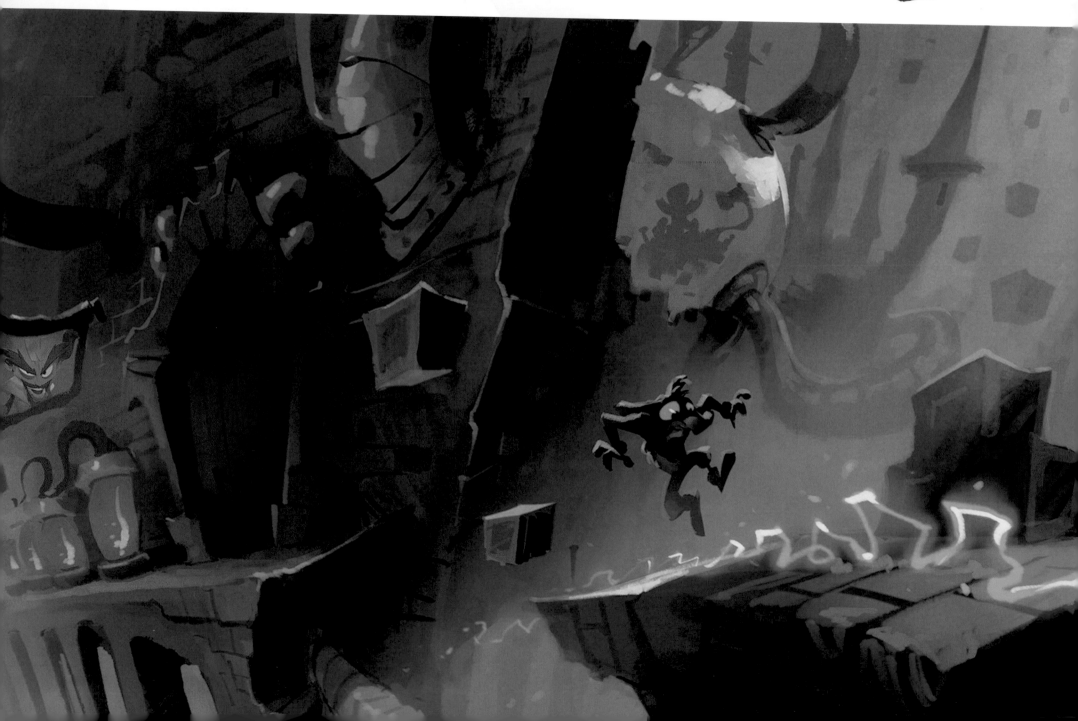

"The flashbacks are another great bit of simple storytelling. We wanted to create a whole bunch of really challenging side-scrolling crate-breaking levels and decided to frame them up as these old experiments that Neo Cortex performed on Crash before he decided to put him into the Cortex Vortex."

—Josh Nadelberg

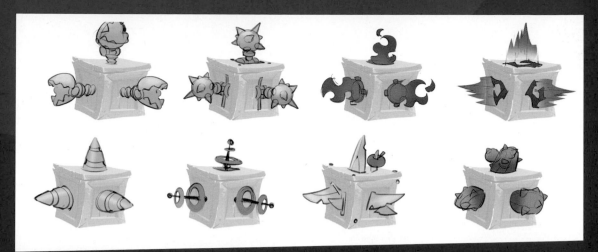

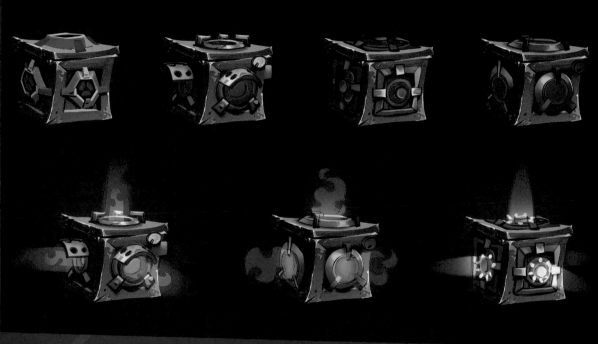

293

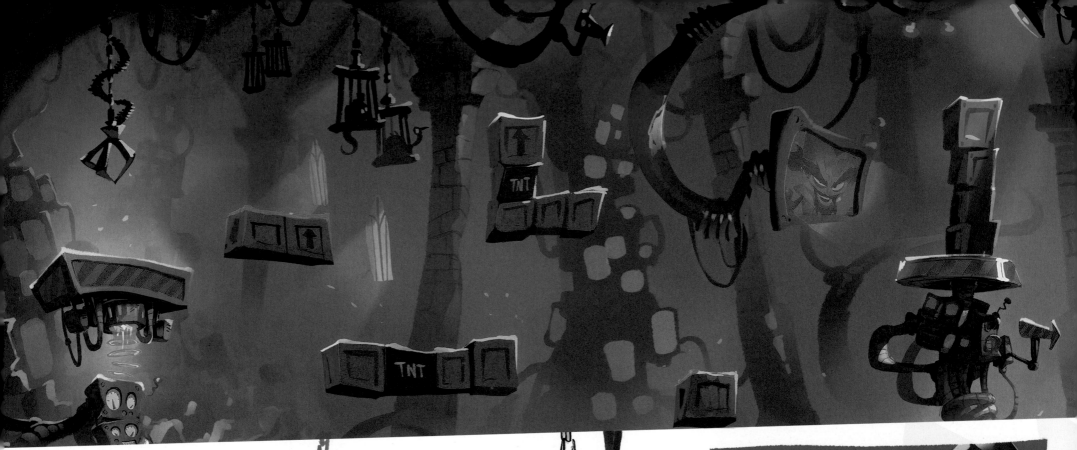

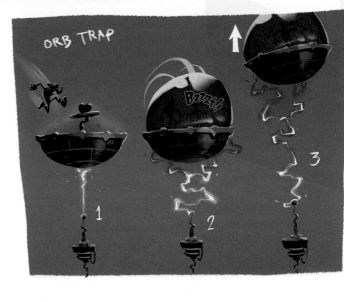

ORB TRAP

1

2

3

LEVEL STARTS

"John came up with all of these funny ideas for the start and end of the flashback levels. Since he's doing these experiments on Crash, we thought it was super funny if he picked him up with a big claw by the scruff of his neck and dropped him at the starting point."

—Josh Nadelberg

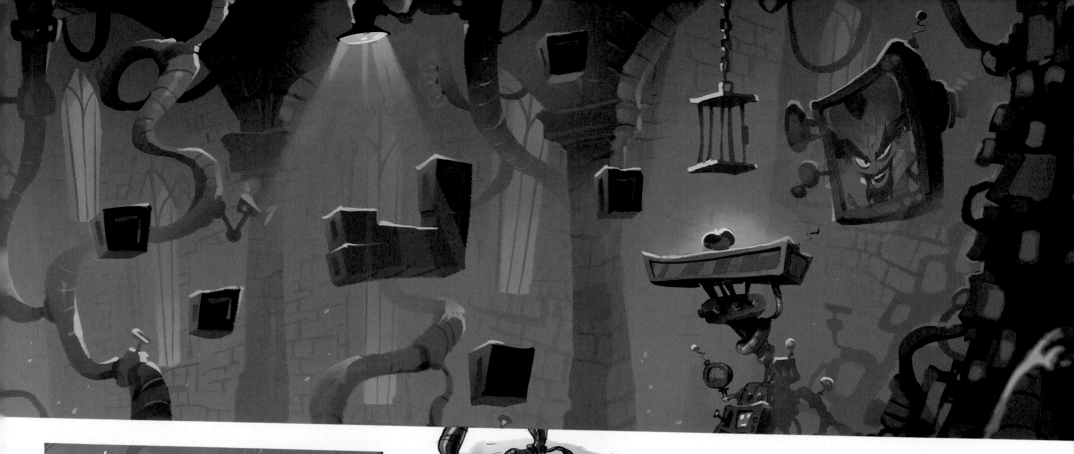

ROBOT

"What is Crash doing these experiments for? What does he get if he's successful? Is he doing these insanely deadly challenges for a measly wumpa fruit? We just wanted to push on the idea that he's a lab experiment. I think we talked about having a giant bandicoot water bottle at the end of the levels!"

—Josh Nadelberg

CUPCAKE LASER CAGE

BzzzzL!

LEVEL ENDINGS

SPECIAL THANKS

Curating a book like this is always a struggle. While it seems like this must be a pretty comprehensive collection, it truly just scratches the surface of all the artwork that was made along the way. The work presented here is also just an early step in the creative process, and it took a team of incredible 3D artists, animators, engineers, and designers to bring this vision to life in the game. Endless thanks to everyone for their boundless creativity, talent, and passion for the project. It was a delight bringing this world to life together.

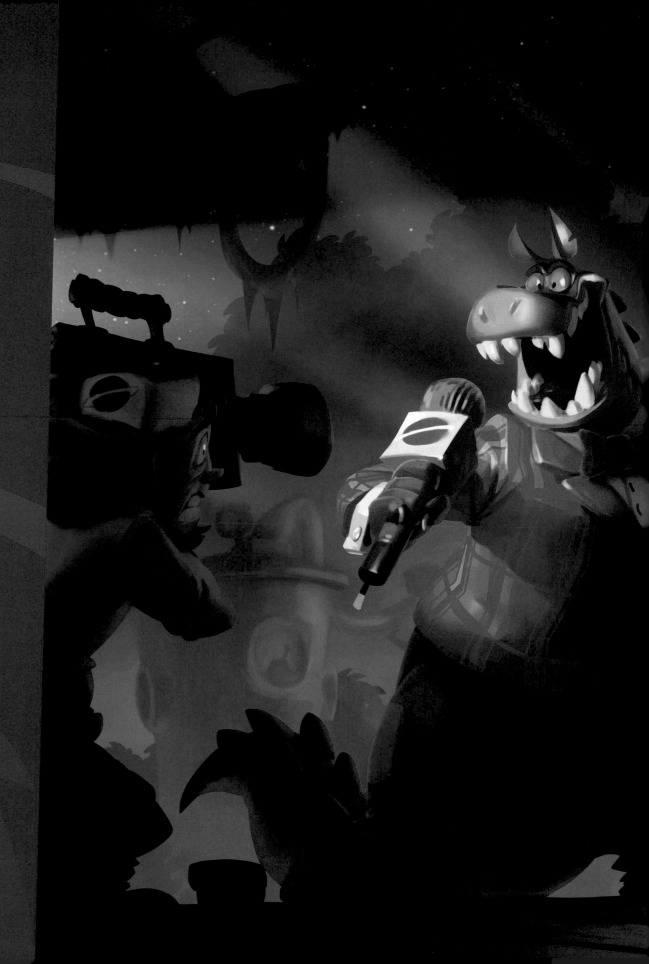

CRASH NARRATOR (V.O.)
Dingodile franchised his restaurant operation, with Dingo's Diner rising to become the first name in chain fast-casual dining.

They closed overnight with officials citing "record health code violations". The original location remains open during its condemnation.

CUT TO:

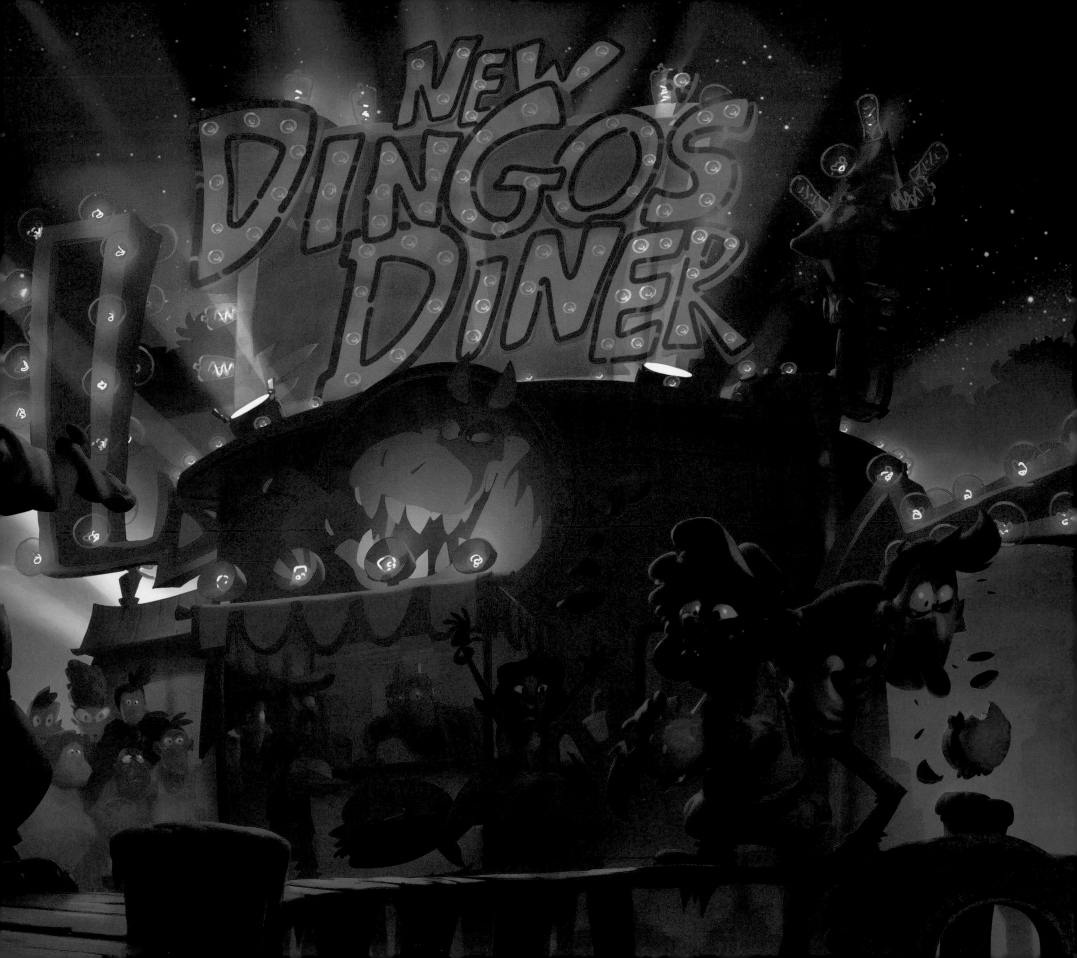

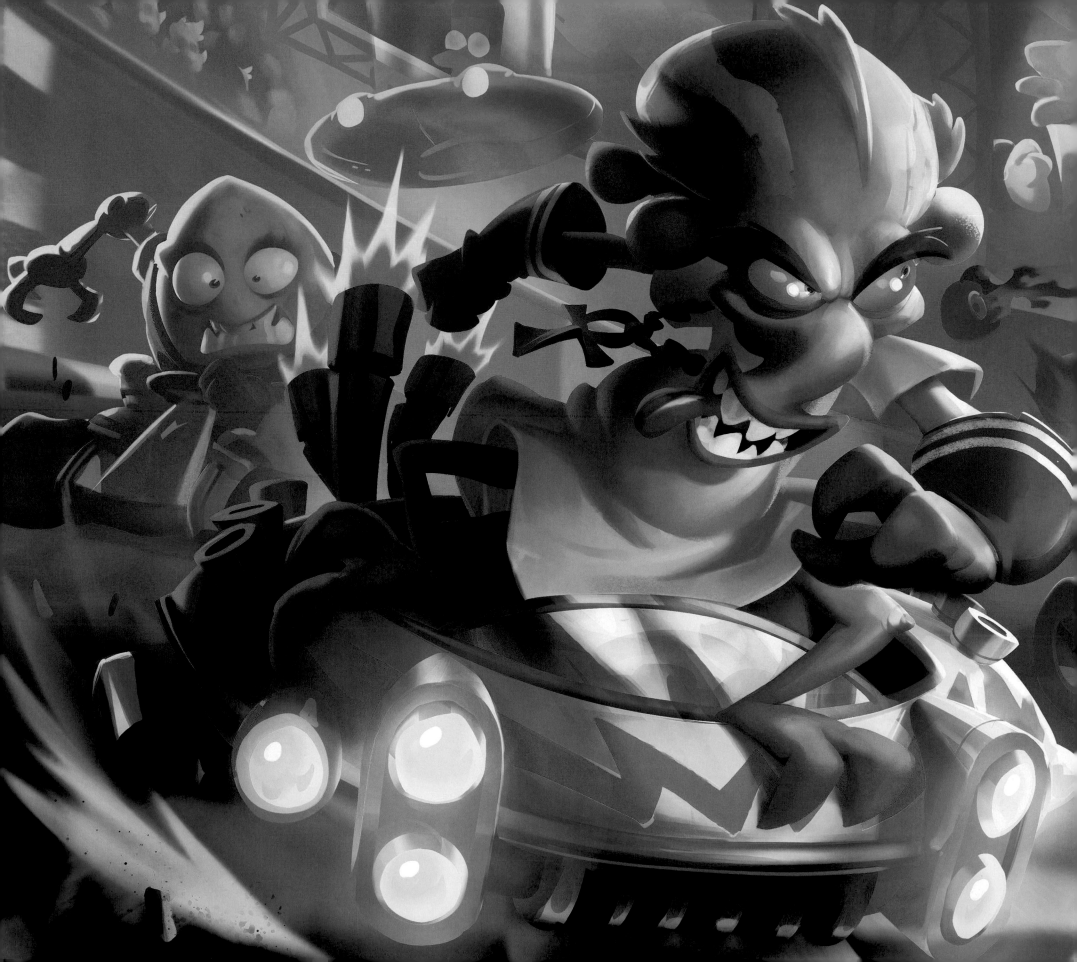

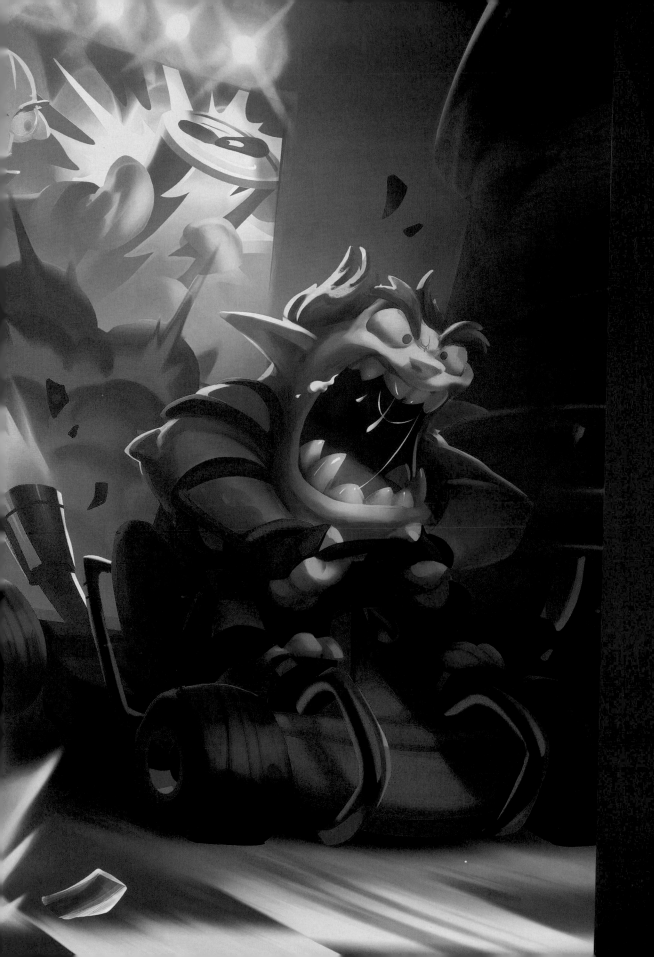

CRASH NARRATOR (V.O.) (ALT)
To fuel his need for speed, Oxide became hooked on caffeine. He was hired as the spokesperson for a leading brand of energy drink.

He is currently in rehab and in the throes of a messy divorce.

CUT TO:

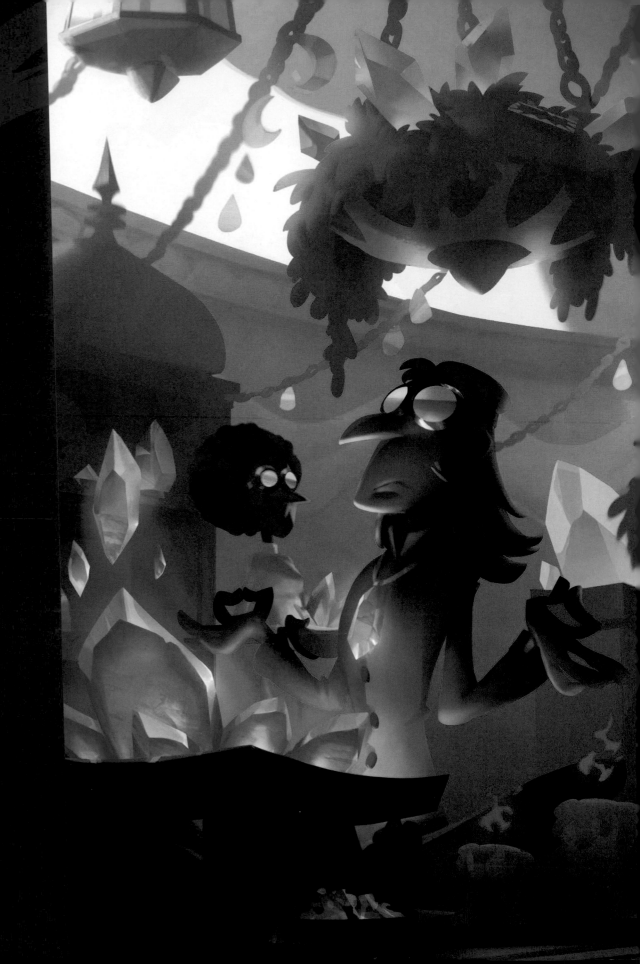

CRASH NARRATOR (V.O.)
Without their master, Cortex's lab assistants
found themselves in need of a new gig.

They renovated his blimp, turning it into
a successful pop-up shop specializing in
healing crystals.

CUT TO:

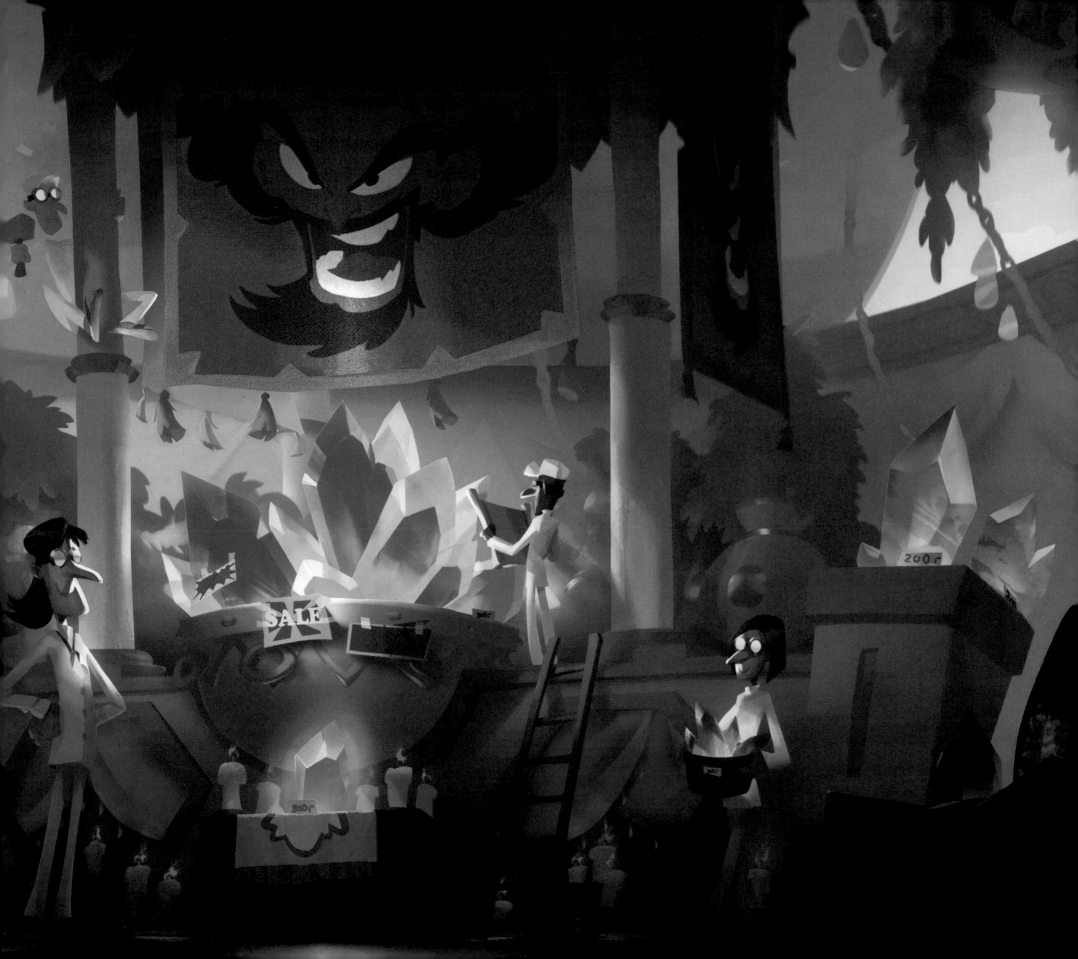

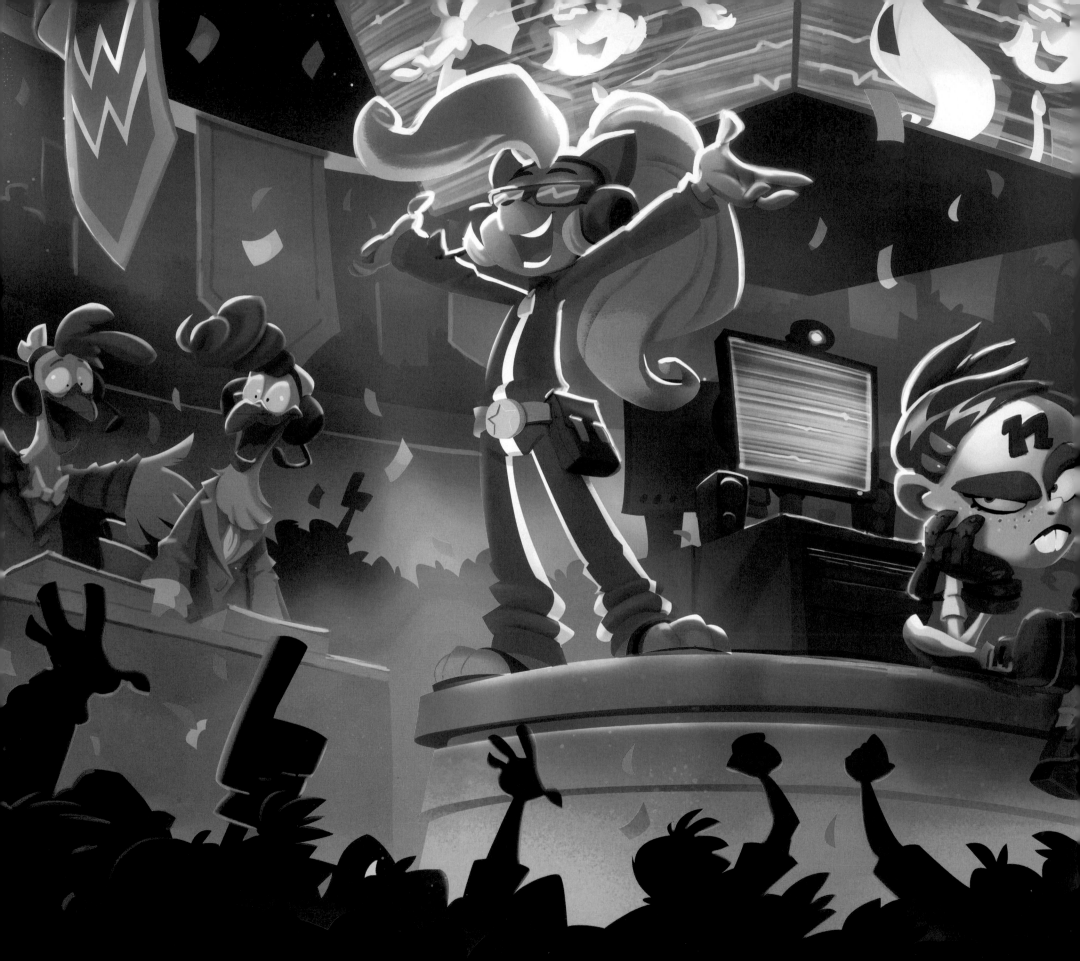

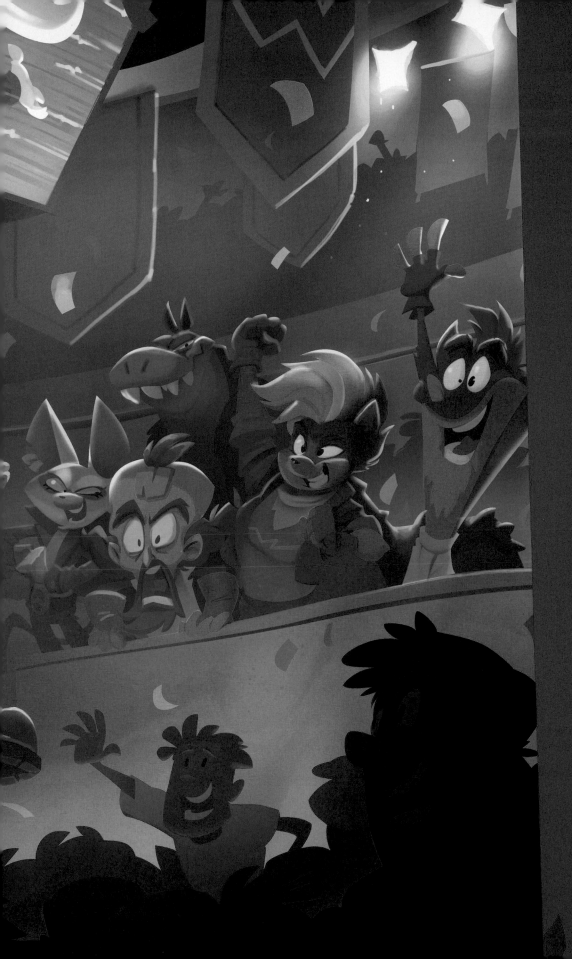

CRASH NARRATOR (V.O.)
After trying and failing to invent the world's
first self-flying flying car, Coco found a new
career as an esports champion.

Don't forget to follow Kickass Coco
and SMASH that "adore" button!

CUT TO:

CRASH NARRATOR (V.O.)
N. Brio was caught and caged after being
mistaken for a flying squirrel.

He is on display in the Art of Taxidermy at
Ripper Roo's Curious Cabinet of Curiosities.

CUT TO:

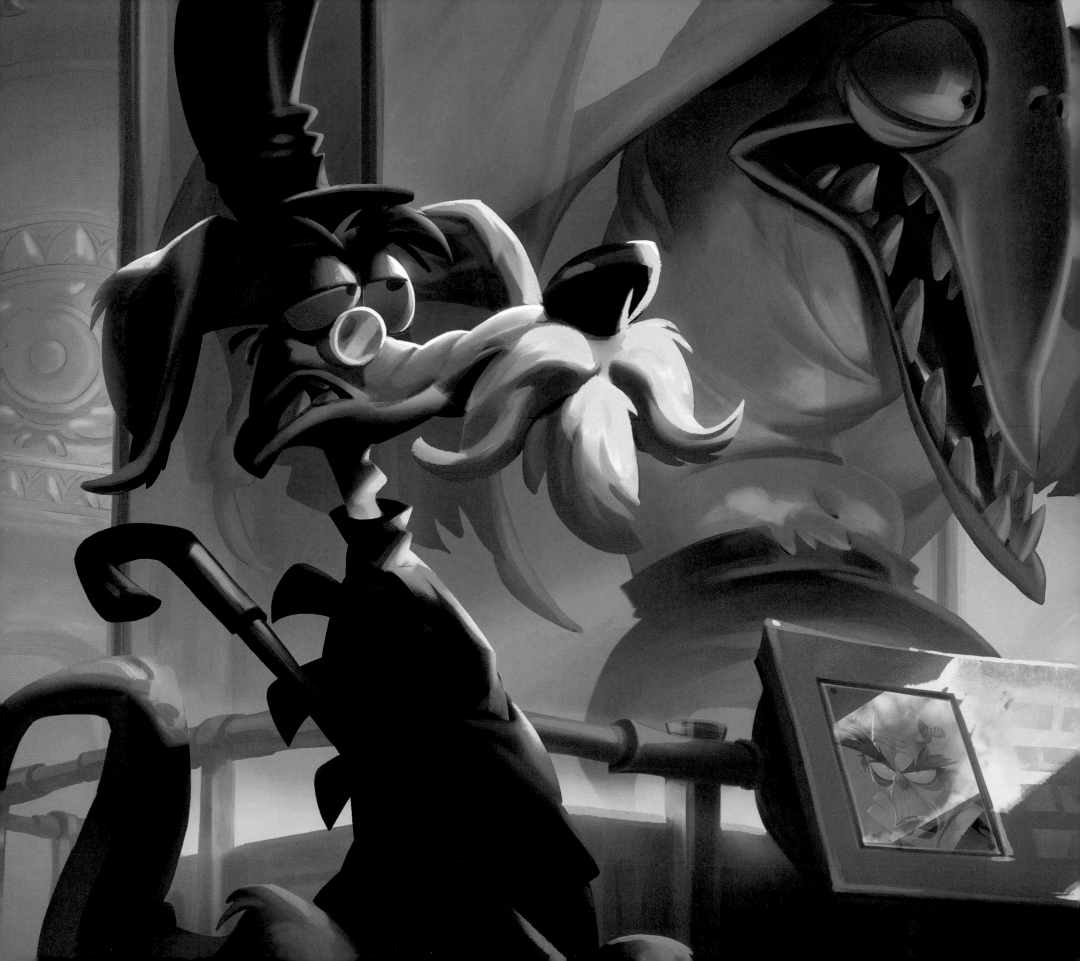

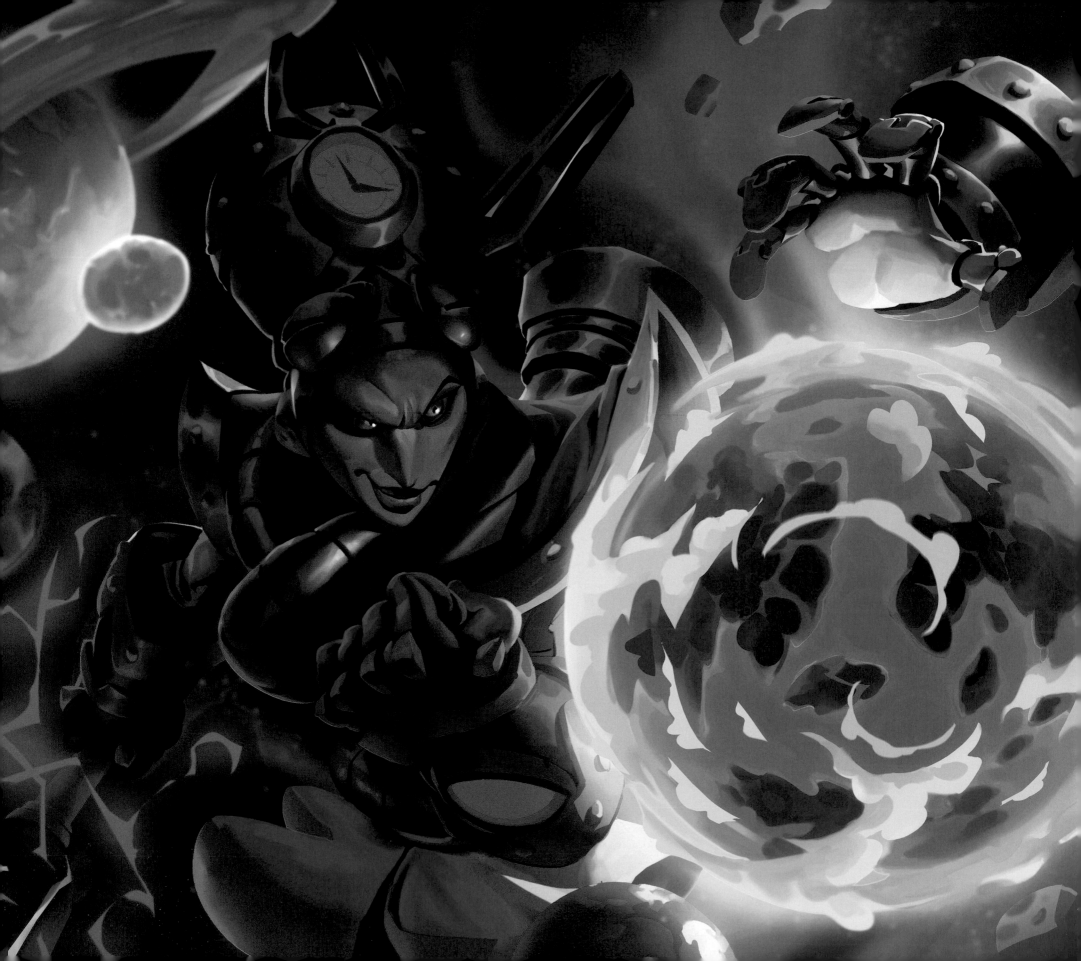

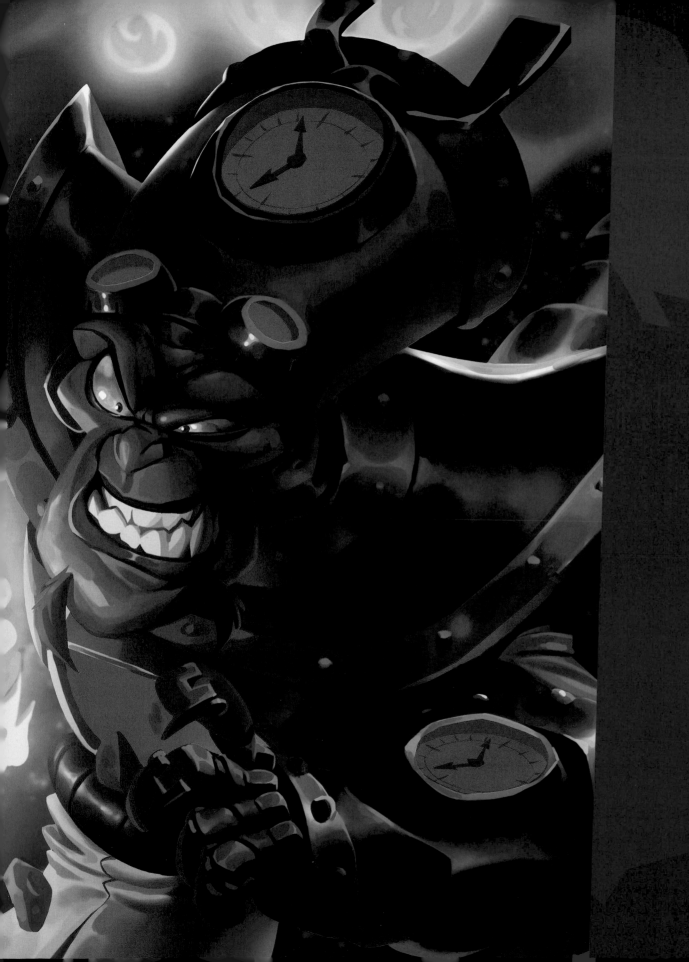

CRASH NARRATOR (V.O.)
The dimensions have heard nothing
more of The Doctors Tropy since
Crash foiled their plans...

But evil geniuses are harder to
squash than cockroaches.

CUT TO:

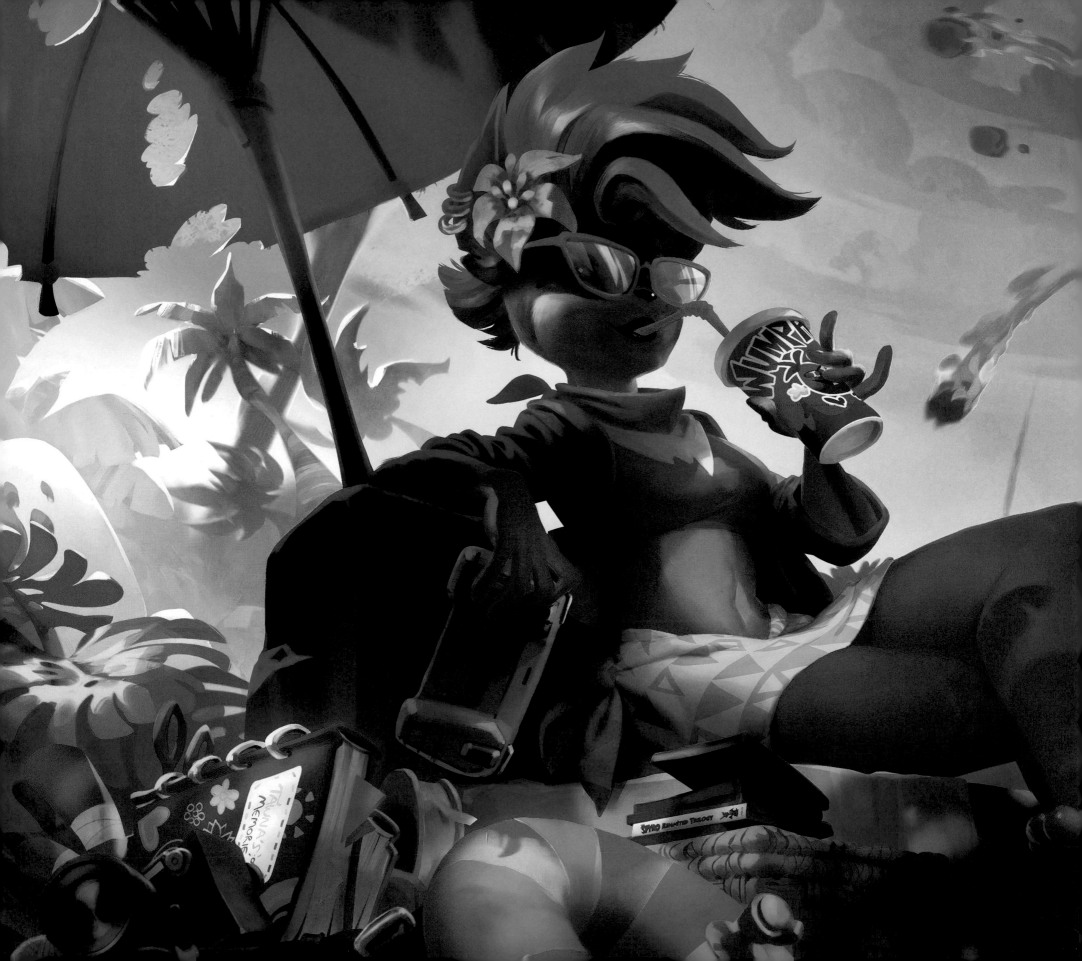

CRASH NARRATOR (V.O.)
After successful expeditions to El
Dorado, Shangri-La, Atlantis, and a
brief fling with some dweeb named
Shmathan Trake, Tawna is taking a brief
hiatus from her adventures to re-center.

She's recently taken up scrapbooking.
She's not very good yet, but she's
getting there.

CUT TO:

CRASH NARRATOR (V.O.)
N. Gin abandoned his heavy metal
lifestyle for one of smoooooth jazzzz.

His album "My Heart is a Doomsday
Device" is currently number one in
elevators all over the world. He'll be
playing in the hotel bar from 3 to 3:30.

MARSUPIAL TEST CHAMBER

MORE
CRATE
IDEAS:

- ~~BANANA CRATE~~
- ★ ELECTRO CRATE
- DEATH SPRING CRATE
- DEATH SPIKE CHAINSAW CRATE
- INVISIBLE CRATE " of DOOM "

DO NOT TRUST HIM!

NAME: TEST SUBJ N43
IQ : NOT FOUND
FEATURES: RED SNEAKERS

NITRO NITRO NITRO

N

ISBN: 9781950366231

Manufactured in China

Published by Blizzard Entertainment

Print run 10 9 8 7 6 5 4 3 2 1

Library of Congress Cataloging-in-Publication Data available.

FINAL NITRO CRATE TEST

N 737

Brett Bean - Page 16 (right), 25 (right), 27 (middle, right), 52 (2nd), 55 (bottom), 56 (bot left), 57 (bot left), 58 (top, bot right), 63 (top), 77 (bottom), 78 (top left), 79 (top), 82 (bot left), 84 (top), 85 (bottom), 86, 89 (top), 90 (top right, bottom), 91 (bottom), 95, 96-97, 250 (bot left), 251 (top), 252 (left), 256-257 (bottom), 260 (top left, top right), 261 (top)

Justin Chan - Page 19 (top left), 45 (top middle, right), 47 (middle left)

Florian Coudray - Page 4 (paint), 28 (top left), 31 (middle), 33 (top), 36 (top), 56 (top), 60-61, 62 (top), 73 (top), 75, 77 (top), 82 (top), 88 (top), 90 (top left), 118-119, 121 (top middle, top right), 130, 142 (right), 143, 232 (top, middle), 234 (top right), 235 (top right), 236 (top, bot left), 246 (top, bot left), 302-303 (paint)

Brun Cros - Page 107 (bot right), 108 (top), 113 (top right), 142 (bot right), 182 (bot right) 208-209 (right), 210 (middle), 211, 214-215, 249 (top), 250 (top left, middle), 251 (mid right), 252-253, 254, 255 (top), 258-259, 260 (bot left, top middle), 264 (middle left, bot left), 265, 266-267, 298-299 (paint)

Max Degan - Page 114-115, 184, 188-189, 193 (bottom) 242-243, 256 (top), 263 (top right), 264 (top left), 288-289, 300-301 (paint), 310-311 (paint)

Rob Duenas - Page 17(bot left), 40 (left), 145 (middle, bottom)

Jean-Brice Dugait - Page 83, 87 (top left), 98, 99 (top), 101 (bottom), 104, 106 (top), 108 (bottom), 144, 171 (top), 180, 182 (bot left), 183 (top), 186 (top), 187, 199 (top), 207, 251 (bot right), 262-263, 268, 286 (left), 290 (left)

Johannes Figlhuber - Page 2-3 (paint), 3 (crate), 6-7, 9, 54, 71 (bot, paint), 76, 82 (middle), 85 (top), 87 (top right), 102 (top left, bottom), 103 (top right, bottom), 106 (bottom), 107 (top), 110-111, 116, 120, 170, 171 (middle), 174-175, 182 (top), 183 (bottom), 185 (top), 190-191, 198, 203, 204 (bottom), 205 (top, middle), 206 (top), 208 (bot left), 216, 240-241, 244-245, 248, 249 (middle), 250-251 (bot Center), 260-261 (bottom), 263 (bot right), 288-289, 292 (top), 299 (right), 300 (left), 308-309 (paint), 309 (right)

Ilka Hesche - 78 (bot left), 79 (bottom), 80-81, 113 (top left), 154 (middle), 155, 192 (top right, bottom), 193 (top), 210 (top, bottom), 212 (right), 245 (right)

Ryan Jones - Page 18, 20 (top left), 40 (bottom), 45 (bottom), 47 (middle right), 48 (bot middle)

Ron Kee - Page 26 (row 1, 2), 66-67, 69, 73 (bottom), 159 (bottom), 167 (bottom), 269 (top), 271 (bottom right), 273

Nicholas Kole - Page 17 (bot right), 20 (middle, bottom), 21, 22, 24, 25 (left), 28 (top right, bottom), 29, 30, 31 (top, left), 32, 33 (bot right), 34-35, 36 (bottom), 37, 40 (top), 41 (top left, right), 42-43, 44, 46, 47 (top), 48 (left, top middle), 49, 94 (bottom), 138 (center), 139 (bottom), 141 (right), 142 (left), 154 (bottom), 158, 159 (top), 160 (left), 192 (top left), 217 (top, bottom), 220-221, 228 (top right), 231, 232 (bot left), 223 (bottom), 234 (left, bottom), 235 (top left, bottom), 236 (bot center, bot right), 237 (bottom), 238-239, 279 (bot right)

Simon Kopp - 12 (painting), 77 (middle), 87 (bottom), 99 (middle), 100-101 (center), 113 (bottom), 176 (top), 178-179, 186 (middle), 200-201, 202 (top), 255 (bottom), 286 (right), 287 (left, top right), 296-297 (painting)

John Loren - Page 1, 194-195, 240 (left), 242 (left), 271 (middle right), 283 (top left, bot right), 284, 292-293 (bottom), 294-295

James Loy Martin - Page 16 (left), 26 (row 3, 4), 27 (left), 45 (top left), 47 (bottom), 48 (top right), 52 (top right), 68, 154 (top), 156-157, 160 (right), 161, 162-163, 169 (right), 217 (middle), 218, 219 (top right, bot right), 222 (left), 224-225 226 -227, 228 (left, bot right), 229, 230, 269 (middle), 270 (bottom), 271 (top left), 279 (top, bot left), 280, 281 (top, bottom left), 282, 296 (left)

Thomas Michaud - 78 (top right, middle), 112 (top), 257 (top)

Jeff Murchie - Page 164 (middle), 165, 166 (top), 167 (top, middle), 168-169, 219 (bot left), 222 (right), 223, 225 (right), 274-275, 276-277, 278

Didier Nguyen - Page 50-51, 52 (left), 59 (bot, top right), 65, 70, 71 (top), 84 (bottom), 91 (top), 92 (bottom), 93, 121 (top left), 122 (top), 128-129 (top left, center), 132-133, 134 (top), 199 (middle paint), 233 (top), 237 (top), 246 (bot right), 306-307 (paint)

Vinod Rams - Page 33 (bot left), 52 (middle), 121 (bottom), 124-125, 128 (bot left), 137 (bot left), 149 (top left), 152 (top)

Nicola Saviori - Cover, Endpapers, Page 2-3 (lines), 4 (lines), 12 (lines), 13, 14-15, 20 (top middle), 38, 40 (middle), 41 (bot left), 47 (middle center), 48 (bot right), 52 (bot right), 56 (middle, left), 61 (bottom), 71 (bot lines), 72, 94 (top), 99 (bottom), 100 (left), 101 (right), 102 (top right), 103 (top left), 105 (right), 109, 110 (left), 117, 129 (right), 131, 137 (top, right), 138 (top right, top left), 145 (top), 146-147, 148, 149 (bot left, right), 150-151, 152 (bottom), 153, 164 (bottom), 166 (bottom), 171 (bottom), 172-173, 176 (bottom), 177, 181, 185 (bottom), 186 (bot left), 188 (left), 196-197, 199 (middle lines, bot right), 202 (bottom), 204 (top), 205 (bottom), 206 (bottom), 208 (top left), 212 (left), 213, 249 (bottom), 250 (top right), 269 (bottom), 270 (top), 281 (bot right), 283 (top right, bot left), 285, 287 (bot right), 291, 296-297 (lines), 298-299 (lines), 300-301 (lines), 302-303 (lines) 304-305 (lines), 306-307 (lines), 308-309 (lines), 310-311 (lines)

Giraud Soulie - Page 78 (bot mid, right), 112 (bottom)

Khoa Viet - Page 55 (top, middle), 57 (top), 61 (top), 62 (bottom), 63 (bottom), 64, 74 (left), 88-89 (bottom), 92 (top), 121 (middle), 122 (bottom), 123, 126-127, 134 (middle, bottom), 135, 136, 139 (top), 140-141, 164 (top left), 247, 293 (top right, middle right), 304-305 (paint)

Oleg Yurkov - Page 10, 17 (top), 19 (top right, bottom), 20 (top right), 57 (bot mid, right), 58 (bot left) 59 (top left), 88 (bot left), 164 (top middle, right), 271 (top right), 272 (left), 312

Artist Credits

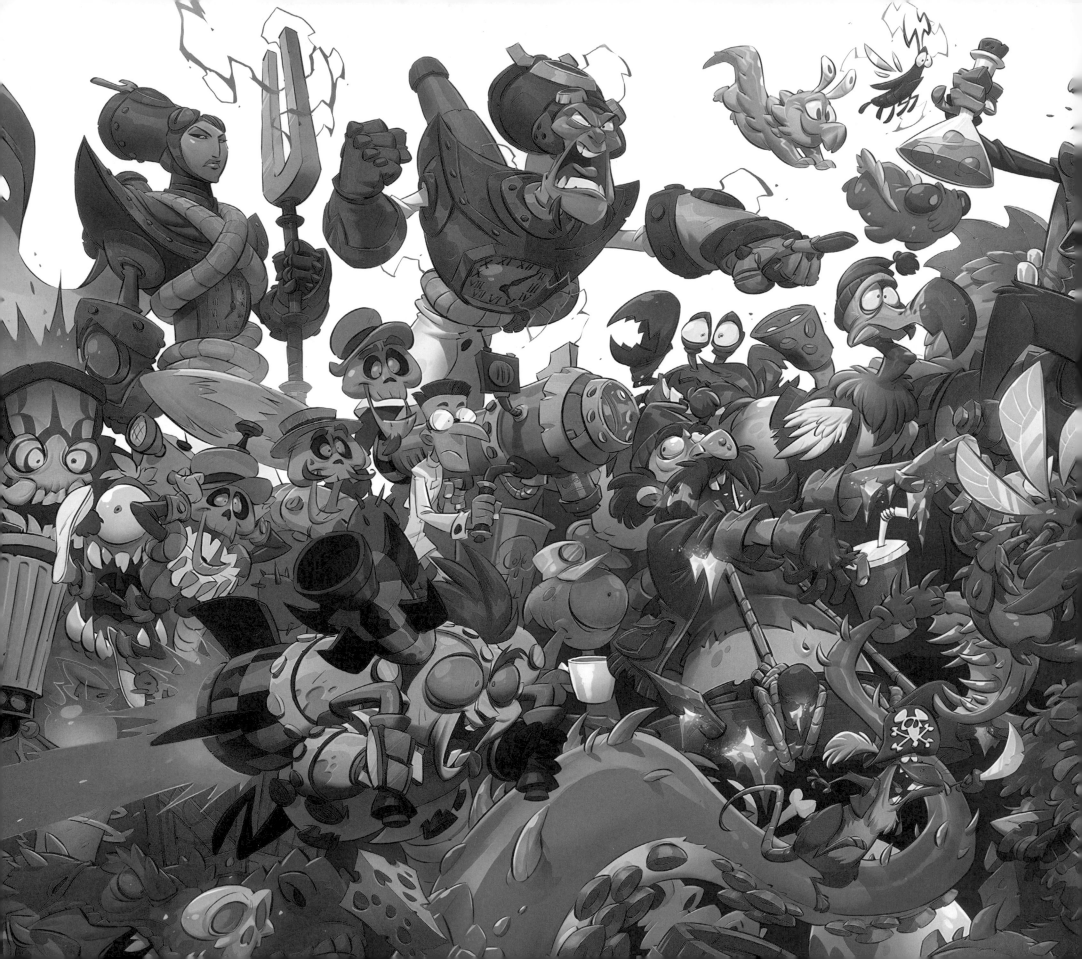